THE JOHNS HOPKINS STUDIES
IN NINETEENTH-CENTURY ARCHITECTURE

THE JOHNS HOPKINS STUDIES
IN NINETEENTH-CENTURY ARCHITECTURE

General Editor
PHOEBE B. STANTON

Advisory Editors
PETER COLLINS
HENRY-RUSSELL HITCHCOCK
WILLIAM H. JORDY
NIKOLAUS PEVSNER

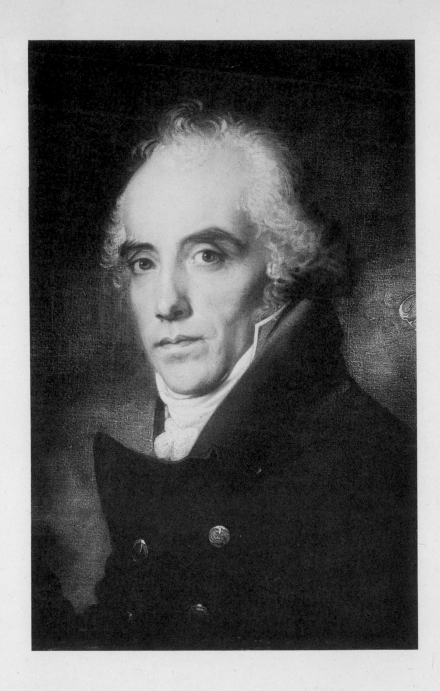

Maximilian Godefroy. Rembrandt Peale. Ca. 1814. Collection of the Peabody Institute of the City of Baltimore, on deposit at the Maryland Historical Society since 1936. Photo Frick Art Reference Library.

The Architecture of
MAXIMILIAN
GODEFROY

ROBERT L. ALEXANDER

THE JOHNS HOPKINS UNIVERSITY PRESS
Baltimore and London

This book has been brought to publication with the generous assistance of the Andrew W. Mellon Foundation and the University of Iowa.

The Johns Hopkins University Press, Baltimore, Maryland 21218
The Johns Hopkins University Press Ltd., London

Library of Congress Catalog Card Number 74–6810
ISBN 0–8018–1286–0

Library of Congress Cataloging in Publication data will be found on the last printed page of this book.

TO MY WIFE AND DAUGHTERS

Contents

List of Figures

LIST OF FIGURES

Foreword

For fourteen years Maximilian Godefroy (1765–1840?) sought to establish roots in the United States. The period from 1805 to 1819 he spent largely in Baltimore, where he moved in an intellectual and cultured society to which his education, taste, and wit gave him entrée. From this select group of friends came most of his clients and supporters. Yet even their power and resources were limited, and in 1819 Godefroy returned to Europe. He spent seven years in England and, from 1827 until he died, in provincial French cities that he occasionally referred to as "Siberia." Although he shuttled uneasily between the Old and the New Worlds, for Godefroy the transition between two ages was more difficult, and much of the interest in a study of his architecture lies in his attempts to reconcile the forceful, blunt demands of the early industrial age with the taste and inclinations established during the last decades of the *ancien régime*.

Godefroy's strong personality worked to his benefit and to his disadvantage: his charm helped convince friends of his taste; his acrimonious tongue created enemies and adversely affected his job opportunities. Partisan politics, too, and the contrary yearnings of the age influenced the range and variety of his professional activity. So highly was he regarded, however, that early in 1815 President James Madison approached him about reconstructing the federal buildings that had been destroyed by the British.

Godefroy's reputation remained high through the middle of the nineteenth century; eclipsed toward the end of the century, it has been revived in modern times. In this, a common cycle for artists' reputations, the downswing is signaled by the *Inland Architect*'s publication in 1889 of a handsome plate of the Unitarian Church in Baltimore with an attribution to Benjamin Henry Latrobe. As late as 1924 a critic gave St. Mary's Chapel, also in Baltimore, to Latrobe, but in 1926, with Joseph Jackson, the modern historical study of Godefroy begins. A chapter in the unpublished work of Claire W. Eckels and several pages in the book by Richard H. Howland and Eleanor P. Spencer, the major examinations of Godefroy's architecture as a whole, ap-

peared two decades ago.[1] Individual buildings by Godefroy have made their way into studies of American art and architecture as typical or standard monuments of the taste of the early nineteenth century. Most recently two of his works, St. Mary's Chapel and the Unitarian Church, have been recognized as National Historic Landmarks on the basis of their architectural merit.

The outlines of Godefroy's life have also been clarified. The perhaps oversympathetic account of Carolina V. Davison, published in 1934, was more than balanced by the critical estimate of Dorothy M. Quynn in 1957.[2] Miss Davison's sources were her large assemblage of Godefroy's letters and reports, written over a period of more than three decades. A fuller picture of the behavior, activities, and personalities of Godefroy and his wife emerged from other writings, both manuscript and published, turned up by Mrs. Quynn's scholarly sleuthing in this country and in France. The present book offers very little additional and new information, but for some variant interpretations the sources are cited in detail. Biography, in fact, plays little part in this study, and details of Godefroy's life have been used only as they advance the study of his architecture.

Both Godefroy and his wife, in the fashion of the times, wrote at length about themselves and their activities. From the large amount of manuscript material that has survived, representative pieces have been published. Several of Godefroy's buildings are well documented, some in great detail, in his own writings, but his statements of architectural theory or artistic judgment are rare. His occasional references to a concept of beauty in architecture or to the distinctive nature of his architecture and style have been cited in this book. It is perhaps

[1] *Inland Architect* 13 (1889), unnumbered pl.; Louis Mumford, *Sticks and Stones* (New York, 1924), p. 77; Joseph Jackson, *Development of American Architecture* (Philadelphia, 1926), pp. 124–25, 187–88; Claire W. Eckels, "Baltimore's Earliest Architects, 1785–1820" (Ph.D. diss., Johns Hopkins University, 1950); Richard H. Howland and Eleanor P. Spencer, *Architecture of Baltimore* (Baltimore, 1953), pp. 39–47, pls. 26–31.

[2] Carolina V. Davison, "Maximilian and Eliza Godefroy," *Maryland Historical Magazine* 29 (1934):1–20, 175–212; Dorothy M. Quynn, "Maximilian and Eliza Godefroy," *Maryland Historical Magazine* 52 (1957):1–34. William D. Hoyt, Jr., has also published several useful letters by Mrs. Godefroy, in "Eliza Godefroy: Destiny's Football," *Maryland Historical Magazine* 36 (1941): 10–21. With commendable foresight Miss Davison accumulated photostatic copies of Godefroy's correspondence with Ebenezer Jackson and the Sulpician fathers at St. Mary's Seminary, and with other individuals. These copies, gathered together with other materials at the Maryland Historical Society, are the only form in which many letters now exist, as the originals have disappeared.

characteristic that such statements appeared in pieces that he intended for publication at the time. His major articles concerning the Battle Monument and the Unitarian Church, two of his most important structures, are quoted here at length; they point to what Godefroy considered significant about them and about architecture in general. The fact of their publication in the early nineteenth century also implies that the editors of these journals considered the ideas of interest to their readership. They illustrate an understanding of the content of architecture that is different from today's.

Just as Godefroy went into debt to his tailor in order to "act the gentleman," so he was concerned with the appearance of his buildings. He was always aware of the impression he was making on others. Publication elsewhere has rendered unnecessary any detailed account of his nonarchitectural compositions,[3] but his architectural drawings have been studied here. Rarely concerned with structural questions, they were made for display and often exhibited publicly, and Godefroy intended to have them engraved. Thus they become another source for our understanding of his conception and intention and occasionally of his correction of a design. For his contemporaries they exemplified a level of architectural sophistication approaching that of Latrobe and contributed to the professionalization of architecture.

A large number of individuals and institutions should be thanked here for their aid and encouragement. Foremost is Henry-Russell Hitchcock, who as mentor and example is responsible for much that is good and valuable in the study. The staff of the Maryland Historical Society, under the directorships of the late James W. Foster and now Harold R. Manakee, has been extraordinarily helpful, especially in making available the large manuscript holdings by and about Godefroy. Wilbur H. Hunter, director of The Peale Museum, provided further materials and information on Godefroy and lit the way through the obscurities of the social, political, and economic history of early nineteenth-century Baltimore. The Graduate College of the University of Iowa has helped cover the costs of typing, photography, and publication. Finally, and not least, a Samuel S. Fels Fellowship a dozen years ago made possible the writing of the first version of this study.

[3] See Robert L. Alexander, "The Drawings and Allegories of Maximilian Godefroy," *Maryland Historical Magazine* 53 (1958):17–34.

The Architecture of Maximilian Godefroy

I. Background and Training

The Paris into which Maximilian Godefroy was born in 1765 was the national center for architectural activity. The strength of the Academy made it the stage for significant developments in theory, teaching, and practice, in the politics of architecture as well as publication on the art. Godefroy gained some kind of training in civil engineering but, aside from a little teaching, rarely practiced as an engineer. The city, where he lived the greatest part of his first forty years, was about to be plunged into turmoil, and the nation's upset is reflected in his life after the Revolution. Two periods of residence outside of Paris are known: he served for eighteen months in the army in 1794–95, and for about fifteen months in 1795–97 he supervised various properties for relatives, one of whom settled a small income on him. Returning to Paris, he served as secretary to a legislator, tutor to a young relative, employee at the Trésorerie nationale, in an office dealing with the national debt, secretary to an engineering officer, and finally employee of the Travaux du canal de Strasbourg. On September 3, 1803, he was arrested by the secret police, following an anonymous denunciation. Suspected of holding ideas inimical to the Napoleonic regime, although never charged or tried he was imprisoned for nineteen months, almost half of this time in southern French strongholds. He sailed in exile to a new life in the United States on March 12, 1805.[1]

[1] Details of Godefroy's life have been published in the following: Carolina V. Davison, "Maximilian and Eliza Godefroy," *Maryland Historical Magazine* 29 (1934):1–20; Carolina V. Davison, "Maximilian Godefroy," *ibid.*, pp. 175–212; William D. Hoyt, Jr., "Eliza Godefroy: Destiny's Football," *ibid.*, 36 (1941):10–21; Dorothy M. Quynn, "Maximilian and Eliza Godefroy," *ibid.*, 52 (1957):1–34. Most of the information on Godefroy's life before 1805 comes from his police dossier, F⁷ 6366 doss. 7484, Archives Nationales, Paris, which was used extensively by Quynn and will be referred to here only for information or interpretation different from hers. J. Fouché (1759–1820), head of Napoleon's secret police, granted the exile on condition of two guarantors. These were L.-B. Francoeur (1773–1849), mathematician, engineer, and professor at the Lycée Charlemagne and later the Sorbonne, and C.-F. Quéquet (1768–1840), a lawyer then employed at the Treasury who during the Restoration received a high court post for his services in behalf of the Bourbons.

Godefroy's education apparently was that of a gentleman of the *ancien régime*. In keeping with the historical interests of the age, he received a strong classical training, as the mythological allusions in his letters and drawings make clear. He was widely read in many fields.[2] The police made a general inventory of the great quantity of papers seized at the time of his arrest and later returned to his sister; now lost, these papers included thousands of pages of notes on literature, the sciences, and mathematics. In writing his manner of expression was generally elegant, clear, and precise, within the limitations of eighteenth-century formality, and displayed an extensive vocabulary, including specialized technical terminology. Even in his later diatribes against Latrobe there was never an impropriety or vulgarity. He wrote few pages carelessly or illegibly; the primary exception is a letter of 1817, when he was under severe pressure both financially, with large debts and little income, and emotionally, having recently quarreled with B. H. Latrobe, who, he feared, was competing with him for the design of the Unitarian Church. Written in haste and spleen, this letter borders on illegibility and incoherence. Normally, however, even in English his vocabulary was large and his grammar relatively correct.[3] Clarity and precision are equally evident in the many pages of detailed calculations and estimates preserved in the departmental archives at Laval.

Although he never painted in oils and could not engrave, Godefroy possessed a competent drawing ability when he arrived in the United States. The strong classicistic element in his technique suggests a training in the Davidian circle of the eighties and nineties.[4] Beyond the question of technique, seven-

[2] In an essay seized by the police and still in Godefroy's dossier, "Mes chateaux dans la Nouvelle-Espagne," dated 1802, he referred to and quoted from Plato, Marcus Aurelius, Plotinus, Galileo, and others.

[3] For letters against Latrobe, see Godefroy to E. Jackson, Richmond, Sept. 7, 1816, and Baltimore, Aug. 13, 1818, both at the Maryland Historical Society. For the almost incoherent letter, see Godefroy to [Tessier], Baltimore, Mar. 29, 1817, Maryland Historical Society. For a letter in English, see Godefroy to Smith, Washington, Oct. 14, 1814, Samuel Smith Papers, Box 7, Library of Congress.

[4] An attempt has been made to identify Godefroy with the first drawing teacher of M.-E.-J. Delécluze: see Rich Bornemann, "Some Ledoux-Inspired Buildings in America," *Journal of the Society of Architectural Historians* 13 (1954):16. That teacher, himself once a student of the painter Jacques-Louis David, frequented the Delécluze household and engaged in royalist activities in Paris during 1794–95 (M.-E.-J. Delécluze, *Louis David: Son école et son temps* [Paris, 1855], pp. 11–13). During the greatest part of this period, Feb. 14, 1794, to Sept. 17, 1795, Godefroy was with the army of the north, outside of Paris, and by Oct. 11, 1795, he was in Beaugency

teenth-century art interested Godefroy, as his knowledge of the paintings of Eustache Le Sueur indicates.[5] A group of physiognomic studies inventoried by the police represented a considerable knowledge of the academic painters' method of depicting emotions through facial expressions. During his imprisonment drawing became one of his chief occupations, his guard reported, and in 1805 he had sufficient knowledge and ability to produce the large, classically organized, many-figured *Battle of Pultowa*.[6]

Godefroy's claim to be an engineer is among the surer facts of his early life, as the police could easily check his statements, but his training and experience are quite uncertain. While in prison he consistently signed himself as "engineer-geographer," and indicated that this was his function in the Treasury. In several appeals to Napoleon he requested exile to America, where he could use his knowledge and talents as a civil engineer. In one police document he was called *ingenieur-hydrologue*, and at one interrogation he gave the works for the canal at Strasbourg as his latest employment. To the weight of these details may be added his friendship with L.-B. Francoeur, one of the guarantors for his exile in 1805. Author of many books on mathematics, astronomy, and mechanics, Francoeur was one of the first students enrolled at the Ecole Polytechnique in 1795. Intermittently he worked at the Treasury, served with the engineer-geographers and with the artillery in the army, and, following his first appointment as *répétiteur*, maintained a continuing relationship with the Polytechnique.[7] He and Godefroy clearly had several activities in common—employment at the Treasury and interests in mapping, mathematics, and engineering. Their friendship highlights the rational, intellectual, and engineering emphasis in Godefroy's education and early life.

Godefroy arrived in New York City on April 26, 1805, with a number of letters of introduction, for the most part addressed to merchants of New York and Philadelphia. Among them, however, was one to James Madison, the secretary of state,

for a fifteen-month stay (Quynn, "Godefroy," p. 7). Delécluze described his tutor as about twenty-four, ten years younger than Godefroy, and both blond and lazy. The police records of 1803–5 make it clear that Godefroy was very dark in hair and beard, and the charge of laziness falls before the astonishing quantity of papers, notes, and other materials he produced.

[5] See the *Observer*, Sept. 19, 1807.

[6] Quynn, "Godefroy," pp. 8–9; for the *Battle of Pultowa* see Robert L. Alexander, "The Drawings and Allegories of Maximilian Godefroy," *Maryland Historical Magazine* 53 (1958):21–22 and illustrations.

[7] *Nouvelle biographie universelle*, s.v. "Francoeur, Louis Benjamin."

and another to Thomas Jefferson, president of the United States.[8] Godefroy stayed in New York less than two weeks. Evidently Philadelphia was more attractive, and he moved there early in May, 1805. He quickly became acquainted with members of the French community and received a few commissions to make drawings. One friend, D. Volozan, a French painter of large allegorical works, was invited to teach at St. Mary's College in Baltimore. When he refused, he recommended Godefroy for the post in flattering terms. Godefroy was accepted as a teacher of drawing, architecture, and fortification, to begin in November, but he delayed his arrival for about three weeks in order to complete a large drawing for a "Monsieur Banduit," a work on which he had already spent a month.

About December 1, 1805, Godefroy arrived in Baltimore. He established himself in the new community so rapidly that within months the artist C.-F. de Saint-Mémin turned over to Godefroy a possible commission for a military emblem, and Benjamin Henry Latrobe began a long correspondence with him.[9] Having become friendly with the strongminded bluestocking Mrs. Eliza Crawford Anderson, he solicited articles on the arts for her newspaper, the *Observer*. She in turn translated and published portions of a pamphlet he wrote on military defense, which appeared in 1806.[10] On December 29, 1808, they were married, and despite their quick tempers and continued financial hardships the two lived together for over thirty years.

[8] Théophile Cazenove to Madison, Paris, Jan. 2, 1805; Godefroy to Madison, Baltimore, Mar. 2, 1806, James Madison Papers, Library of Congress, Washington; Godefroy to Jefferson, Jan. 10, 1806, vol. 155, Thomas Jefferson Papers, Library of Congress. See also Jefferson to Dr. Logan, Washington, Mar. 8, 1806, vol. 157, Jefferson Papers; with his own letter Godefroy included an introduction from Stephen Cathalan, Jr., a longtime friend of Jefferson's and U.S. consul in Marseilles for many years. Among the prominent merchants to whom Godefroy had letters were Robert Livingston, Samuel Bayard, Ebenezer Stevens, and Louis Simond of New York, and Charles Biddle of Philadelphia.

[9] For Saint-Mémin's aid, see Godefroy to J. Williams, Baltimore, May 21, 1806, Papers of the United States Military Philosophical Society, New-York Historical Society. Latrobe's first letter to Godefroy is dated Washington, Aug. 18, 1806, and the correspondence, continuing until 1816, is preserved in the polygraphic Letterbooks of Latrobe in the Maryland Historical Society. (Many of these letters have been published in part, and the polygraphic copies will be referred to only for unpublished material.) The tone of this letter, in response to one of Godefroy's, leaves no doubt as to the frankness and cordiality between these two men.

[10] Portions of Godefroy's *Military Reflections on Four Modes of Defence for the United States* . . . (Baltimore, 1807) appeared in the *Observer*, July 18-Aug. 15, 1807.

Baltimore in 1805 was a rapidly growing city. Its population had nearly tripled in fifteen years. As a trade and shipping center it threatened Philadelphia for first rank. Foreigners were welcome, and the French were especially numerous, including refugees from both France and Santo Domingo.[11] From revolutionary France had come a group of Sulpicians who, in 1790, founded St. Mary's Seminary and later a college.[12] A boom in building was inevitable; while housing had kept up with the growth in population, public and commercial facilities had lagged. A new courthouse was under way, and the Roman Catholics were planning their new cathedral. Numerous banks, chartered early in the century, occupied temporary quarters and would soon require permanent structures. Building trades accounted for the largest number of occupations listed in the city directories. Although several builders and an occasional amateur designed projects, there were no professional architects, an opportunity that may have been in Godefroy's mind on his arrival. The Sulpicians, indeed, were contemplating a large

[11] For Baltimore in this period, see the excellent essay by R. M. Bibbins, "Baltimore, 1797–1850; An Epoch of Commerce and Culture," in Clayton C. Hall, ed., Baltimore, Its History and Its People, 3 vols. (New York and Chicago, 1912), 1:63 ff. For the interweaving of commercial and cultural activities, see Stuart W. Bruchey, Robert Oliver, Merchant of Baltimore, 1783–1819, The Johns Hopkins University Studies in Historical and Political Science 74, no. 1 (Baltimore, 1956), pp. 29–40, 100–103.

Census figures show the rapid growth of the city through the first half of the nineteenth century (George W. Howard, The Monumental City [Baltimore, 1873], pp. 25, 31):

1790	13,503
1800	31,514
1810	46,555
1820	62,738
1830	80,625
1840	102,313
1850	169,054
1860	212,418.

On French influence, see James S. Buckingham, America, Historical, Statistic, and Descriptive, 3 vols. (London, 1841), 1:456–58. For much enlightenment on the political, economic, and social history of Baltimore, I am indebted to Wilbur H. Hunter, director, The Peale Museum.

[12] Godefroy's lengthy correspondence with the Sulpicians at St. Mary's Seminary has survived in the seminary archives. (In the course of amassing a large body of materials on Godefroy, Miss Davison acquired photostatic copies of these letters; for the sake of convenience we shall make references to these copies deposited at the Maryland Historical Society.) Godefroy advertised for private pupils in the newspapers (Baltimore Federal Gazette, Feb. 24–Mar. 1, 1809, Nov. 13–23, 1812, Sept. 27–Oct. 11, 1815; Baltimore American and Commercial Advertiser, Nov. 19–28, 1812, Apr. 12–17, 1813). The Maryland Historical Society has a receipt for "five dollars for his Entrance in the Academy," given by Godefroy to "Mr. Cohoun" on Oct. 31, 1815.

new chapel, and within a few months Godefroy was designing his first building.

Ignorant of the urban political situation, Godefroy allied himself with the class in power. The struggle between the conservative merchant class and the rising mechanics was particularly evident in Baltimore. Even a successful and wealthy man like Col. William Stuart kept his humble title of "stone cutter" after he became mayor. The merchants' intellectual and cosmopolitan interests attracted Godefroy, and they comprised the largest part of his circle of acquaintances. Their support led to his architectural commissions, while their political defeats accounted in part for his later personal and financial failure.

Godefroy had several qualifications for admission to Baltimore's most respected social circles. St. Mary's College, where he taught from 1805 to 1817, was among the best schools in the country, with a prominent clientele. Latrobe sent his sons there, as did James McHenry, once secretary of war; Ebenezer Jackson of Savannah, Georgia, and Middletown, Conn., studied there, along with many young men of French origins. Godefroy's marriage to Eliza Crawford Anderson brought closer relations with the O'Donnells, Olivers, and Pattersons.[13] Well educated and a man of much personal charm, Godefroy moved easily among these people, and several of them became his clients. He hoped for work in Savannah and Philadelphia, but his one attempt to set up elsewhere, in Richmond, was quickly abandoned. Convinced that commissions were awarded through the influence of powerful friends, Godefroy felt his position much weaker outside of Baltimore.

Godefroy visited Washington frequently to seek an appointment as a military engineer with the War Department and spent Christmas there with the Latrobe family. Several friends

[13] Charles G. Herbermann, *The Sulpicians in the United States* (New York, 1916), ch. 4, "St. Mary's College, 1805–1830," pp. 91–123. Ebenezer Jackson (1796–1874) graduated from St. Mary's in 1813 and served in the House of Representatives in 1834–35. Defeated for reelection, he toured Europe and sought out several former acquaintances, including Godefroy. The Godefroys' letters to Jackson in 1816, 1818, and 1836–38 were the basis for Davison's study of Godefroy. Mrs. Godefroy was a niece of the merchant John O'Donnell (1749–1805), who bequeathed to her the use of the house on Hanover Street where she and Godefroy were living. She was a close friend of the wealthy Olivers; Robert Oliver and his sister-in-law, Mrs. John Craig of Philadelphia, lent Godefroy $1,500, which he never repaid, in 1809 (Ledger B, p. 20, Robert Oliver Papers, Maryland Historical Society). She was an intimate of Betsy Patterson, Mme Jerome Bonaparte, accompanied her on an unhappy voyage to Europe, and wrote of her personal affairs.

in Philadelphia and the competition for the Second Bank of the United States accounted for his visits to that city. He left Baltimore in the summers to escape the heat and humidity; one of these trips in 1810 took him to Harpers Ferry, another coincided with a call to work in Richmond in 1816.[14] Despite the apparent success of Latrobe, Godefroy was aware of his financial reverses and his constant despair over the level of popular taste in America. Both men realized that the great quantity of work was being handled by the carpenter and bricklayer and that the professional architect had to turn builder for financial reward.

With this in mind, Godefroy resigned his teaching post in the fall of 1817.[15] The drudgery of teaching never appealed to him, despite his rewarding friendships with a few students. At the time he believed that the income from superintending construction, added to that from his designs, would more than equal his basic teaching salary. He was then actively directing work on the Battle Monument and the Unitarian Church, and similar work for the Baltimore branch of the Bank of the United States was imminent.

Such optimism was premature. By the summer of 1819 all prospects of work and income disappeared. The church was

[14] For the military appointment Godefroy was in Washington on Oct. 13–14, 1814 (Godefroy to Monroe, Oct. 13, 14, 1814, War Department, Letters Received, G-70 [8], Record Group 107, National Archives, Washington). He evidently joined the Latrobe family's Christmas celebrations each year from 1808 to 1812 and visited for part of the summer of 1812 (Latrobe to Godefroy, Washington, Dec. 22, 1808, Dec. 16, 1809, May 20, Dec. 13, 1812, Letterbooks). After his initial stay in 1805, Godefroy was in Philadelphia in June, 1808, in late June, July 27–29, and Aug. 29–Sept. 9, 1818 (E. Godefroy to Bonaparte, Trenton, July 2, 1808, Bonaparte Papers; Godefroy to Jackson, Baltimore, Aug. 13, 1818; E. Godefroy to Girardin, Baltimore, [Aug.] 25, 1818, all Maryland Historical Society). He was friendly with the painters Thomas Sully and John McMurtrie, and his former pupil W. Sitgreaves also lived in Philadelphia (Godefroy to Sully, Baltimore, Aug. 22, 1819, Dreer Collection, Historical Society of Pennsylvania, Philadelphia). The Godefroys probably accompanied Latrobe on the latter's trip to Harpers Ferry in August, 1810, at which time Godefroy made a large drawing exhibited in Philadelphia in 1811 (Latrobe Sketchbooks, vol. 11, nos. 13-5, Maryland Historical Society; First Annual Exhibition of the Society of Artists of the United States, 1811 [Philadelphia, 1811], p. 19). This picturesque landscape had received wide publicity through the recent travel account of John E. Caldwell, A Tour through Part of Virginia (New York, 1809). The Godefroys were in Richmond from July to September, 1816, and in Charlottesville for the first half of October, 1816 (Godefroy to Girardin, Richmond, Sept. 19, 1816, Historical Society of Pennsylvania; Godefroy to Jefferson, Natural Bridge, Oct. 12, 1816, vol. 208, Jefferson Papers).

[15] Godefroy to the president and directors of the Office of Discount and Deposit, Baltimore, Aug. 13, 1819, Maryland Historical Society.

completed, and he had drawn his salary for the monument. The depression of 1819 and the expulsion of his friends from the Bank board led to his arbitrary dismissal from the direction of the building in process. This disaster, and his loss of the bank competition in Philadelphia, he attributed to a cabal engineered by Latrobe, with whom he had quarreled in 1816 over the Baltimore Exchange design.[16] Without work, income, or prospects and laden with debts, he sailed for England on August 27, 1819.

Although Godefroy had arrived in America fourteen years earlier with sufficient ability to teach drawing and with training and experience enough to anticipate some kind of work as an engineer, he undertook architectural design at the first opportunity. The extent of his earlier interest in architecture cannot be gauged, yet the general intellectual public maintained a high interest in the art. Popular journals often carried descriptions, interpretations, and evaluations of architecture, and occasional buildings became symbols of distinction for individuals and groups: the church of Sainte-Geneviève, for example, was renamed the Panthéon to evoke the memory of the Revolutionary heroes whose ashes it received. Architectural criticism and taste were topics for discussion in Parisian salons, such as the one which Godefroy attended.[17] Apparently he was familiar with current theories and developments, with specific buildings, especially recent ones, and with the literary aspects of architecture, including its symbolic content. As no comments by Godefroy on such matters survive, the rapid survey of the architectural background of the late eighteenth and early nineteenth centuries in France and the United States undertaken below can only suggest the theories and buildings that might have formed his architectural taste and understanding.

At the time of Godefroy's birth a strong classicizing trend dominated French architecture. Even before mid-century this trend gained strength by reviving the vocabulary and forms of the seventeenth-century academic tradition. In the middle dec-

[16] Godefroy to Tessier, Baltimore, June 22, 1819, Maryland Historical Society; Talbot F. Hamlin, *Benjamin Henry Latrobe* (New York, 1955), pp. 489–93.

[17] The hostess for a small group of intellectuals, including Godefroy, who were interested primarily in literature, mathematics, and engineering wrote, in an impassioned plea for Godefroy's freedom, "c'est l'assemblage rare des vertues, des talens, des qualités sociales, qui le font aimer si tendrement" (Honoré de Flainville to the minister of the Secret Police, December, 1803, F[7] 6366 doss. 7484).

ades of the eighteenth century, the rediscovery of classical antiquity gave a new intellectual content to architecture, and theorists found new bases for rationalizing planning and construction as well as the visual appearance of buildings. In the last third of the century both architectural theory and actual buildings introduced basic geometric shapes in compositions that, it was felt, revealed the purpose of the structures. This intellectualization of form to impress the viewer with an essentially emotional comprehension of function has been named Romantic Classicism, a term that expresses the diverse sources, methods, and interests of its master architects.

French Neoclassical architecture began with J.-N. Servandoni's front for Saint-Sulpice (Fig. I–1). Designed in 1732, this facade underwent major revisions about 1739 and 1749. Its pedimented center and separated end pavilions carrying the towers clearly follow Sir Christopher Wren's St. Paul's in London, but this English building owed much to Claude Perrault's east front of the Louvre (1667–70), especially the paired columns screening the long vestibule and gallery. As completed, the facade of Saint-Sulpice gains a strong unity from its superposed columns and heavy entablatures stretched across the entire front. Recalling the end pavilions of the Louvre in the disposition of the columns and arches and in the decorative sculpture, the lower stages of the towers terminate the composition, giving a sense of self-containment. In addition to the squared overall shape and the two-story facade common in seventeenth-century churches, the Baroque play of plastic elements against deep voids re-established the visual character of the major Parisian monuments of Louis XIV.[18]

[18] Servandoni's facade for Saint-Sulpice was designed in 1732 when earlier Rococo plans were found unsatisfactory; our illustration shows the first revision, ca. 1739; on Servandoni's death in 1766 Oudot de Mac-Laurin redesigned the upper part of the facade with its long balustrade; in 1775–80 J.-F.-T. Chalgrin completed the north tower and designed the great organ (Louis Hautecoeur, *Histoire de l'architecture classique en France*, 6 vols. [Paris, 1943–55], 3:317–19, 362–65, figs. 262–63, 309–11, 4: 217, 360–61, fig. 208; Wolfgang Herrmann, *Laugier and Eighteenth Century French Theory* [London, 1962], pp. 33–34 et passim, figs. 5, 7; R. D. Middleton, "The Abbé de Cordemoy and the Graeco-Gothic Ideal: A Prelude to Romantic Classicism," *Journal of the Warburg and Courtauld Institutes* 25 [1962]:278–320, 26 [1963]:90–123—for Saint-Sulpice, see 25: 278–80; R. D. Middleton, "French Eighteenth-Century Opinion on Wren," in *Concerning Architecture: Essays on Architectural Writers and Writing Presented to Nikolaus Pevsner*, ed. John Summerson [London, 1968], pp. 46–48). The contrast of this facade with J.-A. Meissonnier's project of 1726 demonstrates the strength of the Neoclassical reaction against the Rococo (Hautecoeur, *Architecture classique*, 3:262, fig. 211; see also Emil Kaufmann, *Architecture in the Age of Reason: Baroque and Post-Baroque in England, Italy and France* [Cambridge, Mass., 1955], p. 137).

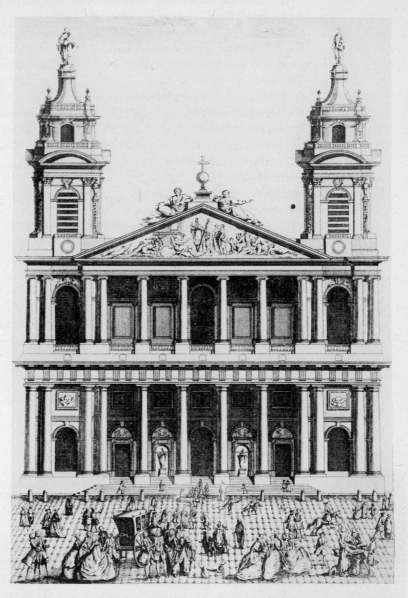

I–1. St.-Sulpice, Paris. J.-N. Servandoni. Revised design, ca. 1739. J.-F. Blondel, *Livre nouveau, ou règles des cinq ordres d'architecture de Vignole.*

In contrast with the assertiveness of Saint-Sulpice, J.-D. Antoine's Hôtel des Monnaies of 1768–75 (Fig. I–2) seems almost an understatement.[19] Filling a large irregular site along the Seine, the building presents a relatively simple facade almost 400 feet long, dominated by a colonnaded central pavilion. The ground floor podium of horizontally rusticated masonry and the smooth-surfaced upper wall are opened by three repetitious rows of rectangular windows. A heavy entablature with large close-set consoles reinforces the planarity of the wall and the horizontality of the composition. The projecting center owes its unifying strength to its intense differentiation and visual contrast with the near monotony of the long flanks. Arched openings pierce the base, six giant Ionic columns stand before the upper stories and support sculptured figures above the cornice, and the whole central portion of the structure rises as an attic story marked simply by rectangular panels. Classical antiquity provided the model for the Erechtheum-like columns, but the design as a whole was an academicized reduction of L. Levau and J. Hardouin-Mansart's garden facade at Versailles of 1669–85. The variety, richness, and versatility of the seventeenth century were restrained in the severe, sober Neoclassical structure that was probably Godefroy's place of employment at about the time when his interest in architecture was awakening.

[19] Hautecoeur, *Architecture classique*, 4:96, 249–54, figs. 124–29; Herrmann, *Laugier*, p. 112, pl. 17.

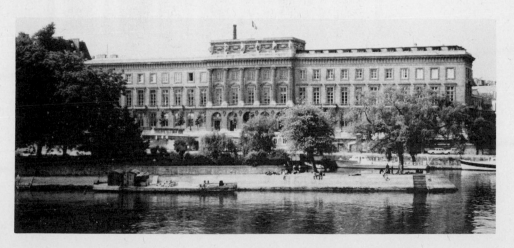

I–2. Hôtel des Monnaies, Paris. J.-D. Antoine. 1768–75.

In emphasizing the continuous wall plane, using freestanding rather than engaged columns and pilasters, replacing the numerous arches with rectilinear openings, and making the consoles support balconies and cornices, Antoine followed the current dictates of the Abbé Laugier.[20] An outspoken critic and rigorous logician, M.-A. Laugier, in his *Essai sur l'architecture* of 1753, based his theory on a hypothetical primitive cabin. In a strictly rational manner he developed from this simple source a great masonry architecture appropriate for the needs of his day. Planning, ordered the Abbé, must forward the purpose and use of the building, which should be so constructed that the interior is kept free of heavy masonry piers. An essentially post and lintel structural method leads to an architecture of rectilinear forms rather than arching curves, and a puristic logic requires each member to perform its function visibly, which would prohibit both superfluous decoration and the decorative use of the orders. Rather than visual charm and seductiveness, such a severe architecture makes an impression on the mind of the beholder, conveying a seriousness of intent through its sobriety and integrity. Laugier was not alone in stating and pressing this strict logic, and the Hôtel des Monnaies was not the only example of this architectural reform. His ideas were taken up by many architects, and both theory and design developed further by the turn of the century.

With a very lively interest in its own theory, of which Laugier was but one, if the loudest voice, Romantic Classicism increasingly freed itself from seventeenth-century models, turning more often to antiquity in the search for architectural forms to embody its aims. Whereas J.-G. Soufflot's Sainte-Geneviève of 1754–91 (Fig. I–3) carries a great crowning dome derived from that of St. Paul's, its portico, with enormous Corinthian columns based on those of ancient Baalbek, conveys the new sober grandeur. Magnificence was appropriate for this church, the largest royal ecclesiastical structure of the age; the columns, moreover, are freestanding. Internally, too, these columns stand in rows and carry entablatures that define the four arms of the Greek-cross plan of the church (Fig. I–4). Extensive vistas along and through the colonnades emphasize the openness of the

[20] Herrmann's *Laugier* is the major study of this theoretician; see also Hautecoeur, *Architecture classique*, 4:49–53; Emil Kaufmann, *Three Revolutionary Architects: Boullée, Ledoux, Lequeu*, Transactions of the American Philosophical Society, n.s., 42, pt. 3 (Philadelphia, 1952):448–50; Kaufmann, *Age of Reason*, p. 134; Middleton, "Abbé de Cordemoy," pp. 97–104.

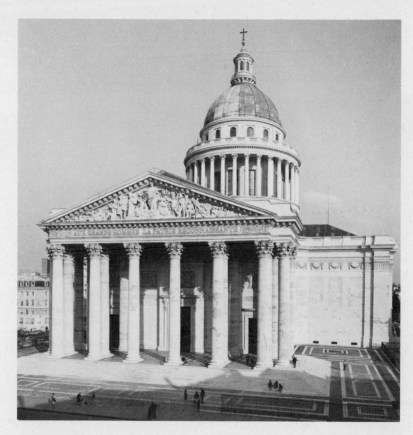

I–3. Sainte-Geneviève, Paris. J.-G. Soufflot. 1754–91. Photo Giraudon.

interior space, an effect continued upward into the four low
domes on pendentives and the vast central dome. Sainte-Gene-
viève was the culmination of the effort to achieve a Gothic
openness, spaciousness, and verticality with classical forms—an
effort of interest not only to Laugier but to many other eight-
eenth-century writers and architects. Another element of Lau-
gier's theory was satisfied by the direct correspondence between
the interior and exterior—the grand though simple cubical
shapes echoed in the four crossing arms, and the vaulted cross-
ing in the cylindrical colonnaded drum and high hemispherical
dome. With the removal of the numerous pedimented windows
and two eastern towers just before completion of the structure,
the austere wall surfaces and exposed geometry of the composi-
tion reflected the taste of the Revolutionary age, the last stage in

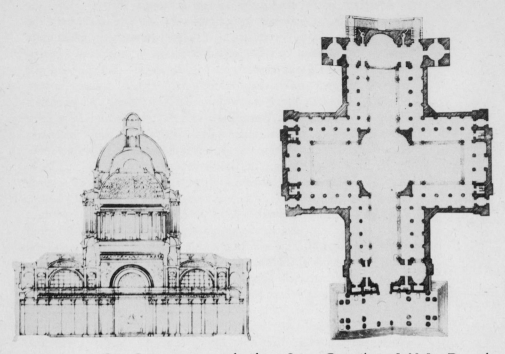

I–4. Cross-section and plan, Sainte-Geneviève. J.-N.-L. Durand, *Précis des leçons d'architecture données à l'Ecole Polytechnique.*

eighteenth-century French architecture. Innocent of Baroque play of light and shadow, Sainte-Geneviève demonstrated, in its vastness and severity, the fundamental nature of the architectural reforms of the age. Completed in 1791, it became, as the Panthéon, the burial place for the heroes of political reform.[21]

[21] Commissioned in 1754, construction began even before Soufflot's plans were officially approved in 1757; he continued to modify details of the design until his death in 1780, when most of the building was completed. M. Brébion, who soon left, and J. Rondelet, both pupils of Soufflot, carried the interior and the lantern to near-completion about 1790. In 1791 A. Quatremère de Quincy made the drastic changes that gave the church its Revolutionary austerity by removing its towers and windows and revising the decorative sculpture and painting. As early as about 1769 P. Patte and others had begun to denounce the dome supports as insufficient, and the ensuing quarrel dominated architectural debate for the rest of the century. Although Soufflot received much backing from other architects, Rondelet in 1806 did have to strengthen the four piers (Hautecoeur, *Architecture classique*, 4:188–96, 336–37, figs. 86–89, 190, 5:121–23; Kaufmann, *Age of Reason*, pp. 138–40; Herrmann, *Laugier*, pp. 117–30, pls. 27–30, 34–36). For the eighteenth-century interest in Gothic qualities, see Middleton, "Abbé de Cordemoy."

Another more obviously romantic trend throve alongside Neoclassicism. Whatever its origins—the cult of nature in the spirit of Rousseau, the influx of English theories on gardening, a romantic interest in ruins, a nationalistic or anticlassical penchant for the Orient or for the Middle Ages—the Picturesque was established and clearly accepted in France by the 1770s. Nothing showed its victory as much as Marie Antoinette's Hameau (1775–84) at Versailles, with paths winding through a large *jardin anglais* containing falsely rustic dwellings and farm buildings, the conception of R. Mique, aided by the gardener A. Richard and the painter Hubert Robert. Guides for those sharing the new taste soon came to hand, like those of Claude Henri Watelet (1774) and Antoine-Nicolas Duchesne (1775), and even the academician J.-F. Blondel recognized its existence in his last publication in the seventies. Major architects adopted the mode rapidly and established it in Paris. Although C.-N. Ledoux adhered to the traditional manner in formal garden layouts for the Hôtel d'Hallwyl of 1766 and the Hôtel d'Uzes of 1767, a decade later the *jardin anglais* appeared prominently at his Hôtel Hocquart (1775–77) and Hôtel Thélusson (1778–81); he gave them a scenery of rocks and foliage that resembled Fragonard's painted settings. Every kind of garden structure, such as ruins, the hermitage, windmills, classical, Gothic, and Oriental structures, came to be used, along with serpentine paths and well-chosen, asymmetrical plantings. In 1809–10 J.-Ch. Krafft published examples of Picturesque gardens designed by many of the leading architects, like J.-F.-T. Chalgrin and A.-T. Brongniart, for houses in the classical manner. This phenomenon became one of the reasons for the creation of the term "Romantic Classicism" to distinguish the late eighteenth-century classical revival.[22]

[22] The *jardin anglais* at Versailles was completed about 1777, and the Hameau was built in 1783–84 (Hautecoeur, *Architecture classique*, 3:573–74, 4:83–84, 88, fig. 23, 5:18, fig. 6). See Claude Henri Watelet, *Essai sur les jardins* (Paris, 1764; for correction of the date of publication to 1774, see Herrmann, *Laugier*, pp. 145–46, n. 58); Antoine-Nicolas Duchesne, *Formation des jardins* (Paris, 1775); Jacques-François Blondel, *Cours d'architecture enseigné dans l'Académie Royale d'Architecture*, text 6 vols., plates 6 vols. in 3 (Paris, 1771–77), vol. 4; Marcel Raval and J.-Ch. Moreux, *Claude-Nicolas Ledoux* (Paris, 1945), pls. 7, 16, 36, 41; Jean-Ch. Krafft, *Plans des plus beaux jardins pittoresques*, 2 vols. (Paris, 1809–10). This publication was preceded by others, e.g., the elaborate work of Alexandre de Laborde, *Description des nouveaux jardins de la France* (Paris, 1808). For a general view of this change in gardening, see Hautecoeur, *Architecture classique*, 5:1–50; Fiske Kimball, "Romantic Classicism in Architecture," *Gazette des Beaux-Arts*, 6th ser., 25 (1944):95–112; see also Henry-Russell Hitchcock, *Architecture, Nineteenth and Twentieth Centuries* (Baltimore, 1958), pp. xxi–xxix.

The Picturesque did not merge with Neoclassicism in France but persisted as a separate, parallel tendency, and in the later eighteenth century appeared primarily in the garden. Its compositional methods and its attendant eclecticism in the use of varied, exotic architectural styles had little effect before the turn of the century at which time the altered social, political, and cultural situation led to its wider recognition. Its acceptance was delayed in part by the emergence of the fully developed Romantic Classicism that became the architectural tongue of the Revolutionary period of the eighties, when Godefroy was a young man.

Theorists as well as designers, Ledoux and L.-E. Boullée were the great masters of this architecture, although of the two Ledoux was far more active in actual construction. His *barrières* of 1785–89, housing customs officials at the forty-nine gateways to Paris, exhibited his remarkable fertility in their variety of shapes, ranging from approximations of the classical temple to compositions of simple geometric forms; exaggerated quoins, voussoirs, and keystones, columns made of alternating drums and cubical blocks, and other devices symbolized the royal force and authority, demonstrating his desire that a building state its purpose through its forms. One of the largest, the Barrière de Saint-Martin (Fig. I–5) (also called de la Villette because of its location in that section of Paris), is among the four remaining tollhouses. Basic shapes, the square and circle, underlie its major and minor forms: a square one-story block serves as

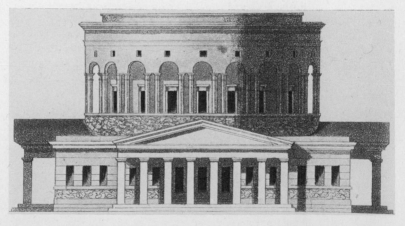

I–5. Barrière de la Villette [Saint-Martin], Paris. C.-N. Ledoux. 1785–89. J.-B.-M. Saint-Victor, *Tableau historique et pittoresque de Paris.*

a podium from which rises a broad two-story cylinder; on each side stood a wide pedimented portico, two of which remain. Horizontal lines of rustication, repeated unframed window and door openings, and the eight square piers of each portico continue the rectilinearity of the block. Pairs of columns and arches open the smooth wall of the cylinder, and the shadows of various shapes cast on the inner cylinder, interrupted by lights from the square upper windows, create a near-Piranesian fantasy of irregular voids and dappled planes curving around and disappearing from sight. Although the parts of the building are consolidated into two opposing masses, the simplified and archaizing Doric order steps back from the developed classical toward the roots of ancient architecture. Reaching for the grandeur of the Sublime rather than a rational beauty, Ledoux sought to affect the viewer's senses and feelings through a larger, more primitive architectural imagery.[23]

Through such structures architecture of the Revolutionary generation achieved something of the same austere grandeur to be found in J.-L. David's history paintings. Isolation of individual buildings, plain wall surfaces, repetition of forms, unbroken skylines, the forceful thrust of geometric elements set baldly against each other, the stark juxtaposition of solid and void, of light and shadow, of contrasting shapes and disproportionate dimensions—these characteristics of the extreme and ideal projects of the advanced thinkers also marked many executed works. While Antoine was still subduing seventeenth-century magnificence in his large but sober Hôtel des Monnaies, J.-F.-T. Chalgrin and J. Gondoin opened the way to the grandiose Louis XVI style in the huge forms of, respectively, the basilican Saint-Philippe-du-Roule (1766–84) and the Ecole de Médecine

[23] For Boullée, see Kaufmann, *Three Revolutionary Architects*, pp. 453–73; for Ledoux, *ibid.*, pp. 474–537; for the *barrières*, *ibid.*, pp. 498–509, figs. 113–29; Moreux and Raval, *Ledoux*, pp. 65–67, figs. 258–329. See also J.-C. Magny, *Visionary Architects* (Houston, Tex., 1968), containing a recent bibliography for the major figures of this generation. Although dealing only with England and primarily with literary figures, Walter John Hipple demonstrates the continuing awareness of the Sublime during the eighteenth century in *The Beautiful, the Sublime, & the Picturesque* (Carbondale, Ill., 1957). In the middle of the century, 1757, the Sublime received its finest definition in Edmund Burke's *Inquiry into the Origins of Our Ideas of the Sublime and Beautiful* as part of the aesthetic experience, as the discovery of forms of pleasure in such emotions as awe, veneration, and terror, which man interpreted as demonstrations of more than normal human power in the shaping of extensive voids, overwhelming masses, etc. Magny places a certain emphasis on this aspect of the architecture of the Revolutionary period in France.

(1769–76). A.-T. Brongniart's Capuchin convent (now the Lycée Condorcet) of 1780–81 joined these two in spreading the new manner through Paris; Ledoux surrounded the city with his tollhouses and inns in the eighties. The National Convention approved the Revolutionary style in accepting J.-P. Gisors' Assembly Hall of 1793. Simple in outline, precise in the distinction of parts, shunning such niceties as column fluting and easy transitions, these works are impressive as products of an age seeking to express rationality in its methods of design and construction and its use of materials. Ornament for the sake of sensory delight disappeared, and sculpture was restricted to occasional *appliqué* figures and relief panels sunk into the wall surface. Weighty and often rather antique forms occurred inside also, where such textural devices as fluting and coffering marked the limits of the masses. Seeking an expressive character, an *architecture parlante* that would convey the purpose or meaning of a building through its forms, these architects often successfully embodied such concepts as purity, nobility, and masculinity.[24]

Individuation of the whole structure and of its parts appeared among the revolutionary aspects of this new style. One very prominent feature was the changed method of emphasizing the central entrance. The high, projecting central pavilion gave way to a portico structure of contrasting shape and size set against the main block, as in some of Ledoux's *barrières*. A colonnade often marked the center, sometimes under a pediment and resembling a temple front, at other times screening the lower part of a recessed vestibule. The doorway might be marked by exaggerated quoins and voussoirs, or it might be a simple, disproportionately large archway with no frame at all. Interiors evidenced a desire to eliminate the vista which formerly connected the major rooms in a glance. Now the rooms were set off from each other, affording greater privacy and convenience and perhaps more economical use of space and at the same time reflecting the separate-

[24] For the relations of this architecture with painting, see Walter Friedlaender, *David to Delacroix* (Cambridge, Mass., 1952), pp. 7–8, 14–17. This architecture is brilliantly discussed in the context of the arts of the age by Robert Rosenblum, *Transformations in Late Eighteenth Century Art* (Princeton, N.J., 1967), esp. chs. 3–4. For the most extensive discussions of Revolutionary architecture in France, see Hautecoeur, *Architecture classique*, vols. 4 and 5; Kaufmann, *Three Revolutionary Architects*; Kaufmann, *Age of Reason*, pp. 141–215; Kaufmann's terminology is used in these paragraphs. For Saint-Philippe-du-Roule, see Hautecoeur, *Architecture classique*, 4:213–16, 348, figs. 99–101, 198; the plan probably antedated 1765. For the Ecole de Médecine, see *ibid.*, 4:243–46, figs. 119–22. For the Capuchin convent, see *ibid.*, 4:300–301, figs. 164–65. For the Assembly Hall, see *ibid.*, 5:117–18, fig. 65; Kaufmann, *Age of Reason*, pp. 205–6, fig. 216.

ness of the juxtaposed geometric shapes. In a widespread build-
ing or a group of buildings, the individual structures rose alone,
related to each other only by similarity in shape or by a com-
mon podium, screen wall, or colonnade. This splendid isolation
implied, as Emil Kaufmann puts it, the breakdown not only of
the old methods of architectural composition, but also of the
political hierarchy.[25]

How much attention Godefroy paid to these works is an
unanswerable question, but reminiscences of the style crop up
in several of his buildings. Certainly other architects were aware
of the sharp break with the past; Blondel saw some good and
some bad in the new manner. A significant operation like the
construction of the *barrières* attracted the attention of all Paris;
Thomas Jefferson was interested enough to drive out to the
works, although their influence on his own designs did not
soon become apparent. For Godefroy and his friends, a minor
group of intellectuals, architectural activities around 1800 must
have been at the least a topic of conversation, for such works
were items of public notice. Typical of the average intelligent
person of the time, the gazetteer Ch. Landon published many
projects that he considered interesting to his readership; oc-
casionally he called attention to uncommissioned designs or
competition entries and thus, as he pointed out, preserved them
from oblivion.[26]

Post-Revolutionary France, under its variety of successive
governments, made new demands on the traditional architec-
tural functions, but the response in the form of actual building
was slow. Some existing structures could be converted to serve
usefully in the changed social complex: Gisors twice altered
large halls designed for royal use to make them into assembly

[25] Kaufmann, *Three Revolutionary Architects*, pp. 483–86, 495–98; as
Kaufmann shows, Ledoux carried out the most consistent experimentation
with the central entrance.

[26] For Blondel, see *ibid.*, 443–46. For Jefferson, see *The Papers of
Thomas Jefferson*, ed. Julian P. Boyd et al., 17 vols. to date (Princeton,
1950–), 12:32. A good example of architectural publication is Jean-Ch.
Krafft and N. Ransonnette, *Plans, coupes, élévations des plus belles mai-
sons et des hôtels construits à Paris & dans les environs* (Paris, 1801–3).
Of works already discussed here, Krafft and Ransonnette illustrated
Saint-Philippe-du-Roule (pls. 103–4), the Ecole de Médecine (pls. 105–6),
and the Capuchin convent (pl. 114); although Ledoux's tollhouses were
not shown, some of his private houses were (pls. 10, 20, 32). For publica-
tion of a specific project, see [Charles Landon], *Annales du Musée* 5
(1803):111–12, pl. 52, showing J.-N. Sobre's project of 1795 for an obelisk
on the place des Victoires.

rooms for large representative bodies; [27] Saint-Philippe became a temple of Concord, symbol of harmony in a rational society. With renovations in keeping with changing tastes, confiscated royal and aristocratic properties could house the Directorate and the Consuls. For over fifteen years, into the early years of the Empire, the period was rich in paper designs but poor in constructed works, largely because of the continuing political and economic turmoil. Pierre Vignon's Madeleine, Brongniart's Bourse, B. Poyet's facade for the Corps Législatif, Chalgrin's Arc de l'Etoile, all begun in 1806, belonged to the future; most, indeed, were completed in post-Napoleonic times.

Occasional private speculative housing projects, a few bridges over the Seine, and some new streets were created. The rue des Colonnes (1798), perhaps by Poyet, and the rues de Castiglione, de Rivoli, and des Pyramides, begun in 1802 by Ch. Percier and P.-F.-L. Fontaine, were not far from the house where Godefroy resided for a year before his arrest in 1803. Although very different from the royal *places*, these streets continued the tradition of controlled exterior design in the long Romantic-Classical buildings with covered walks on the ground level, where rather Italianate arcades rhythmically punctuated the movement along the block. These works presaged the nineteenth-century interest in Italian Renaissance design. At just this time Percier and Fontaine published their drawings of Roman palaces of the Renaissance, which served as a guide to architects and inspired some specific elements in Godefroy's architecture.[28]

The arches of the Etoile and the Carrousel, the columns of the Vendôme and several Napoleonic fountains all were built after Godefroy's departure from France. They were, however,

[27] In addition to the Assembly Hall for the National Convention, Gisors also created the original form of the Chambre des Deputés (1795–97) in the Palais Bourbon (Hautecoeur, *Architecture classique*, 5:134–36, fig. 76; Kaufmann, *Age of Reason*, p. 206, fig. 217).

[28] For the large dwelling and shop block, the Cour Batave of 1791–92, by Sobre and Happe, see Hautecoeur, *Architecture classique*, 5:107, figs. 60, 186; this block was illustrated by Krafft and Ransonnette, *Plans*, pls. 115–18. For Ledoux's Maisons Hosten of 1792, see Kaufmann, *Three Revolutionary Architects*, figs. 108–11. For the pont des Arts and the pont de la Cité, both of 1803, see Pierre Lavedan, *Histoire de l'urbanisme*, 3 vols. (Paris, 1926–52), 3:11; Hautecoeur, *Architecture classique*, 5:228, 331, fig. 148. For the new streets, see Lavedan, *Urbanisme*, 3:14–15, 23–26, pl. 1; Hautecoeur, *Architecture classique*, 5:142, figs. 80, 146; Rosenblum, *Transformations*, pp. 128–31, figs. 145–46, 149. Godefroy lived at 6, rue de la Michodière, having moved to this fashionable quarter in order to be near friends who might help him. For Renaissance palaces, see Charles Percier and P.-F.-L. Fontaine, *Palais, maisons, et autres édifices modernes, dessinés à Rome* (Paris, 1798).

the culmination of much activity in decorative and commemorative architecture that began in 1789. Important anniversaries and other state affairs were celebrated in temporary settings, often with simulated architecture of wood and canvas. The memory of significant events, great generals, and anonymous heroes of the line was perpetuated by classical temples, triumphal arches, and memorial columns and obelisks. Royal portraits, emblems of dynastic privilege, were replaced by the more abstract and generalized architectural symbols of the new spirit. Hundreds of designs were created in Paris alone as the result of numerous competitions, conferences of artists, and unsolicited suggestions. Many were published, in periodicals and pamphlets, and a surprising number were executed. Although most of the construction was temporary, designing of commemoratives was one of the most publicized activities of the time.[29]

One significance of this interlude in the history of stylistic revivals lies in its relation to the ideal of an *architecture parlante*. While Ledoux and Boullée still lived, they were not forgotten, but their method of expressing character through architectonic forms gave way to the more obvious means of communicating with the large public through decorative symbols. Most of the motifs had ancient origins, and some were already popular in America. Symbols of liberty, victory, union, and mourning were applied over the surfaces of monuments to make more specific the traditional meanings of the basic forms—the column, pyramid, obelisk, trumphal arch. In this way the post-Revolutionary governments established an allegorical vocabulary that was in use throughout much of the nineteenth century.[30]

[29] See Hautecoeur, *Architecture classique*, 5:118–26, 191–207, et passim. For related architectural symbolism, see Alfred Neumeyer, "Monuments to 'Genius' in German Classicism," *Journal of the Warburg Institute* 2 (1938–39):159–63.

[30] This change in the nature of the symbolism has been pointed out by Hitchcock, *Architecture*, p. xxxvi. The Phrygian cap was popular in America as the liberty bonnet. Every child learns of the pole and cap erected in Boston, and in 1780 this symbol was proposed as part of the United States seal. In sympathy with the French, similar poles were raised throughout this country in the nineties. The Dutch financier Théophile Cazenove saw several in his journeys, notably in Newark and Morristown, N.J. (Théophile Cazenove, *The Cazenove Journal, 1794*, ed. R. W. Kelsey, Haverford College Studies 13 [Haverford, Pa., 1922], pp. 1, 10). For a representative French example, see Hautecoeur, *Architecture classique*, vol. 5, fig. 67. For this and other symbols used in an *appliqué* manner, see *ibid.*, figs. 75, 118, 173. Ledoux's method of applying ornament against the wall surface was to become a characteristic of nineteenth-century architecture and furniture (Kaufmann, *Three Revolutionary Architects*, p. 520).

The medium of *architecture parlante* was one of the rarest coins minted by the Revolutionary architects, and its devaluation for common use was inevitable. Passing more freely from hand to hand, and accepted at more nearly face value, theories on the importance of materials and construction, on geometric form, and on compositional methods were systematized. A treatise on the problems of construction was published by J.-B. Rondelet, the pupil of Soufflot who completed and later reinforced the Panthéon. The cubic forms and compositional methods of Ledoux, inherited by his pupil L.-A. Dubut, were applied in a strongly eclectic way. Teaching the principles in a form simplified and rationalized even further, Boullée's pupil J.-N.-L. Durand issued a coinage so standardized that it was accepted internationally and for several generations.[31]

During a period of about two decades, say from 1790 to 1810, an important change occurred in the relationship between the architect and the engineer. Although military engineering had long been a specialty, civil engineering now for the first time received that recognition. Not only had construction attracted more attention since the mid-century, but new problems were raised by the increasing use of different materials, such as iron. Engineers, especially those with the Ponts et chaussées, received a number of the commissions which would formerly have been given to architects, and this trend continued after Napoleon's rise. In 1795 specialized education was provided for engineers with the establishment of the Ecole Polytechnique, and there they received a brief basic training in architectural design. It was at the Polytechnique that Durand perfected and disseminated his simplified Romantic-Classical design. The thrust of this education, however, was to identify the soon-flourishing practice of civil engineering as a profession separate from architecture.[32]

The atmosphere of the Directory and the Consulate might well have induced a competent engineer to branch out into architecture, especially if he personally inclined toward the intellectual rather than the practical. Constitutionally an oppor-

[31] Jean Rondelet, *Traité théorique et pratique de l'art de batir* (Paris, 1803); Louis-Ambroise Dubut, *Architecture civile* (Paris, XI [1803]); Jean-Nicholas-Louis Durand, *Précis des leçons d'architecture données à l'Ecole Polytechnique*, 2 vols. (Paris, 1802–5).

[32] Hautecoeur, *Architecture classique*, 4:62–66, 5:259–64; Lavedan, *Urbanisme*, 3:7–8.

tunist, Godefroy undoubtedly recognized the trend or perhaps heard of it through salon discussion, for his interest in architecture, he later stated,[33] arose only shortly before his arrest in 1803. Among his papers inventoried by the police was a group of sketches of architecture and fortifications, but without any qualifying or descriptive comments. His study of architecture was conducted not under a teacher but in a purely personal manner, based on books, conversation, and probably observation of actual buildings. A example of his method of research and study is his book on Louisiana, published at just this time, May, 1803.[34] In this work of twenty-three pages, he cited fifteen books on history, geography, and travel in the New World, as well as several maps; for two years he had sought out merchants, travelers, and others who had been to America. Godefroy doubtless used similar methods in approaching architectural design, studying recent publications as well as those of earlier writers. He must have examined with new interest many of the buildings discussed above, so that they established his standards of monumental public architecture.

A specific branch of engineering in which Godefroy claimed competence was military engineering. By 1809 he was advertising fortification as one of the subjects he taught. He took to America a number of books on this science, which he then made available to his private students. His book on methods of defense appropriate for the United States was praised by a reviewer for being very up to date. Latrobe found in the book signs of great knowledge and penetration, asked Godefroy's opinion on fortification problems, and, when introducing his son to General Andrew Jackson in 1815, thought it sufficient to say that he had been trained in engineering by Godefroy.[35] Military engineering and fortification, civil engineering, and mapmaking shared with architecture, as they still do to some extent, a common method of draftsmanship. A manual of 1803 made no distinctions in the rules for civil and for military arch-

[33] J.-J.-M. Huvé to the Duc de Doudeauville, Mar. 5, 1827, F[13] 650, Archives Nationales.

[34] *Coup-d'oeil sur l'intéret de l'Europe dans les débats actuels du congrès des Etats-Unis, au sujet de la Louisiane* (Paris, 1803); both the manuscript and a copy of the book are in his police dossier. Godefroy indicated his authorship of this book as "Max . . . *cosmopolite*."

[35] Godefroy advertised the use of his library as a special attraction for his students (*Baltimore Federal Gazette*, Feb. 24, 1809). His *Military Reflections* was reviewed in the *Baltimore American*, Oct. 20, 1807. See Latrobe to Godefroy, Washington, Oct. 29, 1806, Jan. 28, 1815; Latrobe to Jackson, Washington, July 19, Dec. 12, 1815; all in Letterbooks.

itecture. An architectural student of Percier not only worked for Latrobe but also mapped existing fortifications and planned new ones for the United States Army. P.-C. L'Enfant and J.-F. Mangin engaged with equal readiness in surveying and map-making, fortification, and architecture.[36] Thus, even without specific training in architecture, one can assume that Godefroy was fairly proficient in the techniques of schematic representation and could perhaps relate a concept to a plan and to a completed structure. There is an observation on Godefroy's ability at this point in his career; he brought from France one set of drawings, and in 1806 showed them to Latrobe and Jefferson. The latter judged him more skilled on paper than in practice.[37]

We do not know whether Godefroy had actual experience or only theoretical knowledge of the problems of construction. As Jefferson realized, it is probable that his engineering activities were confined to mapmaking and similar drafting and paper activities. Godefroy sought Latrobe's advice on problems of construction and finish, moreover, and Latrobe once lent him a book on carpentry.

Godefroy's first building, St. Mary's Chapel (1806–8), appeared more the result of a picturesque concept or drawing than of familiarity with structure (Figs. II–1, II–2, II–7). The lack of alignment between the facade and the nave and between the nave and the chevet is both irrational and uneconomical. He did not superintend the construction, but the decorative rather than functional placement of the buttresses, the exaggeratedly heavy foundations, and the flimsy tower and attic were his. Dissatisfaction with this building may have been a prime reason for his decision to study construction, which was, in any case, a recognized part of the architect's competence. Several years later he recommended as contractors for brick- and stonework a group of men who, he had found from previous collaborations, understood his needs, methods, and aims. By 1815 he was superintending actual construction but, as Latrobe wrote,

[36] On drawing, see Claude-Mathieu Delagardette, *Nouvelles règles pour la pratique du dessin et du lavis de l'architecture civile et militaire* (Paris, 1803); this was a revision of his 1786 publication. William Tell Poussin, trained by Percier, recounted his varied activities several times, but most concisely in Guillaume-Tell Poussin, *Les Etats-Unis d'Amérique* (Paris, 1874), pp. 93–94. See *Dictionary of American Biography*, s.v. "L'Enfant, Pierre Charles" and "Mangin, Joseph Francois."

[37] For Jefferson's opinion, see Latrobe's letter to Henry Clay, Washington, Dec. 11, 1811 (Henry Clay, *The Papers of Henry Clay*, ed. James F. Hopkins and Mary W. M. Hargreaves, 3 vols. to date [Lexington, Ky., 1959–], 1:599–600).

still needed aid on the technical problems. Superintending paid better and more regularly, so that Godefroy occasionally offered designs free on the condition that he be hired for the later work.[38] By the time that his last French works were built, he had little difficulty in the construction.

When he arrived in New York in April, 1805, and moved on to Philadelphia in two weeks, Godefroy would have seen nothing to make him question his own taste and ability. There was little for which he could have genuine admiration. The great mass of vernacular construction, in wood, brick, and occasionally stone, would scarcely attract his attention. His taste, as we judge it from occasional remarks and his own works, was not sympathetic to the late Georgian and Federal works so dependent on English sources. The Girard Bank of Philadelphia of 1795–98, a late Georgian house monumentalized by a tall portico, was far too rich for its Corinthian columns to possess the character appropriate for a bank. Completed just as Godefroy arrived in Philadelphia in 1805, the Center House of the Pennsylvania Hospital presented, like the bank, the pyramidal form required by Louis XV practice but, again like the bank, was built largely of exposed brick, a material Godefroy found unsuited to monumental public buildings. It would be interesting to know what he felt about L'Enfant's already dilapidated Federal Hall of 1789 and the City Hall of 1802–10, designed by J.-F. Mangin and J. McComb, Jr., then under construction, if he saw these two buildings during his brief stay in New York City.[39]

Philadelphia possessed, however, two structures resembling the manner that had swept over Paris in the previous quarter-century. Both by Latrobe, the Bank of Pennsylvania of 1799–1801 and the Center Square Pump House of 1799–1800 displayed the same boldly juxtaposed geometric forms, play of

[38] On construction, see Godefroy to the Committee for the Monument, Baltimore, Mar. 22, 1815, Maryland Historical Society. On technical aid, see Latrobe to Godefroy, Washington, July 19, 1815, Letterbooks. On superintending, see Godefroy to Jackson, Richmond, Sept. 7, 1816, Maryland Historical Society.

[39] For the Girard Bank, by Samuel Blodgett, see Owen Biddle, *The Young Carpenter's Assistant* (Philadelphia, 1805), p. 55, pl. 43. For Center House, Philadelphia Hospital, of 1794–1805, by David Evans, Jr., see Theo B. White et al., *Philadelphia Architecture in the Nineteenth Century* (Philadelphia, 1953), p. 22, pl. 1. For Federal Hall, see Talbot F. Hamlin, *Greek Revival Architecture in America* (New York, 1944), pp. 6–8. For City Hall, see *ibid.*, pp. 40, 123–24, pl. 28.

solid and void, and reiteration of simple motifs. Grandly conceived in three dimensions, they stood isolated, whether in landscaped or city setting, and self-contained by the smooth flow and enframement of the main lines and edges. The Pump House was very close to the forms of Revolutionary architecture in France, repeating the block and cylinder of Ledoux's Barrière de Saint-Martin; more than Ledoux, Latrobe emphasized the antithesis of the two major forms by using arched openings in the block and rectangular shapes in the cylinder. A hemispherical dome increased the geometricism, and a vestibule recessed behind a column screen introduced a motif frequent in European Romantic Classicism. Latrobe's structures were tailored to satisfy the demands of the new urban industrial society, demands that led many French Romantic Classicists to establish new building types and to give new dignity to existing utilitarian ones. Most important, from Godefroy's point of view, was the material of these two buildings; in a city predominantly of brick, they were constructed of marble.[40]

When he reached Baltimore in December, 1805, Godefroy found no monumental work in stone or marble. Wood and especially brick were used to house every kind of activity in this rapidly growing city. The wooden Holliday Street Theatre of 1794 was not rebuilt in brick and stone until 1813. Rich local sources provided the clay burned in numerous kilns for bricks used by the millions in housing and public buildings, like the Assembly Room and Library of 1793 and the jail of 1800–1802. Even elegant private houses, like R. C. Long's Robert Oliver house of 1804–7, so strongly censured by Latrobe, were of brick, although some country houses boasted marble string courses, lintels, and decorative panels or were stuccoed in an effort to achieve a more modern flavor.[41] These two different treatments

[40] For the Bank of Pennsylvania, see Hamlin, *Latrobe*, pp. 152–57, fig. 12, pls. 12–13. For the Pump House, see *ibid.*, pp. 156–67, pl. 14.

[41] The wooden theater building was probably designed by H. Reinagle and was built by Warren and Wood; the brick and stone version was designed by a Mr. Robins and built by Robert Cary Long I, W. Stuart, and J. Mosher (Thomas W. Griffith, *The Annals of Baltimore* [Baltimore, 1824], p. 146; Francis Beirne, *Baltimore . . . a Picture History, 1858–1958* [New York, 1957], pp. 14–15). Both the Assembly Hall and the jail were designed by Col. Nicholas Rogers, a gentleman-architect, and built by Long (Griffith, *Annals of Baltimore*, pp. 160, 175–76; Beirne, *Baltimore*, p. 21). On the place of brick in Baltimore, see Richard H. Howland and Eleanor P. Spencer, *Architecture of Baltimore* (Baltimore, 1953), pp. 5–6. For the use of stucco and of marble in "Homewood" and "Montibello," see *ibid.*, pls. 7–8, 10–14. For Latrobe's criticism of the Oliver house, see Latrobe to Godefroy, Washington, Dec. 27, 1806, Letterbooks.

characterized advanced building in Baltimore for the next generation; works by native designers would employ brick, perhaps with stone or marble orders and other decoration; foreign-born architects and their followers would stucco where they could not build entirely of stone.

Two projects begun just prior to Godefroy's arrival signaled the coming of age in Baltimore of these two significant aspects of the Federal style as an American phase of Romantic Classicism. While Latrobe wrestled with problems of design and a difficult building committee in creating his great cathedral, the city's first monumental work in masonry, the carpenter and self-taught designer George Milleman was planning Baltimore's new courthouse, built in 1805–9.[42] Not yet completed when Godefroy left America in 1819, the cathedral symbolized the modern European standards of design and construction. In addition, Latrobe's trips to Baltimore in connection with this work fostered the friendship between the two, a friendship which was already fairly intimate by the summer of 1806. Study of Latrobe's various plans for this building, both Gothic and classical, may have formed a part of Godefroy's architectural education. Here in Baltimore he and Latrobe could joke together about the efforts of local carpenters and brickmasons. Milleman's courthouse (see Fig. II–36 *left*) represented the love of novelty and pretentiousness, the lack of taste and knowledge, that Latrobe and Godefroy felt to be their great antagonists in America. For them these elegant and flattened forms, derived at several removes from Robert Adam, were at least a generation out of date. Attenuated pilasters and fanciful entablatures applied to the surface and the unorthodox spacing and proportions of the orders attested to a willful freedom on the part of the Federal builder-designer. Most Baltimoreans, however, admired the courthouse unceasingly for its sound construction and its satisfactory response to the need to house the several courts and related officials. It was built of brick with pilasters and decoration in marble and stone, the combination of materials used for innumerable dwellings, churches, and public buildings that gave the city a sober variety and dignified elegance.

Travel to other cities provided Godefroy with a broad view

[42] For the cathedral, see Hamlin, *Latrobe*, pp. 233–45. For the courthouse, see Griffith, *Annals of Baltimore*, p. 181; [John H. B. Latrobe], *Picture of Baltimore* (Baltimore, 1832), pp. 81–82; Charles Varle, *Complete View of Baltimore* (Baltimore, 1833), p. 18; Howard, *Monumental City*, p. 26.

of current architectural activities in America. No record of his attitude toward specific buildings has been preserved, but he later made a general criticism of the style of Latrobe's public buildings as lacking monumentality. He saw that style spreading, in the work of Latrobe as well as that of his pupils Mills and Strickland, who each bested Godefroy in an important competition. Even more devastating to his ambitions, both these prizes went to designs strongly opposed to his taste. Mills' Washington Monument he derided as a pagoda, and the specification for an imitation Greek structure for the Second Bank of the United States, Philadelphia, he denounced as demanding an antiarchitectural style.[43]

Insulated by his convictions and prejudices, Godefroy was virtually untouched by contemporary American architecture. His rejection of both the Latrobean manner and the revival of the Greek and his scorn for native Federal work inhibited his enjoyment and emulation of what he saw. His style and taste had been formed by his years of exposure to French architecture and by his continuing study of French theory.

In the United States during the early nineteenth century success was possible for the untrained professional. Relatively few books sufficed for most of the self-taught, and Godefroy's distinction lay in the sources upon which he drew. The library collected by the Godefroys filled shelves in almost every room of their Baltimore house. A translator, editor, and reviewer, Eliza Godefroy looked upon them as tools of her trade, and he certainly did as well. In 1811 he arranged to have the books which he had left in France in 1805 shipped to him.[44] Although in his last lean years in America he was forced to sell much of his library, he shipped fourteen hundred books to England in 1819. Damage from storms and pillaging in customs and in quasi-storage from 1826 to 1837 reduced to about 250 the number that he shipped from England to France.[45] Their titles are unknown, and he himself mentions few specific authors. Those which can be provisionally identified will be discussed below.

The book on carpentry that Latrobe lent Godefroy was probably Nicholson's *Carpenter and Joiner's Assistant*, a recent

[43] Godefroy to Jackson, Richmond, Sept. 7, 1816, and Baltimore, Aug. 13, 1818, both at the Maryland Historical Society.

[44] Godefroy to Warden, Baltimore, June 29, 1811, David B. Warden Papers, Library of Congress.

[45] Godefroy to Jackson, Laval, May 8, 1837, Maryland Historical Society.

English publication.[46] The framing of a dome on pendentives, the construction of a stairway with two runs joining in a semicircle, and other details in Godefroy's buildings (Fig. II–7) may derive from this source. From 1812 to 1818 he had on loan from the Baltimore Library Company Nicholson's three-volume *Principles of Architecture*.[47] Because he had this work at hand when he was working on specific buildings, the extent of his use of it can be fairly well identified. The second volume, a study of light and shadow, helped him improve his rendering technique; the third volume gave him precise instructions for detailing orders and moldings. He borrowed nothing else of the Company's extensive holdings on architecture.

Nothing is known positively about the contents of his library. He made just one specific reference to an architectural writer, and that near the end of his career, when he recommended Philibert Delorme's method for reroofing the Hôtel de la Préfecture at Laval in 1836; however, that method was described in several books of the period.[48] Another seventeenth-century influence is suggested by the baptismal font (Fig. III–22) he designed for St. Paul's Church about 1816. Its plinth, obelisk, and basin evoke François Blondel's description of the ancient use of the obelisk; topped by a bowl containing the ashes of a hero, this form was seen as the prototype of the Doric order. Godefroy's font followed the obelisk in Blondel's plate, substituting winged heads for the spheres supporting the obelisk.[49] The plates in a publication by the eighteenth-century architect and teacher

[46] Peter Nicholson, *Carpenter and Joiner's Assistant* (London, 1797). Tracing the bibliography of Nicholson's publications is extremely difficult. Very successful, they were reprinted frequently and pirated. They became handbooks for both English and American carpenters and designers. The loan is noted in a letter from Latrobe to Godefroy, Washington, Oct. 1, 1808, Letterbooks.

[47] Peter Nicholson, *Principles of Architecture*, 3 vols. (London, 1795–98). Godefroy had all three volumes of this work from July 25 to Dec. 28, 1812, two volumes (probably the second and third) from Dec. 2 to 15, 1815, and the third volume from Apr. 14 to May 4, 1814, from July 17 to Aug. 21, 1815, from Nov. 26, 1817, to Apr. 1, 1818, and from Aug. 22 to 31, 1818. Godefroy's borrowing was recorded in the membership record of his father-in-law, Dr. John Crawford, in the *Librarian's Ledger*, Baltimore Library Company, now in the Maryland Historical Society.

[48] Godefroy to the prefect, Apr. 25, 1836, M. 834, Archives de la Mayenne, Laval.

[49] For the attribution of this font to Godefroy, see Davison, "Godefroy," p. 207; identical newspaper accounts described its dedication (*Baltimore American* and *Baltimore Federal Gazette*, Mar. 12, 1817). See François Blondel, *Cours d'architecture enseigné dans l'Académie Royale d'Architecture*, 3 vols. in 2 (Paris, 1675–83), vol. 1, pt. 2, bk. 8, ch. 8, pp. 164–67 and pl.

Jacques-François Blondel evoke some parallels with Godefroy's chapel for St. Mary's Seminary. A squared facade with a parapet pierced by quatrefoils characterized the later Blondel's interpretation of the Gothic cathedrals of Paris, Reims, and Rouen, all illustrated in the body of plates supplementing his edition of Vignola.[50] His plates of the Vignola orders include mid-eighteenth-century figures engaged in appropriate activities, many concerned with building, like the figure in Godefroy's drawing of the flying buttress for the chapel (Fig. II–10). Blondel's Vignola was a deluxe edition, an eighteenth-century version of the coffee-table publication, intended for the wealthy amateur. He also published a small edition convenient for the student and working architect, but the large, more elaborate volume, with its allegorical illustrations, went through three printings and would have appealed to the intellectual circles in which Godefroy moved around 1800. If the two Blondels served as sources for Godefroy, with their motifs translated into contemporary statements, in no case can it be shown that he used the ordinary English or American handbooks—the guides of Swan, Pain, and Biddle—which were design sources for the average carpenter-architect. Not only was his orientation French, but he probably scorned them as inferior in intellectual content and taste.

From a recent publication by a French academician, Quatremère de Quincy's *De l'Architecture égyptienne*, Godefroy adapted some Egyptian elements for use on the double tomb vault of Robert and William Smith, ca. 1815 (Fig. II–31). The capital of the engaged order employs lanceolate leaves rising from a horizontal row of small scrolls, resembling in the latter respect a capital illustrated by Quatremère (Fig. II–32); the illustration shows also the rectangular block that, in Egyptian architecture as well as on this vault, separates the capital and architrave. At its base the column shaft is undercut and ends in a bulging melon-like treatment, again a form represented by Quatremère. The book was published in 1803, and he may have seen it before he left France.[51]

Not all the books Godefroy used were architectural publications, as is shown by another of the few instances of an

[50] Jacques-François Blondel, *Livre nouveau, ou règles des cinq ordres d'architecture de Vignole* (Paris, 1757; later printings of 1761, 1766).

[51] A. Quatremère de Quincy, *De l'Architecture égyptienne* (Paris, 1803), pls. 2, 4. The publication of this work was probably spurred by the great success of Denon's Egyptian travel report (see next note); written in 1785, it shows no signs of having been brought up to date.

architectural motif copied from an illustration. The podium of the Battle Monument of 1815–22 (Fig. II–36), with its cavetto cornice, winged disks, and canted doorways, came fairly directly from a plate (Fig. II–39) in Denon's record of travels in Egypt with Napoleon. First published in 1802, this work became extremely popular and appeared in many editions and translations. Mrs. Godefroy, before their marriage, reviewed three English translations in her newspaper in 1807.[52] Such a work obviously had the requisite intellectual respectability. Godefroy's use of it indicates the unusual nature of the books he read and drew upon. He probably had seen the book when it was first published, inasmuch as he stated to the police in 1803 that he was acquainted with its author, then newly appointed as directeur-général des médailles.

A few other motifs in his work may have been drawn from similarly unusual books, like Britton's pioneering study of English Gothic monuments and the descriptive guide of Paris by Legrand and Landon.[53] The difficulty of identifying specific parallels between such studies and Godefroy's designs suggests that he wanted from books more than mere patterns he could follow or adapt. When he began his study of architecture, his interest was in theory and general principles, and two works could supply these wants in different ways, the textbooks of J.-F. Blondel and J.-N.-L. Durand.[54] Blondel's voluminous *Cours d'architecture* was far more than a mere textbook; it recorded the academic standard of architectural theory and teaching during the later eighteenth century. It was thus natural for Godefroy to turn to Blondel to guide his studies shortly after 1800. The

[52] Dominique-Vivant Denon (often called Vivant-Denon), *Voyage dans la basse et la haute Egypte*, 2 vols. and atlas (Paris, 1802), pl. 80. Mrs. Godefroy's review appeared in the *Observer*, Oct. 10, 1807.

[53] John Britton, *Architectural Antiquities of Great Britain*, 5 vols. (London, 1807–26); Jean-G. Legrand and Charles P. Landon, *Description de Paris*, 2 vols. (Paris, 1806–9). For Latrobe's possession and probable use of Britton's book, see Robert L. Alexander, "The Union Bank, by Long after Soane," *Journal of the Society of Architectural Historians* 22 (1963):138.

[54] For Blondel's *Cours*, see above, n. 22; for Durand's *Précis*, see above, n. 31. References to these two works will be given parenthetically in the text through the balance of this chapter. For Blondel, see Hautecoeur, *Architecture classique*, 3:465–72 et passim; Kaufmann, *Three Revolutionary Architects*, pp. 436–46; Robin Middleton, "Jacques François Blondel and the *Cours d'Architecture*," *Journal of the Society of Architectural Historians* 18 (1959):140–48; Herrmann, *Laugier*, pp. 243–44. For Durand, see Hautecoeur, *Architecture classique*, 5:259–63 et passim; Kaufmann, *Age of Reason*, pp. 210–14; Hitchcock, *Architecture*, pp. 18–19, and ch. 2, "The Doctrine of J.-N.-L. Durand and Its Application in Northern Europe," pp. 20–42.

nearest approach in his work to a motif copied from Blondel is the obelisk on the gateposts (Fig. II–26) of the First Presbyterian Churchyard. Blondel approved of this motif as used in the Porte Saint-Denis in Paris, and especially as a symbol in sacred and mortuary works (*Cours*, 1:321–23, 416; 2:261–63).

Rather than adopting motifs from Blondel, however, Godefroy pursued his teachings on the idea of character in architecture. In both design and execution St. Mary's Chapel retained the delicacy and elegance Blondel found in fine Gothic works, for he greatly admired that style (*Cours*, 1:416; 2:317–18).[55] Godefroy followed Blondel's prescription for a single tower in the center and gave the facade an elegant, feminine character by avoiding bold projections, keeping it flat, and using the sinuous lines of the pointed arches as a primary decorative motif (*Cours*, 2:355). Inside he raised the sanctuary, elevated the altar even further, and made room for the clergy behind the altar in the spacious apse, all of which devices Blondel recommended for heightening the spiritual character of a church (*Cours*, 2:308–10, 325–28, 366–67).

Few of Godefroy's works adhered so closely to Blondel as the chapel, but his objections to the Baltimore Exchange design (Fig. III–1), on which he and Latrobe collaborated in 1815–16, suggest that he went back to this source while working on his own new study (Fig. III–2). He objected to the large arched windows in the center of the first design and in his own substituted simple rectangles; he eliminated sculpture, although the sculpture Latrobe had used was at Godefroy's own earlier suggestion; he stigmatized the style of modern English, and Latrobe's, public buildings as not "masculine."[56] Behind these complaints lay Blondel's recommendations for a masculine architecture for public markets:

By a "masculine architecture" is understood one that, without being ponderous, retains in its disposition a character of firmness suitable to the size of the site and the type of building; one that is simple in its general composition, sober in its forms, and not overloaded with details in its decoration; one that is characterized by rectilinear plans, by right angles, by projecting parts that cast large shadows; one that, intended for public markets, fairs, hospitals, and especially for military structures, should be composed of fine

[55] Blondel also recommended that enlargement or renovation of Gothic structures be carried out in the same style; see his comments on Metz and Sainte-Croix d'Orléans in *Cours*, 2:311–12. On Blondel's attitude toward the Gothic, see Herrmann, *Laugier*, pp. 88–89.

[56] Godefroy to Jackson, Richmond, Sept. 7, 1816, Maryland Historical Society.

masses in which trifling parts are carefully avoided, the mean and the noble not going together.[57]

Another verbal link between Blondel and Godefroy appears in Latrobe's paraphrase of Godefroy's explanation of the taste "of the School of his time, that of Louis XIV, when Masses were made of accumulated details." [58] The source of this statement was surely Blondel's praise of certain examples of Sublime architecture which "by the beauty of their masses and the concatenation of their details assure to the reign of Louis XIV . . . a truly immortal glory" (Cours, 1:380). What is significant from our point of view is the degree to which Godefroy's design, ideas, and even words echoed the text of the teacher of the Revolutionary generations. There is little room for doubt that he possessed a copy of the Cours d'architecture.

In the chapter from which both quotations were drawn, Blondel summed up ideas current at the time (the 1770s) and which he had long been teaching (Cours, 1:373–447).[59] For him the nature, purpose, and character of a building were to be expressed solely by its architectural forms. Throughout the chapter he defined each variety of architectural character, described the means for obtaining each, and offered instructive examples, both successful and unsuccessful. To further expression, this academic classicist linked the orders with specific categories of buildings in relationships that paralleled the social and political hierarchy: "a Tuscan order in military works, a Doric in ecclesiastical buildings, an Ionic in pleasure houses, a Corinthian in royal palaces, a Composite in public festivals" (Cours, 1:410). Sculpture should aid the process: "sculpture will become the symbol of architecture and contribute to depicting, in the

[57] Cours, 1:411–12.

[58] Latrobe to R. G. Harper, Washington, Jan. 12, 1816, Letterbooks.

[59] Ch. 4 is entitled "Analyse de l'Art, ou moyen de parvenir à distinguer la bonne Architecture, d'avec l'Architecture médiocre"; indicative of the importance of character to Blondel, he made it the basis for judgment of architecture. That Godefroy paid particular attention to this chapter reinforces my feeling that he sought general principles in the books he used. Blondel's sources and concept of character in architecture have been studied in Kaufmann, Three Revolutionary Architects, p. 440; Kaufmann, Age of Reason, p. 150; Middleton, "Blondel," pp. 145–46. A good example of this conception of character and function appears in an evaluation of Ledoux's Barrière de Saint-Martin made in 1806 by French contemporaries of Godefroy: "The firm, masculine character of this decoration in the Tuscan order is the one which is appropriate for this kind of monument and should proclaim its solidity" (Legrand and Landon, Paris, 2:57). Peter Collins has noted that the Greek Revival could be justified on the grounds of "male simplicity" (Changing Ideals in Modern Architecture, 1750–1950 [Montreal, 1965], p. 90).

eyes of the viewer, the true character of the edifice"; and the function of architectural sculpture, he specified, was to "express by various attributes the purpose of a building" (*Cours*, 1:362–63, 340). More advanced theoreticians of the mid-century, like Laugier, called for the suppression of ornament and the expression of purpose and of materials and structure through planning and composition.

The next generation, including Ledoux and Boullée, went beyond its teachers, attempting to create an *architecture parlante*. The younger men realized that intellectual devices were insufficient, that a building had also to affect the emotions of the viewer. Their new compositional methods were intended to evoke strong psychological responses that would be reinforced by a play of light and shadow over contrasting shapes and sizes, voids and solids. The explicit relationship between the character of a building and its purpose, like many explanations of modern painting, often seems personal and arbitrary.[60] The notes of exaltation and passion in both writings and designs, however, evidence the earnest sincerity and intense concentration of these men. The generation that followed them lost sight of the goal, found the struggle too intense, or simply gave way to other, perhaps public pressures, and turned to symbolic and allegorical decoration to carry the meaning of a building.

It cannot be said that Godefroy developed the *architecture parlante* of Ledoux and Boullée, but like them he was strongly influenced by Blondel's emphasis on character. The Tuscan order gave an appropriate solemnity to his Unitarian Church (Fig. III–10) and the Doric to his Richmond courthouse (Fig. III–6). Jefferson's capitol in Richmond, housing the legislative bodies that gave order to human relationships, demanded a formal plan for the square (Fig. III–4). The classicizing sculpture on several works aided in identifying the nature and purpose of the buildings. Strongly inclined toward allegory, Godefroy carried it as far as he could in architecture and sculpture; that is to say, the theory of Blondel lay behind the forms employed by Godefroy.

Of equal value was the aid Godefroy might have received from Durand's *Précis des leçons d'architecture*, the first volume of which appeared in 1802 and the second in 1805. His good friend Francoeur was a colleague of Durand's at the Ecole Poly-

[60] E.g., C.-N. Ledoux, *L'Architecture considérée sous le rapport de l'art, des moeurs et de la législation* (Paris, 1804), p. 194. The new compositional methods have been discussed by Kaufmann, *Age of Reason*, ch. 3, esp. pp. 188–90.

technique and had recently published his own textbook on mechanics. He may have been the means by which Godefroy learned of Durand's new work, modern in its style and methods and soon to become a guide for nineteenth-century architects.[61] Several aspects of the *Précis* would have appealed to Godefroy from the first. In his preface Durand made clear his purpose in teaching and writing for engineers: it would fall to their lot, when they took up positions in remote provinces, to design many kinds of buildings (*Précis*, 1:i). Godefroy could see himself in this very position on arriving in Baltimore, but even in 1802 he deemed himself an engineer, and these words could have stimulated his interest in architecture.

Durand taught by means of general principles (*Précis*, 2:19–20), a method that made the *Précis* well suited to the process of self-instruction that Godefroy employed. Without benefit of a modern educationist's theory Durand proceeded step by step from the simple to the complex, from the known to the unknown (2:5). He wrote clearly and simply, dealing concisely with materials and their uses and with the parts making up a building (1, pts. 1–2). He offered what he called a "mécanisme de la composition," a rationalized procedure for correlating the problems of construction, of planning and grouping rooms for varied human needs, and of dealing with the elevation and decoration of buildings (2:20).[62] He gave specific answers to innumerable questions on design and construction but permitted great latitude when circumstances required it. The teaching method doubtless proved invaluable to Godefroy as a teacher of architecture; the compositional system and forms and the technical advice were heeded in varying degrees in his actual building.

His first work, St. Mary's Chapel, shows Durandesque qualities in the planning. The separateness of the three main parts—the sanctuary and apse flanked by large rectangular chambers, the body of the chapel, and the entrance screen with porches, vestibules, and staircases—suggests Durand's sequential treatment of the parts of a building (*Précis*, 1:94–103). The separate parts were not brought into a whole compact mass at this early stage of Godefroy's career. In the decoration, moreover, he followed the injunction to avoid useless, and therefore harmful, "architectonic decoration," relying on approved painting, sculp-

[61] For an account of Durand's influence, see Hitchcock, *Architecture*, pp. 20–58.

[62] The "mécanisme de la composition" is essentially the subject of the second part of vol. 1.

ture, inscriptions, and methods of suggesting the construction (*Précis*, 1:18–19, 55–56, 92, 99). The only convincing example in Godefroy's work of a direct borrowing from Durand occurs in the broad band of ornament across the chapel vault (Fig. II–5); a pattern of large diamond shapes with a four-leafed ornament in each sunken panel follows Durand's example (Fig. II–6) of vault compartmentation (*Précis*, 1, pt. 1, pl. 11). Inasmuch as this band marks the separation between nave and sanctuary, it performs a significant function.

Occasional parallels to Durand's practices occurred in works of the following years, but the most impressive signs of this influence appeared in 1816–17, in Godefroy's Baltimore Exchange study, the buildings in Richmond, and the Unitarian Church. Whereas his concern with expression of architectural character had led him back to Blondel, he apparently restudied Durand in a search for modern forms. In a new design for the Baltimore Exchange, Godefroy introduced a one-story portico for pedestrians running the full length of the building: raised panels above the cornice marked the center and ends, while a pair of piers at either end reinforced the planarity of the Doric colonnade (*Précis*, 1:84, 2:25–26). In the drastically flattened wall of the main building the Romantic-Classical penchant for reiteration determined the multiplicity of identical windows of a simple rectangular shape; those of the first two stories had a proportion of two to one, while the top ones were reduced to one and a half to one; those of the second story had an architrave with supporting blocks, and the top ones were set on a string course—all specific recommendations by Durand (1:80–81, 90). The curve of the dome and its stepped buttressing recalled Durand's preference for the Roman Pantheon silhouette, while the modified Palladian forms in the end pavilions followed his rule for lighting a high vaulted hall with a semicircular window at the end (1:97, pt. 2, pl. 15). The extreme contrast between this study and the design earlier agreed upon by Latrobe and Godefroy resulted from the latter's most serious study of his architectural guides.

The renewed vigor Godefroy derived from these French sources found its outlet in designs in Richmond in the summer of 1816. He joined two adjacent bank buildings (Fig. III–9), already under construction, by stretching an arcaded portico over their combined fronts and setting a sentry box at either end (*Précis*, 1:94, pt. 2, pls. 3, 6, 10). Much more extensive were his alterations of Mills' design for the courthouse. He raised one-story wings to the height of the main block, set a tall un-

pedimented tetrastyle portico at each end, and united the whole with a Doric entablature (Fig. III–6). A modified Palladian form appeared on the lateral entry, but all other openings were rectangular. In restudying the plan Godefroy made the parts more distinct; the change from an oval to a circular courtroom introduced a shape preferred by Durand and permitted an integrated dome arising from the main block (*Précis*, 1:17, 2:42–43). Thus several aspects of the building combined to give it a more Gallic flavor, one specifically related to activities of the Revolutionary age. More important, perhaps, Godefroy could follow one more piece of advice offered by Durand, to compose beginning with the ensemble rather than parts and details, and thus achieve the tightly knit organization lacking in St. Mary's Chapel (*Précis*, 2:96–97).

To list Durandesque aspects in the Unitarian Church is to repeat much of the foregoing: the compactness of the building with its several essential parts closely integrated, the stepped dome growing out of the structure, the arcaded portico, the nonarchitectonic decoration against plain wall surfaces. The simple geometric shapes were related to Durand's preference for a square to a rectangle, and for a circle to a square, the circle, and less so the square, being more economical to build and providing greater symmetry, regularity, and simplicity (*Précis*, 1:17). Planning may have been carried out on squared paper as Durand recommended, so that the exterior columns and walls were geometrically as well as structurally related to the interior walls, columns, and other supports (Fig. III–19). The large rounded apse projecting from the rear of the building was warranted by the *Précis*, as were the coffers of domes and arch soffits (1:83). Forming the vestibule and supporting the choir and organ loft were eight columns with capitals modeled after the Tower of the Winds (Fig. III–12), a reflection of Durand's hope that the savants might soon publish Egyptian orders that would be more structural and economical than the classical orders (1:76). The elegant, illusionistically painted Empire decoration—indeed the precise linearity of all the separate parts, both surface and void—comprised a three-dimensional equivalent to the fine-line engravings illustrating Durand's publication. It is no wonder that a French general regretted that the building was not in France, observing that he had seen many more vast but none so pure.[63]

<hr/>

[63] E. Godefroy to Jackson, Laval, Sept. 22, 1836, Maryland Historical Society.

Although Godefroy drew specific elements from Durand, he also took to heart his general advice to allow economy and the functions of a particular building to dictate many variations from the rules (1:16). The arched portico of the Unitarian Church, with its groin-vaulted ceiling (Fig. III–15) did not duplicate a specific model. In this and other examples of the Tuscan order Godefroy's variations on the traditional proportions and spacing had Durand's blessing (1:67–68, 88). The Renaissance system of arches, pendentives, and dome, and the use of piers rather than columns, are quite unlike anything in the *Précis*. Feeling himself fully competent, as his letters show, and disinclined to extensive copying or even relying heavily on anyone else, Godefroy made the church his masterpiece.

Although Godefroy's confidence in his ability never failed, his mastery and maturity had little opportunity to develop. His seven years in England were almost fruitless. In France, during the last thirteen years of his life, his numerous projects and several building complexes showed extreme reliance on Durand: alternative projects for the Rennes *chapelle funéraire* and for the *mairie* of Chateau-Gontier (Fig. IV–22) grew out of Durand's system of horizontal and vertical combinations (*Précis*, 1:87–93). The two pavilions of the Laval Préfecture (Fig. IV–16) were but slight variations on a Durand model (Fig. IV–10). In the Asile at Mayenne (Fig. IV–7) Durand's plates could almost have been used directly by the builder as drawings for the battered base and the heavy voussoirs and quoins. More specifically, the arcaded wings may be Godefroy's adaptation from Durand's suggestion for hospitals (2, pl. 18). To reroof the Hôtel de la Préfecture in Laval, Godefroy recommended, as did Durand, the method of Philibert Delorme (1:61–62). There was sufficient reason, beyond old age, to account for this dependence; Durand himself was alive and active until 1840, and his *Précis* was still being reprinted. The directeur général des travaux publics and inspecteur des bâtiments civils, H. Rohault de Fleury, Godefroy's superior, was also a student of Durand.[64]

Blondel represented the style, taste, and manners of Godefroy's youth, and Durand provided the most modern approach available when he turned to architecture. One stimulated Godefroy's allegorical temperament through emphasis on character in architecture, while the rationalized method of the other ap-

[64] C. Bauchal, *Nouveau dictionnaire biographique et critique des architectes français* (Paris, 1887), p. 719.

pealed to his analytical, even if erratic, intellect. His problem, and his feat, was to reconcile his two sources. In large part he succeeded by drawing his principles from Blondel and his forms from Durand. Where Blondel identified character as an element of style and associated it with specific orders, like the religiosity of the Doric, Durand saw character as an aspect of beauty emerging from the display of useful, effective construction, such as battered walls (*Précis*, 1:93). As noted above, for a masculine character in markets Blondel advised simple rectilinear lines and right angles, large masses without petty details, advancing parts throwing grand shadows; for the Baltimore Exchange study, where he sought this character, Godefroy drew from Durand the projecting portico with a colonnade, the solid mass of the main block lightened by rectangular windows, and the Pantheon dome on an octagonal drum decorated solely by the careful rustication of the ashlar. For the Unitarian Church he agreed with Durand in shunning pretentious and expensive decorative architecture, but heeded Blondel in making his sculpture symbolic, in a classical manner, of the nature of the building.

Godefroy did not hesitate to adapt modern French forms to different materials. Durand, for example, considered coffering a satisfying decoration because it grew naturally out of stone, brick, or carpentry construction (*Précis*, 1:83, pt. 2, pl. 15). In the Unitarian Church Godefroy had coffers built up of lath and plaster; their rosettes and other interior sculpture were actually illusionistic painting. For the exterior moldings and ashlar rustication recommended by Durand, Godefroy resorted to lined stucco on the Unitarian Church, as he had intended earlier for St. Mary's Chapel (*Précis*, 1:64–65, pt. 1, pl. 2). Illusion, deceit, or whatever it may be called, the practice stemmed from Durand's forms but was motivated by Blondel's theory of character (*Cours*, 1:392–93).

Godefroy's individual style, then, derived from the peculiar nature of his personality, from his experience, and from his architectural study under these disparate masters. His successful reconciliation of Blondel and Durand is attested by the recent observation that some of his American buildings could have been designed a generation earlier in France, for there Blondel's theory was still strong and Durand's forms were current.[65] His professional fortune lay in being in America where, to his clientele, his architecture appeared modern and cosmopolitan.

[65] Hitchcock, *Architecture*, pp. 6–7.

II. First American Works, 1805-15

Godefroy's years in America were the most productive of his career. His first building was under way less than a year after he landed in this country; he was still busy, although without much financial profit, up until a few months before he left for England. The wide range of his activities was characteristic of the time—several churches and banks, a courthouse, an exchange, landscaping, monuments and burial vaults, and fortifications. It was unusual that, unlike other architects, his name was connected with only one domestic work. Figural and decorative sculpture of his own design was an integral part of his architectural compositions. In addition, he produced numerous drawings, often with gray or colored washes, for a variety of purposes—a military banner, a college diploma, advertising, a magazine title page, and landscape representations.[1]

Chapel, St. Mary's Seminary In 1791 a group of Sulpicians settled in Baltimore and established St. Mary's Seminary.[2] Several years later, with the hope of furnishing a supply of seminarians, they opened a college

[1] For these designs, see Robert L. Alexander, "The Drawings and Allegories of Maximilian Godefroy," *Maryland Historical Magazine* 53 (1958):17–33. Most of Godefroy's works in America have been touched on at least briefly in Carolina V. Davison, "Maximilian Godefroy," *ibid.*, 29 (1934):200–211, and continued reference will not be made to this basic study.

[2] For the history of St. Mary's Seminary, see Charles G. Herbermann, *The Sulpicians in the United States* (New York, 1916); for St. Mary's College, *ibid.*, pp. 91–123. The chapel was studied in William S. Rusk, "Godefroy and St. Mary's Chapel," *Liturgical Arts* 3 (1933):140–45. In preparation for its recent thorough and careful restoration, the sources, appearance, and history of the chapel were recounted in Phoebe B. Stanton, "The Quality of Delight," *The Voice* 45 (1968):6–12; details of the structure and restoration were presented by Alexander S. Cochran, "Paca Street Chapel Restored," *ibid.*, pp. 13–16. Although the design was completed early in 1806, Godefroy may have continued to draw details as late as 1808 (Godefroy to Dubourg, Baltimore, Oct. 1, 1806, Maryland Historical Society). The total cost of the chapel was $33,828.20. Its interior length is 88 feet; its width across the facade is 61 feet and through the transept 70 feet. The sanctuary is 36 feet long; both sanctuary and nave are 25 feet wide, the aisles 5 feet.

which flourished as the high quality of its education became recognized. Godefroy arrived in Baltimore in December, 1805, to teach at the college, and by the following March he had designed a new chapel. The contract for its construction was let to George Weiss. The cornerstone ceremony was held on June 26, 1806, and the consecration on June 16, 1808.

The diaries and accounts of John Tessier, then treasurer and later superior of St. Mary's, record the significant stages in the construction. Excavation was begun in May, 1806; a month later the brick side walls above ground were started. In July the facade was begun, in August the roofing of the sacristy. At the same time Godefroy was complaining to Latrobe about the changes he was being forced to make. By winter the exterior was virtually completed, although Godefroy was still drawing details. In 1807 progress was slow; the flèche was erected, some other exterior ornament was finished, and the grounds around the chapel were regulated. From March to May, 1808, the sculptor Giovanni Andrei and his assistants were borrowed from Latrobe to complete the interior decoration, and the necessary church furniture was installed in time for the dedication.[3]

Since these well-recorded beginnings, the chapel has undergone several renovations, but it has survived these "improvements" and become recognized as a major monument of the early Gothic Revival in America. Numerous pointed arches, buttresses, and other details immediately stamp the building with a medievalizing character and contribute to its verticality and richness. On the facade the slightly projecting central portion, the pyramid of steps, doorway, recessed stucco panel, and rose window establish a major vertical axis (Fig. II–1). The portal arch, flanking niches, and smaller niches grouped higher stimulate a rising movement fanned out over the surface and contained by the clustered columns and buttresses on either side. Two lateral portal structures and the horizontal cornices aid in measuring an upward rise that would culminate in a tower as the peak of a triangle. The horizontal finish crossing the top—squat piers, panel, and pierced balustrades—emphasizes not

[3] Father Tessier's manuscript diaries in the archives of St. Mary's Seminary are the source of many details offered here, and all references there to Godefroy's chapel have been extracted and presented in the appendix to this volume. The date of the interior stucco work (capitals, vault decoration, etc.) is well fixed by Latrobe's letters concerning the "loan" of Andrei and his assistants (Latrobe to Andrei, Washington, Mar. 26, 1808; Latrobe to Dubourg, Washington, May 24, 1808, both in Latrobe's Letterbooks, Maryland Historical Society).

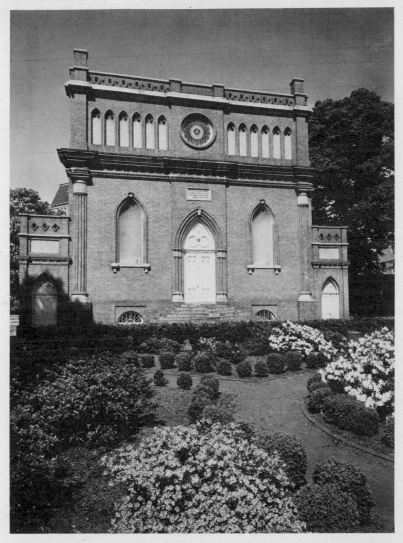

II–1. Facade, St. Mary's Chapel, Baltimore. 1806–8. Photo A. Aubrey Bodine Collection, Peale Museum.

only the squareness but also the flatness of the chapel front as a surface for the decorative treatment. From the ground up the wall plane is evident: it is prominent on the main level, surrounds the arches, gives relief to columns and cornices, and emerges and finishes as the balustrade. Rectangles evoke the general shape of the facade in its major subdivisions and side portals, in the three over-door panels, and around the rose and

basement windows. An equally intricate arrangement ensues from reiteration of the pointed arch in portals, niches, and the corbeled cornice. The two separate motifs unite in the common materials and colors; red brick serves as both matrix and molding, but white crops out over the whole facade, stucco in the niches, cornices, and panels, and sandstone, spotted like a series of gems, in bases and capitals, sills, corbels, and keystones. Since the moldings, orders, and other parts have but slight relief from the wall surface, light and shadow patterns tend to be small and broken, delicate rather than bold, underscoring the linear elegance of the overall composition.

Godefroy concentrated the rich decoration on the facade, so that the rest of the chapel appears almost barren. In a lateral view of the building (Fig. II–2) the facade itself provides the most unusual feature; its upper level is largely a false front, supported by a spur wall and brace in the form of a flying buttress. Along each side wall three simple pointed windows

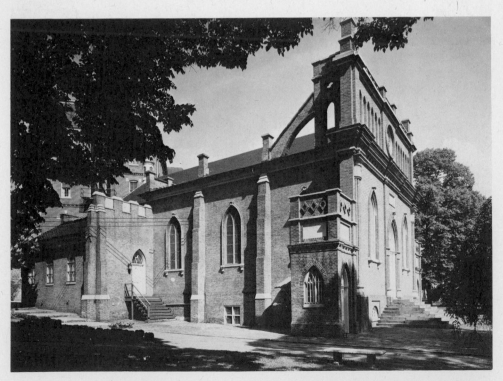

II–2. Side, St. Mary's Chapel. Photo A. Aubrey Bodine Collection, Peale Museum.

alternate with buttresses. Then come transeptal projections, wider than the facade and almost as deep as the nave wall, with corner buttresses and crenellations at the front but simpler at the back, where the north wing shows cornices suggesting a gable roof and a spur wall joining with the apse (Fig. II–3). A door at the front, three pointed windows on the side, and a semicircular window at the back open the walls of the wing. At the back of the chapel the curve of the apse projects between the transept wings and four buttresses make bays for two windows and the later central apsidiole; part of the apse and south transept wing are concealed by a passageway that connects the chapel directly with a later seminary building. In contrast with the facade, the body of the chapel is relieved of ornament and pleases the modern eye by its simplicity and the functional expression of the buttresses.

Entering the chapel, one moves under the gallery toward the wide and deep inner space (Fig. II–4). From nave to sanctuary the interior is unified by the steady march of tall bundled columns and the barrel vault that flows to the curving apse at the

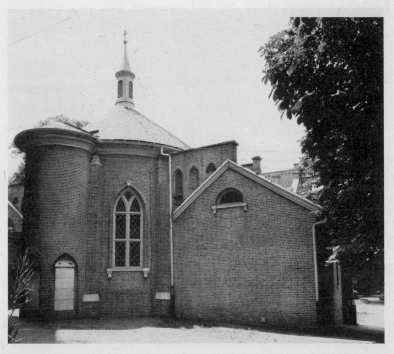

II–3. North transept and apse, St. Mary's Chapel. Photo Peale Museum.

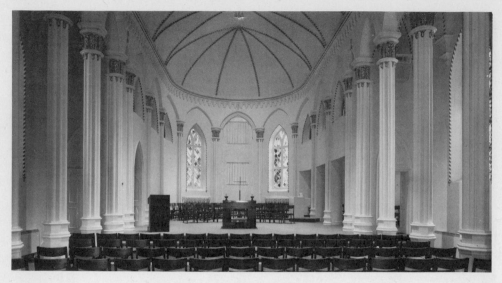

II–4. Interior, St. Mary's Chapel. Photo Peale Museum.

far end. Repeated bases and capitals, small pointed arches, and simulated vault ribbing join with the continuous corbel table and cornice to outline the volume. In the sanctuary, however, a significant change occurs; the columns are engaged in walls which, despite numerous recesses, doors, and windows, enclose the area of the altar and choir. The nave, in contrast, with its freestanding columns and flanking aisles, possesses a lateral expansiveness. Architectural elements clearly mark the transition between nave and chancel by the steps indicating a change in floor level, the close-set columns and a tiny arch with foliate ornament rising up the side wall, and a broad decorative band crossing the vault overhead (Fig. II–5). Despite the continuity of the whole interior volume, its character thus changes, with the aid of structure and ornament, from the openness of the profane area to the enclosure of the sacred. From the sanctuary toward the entrance the view sweeps back and up to a climax in the group of forms above the gallery. The sequence of planes from gallery front to piers and arch and to rose window defines a farther spatial extension centered on the organ and thus implying a specific musical character for this portion of the chapel. Piercing of the pattern—rosettes, arches, and diamond—turns the paneled gallery front into a screen, its ornament repeating motifs from other parts of the chapel. Only the lower meander border is unique, but its Greek form is closely related

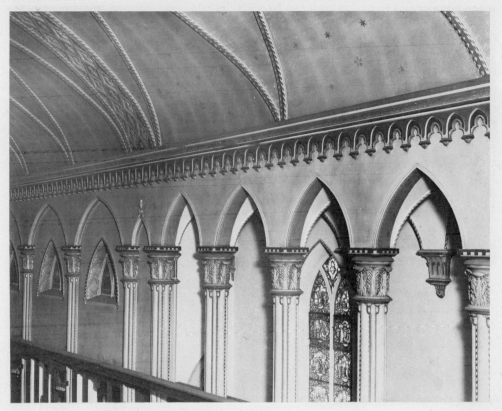

II–5. Detail of nave vault and arcade, showing decorative band separating nave and sanctuary, St. Mary's Chapel. Condition ca. 1936. Photo Historic American Buildings Survey, Library of Congress.

to the acanthus leaf capitals of the colonnades. Classical and Gothic elements combine again in the side aisles, where the ribbed vaults rise on one side from columns but on the other from wall brackets that might have been designed in late eighteenth-century France. In the fusion of medieval and classical forms Godefroy's chapel has more of the Gothic than comparable European examples, but the pointed arch and related curvilinears give vibrance to the elegant interior organization.

Some unusual features of the chapel have already been noted; others, such as the large sacristy, were a response to the special needs of a seminary with a large number of ordained priests; another, the deep transept, seems to be linked with the prehistory of the building. The transept actually comprises two separate chambers flanking the choir and apse, the uses of

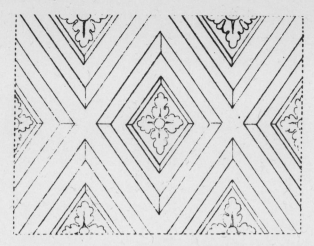

II–6. Coffer design. J.-N.-L. Durand. Durand, *Précis des leçons d'architecture données à l'Ecole Polytechnique.*

which have varied in time (Fig. II–7). Reached by the side aisles, the exterior doors, and the doors in the sanctuary arcade, the south wing originally served as a sacristy, and the north was used primarily for the collegians; each contained a small altar. The origins of the north wing are suggested by implication in Father Tessier's journals. Although he detailed significant stages in the construction of the *chapelle basse* (below ground level), the *sacristie* (the south transept), the *front* (facade), and the *chapelle* (including the nave and choir), he made no reference to the part now called the "north transept." On the other hand, he wrote of the *petite chapelle* which had served since 1791. In July, 1809, a year after the *petite chapelle* ceased to house the Host, its roof was removed so that it could be salvaged as a *chambre.* Five months later doors were placed on the chapel, the sacristy, the *petite chapelle*, and the *chapelle basse.* The nature of these references points to the identity of the old small chapel and the north transept wing. There is structural support for this conclusion in the lower roof height, which permits three clerestory windows opening into the north side of the choir; the discontinuity of the brick courses between the back wall and the arcaded spur wall above the gable indicates that the raking cornices mark the original gables and that the spur wall is an addition to mask the junction between the old building and the apse. The roof slope of the south wing, in contrast, continues that of the chapel roof, suggesting contem-

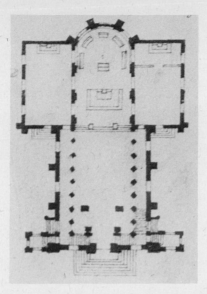

II–7. Plan, St. Mary's Chapel [detail of Fig. II–18]. Photo Maryland Historical Society.

poraneous construction. Thus a desire to incorporate the existing structure may have influenced the planning of the new chapel. Its duplication in the south transept wing provided the large sacristy needed for a seminary. Its length determined that of the sanctuary, and its wall openings determined the position of the piers and the proportions of the arcade in the choir.[4]

Although not wealthy, the Sulpician community in Baltimore was growing, and the new chapel had to reflect its diversified activities. A group of college and seminary buildings existed to the north of the chapel plot. The sacristy was located on the south side, in anticipation of the seminary buildings to be constructed in that direction. Equally accessible to both institu-

[4] All the doorways on either side of the sanctuary were probably openings of a pointed arch shape; Godefroy's plan suggests that the last ones were niches on the sanctuary side. The windows are still pointed and resemble those in Latrobe's Gothic design for the cathedral (Stanton, "Quality of Delight," p. 7); this resemblance is strong evidence for Godefroy's knowledge of Latrobe's design. For Tessier's record, see the appendix. For a different interpretation, questioning the preexistence of the north wing as the earlier chapel, see Stanton, "Quality of Delight," pp. 9–10. Examination of the building during its recent restoration neither substantiated nor denied the previous existence of the north wing. In Godefroy's plan of the chapel, the steps for the transept wings are much too low for the doors at their present height; perhaps an earlier door in the north wing was placed lower.

tions, the chapel separated their physical plants, housing the collegians in the north transept wing and the seminarians in the nave. The chapel also served a small lay congregation in the gallery; a high brick wall constructed in April, 1808, guarded the college area from extensive public intrusion. Numerous entrances provided for the variety of congregations using the chapel, and internal divisions kept them separated during services.[5] With a rather large complex developing, the Sulpicians clearly were attempting to direct the growth of the organization in an orderly manner. Although the rectilinear pattern was partly a matter of improvisation, the front of the chapel continued the line of the college buildings on the north. Thus the length of the nave, the several entrances, and the large gallery were determined by factors different from and in addition to the existence of the old chapel.

Still another factor became significant during construction. The Sulpicians were determined to build as economically as possible. Godefroy's original plans suffered drastic alterations, which he enumerated a decade later. The barrel vault was flattened by three and a half feet, and the columns he originally planned inside the front door were suppressed, only to be inserted later for the support of the roof. The Epistle pulpit

[5] The west end of the chapel interior is almost unknown. Godefroy's plan is not entirely clear; no old photographs or drawings are known; and descriptions of it are very scanty. On the plan two staircases rise beside the main door to landings on the way to the gallery; an interior staircase to the gallery appears in the south aisle of the chapel, yet the staircase takes several more risers to reach the landing than does the one in the vestibule. The existence of stairs and entrances from the lateral portals is put in question by Godefroy's oblique comment on another drawing: "The framing of the Steepel, & the passage going downstaires is my own work, after the two side doors was finished with Great Exps. and no use for them." The small exterior staircase on the north side goes to the basement, not into the chapel, as the plan suggests; its counterpart on the south side has no reason for being and, if ever built, has left no traces. Visiting the chapel in 1827, Mrs. Trollope gave a tantalizingly brief description of its interior: "A solitary lamp, whose glare is tempered by delicately tinged glass, hangs before the altar; the light of day enters dimly, yet richly, through crimson curtains; and the silence with which the well-lined doors opened from time to time, admitting a youth of the establishment who, with noiseless tread, approached the altar, and kneeling, offered a whispering prayer, and retired, had something in it more calculated, perhaps, to generate holy thoughts, than even the swelling anthems heard beneath the resounding dome of St. Peter's" (Frances Trollope, *Domestic Manners of the Americans*, 2 vols. [London, 1832] 1: 294–95). The "well-lined" doors probably were interior ones opening from a vestibule enclosed by arched wooden screening under the gallery and between the columns. This vestibule was somewhere between one and three bays deep, and was ceiled separately, with vaults under stairways (see Stanton, "Quality of Delight," p. 9).

thrust into the wall at the sanctuary entry further constricted passage from the narrow aisle to the sacristy. If his single roof of lead had been used instead of the expensive double roof of wood shingles, enough money would have been saved to build the exterior arcade he planned above the side walls. Inside, his gallery, by its extension, was turned into a barbarous amphitheater. Godefroy complained of the "kitchen windows" made for the *chapelle basse* by an ignorant carpenter, of the over-large niches substituted for facade windows, and of the changes in the altar that concealed the anatomical beauty of a crucifix on the apse wall.[6]

Some alterations made for the sake of economy had more fundamental effects, a few of which he indignantly reported to Latrobe while the building was in construction. The aisles were made too narrow, perhaps because the side walls were shifted inward to avoid the door in the center of the old chapel. A gallery which Godefroy intended to be only one bay deep was extended and supported by heavy rectangular piers and the first wall buttresses, creating what Godefroy called an amphitheater. The barrel vault was depressed so far that the rose window did not open directly into it but into an odd chamber constructed in the tower base. Undoubtedly he intended raising the ceiling of the gallery to the height of the facade attic, where he desired six rectangular windows instead of the twelve niches. When the Sulpicians received an estimate of $100 each, twice what they were willing to pay, for statues of the apostles, they decided to leave the niches vacant. Godefroy wanted stone, but at the very beginning brick was substituted. He then intended to stucco the exterior, and obtained from Latrobe a recipe for imitation stone paint; in no other way could the coarse brick and the crude bricklaying be countenanced.[7]

[6] Godefroy to Tessier, Baltimore, Mar. 29, 1817, Maryland Historical Society, quoted in part in Rusk, "Godefroy and St. Mary's Chapel," p. 143. Restoration in 1959-60 showed the double roof of shingles running the full length of the nave and choir; among the workmen there arose the erroneous opinion that a separate building, with its original roof, was incorporated into the chapel. A slate roof was added in 1853. Godefroy's "arcade" probably was the dwarf gallery shown on his drawing of the flying buttress. Perhaps he referred to the altar established in November, 1816, with a retable rather than Godefroy's baldachin, so that it cut off from view the back of the apse.

[7] On the statues, see Latrobe to Dubourg, Washington, Oct. 1, 1808; on the substitution of brick, see Latrobe to Godefroy, Washington, Aug. 18, 1806, both in Letterbooks. The facade has a good facing brick, but cheap, smaller brick is used for the rest of the building. The molded brick for the clustered columns and for window and door frames is even smaller. Not

A group of seventeen working drawings for the chapel is still owned by St. Mary's Seminary. A handwritten note on one sheet informs us that others were returned to Godefroy at his request, and the remainder show only details. Five deal with exterior elements, six with interior elements and furnishings, two with window tracery, and four with the organ. All of these drawings were probably made while construction was in progress. In a letter of October 1, 1806, Godefroy reported that he was still very busy providing the contractor with drawings. Estimates and contracts, made from January to April, 1806, must have been based on overall plan, elevation, and section drawings. After April 22, when the ground was staked for excavations, Godefroy had to produce drawings to keep ahead of the workmen.

The drawing of facade details (Fig. II–8) may be the earliest of Godefroy's surviving designs, dating before its construction commenced on July 31. It is, then, the best evidence of his competence at this time. In the collocation of front and profile views with plan (or section), for both the capital and base of the order, the drawing indicates his dependence on the method of illustration employed in architectural handbooks. The clustered shafts and faceted capital are reminiscent of Batty Langley's orders; the channeled necking of the capital is vaguely Vignolesque, although no precise parallels can be cited from either source.[8] One detail in the drawing shows how specially

one of the many butt joints on the building has the courses of brick matched precisely, yet they are bonded. Baltimore bricklayers were capable of very fine work; cf. Long's Medical College of 1812. Walter Athey, in charge of the brickwork at the chapel, could only have permitted the poor work on condition that it would be concealed (Godefroy to the Committee for the Monument, Baltimore, Mar. 22, 1815, Maryland Historical Society). For Latrobe's formula, see Latrobe to Godefroy, Philadelphia, Jan. 17, 1807, Letterbooks; see also Durand's recommendation of stucco for a smooth surface (*Précis des leçons d'architecture données à l'Ecole Polytechnique*, 2 vols. [Paris, 1802–5], 1:33).

[8] The drawing consists of seven pieces of paper pasted together, with overall dimensions of 19¾ by 15⅝ inches, in ink, pencil, and gray wash. See *Livre nouveau, ou règles des cinq ordres d'architecture, par Jacques Barozzio de Vignole*, ed. J.-F. Blondel (Paris, 1757), pls. 12–14; and Batty Langley, *Gothic Architecture* (London, 1747), pl. 10, the fourth order. Channelling was widely employed in the later eighteenth century in many ways; Jean-Ch. Delafosse, in *Nouvelle iconologie historique* (Paris, 1768), adapted grooving to many forms in his plates, e.g., pls. 18, 19, 27, 33, etc., esp. 62 and 85; rich in allegorical content, this book evidently proved so successful that its author published a second, enlarged edition in 1771. Godefroy, too, applied channels in several ways internally and externally on the chapel.

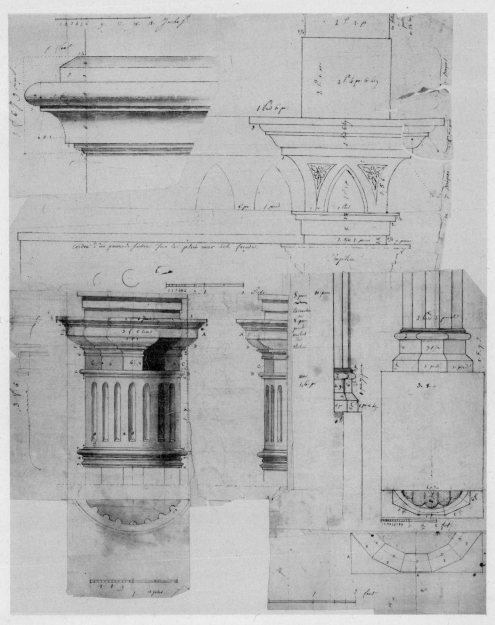

II–8. Drawing for details of facade, St. Mary's Chapel. 1806. Photo Peale Museum.

molded bricks with curved ends, used on openings and niches throughout the structure, were laid as headers stepped forward regularly from the wall to form the clustered shafts of the engaged columns; the cross-section of the column resembles rather closely the section of an Egyptian bundled column illustrated by Quatremère (Fig. II–9). Fine floral elements in the cornice were not reproduced in stucco, and Godefroy omitted similar refinements from later drawings, but in most respects the builder followed the drawing closely. In its fine ruled lines and sparing use of gray wash for shading, the technique of draftsmanship evokes the engraved plates in architectural books. Each part of the drawing includes its own scale, again a common feature of such books. Dimensions indicated by *pieds* and *pouces*, "feet" and "inches," was an eighteenth-century French practice, and Godefroy wrote them in either French or English on his early drawings; later he used only the English terms.

Rather later is the large drawing for the structures bracing the screen portions of the upper facade wall (Fig. II–10). Dimensions are written in English, small decorative details are

II–9. Bundled column of Egyptian type. A. Quatremère de Quincy, *De l'Architecture égyptienne.*

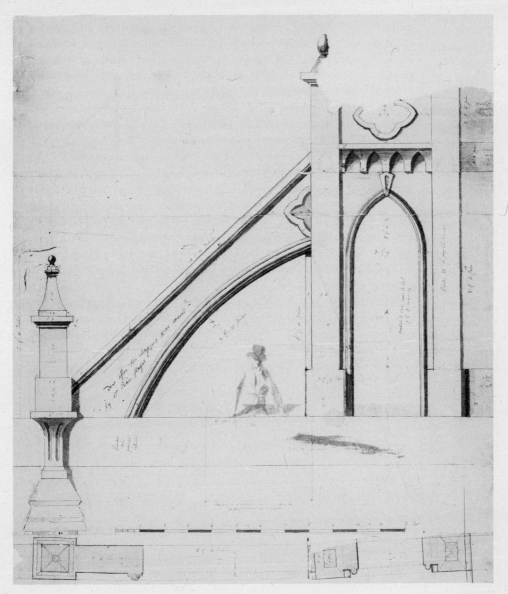

II–10. Drawing for flying buttress, St. Mary's Chapel. 1807–8. Photo
Peale Museum.

omitted, and the gray washed shadows are quite fluent. The
elevation, still linked directly with its plan, extends the Gothic
motif to the point of including the flying buttress that con-
nects the arched spur wall with the first wall buttress. Perhaps

the awkward device was necessitated by the clergymen's decision to lower the nave vault by three and a half feet, thus leaving large areas of the facade wall without lateral support. A season of strong winds, February to May, 1807, may have shown the need for supplementary buttressing and offers a possible date for the drawing. Godefroy noted, on the flying buttress, that this part (and perhaps the entire bracing structure) was built after the date of consecration, June 16, 1808. He evidently had resigned himself to construction in brick, for this portion of the drawing is washed in pink, the customary symbol for brick. Having seen how his pierced ornament for the facade parapet had been coarsened by translation into brick, Godefroy here explicitly indicated a simple broad frame for the quatrefoil openings. At the same time the concave sides of the pyramid atop the buttress introduce a note of elegance. The arcade above the pointed arch was not built, and probably this was the omission he complained of in his letter of 1817. Certainly the most intriguing element in the drawing is the lightly indicated half-length male figure holding a cane or yardstick. Perhaps a self-portrait, the image recalls the plates of Blondel's edition of Vignola (Fig. II–11), where the activities of architects are depicted.[9]

Several of the drawings clarify details of Godefroy's work. One, for example, shows the turrets originally built above the corners of the facade, and another has Godefroy's first conception for the tower, set on a roof ridge that rises above the level of the roof actually constructed (Fig. II–12). The one-story tower has corner piers topped by obelisks, and the central spire supports a simple cross. Robert Cary Long II utilized this idea for the upper half of the tower he built on the chapel in 1840.[10] Godefroy's drawing for the rose window (Fig. II–13) shows that it was carried out essentially as he designed it but without the

[9] The elevation and the plan are two separate pieces of paper pasted together, with overall dimensions of 29¼ by 21¼ inches, in ink, pencil, and gray and pink washes. One drawing in this collection bears the profile of the buttresses of the upper half of the facade. Attached is a drawing for the parapet decoration, ribbons intertwined in circles, alternating large and small. This ornament, translated grossly into ovals and diamonds of brick on the chapel, occurred frequently in eighteenth-century publications (e.g., Delafosse, *Nouvelle iconologie*, pl. 47). Architects in various activities appear in Blondel's edition of Vignola, pls. 3, 22, 30.

[10] See the drawings by Robert Cary Long II (Stanton, "Quality of Delight," illus. 6–7). Comparison of these drawings with published engravings of 1822 and 1830 shows that Long altered the tower section containing a triangular symbol and changed the arched doorway with a stone cross to the wooden form that exists today. The radiant triangle appeared in Blondel's edition of Vignola (e.g., pls. 36–37).

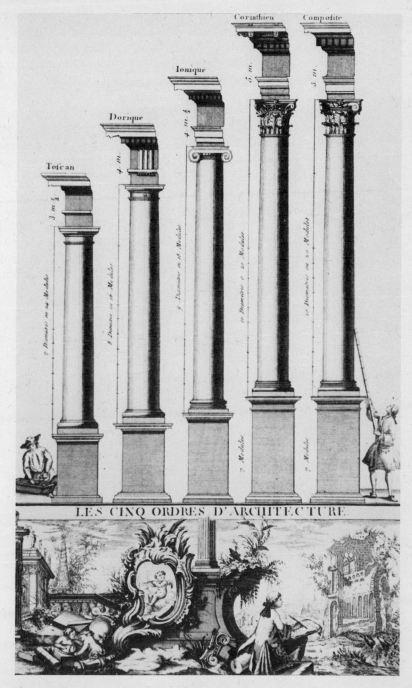

II–11. The five orders of architecture. J.-F. Blondel. Blondel, *Livre nouveau, ou règles des cinq ordres d'architecture de Vignole.*

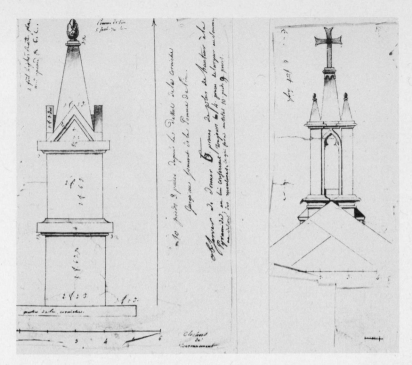

II–12. Drawings for corner turret and tower, St. Mary's Chapel.
1806–7. Photo Peale Museum.

pink, blue, and yellow glass that he intended. The elaborate
initial "M" and the date 1807, in the central hub of the window,
which appear in his design, recall French practice.[11] A draw-
ing of the altar and its railing confirms the disposition shown
in the small plan on Godefroy's exhibition drawing. Apparently
the altar had a relatively simple table-like form, just over six
feet wide, and its area was marked off by a three-part enclosure.
A group of three sketches for the railing shows prismatic, even
obeliskoid, balusters and posts with diamond-shaped panels.
A pulpit was built over the railing between the sanctuary and
nave, engaged with the wall and close-set columns; and al-
though a drawing shows it on the south side, Godefroy later
noted that it was changed to the other side, causing additional

[11] During the course of late seventeenth-century construction on the
Gothic Sainte-Croix d'Orléans, the rose window of the south portal re-
ceived a central medallion which bore prominently the date 1679 (G.
Chenesseau, Sainte-Croix d'Orléans, 3 vols. [Paris, 1921], fig. 76).

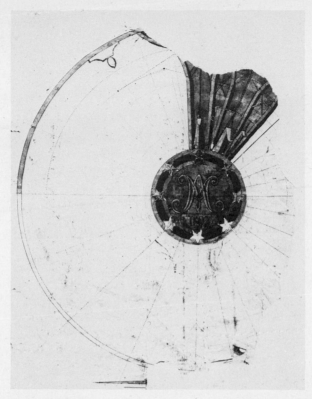

II–13. Drawing for rose window, St. Mary's Chapel. 1806–7. Photo Peale Museum.

expense. Other drawings confirm such details as the original vault slope, the window tracery, and the interior moldings. On the whole, the chapel as built closely adhered to Godefroy's ideas, and clearly he learned a great deal in the process of construction.

In one instance, differences between the original design and the finished pieces show the intervention of another hand and taste. The interior capitals (Fig. II–14) are a free invention of acanthus leaves in stucco set against a cylinder of wood; curled tips alternate with flat leaves, and acorns hang from the lower molding. In Godefroy's drawing (Fig. II–15), broad, relatively flat leaves are set close together, and in the space between the upper parts rise rounded forms carrying lily blossoms. His fantasy seems to have fed on Quatremère's equally fantastic Egyptian capitals (Fig. II–16), drawn with a profusion of acanthus leaves and lilies in a crinkly, spiky, linear but elegant style.

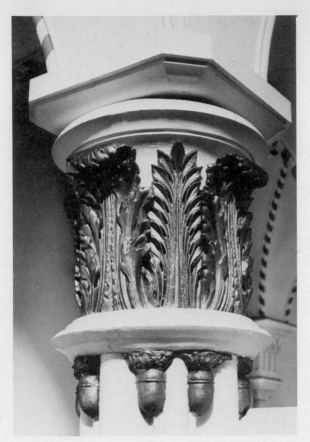

II–14. Interior capital, St. Mary's Chapel. Photo Peale Museum.

In making the clay models after which the actual parts were cast, Andrei changed the character completely by introducing a dry Neoclassical perfection; the acorns, too, may have been his contribution.[12]

[12] The drawing is in pencil, measuring 19¾ by 15⅜ inches; Godefroy later noted on the drawing that the contractor, Weiss, made the capitals for twelve dollars each, while Poore, a plasterer, bid twenty dollars for the job. For the "Egyptian" capitals, see Quatremère de Quincy, *De l'Architecture égyptienne*, pl. 3; for lilies, see esp. pl. 1. For somewhat similar capitals, see the Nicolaikirche in Leipzig, of 1784, by Johann Friedrich Dauthe, illustrated in Wolfgang Herrmann, *Laugier and Eighteenth Century French Theory* (London, 1962), pl. 40; the probability of Godefroy's knowing this church is extremely small, yet Latrobe may have seen it (Talbot F. Hamlin, *Benjamin Henry Latrobe* [Oxford, 1955], pp. 13–17). In the late eighteenth century architects frequently invented new

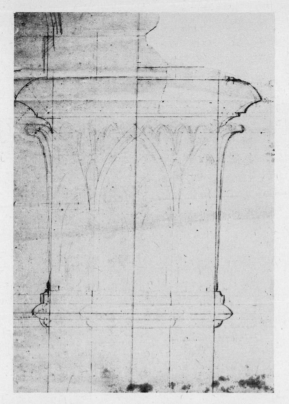

II–15. Drawing for interior capital, St. Mary's Chapel. 1807–8. Photo Peale Museum.

Two ecclesiastical furnishings called for Godefroy's special attention, the organ and the altar, for they were to be focal points at either end of the chapel. Four drawings show his enlargement of the existing organ, presumably used in the old chapel, to fill the space between the large piers in the gallery. Using all the parts, such as the pipe cases, he gothicized them by adding spires and crockets, pointed arches, and corbel tables similar to elements in the architecture. For the organist he designed a bench backed by a high railing with pierced circles and pointed arches, thus harmonizing with the gallery front

orders to express special meanings, and this occurred in the United States too: L'Enfant created an American order for Federal Hall in New York, and Latrobe designed corn and tobacco orders for the Capitol in Washington. Thus any similarities between Godefroy's capitals and those made elsewhere may result from the shared intellectual atmosphere rather than from conscious knowledge of the inventions of others.

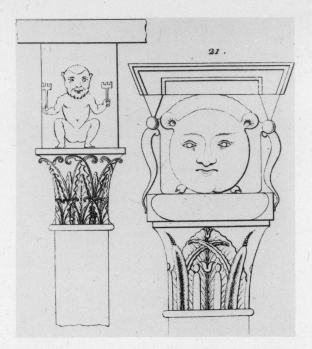

II–16. Egyptian capitals. Quatremère de Quincy, *De l'Architecture égyptienne.*

above which it would be seen. An equal-armed cross surrounded by rays, each arm ending in a trefoil, was to be set still higher within a large trefoil on the organ front. He noted on the drawing that although Andrei spent two days modeling this cross, it was not used. Only a tiny drawing records Godefroy's design for the altar. It was to be high, approached by a pyramid of three steps. A cross with rays and clouds of glory appears on the frontal; the mensa supports a block with a monstrance and additional clouds and a cross (Fig. II–17). Two pairs of slim columns carry an arched baldachin of Gothic forms between two obelisks, and at the top another obelisk raises a cross almost to the peak of the vault. Except for the Gothic elements, this design resembles baldachined altars of late eighteenth-century France.[13] Through repetition of similar forms, especially

[13] Through Latrobe Godefroy sought the aid of Andrei and Giuseppe Franzoni in carrying out this design. Andrei recommended constructing the lower part of brick, faced with marble or stucco, and the columns and baldachin of freestone (Latrobe to Godefroy, Washington, Sept. 14, 20, 1811, Letterbooks). Work on the stone parts may have been the reason

II–17. Ciborium, St. Mary's Chapel [detail of Fig. II–18]. Photo Maryland Historical Society.

the rayed cross, in these two commanding objects, Godefroy intended to contrast, yet tie together, the opposite ends of the chapel axis.

Godefroy made a handsome exhibition drawing of the chapel,

why Godefroy wanted the services of Franzoni in 1812 (Latrobe to Godefroy, Washington, Apr. 28, May 20, 1812, Letterbooks). In the following year Godefroy exhibited a large drawing of this altar (*Third Annual Exhibition of the Columbian Society of Artists and the Pennsylvania Academy. 1813* [Philadelphia, 1813], p. 12). According to Blondel, an elevated sanctuary and even higher altar were the source of character in a church (*Cours,* 2:366–67); in his edition of Vignola, Blondel illustrated several altars with baldachins, including that of Saint-Sulpice (pls. 48–50).

The first altar near the front of the sanctuary was replaced in November, 1816, with a larger one, probably an adaptation of Godefroy's design. About 1840 R. C. Long II may have introduced the cast-iron altar at the back of the apse. A white marble altar of 1842 established near the front was remodeled and set back in 1916, the iron altar being removed to the seminary building. The simple modern altar table of 1967–68 stands again near the front.

which included an elevation of the facade and a small plan and section showing the altar (Fig. II–18).[14] Between the two small drawings at the bottom is an inscription in elaborate calligraphy on a separate piece of paper: "Front of the Chapel of St. Mary's Seminary at Baltimore, erected after the design and under the direction of Maximn. Godefroy. A.D. 1807." The chapel is in the center, with a group of trees on either side isolating it and creating a spacious foreground; a plane of foliage closes the background. A late afternoon sun throws its light across the picture plane; trees shadow the lower part of the facade at the left, and a cloud shades the tower. The sky is light blue, the foliage bluish green, the building rather pink. Despite the shadows, the building is clearly delineated; its major outlines are strengthened by careful silhouetting. A few slight alterations, including changes from his own earlier designs, show the building as Godefroy wished it. Everywhere proportions are more elegant, the lines and decoration both lighter and more graceful, than in the actual building. Instead of the two large niches, he showed windows placed higher on the wall. That the very tall tower is shadowed by a cloud may be an indication that it was not constructed. Instead of the clustered quasi-Tuscan columns, Godefroy introduced slim buttresses with an elegant Gothic decoration. Boys playing at the left of the chapel and a group

[14] The whole consists of three parts mounted on a single base measuring 20⅝ by 17½ inches. This exhibition drawing, now in the Maryland Historical Society, may be the one shown in Philadelphia in 1811 (*First Annual Exhibition of the Society of Artists of the United States. 1811* [Philadelphia, 1811], p. 18). Godefroy evidently owned another copy of this handsome drawing for exhibition in Paris (F^{13} 650, Archives Nationales). Another drawing was circulating in Philadelphia in 1807 (*Observer*, Feb. 28, 1807). Around 1814 Godefroy incorporated the chapel into his design for the policy form of the Baltimore Fire Insurance Company (Alexander, "Drawings and Allegories," illus. following p. 24). He made a few changes, including a simpler tower and a higher roofline, and substituted three rectangular windows for each group of six niches in the attic. These changes need not reflect different intentions for the chapel, only simplifications for use of the building in the allegorical decoration of the insurance policy.

This plan and elevation, dated 1807, differ in some details from the chapel as constructed in 1806–7. With a simple altar and supports for the deep gallery, the plan more or less records the actual building, although the pulpit and the vestibule enclosures do not appear. Some elements of the facade correspond with Godefroy's statement of his original intention, e.g., windows instead of the large niches. In other respects the constructed form appears; the ovals and diamonds of the parapet are brick translations of alternating large and small circles that appear in another drawing. Working drawings still exist for the tall Tuscan orders and a simple tower; the Gothic buttresses and high tower of the elevation probably represent afterthoughts.

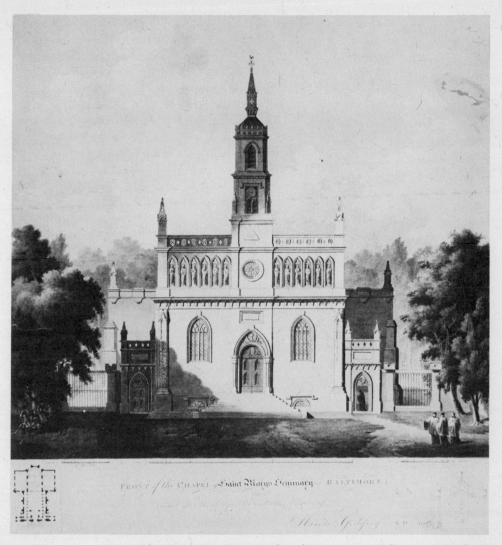

II–18. Elevation, St. Mary's Chapel. Ca. 1807. Collection Maryland Historical Society. Photo Peale Museum.

of conversing seminarians at the right indicate the distinction between college and seminary.

A number of Revolutionary principles of composition can be seen more easily in this drawing than in the building itself. Small rectangular panels over each of the three doors reflect in capsule form the overall rectangularity of the facade and its constituent parts. The pointed arch appears alone in large sizes

for doors and windows, in groups of smaller sizes for niches and tower windows, and smallest of all in the cornices. The two themes interweave horizontally and vertically over the surface; symmetry, balance, contrast, and wide spacing create tensions emphasizing the flatness of the wall.

Although this composition reflects contemporary French methods, the Gothic stylistic traits are more difficult to explain. In Paris the Sulpicians had completed the front of their mother church in a classical manner only a generation earlier. There are indications that the existing *petite chapelle* followed the simplified late Georgian of Baltimore; it retains its raking cornices and a semicircular window high on the back wall; the brickwork of other windows and the door, now all with pointed arches, has definitely been disturbed. Latrobe had created some interest in Gothic in the Baltimore diocese by his letters and drawings for the cathedral, but he was not in the city in the period December, 1805, to March, 1806, when the chapel was being designed. Although eclecticism was common in Romantic Classicism and the Picturesque, the revival of Gothic had little appeal in France at this time. Yet some elements of this building suggest that Godefroy may have had in mind Notre-Dame in Paris as a partial source (Fig. II–19). The tower in his exhibition drawing is topped by a sphere from which rises a cross supporting a Gallic cock, just as in a plate of the cathedral in Blondel's edition of Vignola. The same plate shows classical arched portals flanking the cathedral, which may be the origin of the unusual portal structures Godefroy placed on either side of the chapel facade. Again, pierced parapets atop the cathedral towers are hinted at by the topmost element of the chapel facade. Indeed, the whole emphasis in the Blondel plate is on the roughly square shape of the Gothic facade, the usual seventeenth- and eighteenth-century interpretation followed by Godefroy in the chapel. Father Tessier recorded with obvious satisfaction the stages of work on the *basse chapelle*, and the idea of two levels in the building may have evoked the image of Sainte-Chapelle in Paris. This building, too, carried a great tower with a cock at the top. No matter how freely Godefroy adapted the motifs, evocations of Parisian ecclesiastical architecture could only delight the exiled French priests and give the building more favor in their eyes. Perhaps the best explanation for the medievalism lies in the eighteenth-century French effort to achieve the high, spacious interiors of Gothic cathedrals in Neoclassical churches. The tall columns in the chapel leave little room for pointed arches, but they increase the verticality of the

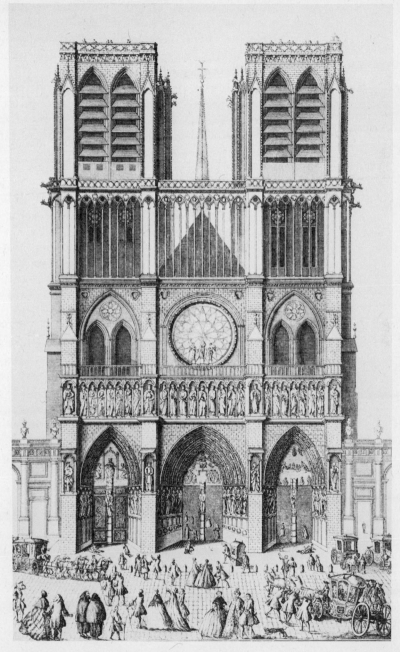

II–19. Facade, Notre Dame, Paris. Blondel, *Livre nouveau.*

nave. In decorative vocabulary Godefroy went further than his countrymen, mingling Gothic forms with classical.[15]

For practitioners of the early Gothic revival this style expressed a religious character. Latrobe felt that it drew forth from beholders a sense of veneration. Blondel, too, emphasized the effectiveness of the Gothic in evoking the related feelings of sublimity and religiosity:

> The Sublime style of which we speak should be, for example, the very style of our temples; every part, in fact, should seem designed by a divine hand; their disposition should have a sacred character that summons man to God, to religion, to himself. Note carefully, certain modern Gothic churches convey this impression: a great vaulted height in which there is nothing ungraceful, spacious naves and side aisles, subdued lighting in accord with the spiritual mystery, lofty and peaked facades, internal symmetry between the respective sides; finally, measurements which show that rules were followed, even though they are for the most part unknown to us—these are the beauties that are observed in some works of this style, and that should at the least serve us as examples in the construction of the monuments of which we speak.[16]

Several times Blondel mentioned the Gothic with approval, remembering that he had worked on the completion of Sainte-Croix d'Orléans. Godefroy himself had shown a literary interest in the Middle Ages; in a fictitious essay seized by Napoleon's secret police, he described trophies of glory hanging from ogival vaults. Closer to the preoccupation of his age with the Sublime, he described a city with "the Gothic cornices of its buildings overturned in the sands." As he read Blondel's discussion of the Sublime in architecture, so worthy of emulation in modern

[15] For Latrobe's cathedral design, see Hamlin, *Latrobe*, pp. 234–36. In France appreciation of the Gothic was strong among literary figures like Chateaubriand. To architects the major Gothic cathedrals had interest as impressive ancient works; see Jean-G. Legrand and Charles-P. Landon, *Description de Paris et de ses édifices*, 2 vols. (Paris, 1806–9), 1:39–48, pl. 2, where Notre-Dame is described in favorable terms and made to appear in the plate like a nineteenth-century version of Gothic. Blondel included the cathedrals of Paris, Reims, and Rouen in the collection of engravings added to his edition of Vignola (pls. 32–34). Sainte-Chapelle had recently been well published in Sauveur-Jérome Morand, *Histoire de la Ste-Chapelle Royale* (Paris, 1790), pl. facing p. 31 (section) and frontispiece. For the eighteenth-century French classicizing of the Gothic, see R. E. Middleton, "The Abbé de Cordemoy and the Graeco-Gothic Ideal: A Prelude to Romantic Classicism," *Journal of the Warburg and Courtauld Institutes* 25 (1962):278–320, 26 (1963):90–123.

[16] Jacques-François Blondel, *Cours d'architecture enseigné dans l'Académie Royale d'Architecture*, text 6 vols., plates 6 vols. in 3 (Paris, 1771–77), 1:378.

churches, Godefroy may well have decided to profit by the climate in Baltimore favorable to a modern Gothic church which Latrobe had provided.[17]

In addition to describing the general religious feeling, Blondel gave instructions for achieving a delicate and feminine architecture through sinuous lines and a relatively flat surface, without strong projections. This architecture, at once feminine and religious, was most appropriate for a chapel dedicated particularly to the Virgin; it was, moreover, a private rather than a public structure, so that the informality of the Gothic was the more suitable. It is not only the compositional method which seems related to the Revolutionary age; a Blondellian feeling rises from the lightness and grace of the curving rhythms of the exterior and the interior and from the strong emphasis on the elevated sanctuary and high altar.[18]

For the particular forms employed in the chapel Blondel offered little beyond the large cathedrals illustrated in his edition of Vignola. Britton's plates of English Gothic monuments were probably available to Godefroy and might have been responsible for the faint English flavor of the interior. Batty Langley has been suggested as a source for the facade columns, but the majority of the simple pointed arches and tracery of the chapel have little in common with Langley's fish-bladder and ass's-back shapes. The simplicity, in fact, points the more strongly to Godefroy's stubborn self-reliance in this composition; his inexperience ruled out great complexity in this, his first building. Indeed, his lack of experience becomes apparent in the ineptness of transitions at difficult points, e.g., the wall and roof at the aisle-transept junction, in the strange admixture of motifs, e.g., acanthus leaf capitals in a Gothic setting, and in the awkard improvisations necessitated by changes in plan, e.g., flying buttresses and narrow aisles. Contemporaries, however, looked upon the chapel positively, and Latrobe expressed his admiration while it was still under construction. It became well known and attracted attention to Godefroy himself. A newspaper of 1812 recorded it as the work of the same man then erecting the Commercial and Farmers Bank, and both Poppleton's 1822 map of Baltimore and Griffith, the contemporary his-

[17] *Ibid.*, pp. 416, 419–21, 2:311–12, 317–18; Chenesseau, *Sainte-Croix d'Orléans*, 1:253–70, 338–39. Godefroy's manuscript *Mémoires d'une famille d'indépendans hongrois*, ca. 1802, is in his police file, F⁷ 6366, doss. 7484, Archives Nationales.

[18] Blondel, *Cours*, 1:416, 419–21: "A delicate architecture . . . similar to the finest Gothic productions"; see also 2:366–67.

torian, singled out Godefroy's chapel as a significant monument of the city.[19]

The beauty and character of the chapel noted by many commentators, Latrobe's "sense of veneration," and Blondel's "sacred character" were all qualities of the eighteenth-century Sublime that characterized the first stage of the Gothic revival. For Mrs. Trollope, who called the chapel "a little bijou," it still in 1827 possessed a "touching and impressive character" (her reaction to its subdued lighting and peaceful silence).[20] Although some details may have derived from English sources, the merging of Gothic and classical forms arose in French Romantic Classicism, Godefroy's own background. The first significant Gothic Revival church in the United States, the chapel was, in fact, backward-looking; it might serve as inspiration but not as model for later architects who pursued greater archeological correctness.

In referring to the chapel as "a design of great verve in a sort of strange picture-book Gothic," one modern authority was not derogating it, for he admired it greatly; rather, he was expressing his belief that here Godefroy was a beginner in architecture.[21] Although this is true, the statement missed the point of Godefroy's design. No picture book was responsible

[19] Rusk ("Godefroy and St. Mary's Chapel," p. 145) makes a not very convincing comparison of Langley's second Gothic order (Langley, *Gothic Architecture*, pls. 4–6) with the Tuscan capitals of the chapel facade. In addition to letters already cited, see Latrobe to Godefroy, Washington, Mar. 26, May 24, 1808, Letterbooks. All early accounts praised Godefroy's work highly, especially for its use of the Gothic (*Observer*, Nov. 7, 1807; "The City of Baltimore," *Niles's Weekly Register*, Sept. 19, 1812, p. 46; Thomas W. Griffith, *The Annals of Baltimore* [Baltimore, 1824], pp. 130, 165; [John H. B. Latrobe], *Picture of Baltimore* [Baltimore, 1832], p. 130; Charles Varle, *A Complete View of Baltimore* [Baltimore, 1833], p. 47). Two copies of the chapel indicate the general admiration for the building. One, St. Thomas' of 1812–16, in Bardstown, Kentucky, was designed by Godefroy (see below). The other was a coarse adaptation by a brickmason, Zion Lutheran Church, built in 1806–8 in Baltimore, insured at less than a third of the cost of the chapel (Latrobe to Godefroy, Washington, Dec. 27, 1806, Letterbooks; *Observer*, Feb. 28, Nov. 14, 1807; Baltimore Fire Insurance Company Records, vol. 2, no. 164, Oct. 21, 1808, value $10,000, Maryland Historical Society).

[20] In its origins in the eighteenth-century Sublime, Godefroy's Neo-Gothic corresponds with that of Latrobe and Wyatt (Henry-Russell Hitchcock, *Architecture, Nineteenth and Twentieth Centuries* [Baltimore, 1958], pp. 2–3, 6). For Mrs. Trollope's comments, see n. 5 above.

[21] Hamlin, *Latrobe*, p. 239n. Useful references not otherwise cited here include Joseph Jackson, *The Development of American Architecture* (Philadelphia, 1926), p. 125; Agnes Addison, *Romanticism and the Gothic Revival* (New York, 1938), p. 132; Annabelle M. Melville, *John Carroll of Baltimore* (New York, 1955), pp. 181–82, 284.

for the active, wiry decoration spread over the flat surface. These elements were employed, with a beginner's innocence and enthusiasm as sources of architectural character.

The Washington Monument Project
In January and February, 1810, the legislature of Maryland passed acts naming a Board of Managers with power to erect a statue or monument to the memory of George Washington. Apparently Godefroy was asked to make a design, for he began working immediately. Late in March he wrote to Latrobe for advice and to confirm the rumor that Latrobe had also been approached for this project. Latrobe answered reassuringly that he had too much affection and respect for Godefroy's talent to compete with him, and that he was too busy anyway; he guardedly advised 2.5 percent of the estimate as a suitable payment for a design not accepted. Apparently Godefroy requested the aid of Giuseppe Franzoni, the Italian sculptor who succeeded Andrei in work for the Capitol building, for Latrobe opposed an equestrian statue, as Franzoni was best on figures, especially female; if there was to be a great deal of sculpture, whether marble or bronze, he suggested having it done in Italy under Andrei's supervision, where it would be much cheaper. Latrobe also sent a note to Franzoni enlisting his help on the project, mentioning $5,000 to $8,000 as the maximum cost for the sculpture.[22]

At a special meeting on February 15, 1813, the Board heard a report on the difficulty of persuading artists to proffer designs without payment. One suggested course of action was to approach Canova, who had just completed a statue of Napoleon; another, the one followed, was to hold a competition open to European as well as American artists. The Board authorized a premium of $500 for the best plan of a monument costing no more than $100,000. On December 30, at the request of Robert Mills, the Board extended the deadline from January 1 to April

[22] "Papers Relating to Washington Monument," Maryland Historical Society; for studies on the origins of the monument and of the column by Mills, see [William D. Hoyt, Jr.], "Robert Mills and the Washington Monument in Baltimore," Maryland Historical Magazine 34 (1939):144–60; and J. Jefferson Miller II, "The Designs for the Washington Monument in Baltimore," Journal of the Society of Architectural Historians 23 (1964):19–28. The Board of Managers included these clients and friends of Godefroy: J. A. Buchanan, R. Gilmor, James Calhoun, Jr., William Gwynn, and R. J. Coale. For Latrobe's part, see Latrobe to Godefroy, Washington, Apr. 1, 1810, Latrobe to Franzoni, Washington, Apr. 1, 1810, both in Letterbooks.

15, 1814, and on January 12 Mills submitted his designs along with an essay on monuments. On May 2 the Board voted the premium to Mills' plan, and six weeks later it authorized him to begin work.[23]

Evidently Godefroy protested the decision, claiming that he had done his work at the request of the Board's representative; the Board voted him a compensation of $250, which he refused. Mills, on the other hand, pointed out that Godefroy had not been given an order signed by a majority of the managers. Calling his former pupil a wretched designer best suited for domestic works, Latrobe sympathized with Godefroy, who never forgave Mills this victory and taunt and thereafter referred to the monument as the pagoda of "Bob the Small."[24]

With a certain profligacy Godefroy made several drawings of at least two quite different conceptions for the monument (Fig. II–20). He exhibited six drawings at the Pennsylvania Academy in 1811, three of them related to a rotunda. In this project Ionic or Greek Doric columns were to support a cupola, and a statue of Washington, either pedestrian or equestrian, would be under or on top of the dome. Trophies and figured bas-reliefs would characterize Washington as the victorious Revolutionary leader resigning his commission to become the man of peace. Godefroy considered making this rotunda a public fountain, which suggests that he was aware of contemporary Napoleonic memorial fountains in Paris.[25]

Of the other three designs exhibited in Philadelphia, one showed a pedestrian sculpture, and two, a plan and an elevation, were related to the drawing presented to the Board and exhibited today in the base of the monument. This conception utilizes a triumphal arch with a single opening, before which stands an equestrian Washington on a tall base. On a high attic and protected by a cornice is a relief of Washington in ancient garb and in the *ad locutio* pose, resigning his commission to Congress; Victories in the spandrels of the arch flank an inscription, "To Washington." An engaged column on either pier is laden with military trophies and supports a hemisphere on which stands an eagle posed like the French cock. The arch,

[23] *Baltimore Federal Gazette*, May 2, 1814.

[24] Godefroy to Jackson, Richmond, Sept. 7, 1816, Maryland Historical Society. For Latrobe's opinion of Mills, see Davison, "Godefroy," p. 209.

[25] *First Annual Exhibition*, pp. 18–20. For Napoleonic fountains, see Pierre Lavedan, *Histoire de l'urbanisme*, 3 vols. (Paris, 1926–52), 3:10–1; and Louis Hautecoeur, *Histoire de l'architecture classique en France*, 6 vols. (Paris, 1943–55), 5:212–20.

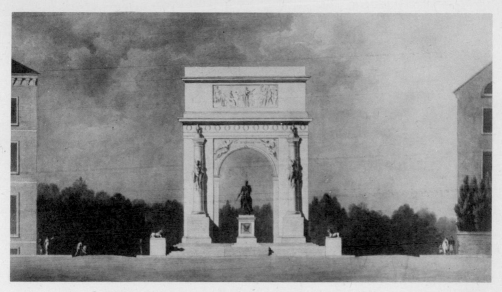

II–20. Drawing for Washington Monument, Baltimore. 1810. Collection Peale Museum. Photo Peale Museum.

with its imposts, is recessed to the same plane as the relief above, so that the piers continue up beyond the entablature to become the surface plane of the attic, which in turn rises above a second cornice, thus emphasizing the geometry of the grouping. At the corners of the stepped platform sphinxes rest on large blocks that combine with the statue socle and the column podia to form a motif enhancing the cubicity of the monument. Crowns of victory in the frieze further witness Godefroy's desire to make the sculpture and decoration contribute to the character of the monument. The sculpture evokes the memory of Washington's military and political career through narration and allegory; large, simple, bold shapes in the arch and blocks and the Doric columns project a masculine character.

J.-J. Ramée's well known design of 1813 is closer to the contemporary French ideal, particularly in its elimination of engaged columns, as Durand had recommended; in Godefroy's design they are a carryover from Blondel or perhaps Ledoux. More remarkable than the differences, however, are the similarities between the two designs which show the Revolutionary background of both men. Simple geometric forms and plane surfaces, trophies and other sculpture and inscriptions, high steps and corner blocks making the monuments self-sufficient

and isolated—all derive from the manner of Ledoux and Boullée. So new to architecture in comparison with Ramée, who had achieved success in Paris twenty years earlier, Godefroy had learned his lessons well despite the imposition of a Blondellian character on his monument to Washington.[26]

While Godefroy's drawing for the Washington Monument lacks the brilliance of Ramée's and the detailed thoroughness of Mills', its competence justifies the self-confidence evident in a legend prepared as though for engraving, "Max.ᵐ Godefroy invenit et delineavit 1810." [27] At the sides two pink-red brick buildings frame and increase the isolation of the white monument against a clouded sky. The back is closed by a muddy blue-black range of foliage, massed so that no individual trees stand out. A family group walks by on the right, looking at the structure; on the left a couple in conversation gesture toward the monument. Characteristic of figures in Godefroy's drawings, and unlike those in Latrobe's, they assert themselves by their actions and gestures rather than merely serving as an indication of scale. Comparison with the three-story houses shows that the figures are undersized and thus exaggerate the grandeur of the monument. One figure especially, standing beside the sphinx podium, resembles the underscaled figures in Blondel's edition of Vignola, and a workman with a wheelbarrow recalls masons and carpenters in the same volume. Win-

[26] For Ramée and his design, see Talbot F. Hamlin, *Greek Revival Architecture in America* (New York, 1944), pp. 40–41, pl. 10; Miller, "Designs for the Washington Monument," p. 21; see also Emil Kaufmann, *Architecture in the Age of Reason: Baroque and Post-Baroque in England, Italy and France* (Cambridge, Mass., 1955), p. 183; Blondel, *Cours*, 2:253–54; Durand, *Précis*, 2:24–25. Durand had some difficulty in seeing what contribution nonstructural columns could make toward commemorating a great man. Ledoux, on the other hand, employed such columns, setting them against piers and lading them with trophies and sculpture, as in his portal for the Hôtel d'Uzes of 1767; see also his projected arch for Cassel of 1776 (Marcel Raval and J.-Ch. Moreux, *Claude-Nicolas Ledoux* [Paris, 1945], pls. 17, 150). Since we have no knowledge of an acquaintance through personal experience or publications with the works of Ledoux, we can suggest no more than that Godefroy, in belatedly following similar intellectual currents, arrived at conclusions similar to those of Ledoux. Another parallel can be made between Godefroy's arch and J.-Ph. Moitte's city gate design; similar in the disposition of shapes, Godefroy's project is much simpler (Kaufmann, *Age of Reason*, fig. 207).

[27] Owned by The Peale Museum, the drawing is exhibited in the base of Mills' monument. It measures 18 by 24 inches. Its title reads: "Elevation of the front of a Triumphal Arch of the Roman Doric Order designed to accompany a pedestrian or Equestrian Statue of WASHINGTON upon the Place where the Old Court House now stands in Baltimore." A similar drawing was exhibited in London (*The Exhibition of the Royal Academy* [London, 1821], no. 1094).

dows in the buildings are dark oblongs, showing no subdivisions for glazing, similar to representations in handbook plates and eighteenth-century engravings. These elements indicate Godefroy's continued use of older books brought from France.

The Commercial and Farmers Bank

The Commercial and Farmers Bank of Baltimore was incorporated by the legislature on December 23, 1810, and its one-story building was under way within two years. Utilizing a corner plot 37 by 47 feet at the juncture of Howard and Redwood (then German) streets, Godefroy superintended the construction, employing Walter Athey and John Neale, brick and stone masons, respectively. He submitted an elevation of the entrance for the 1813 exhibition of the Pennsylvania Academy, and noted that the bank was then under construction. In April and May of 1813 Franzoni was preparing clay models of the reliefs and dickering over the price of the sculpture. In March, 1816, in Washington Latrobe was trying to get a good price for the casting of the gates; perhaps this final xterior work had been delayed by the war.[28]

The interior of the building is virtually unknown, but the exterior is well recorded in early representations and later photographs (Fig. II–21). An insurance survey laconically rec-

[28] *Laws of Maryland* (1810), Nov. sess., ch. 68; "The City of Baltimore," *Niles's Weekly Register*, Sept. 19, 1812, p. 46; Richard H. Howland and Eleanor P. Spencer, *Architecture of Baltimore* (Baltimore, 1953), p. 46; Rich Bornemann, "Some Ledoux-Inspired Buildings in America," *Journal of the Society of Architectural Historians* 13 (1954):16. None of the principal stockholders named in the legislative act has any other connection with Godefroy. Robert Cary Long I, William Patterson, James Calhoun, and Edward Johnson, all friends or patrons of Godefroy, were prominent stockholders or directors of the Baltimore Fire Insurance Company, which held a large block of the bank stock and on May 6, 1811, formed the ticket for the election of the bank directors (Baltimore Fire Insurance Company Records, 1:1–8, 20, 66, 76, 133, Maryland Historical Society). Some of these men probably suggested Godefroy for the design of the bank. See *Third Annual Exhibition*, p. 12; Godefroy to the Committee for the Monument, Baltimore, Mar. 22, 1815, Maryland Historical Society; Latrobe to Godefroy, Washington, Apr. 29, May 6, 1813, Mar. 3, 11, 1816, all in Letterbooks; Latrobe's letters of 1816 may refer to the gates of the First Presbyterian Churchyard (see below). The bank gates do not appear in engravings of 1822 and 1832, evidence that neither supports nor opposes their originality, but Latrobe's reference to "detailed molding" seems more appropriate to the bank gates than to those of the churchyard.

Enlargements and the addition of a second story about 1857 accompanied vast interior changes. When the building was razed in 1955, the relief sculpture on the entrance was salvaged (Wilbur H. Hunter, Jr., "Salvage of 1810 Sculpture," *Journal of the Society of Architectural Historians* 14 [1955]:27–28).

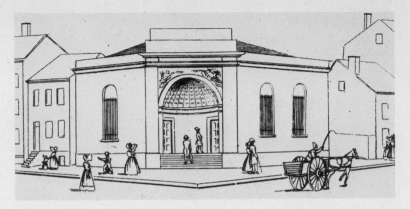

II–21. Commercial and Farmers Bank, Baltimore. 1812–13; engraving ca. 1832. John H. B. Latrobe, *Picture of Baltimore.*

ords a plain finish and some vaults inside. For the exterior Godefroy took advantage of the site by designing a corner entrance on an angle with the rest of the building, a form unique in Baltimore. Although the side walls with tall arched windows were of brick, the entrance employed stone. Steps rose to an apsidal vestibule with plaster coffered vaulting; two doors led inward, perhaps one to the main banking room and the other to more restricted areas such as offices.[29]

Godefroy adapted the triumphal arch from his design for the Washington Monument for the corner entrance of the bank (Fig. II–22). The plane of the flanking piers was continued through the entablature to the panel above; the steps were flanked by projecting blocks; the sixteen-foot arch, its imposts, and the relief sculpture formed a slightly recessed plane. Instead of Victories, figures of Mercury and Ceres, holding the fasces, flew in the spandrels, denoting commerce and agriculture giving common support and strength to the nation. The fasces and lances of the gates contributed to the message of strength through union; the acorn shape atop the fascial posts, recalling the same motif in St. Mary's Chapel, perhaps symbolized strength.

Recognized as unique and admired for its "neatness," the

[29] The insurance survey provides a laconic description: "One high story with Ornamented passage therein . . . plain finished, with vaults" (Record of Surveys, bk. E, p. 289, no. 6075, Dec. 1, 1819, value $9,000, Baltimore Equitable Society). The word "vaults" may in fact refer to strongrooms as well as vaulted ceilings.

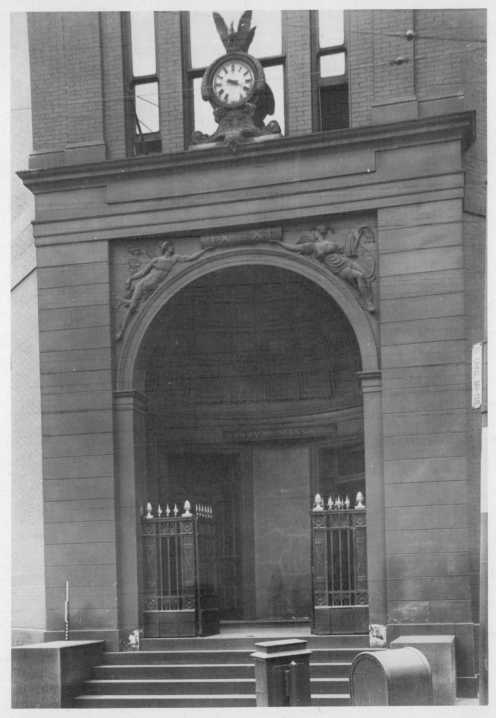

II–22. Corner entrance, Commercial and Farmers Bank. Photo Historic American Buildings Survey, Library of Congress.

corner entry attracted all of Godefroy's attention.[30] Its huge dimensions and the repetition of its arched shape in the smaller lateral windows only exaggerated its isolation from the rest of the building. Described by Godefroy in the 1813 exhibition catalogue as "a *Loggia* forming the front and vestibule" of the bank, he separated it from the rest in his mind, just as the piers with horizontal coursing, the blocking courses above the entablature, and the staircase blocks set this feature apart from the brick fabric of the structure. It revealed his intention to remove the bank from the category of modified domestic architecture by giving it the character of a public building. Weak in the integration of function and composition, the design succeeded because of the unopposed dominance of the richly finished entrance over the rest of the structure.

The unrewarding search for prototypes for this building highlights its determined difference from similar establishments. One architectural book can be directly related to the period of the composition of the bank: Godefroy borrowed Nicholson's *Principles of Architecture* from the Library Company and renewed the loan in order to keep it from July 25 to December 28, 1812. Details, like the imposts and perhaps the interior finish, may derive from this publication; it certainly aided him in the difficult drawing of the shadows projected over the coffered vault. The corner entrance was a rarity at this date; one example in the work of Ledoux was completely opposed to Godefroy's in form as well as in the relation of the entry to the mass of the building. The great arched opening with apsidal recess was a common enough motif in the circle of Ledoux, but in Godefroy's design the lack of a column screen weakened its intended effect of enhancing the interpenetration of voids and solids. By implication, Durand's discussion of building parts lay behind this design, as did also the term "*loggia*," although the bank differed from the paradigms in the *Précis*.[31]

On the whole the Commercial and Farmers Bank reflected Godefroy's inexperience, his erratic architectural study, and his lack of discipline. The triumphal arch was combined with

[30] [Latrobe], *Picture of Baltimore*, p. 110. Perhaps Godefroy determinedly differentiated his bank building from the slightly earlier larger one by Robert Cary Long I; see Robert L. Alexander, "The Union Bank, by Long after Soane," *Journal of the Society of Architectural Historians* 22 (1963):135–38.

[31] Peter Nicholson, *Principles of Architecture*, 3 vols. (London, 1795–98). For the Ledoux comparison, see Emil Kaufmann, *Three Revolutionary Architects*, Transactions of the American Philosophical Society, n.s., vol. 42, pt. 3 (Philadelphia, 1952), fig. 50. Durand, *Précis*, vol. 1, pt. 2, pl. 7.

the apsidal recess and the whole imposed upon a modest brick structure. In contrast with the Federal elegance of structures being built at that time in Baltimore, however, it demonstrated what Godefroy was groping for in the way of grandeur and character for public buildings.

Bardstown, Kentucky, St. Thomas' Church

Early in 1812 Godefroy was again requested by the Sulpicians to design a church (and temporary cathedral) for a branch of their order recently established near Bardstown, Kentucky. Within months the seminarians were making bricks, but the construction of St. Thomas' Church was slow. The cornerstone ceremony, with Bishop Benedict Flaget officiating, was held on August 23, 1813. Roofing began the following April, and the consecration took place on August 13, 1816 (Fig. II–23).[32]

St. Thomas' is but a slightly reduced version of St. Mary's Chapel, a sign of the Sulpicians' acceptance not only of Gode-

[32] William J. Howlett, *Historical Tribute to St. Thomas' Seminary* (St. Louis, Mo., 1906), pp. 34–37, 59–60. For information on this building, I am indebted to Charles Boldrick, of Lebanon, Ky., author of the Historic American Buildings Survey study and measured drawings of St. Thomas' Church.

II–23. Facade and flank, St. Thomas' Church, Bardstown, Ky. 1812–16. Photo D. Kawami.

froy's Neo-Gothic but of his spatial organization. The chapel
dimensions are reduced by a third, and the facade decoration,
drastically simplified, resembles Godefroy's drawing of the chapel.
The church is constructed entirely of brick with only the niches
stuccoed; wood is employed for such decorative elements as the
paneled buttresses and corbeled cornice of the facade. There is
no way of knowing whether Godefroy intended St. Thomas'
to have the two groups of five, rather than six, niches in the
attic; perhaps the smaller size forced this and other minor
changes in the design. Lacking the richness and elegance of
St. Mary's, St. Thomas' has the simpler and slightly awkward
dignity of a country cousin.

As in the chapel, certain of the compositional methods resem-
ble those of the French Revolutionary architects. Two motifs,
the rectangle and the pointed arch, have been used in varying
sizes as surface elements distributed over the exterior and the
interior and as determinants of large shapes and volumes. One
exterior aspect of St. Thomas' Church, even more than at the
chapel, hints at a French source. From the back it is a simple,
symmetrical structure—a cylindrical apse (Fig. II–24), topped
by a conical roof and flanked by cubical, hip-roofed sacristies—
all the more imposing for its smooth, unadorned walls. The

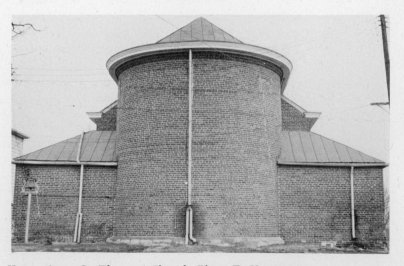

II–24. Apse, St. Thomas' Church. Photo D. Kawami.

closest parallel to this kind of apsidal composition occurred in Durand's *Précis*.[33]

At St. Thomas' the same wide nave and narrow aisles, wide, deep sanctuary, and rather large pastophoria were desired. Despite the anticipation of a lay congregation, liturgical requirements and the special needs of a seminary received priority. One significant concession to the needs of a parish was the creation of a baptistery under the staircase leading to the gallery.

In Bardstown the smaller gallery was constructed, and instead of the handsome acanthus leaf capitals on four-lobed piers, the local carpenter introduced a simple shaft standing on an Ionic base and carrying a thin abacus and cornice block. Three widely spaced columns carry the pointed arches with greater ease than the seven crowded in at St. Mary's but with a consequent reduction in the vertical effect. St. Thomas' retains the three wide steps and has a pulpit at the right side of the sanctuary opening. Its present altar, introduced in 1950, is located at the back of the apse; Godefroy probably had it near the front, where, raised high by the three steps, it would dominate the interior view, as Blondel advised, and still leave sufficient space farther back for the numerous priests attached to the seminary. Doors, windows, arches, and nave ceiling have the pointed Gothic shape, but the rich interior decoration of St. Mary's is completely absent. Nor does St. Thomas' possess an air of mystery; four large windows in the smaller building provide bright illumination that is both reflected by the continuous white surfaces and transmitted through the wide arcade openings.

Despite the general simplification, a number of details closely resemble those of St. Mary's Chapel: the inscribed rectangular panels of the facade, the round arched doorway, and the circular window and symbolic triangle in the center of the attic. The smaller, lower pastophoria, on the other hand, seem overwhelmed by the tall and broad apse, and the resulting composition suggests Godefroy's increased interest in his modern French sources.

[33] Durand, *Précis*, vol. 1, pt. 2, pl. 12. There is some question about the original size of the rooms flanking the apse. While the facade, side walls, and apse are all carried on a molded stone foundation course, these rooms are not, nor are their brick courses properly bonded with the main structure. They may not have been built originally, or they may have been considerably smaller.

In November, 1805, the state legislature enabled the Grand
Lodge of Maryland to hold a lottery for $12,500 in order to
construct a Masonic Hall; in 1812 the amount was raised to
$35,000. On November 5, 1811, a committee was named to
supervise the lottery and all other details relating to the con-
struction of the building. Godefroy's father-in-law was Dr. John
Crawford, Grand Master of Maryland. Godefroy soon offered
a design that he recalled to the attention of the lodge by letter
about November 1, 1813, after progress had been made in
raising funds. This design was engraved by William Strickland
for publication in 1817 (Fig. II–25).[34]

Construction began, perhaps late in 1813, and elaborate
cornerstone ceremonies were held on May 16, 1814. The corner-
stone and news accounts on the occasion name as architect
Jacob Small, carpenter, builder, lumber merchant, and later
mayor of Baltimore.[35] Only Schultz, historian of Freemasonry
in Maryland, and Griffith, a local historian, recorded Godefroy's
authorship of the original design. A Roman Catholic, Godefroy
could hardly have been honored by the Masons, while their
eminent and respected member Small enjoyed the honor as
sufficient recompense for superintending construction.

Once begun, construction faltered, hampered by the slow
sale of building stocks. Apparently nothing rose above the cor-

[34] Griffith, *Annals of Baltimore*, p. 209; Edward T. Schultz, *History of
Freemasonry in Maryland*, 2 vols. (Baltimore, 1884–88), 2:157, 184, 191–
210, 306, 348–49, illus. p. 209; Bornemann, "Ledoux-Inspired Buildings," p.
17. Strickland's print was first published in *The Freemason's Library and
General Ahiman Rezon*, ed. Samuel Cole (Baltimore, 1817). Further infor-
mation on this building as completed is provided by Record of Surveys,
bk. G, p. 145, no. 7575, May 1, 1823, value $30,000, Baltimore Equitable
Society; [Latrobe], *Picture of Baltimore*, p. 159; Varle, *Complete View of
Baltimore*, p. 41; Jackson, *American Architecture*, p. 125.

In April, 1812, Godefroy was approached to design the Medical College
in Baltimore. Responding to a request for advice, Latrobe suggested a
compensation of 2.5 percent of the total cost and offered to act as Gode-
froy's intermediary. He also sketched a method of constructing the build-
ing in two stages, the auditorium section first, with the entry and fore-
structure to be added as more space was required (Latrobe to Godefroy,
Washington, Apr. 28, 1812, Letterbooks). Godefroy's project is unknown,
for the commission was given to Robert Cary Long I, whose building is
illustrated in Howland and Spencer, *Architecture of Baltimore*, pl. 50.

[35] *Baltimore Federal Gazette*, May 16, 19, 1814; *Baltimore American*,
May 17, 19, 1814. The actual cornerstone still exists, displayed in the
present Masonic Hall. In Philadelphia, too, there was conflicting testimony
concerning the designer of the Masonic Hall (Agnes A. Gilchrist, *William
Strickland: Architect and Engineer, 1788–1854* [Philadelphia, 1950], pp.
45–46).

II–25. Project for Masonic Hall. Ca. 1812; engraving by W. Strickland ca. 1817. Photo Peale Museum.

nerstone for five years. In 1819 Small complained of his financial losses; he had prepared all the wooden parts of the building, and much of it had been lying on the site for years, rotting from the weather. Similarly, he wrote, all the stone materials provided by William Stuart were suffering from weather and youthful mischief.[36]

Work resumed in 1820 and was finished two years later, at a total cost of $36,000. The decision to house several courts, thus ensuring a regular income, required a much large building; however, it retained most of Godefroy's conception. Occasionally explained as the work of Jacob Small, the new design was probably made by his son William, a pupil of Latrobe.[37] The building stood on a raised platform 40 feet 6 inches long on St. Paul Street and extended on its completion for 97 feet on Courthouse Lane; the present courthouse, built in 1894–99, now covers the site.

[36] Small to C. Wirgman, Baltimore, May 5, 1819, Maryland Historical Society.
[37] See Robert L. Alexander, "William F. Small, 'Architect of the City,'" *Journal of the Society of Architectural Historians* 20 (1961):75.

In this composition Godefroy displayed an increasing mastery of three-dimensional organization. His conception of the building as a whole was clearer, and the parts were interrelated in both function and design. Slightly over half of the facade served as the entrance porch; enlarged rectangular piers—hardly pavilions, yet that is the term used by Durand—on each side of the porch housed vestibules and stairways.[38] A continuous entablature with a deep cornice ran across the upper part of the facade. Basically similar to his monument and bank designs, the facade plane was broken into two levels by the slight projection of the pavilions; the two levels continued in the entablature and the block course above it. The slight action of the planes, and the implicit volumes, suggested a geometric interpenetration which was under Godefroy's control for the first time.

The entrance comprised four steps between projecting blocks, four Greek Doric columns carrying a low entablature, and a high attic with a large recessed panel. In the rectangular porch, perhaps eight feet deep, a door at each end opened into the pavilions; either brick groin vaulting or, more likely, a wooden construction was planned for the ceiling. Three niches topped, surprisingly enough, by pointed arches, reminiscent of the Gothic of St. Mary's Chapel, decorated the back wall of the porch; above and below the niches were small rectangular panels, the upper ones containing garlands. Each pavilion, or pier, had a large pointed niche set within a rectangular panel and on a projecting socle with a recessed panel.[39] Above the cornice the piers each bore still another panel, this one containing a lambrequin that Godefroy may have intended for inscription.

Whether consciously or not, Godefroy showed here the strong effects of his French background and the Revolutionary architects' methods of balancing and contrasting geometric masses and voids and using light and shadow in a controlled way. Although parallels for the specific organization would be hard to find in actual works, for example, those of Ledoux, Durand pointed to this kind of tetrastyle porch with the colonnade held in the plane of the end walls.[40] More generally, though, Godefroy employed some of the Revolutionary com-

[38] Durand, *Précis*, vol. 1, pt. 2, pl. 8.
[39] Although the term "niche" is used here, they were flat-backed recesses, not curved in plan. Never intended for sculpture, they provided variations in surface levels and enrichment of light and shadow patterns.
[40] Durand, *Précis*, 1:84; vol. 1, pt. 2, pls. 9–10.

positional principles. The pointed arches on the pavilions were each part of a complex as tall as the columns, thus vying with them in compositional importance, and being set at the ends of the facade, they created a tension across the whole of it. Reiteration of the pointed arch across the back of the porch not only forced a relationship in space, but also pointed up the contrast between the disparate sizes of the individual motifs and the fields on which they occurred. Another motif, the horizontal panel, set up its own interweaving rhythm: the largest panel occurred in the central attic, the next in size occurred on the piers, and the smallest but most numerous on the porch wall. The superfluity of these panels and the awkwardness of the pointed arch shape were, moreover, the most evident signs of Godefroy's inexperience in this manner of composition.

Substitution of a Durandesque pattern of niches and panels for a Blondellian figural and allegorical sculpture does not necessarily indicate a loss of concern with architectural character. The severity of composition, utilizing a great many rectilinear parts, and the Greek Doric order were architectural techniques for giving the building a strong, masculine character with overtones of a sacred nature; inclusion of the curving lines of the pointed arches would show the combined religious, mysterious, and private aspects of its purpose. The forms reflect, furthermore, contemporary French sources of invention. No engaged columns, all were freestanding and working, as Durand required, nor was there any other "architectonic decoration." The pattern of two pavilions flanking and isolating the building was a favorite one of Durand's. Godefroy's freedom in using Doric columns without a proper Doric entablature would not have been countenanced by Blondel; it stemmed rather from Durand's anticlassical attitude toward the orders.[41]

The Masonic Hall was probably designed in 1812, while Godefroy was still at work on the Commercial and Farmers Bank. He had on hand at the time Nicholson's *Principles of Architecture*. The third volume provides information on the Doric order; the second gives instructions on handling lights and shadows, which are reflected in his drawing of the columns. As a record of the original drawings only Strickland's aquatint remains. The man and gesturing boy in front of the structure typify Godefroy's figures. The clouds, the lights and shadows on the ground, and the plane of foliage along the background are similar to those in the chapel drawing, while the picturesque

[41] Durand, *Précis*, 1:49, 71–72.

array of architectural fragments resembles those in a later per-
spective of the Unitarian Church. Capable enough in handling
the shadows of slight projections and recesses, he had more
difficulty here with the recessed portico. He studied Nicholson,
but the shadow across the portico is impossible in the recession
he portrayed.

In execution the design was enlarged, doubled in height and
length, and much altered; the result was an improvement, for
example, in the elimination of Gothic arches. This building
bears witness to a considerable development of Godefroy's
architectural imagination in coordinating the separate parts of
the composition into a compact whole. In this respect it looks
ahead to the Unitarian Church.

**First
Presbyterian
Churchyard,
Gates and
Vaults**

In an advertisement in the *Federal Gazette*, September 15, 1815,
Godefroy invited prospective clients to examine specimens of
his work, including the gates and vaults in the burial grounds
of the First Presbyterian Church. This churchyard, at the cor-
ner of Greene and Fayette Streets, still exists. An iron fence
of the later nineteenth century replaced its wall and pedestrian
entrance on Fayette Street, but the carriage entrance on Greene
Street (Fig. II–26) remains unchanged.[42]

Interrupting the stone and brick walls, metal gates of the purest
Empire linealism swing from masonry piers reminiscent of the
ancien régime's massiveness. Rectangular meanders border the
upper and lower sections of the gates, while three lekythoi,
known to that age as lachrymal urns, stand on the top bar. The
tall piers have cavetto cornices around the top and a large
obelisk adossed to the outer side. The tondo relief, a winged
hourglass on each obelisk, emphasizes the mortuary character
imputed to it by Blondel; the cornice, with its Egyptian flavor,
strengthens the reference to eternity (Fig. II–27).[43]

[42] Davison, "Godefroy," pp. 205–7; Howland and Spencer, *Architecture
of Baltimore*, p. 46. The burial yard still belongs to the First Presbyterian
Church, although part of the area is covered by the Westminster Pres-
byterian Church, built in 1851–52 to obviate a city ordinance that required
removal of graves on property where no church stood. Damage to one
gatepost, done in 1967, has been repaired.

[43] Blondel, *Cours*, 1:321–23, 2:261–63. For a French example of the
winged hourglass, see Jean-Ch. Delafosse, *Style Louis XVI*, ed. A.
Guérinet, 2 vols. (Paris, n.d.), vol. 2, pl. 6. Godefroy's reliefs of the winged
hourglass and the inverted torch (see his Crookshanks-McClellan vault)
were probably the source for the use of the same motifs by Solomon
Willard on the entry and fenceposts of the Granary Burial Ground in
Boston; in 1818 Willard spent at least six months carving ornamental work
at Godefroy's Unitarian Church (William W. Wheildon, *Memoir of Solo-
mon Willard* [Boston, 1865], pp. 229–30).

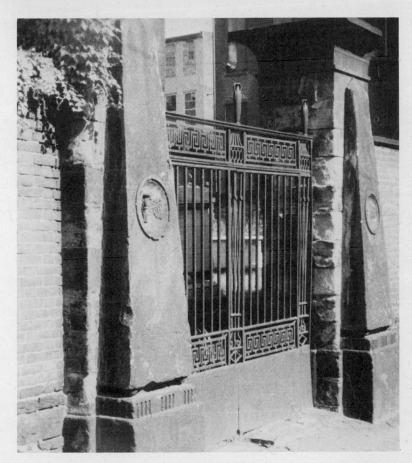

II–26. Carriage entrance, First Presbyterian Churchyard, Baltimore. Ca. 1813–15.

The burial vaults that may be attributed to Godefroy are the five largest and oldest, concentrated near the center of the yard. One is a pyramid on a high square base with two hatchways in its front; one is a square mausoleum with three columns forming bays for two doors in its front; three are rectangular with single doors (Fig. II-28). The pyramid, of granite, has no orders or other decoration. The others are built of local freestone, a common material for Baltimore, now badly weathered and lichened; these are roofed with slate. The identical door frames are all canted, like a Ptolemaic example illustrated by Denon, and the valve is a sheet of slate or black marble, the latter worked in panels; all have a series of metal

II–27. Gatepost detail, First Presbyterian Churchyard.

knobs to be worked in combination to unlock the entries. The fine masonry technique is identical on all, and they have survived better than many later vaults in the same cemetery. Unique to this group is the system of slits worked in the masonry to provide air circulation, a device borrowed from military architecture, in which Godefroy claimed proficiency; it was the normal method for ventilating powder magazines.[44]

Perhaps the earliest of the group, the mausoleum for John O'Donnell (Fig. II–29), is a cross between a large sarcophagus and a small temple. O'Donnell died in 1805, and presumably the vault was built within the next several years. Its gable roof has antefixes at the front corners. Herms on the short front

[44] For the Egyptian doors, see Dominique-Vivant Denon, *Voyage dans la basse et la haute Egypte*, 2 vols. and atlas (Paris, 1802), pl. 80. For magazine construction, see Bernard-F. de Belidor, *La science des ingenieurs dans la conduite des travaux de fortification et d'architecture civile* (Paris, 1729), bk. 4, pp. 64–68, pls. 26–27. The vaults, with large chambers extending below ground level, were family tombs; that of John O'Donnell, for example, contains at least fifteen burials.

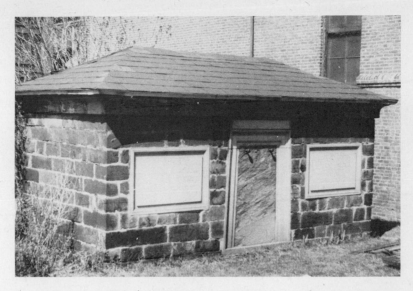

II–28. Dugan-Hollins vault, First Presbyterian Churchyard. Ca. 1813–15.

end flank the door and support a low entablature with a cavetto cornice. The heads differ—one is a young female, the other an old male—but both are heavily swathed with drapery over the forehead, the sides, and the neck. Above the canted door frame a frieze and cornice support a recessed panel with a winged hourglass in relief. The cavetto cornice circles the building, supported at the back corners by engaged columns whose capitals are a modified form of those of the Tower of the Winds.[45]

Opposite the O'Donnell tomb and facing it across one of the main avenues through the cemetery, a large pyramid à la Gaius Cestius covers two plots (Fig. II–30). The names of the owners, James Calhoun and James Buchanan, are inscribed on the low entryways. Both were prominent merchants and politicians; Calhoun, deceased in 1816, was the first mayor of Baltimore. The idea for this vault might have come from Denon; it would have appealed to Blondel, and Durand actually offered a model for a pyramidal mausoleum. The most probable source, however, was Latrobe, who in 1812 projected a large pyramidal monument to commemorate the victims of Richmond's disas-

[45] The sculptural parts have been identified as Rosicrucian symbols, and occasional rituals held in front of the vault honor O'Donnell as the founder of that movement in this country (*Baltimore News*, Oct. 29, 1931).

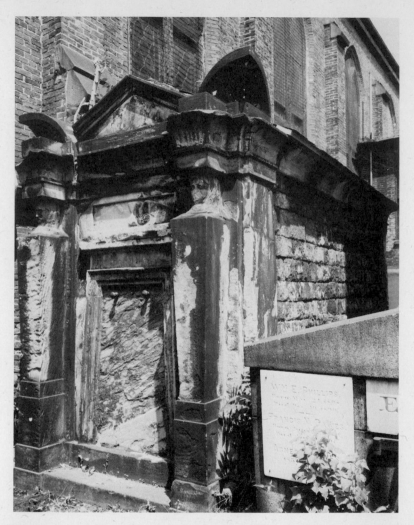

II–29. O'Donnell vault, First Presbyterian Churchyard. Ca. 1813–15. Photo Peale Museum.

trous fire. The large square base is the distinctive feature relating Latrobe's project and this vault.[46]

Beside the pyramid a square pseudo-temple covers two plots belonging to Robert Smith and William Smith (Fig. II–31). The

[46] Durand, *Précis*, vol. 2, pl. 1; Latrobe to J. Wickham, Washington, Jan. 21, 1812, Letterbooks; Robert L. Alexander, "Architecture and Aristocracy: The Cosmopolitan Style of Latrobe and Godefroy," *Maryland Historical Magazine* 56 (1961):236 and illus. facing p. 233. See also James E. P. Boulden, *Presbyterians of Baltimore* (Baltimore, 1875), p. 67.

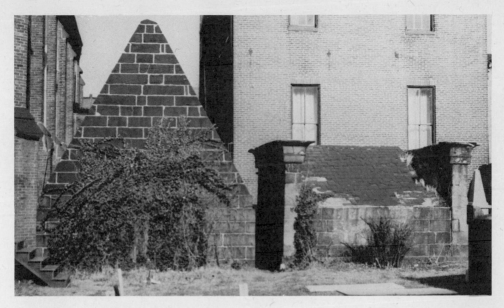

II–30. Rear view, Calhoun-Buchanan pyramid and Robert and William Smith vault, First Presbyterian Churchyard. Ca. 1813–15.

two doorways are identical with that on the O'Donnell tomb except for the omission here of the frieze and cornice; panels above the doors bear the names of the two Smiths. Bays are created by three columns with capitals resembling the Tower of the Winds order, an order that seemed to this age close to ancient Egyptian forms (Figs. II–32-II–33). As has been noted, Godefroy further Egyptianized the order, and in doing so he may have felt that he was designing a simpler, more fundamental order, thus reflecting Durand's hope for guidance from the Napoleonic savants. Durand is evoked again by the degree of relief of the columns, for they stand about two-thirds free of the wall; Godefroy attempted to minimize the fact that they are engaged, a practice Durand opposed. A simple architrave and cavetto cornice run along the false front and the side walls, which conceal the much lower vault roof. Robert Smith's particular interest in Godefroy, shown in 1815, helps link this mausoleum with the architect.[47]

[47] For the Egyptian discussion, see Chapter 1, n. 51, above; Durand, Précis, 1:76. In a description of Godefroy's Unitarian Church published in 1819, the Tower of the Winds capital was called Egyptian. Dora Wiebenson also suggests that to the nineteenth century this order resembled Egyptian capitals (Sources of Greek Revival Architecture [London, 1969],

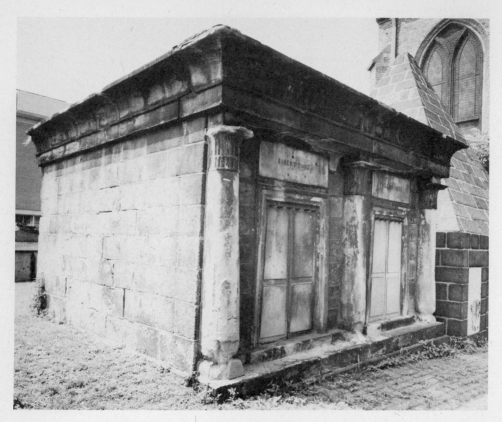

II–31. Front view, Robert and William Smith vault, First Presbyterian Churchyard. Photo Peale Museum.

The vault on a plot owned by Cumberland Dugan stands with its long side on the cemetery path. Its doorway, identical with those on the Smith tomb, is flanked by two large marble panels bearing inscriptions concerning those interred within. A cavetto cornice on all four sides forms the eaves of the hipped roof. The simplicity of the structure gives full play to the effect of the materials, the nice contrast of proportions, and the surface interest supplied by the white marble panels (Fig. II–28).

The final vault is enclosed by the foundation walls of the later church structure and is no longer visible. Square and low,

p. 67). For Smith's interest, see Latrobe to R. Harper, Washington, July 11, 1815, Letterbooks. A web of intermarriages linked the families of all these vault owners, Smith, Dugan, Hollins, and Buchanan. O'Donnell's son continued to aid Mrs. Godefroy in later years.

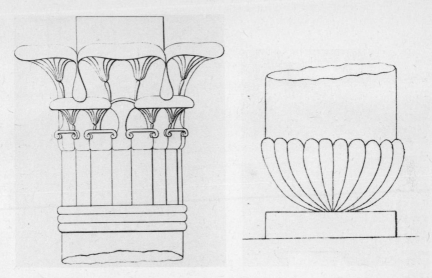

II–32. (left) Egyptian capital. II–33. (right) Base and shaft of Egyptian column. Quatremère de Quincy, *De l'Architecture égyptienne.*

it resembles the Smith vault much simplified, without orders, and about half as tall. On piers flanking Godefroy's usual door form are carved inverted torches, an old and common symbol for the extinguishing of life. Although the plot belonged to C. Crookshanks and S. McClellan, no inscription or panel identified the structure itself.

The newspaper advertisement makes it clear that at least some and perhaps all the vaults were completed by the summer of 1815. The identical handling of details, columns, and doors and the common structural technique indicate a single group of workmen. While the O'Donnell vault may have been designed as early as 1806, the relation between the pyramidal mausoleum and Latrobe's church plan for Richmond suggests a date not long after 1812 for the Calhoun-Buchanan vault.

One monument which once stood in the churchyard can be connected with Godefroy, the stone for his father-in-law in a plot behind the O'Donnell vault. Dr. Crawford died on May 5, 1813, while holding the office of Grand Master of the Maryland lodge. On May 9 the Masons voted up to $100 for a suitable tombstone; the next day they received a letter from Godefroy, presumably containing a design for the monument. With suitable ceremonies the lodge in 1815 dedicated "a triangular monument, made of sandstone with marble panels; on

the respective sides, a heart pierced with a dagger; the hour glass; and friendship, represented by two hands grasped." Both the combination of materials and the allegorical sculpture relate this tombstone to the vaults.[48]

The gates, vaults, and monument demonstrate a consistent attitude toward design and meaning. On the whole, the disparate elements, some new, some a generation or more old, some so individual as to be without parallel, are fused in the allegorical program. Both architecture and sculpture mourn the brevity of life and celebrate the eternity of the spirit. The interest in architectural character and the combination of motifs were beyond the range of any other designer in Baltimore.

Military Engineering: Work at Fort McHenry

From at least the Renaissance until the Napoleonic era, military engineering could be practiced by any person learned in the arts or sciences. For an occasional figure, like the Marquis de Vauban, it was a *raison d'être*; for others, from Michelangelo and Leonardo to a man like Latrobe, it was a sideline. Consisting primarily of the construction of permanent and temporary fortifications, it was considered an activity well within the competence of the builder and architect. After the French Revolution civil and military engineering became fields which demanded highly specialized knowledge and techniques. For a time, however, while the rest of the world learned to recognize the new status of such engineers, men like Godefroy might still offer themselves as military experts.

His actual European background in this subject is suspiciously small. We know only that he served for about a year as secretary to an engineering officer. The several references to his army career were accounts of his brave and honorable exploits, mostly in the cavalry. Following his usual method of self-tutoring, Godefroy had read and made extensive notes on the "military art," and some volumes on military engineering were included in the library he transported to America.

When he settled in Baltimore Godefroy did not hesitate to pose as an expert on all phases of warfare. Latrobe consulted him on special problems and for years tried to effect his employment by the army. Godefroy taught fortification privately and at St. Mary's College, and, as was noted earlier, within a year

[48] Schultz, *Freemasonry*, 2:180–82, 297–307. The stone also bore a long inscription, repeated on the simple granite block that replaced the original monument many years later.

of his arrival wrote a small book offering his ideas on the methods of defense appropriate for this country.[49]

With the outbreak of hostilities in 1812, engineers were in short supply. The British ranged almost unchecked in the Chesapeake. On May 6, 1813, Latrobe wrote to Godefroy concerning the outrageous burning of Havre de Grace and other towns, and the latter responded with an essay on British strategy in the conduct of the war.[50] For economic reasons, Godefroy wrote, they would destroy flourishing ports like Baltimore and for political reasons would go on to capture Washington. He had been consulted about six weeks earlier on the strengthening of Baltimore's defenses, but the work was to be handled by the carpenters, "the Phydiases and Vaubans of Baltimore." He had suggested changes inside Fort McHenry as well as in three sites on the Ferry Branch and the Lazaretto, where additional batteries and cross fire would give the harbor greater protection; apparently batteries were established at these points during 1813–14. At this time, he observed, the vulnerable northeast side of the city lacked protection. Not until after the British bombardment, a year and a half later, was Godefroy provided an opportunity to direct military works.

Although Baltimore survived the attack by land and sea, its defenses were severely damaged. Expecting a return of the enemy, Major-General Samuel Smith and the Committee of Vigilance and Safety hastily strengthened both Fort McHenry and the emergency fortifications along the northeast side of the city. Emphasizing the urgency of the situation, Smith repeatedly sought a military engineer from the secretary of war, James

[49] Latrobe to Godefroy, Washington, Jan. 28, 1807, Letterbooks; Hamlin, *Latrobe*, pp. 385–86. The first edition of *Military Reflections* was published in 1807; in 1812 Latrobe had two hundred copies bound with a new title page (Latrobe to Godefroy, Washington, Jan. 12, Apr. 28, 1812, Letterbooks). The two-page Advertisement records approval of Godefroy's proposals by the late "J. Hamilton Davies." Joseph Hamilton Daviess, pamphleteer and major in the Indiana Territory Militia, was killed on Nov. 19, 1811, at Tippecanoe (General Index, 1784–1811, War Department, Record Group 107, National Archives, Washington). Through Henry Clay, Latrobe attempted to get a portrait and some papers from Daviess' widow, possibly for use in the new edition of *Military Reflections* (Henry Clay, *Papers of Henry Clay*, ed. James F. Hopkins and Mary W. M. Hargreaves, 3 vols. to date [Lexington, Ky., 1959–], 1:599–600; Latrobe to Godefroy, Washington, Dec. 14, 1811, Letterbooks). As late as 1837 Godefroy retained part of his correspondence with Daviess (Godefroy to Jackson, Laval, May 8, 1837, Maryland Historical Society).

[50] Latrobe to Godefroy, Washington, May 6, 1813, Letterbooks, quoted in part in Hamlin, *Latrobe*, p. 393; Godefroy to [Latrobe, Baltimore, May 9, 1813], Letters Received. G-73(7) Enc., War Department, Record Group 107, National Archives.

Monroe. As no officers were available, Monroe authorized the employment of Godefroy, whom he had heard well recommended. Apparently Godefroy was promised a colonelcy or equivalent recognition, but he received only $300 for his work through October and November, 1814. A few months later, to salve the national conscience, President Madison suggested, through roundabout channels, that Godefroy apply for the appointment to rebuild the president's house and the capitol in Washington. In Godefroy's letter of refusal he lauded Latrobe, who received that appointment shortly thereafter.[51]

Godefroy's work on the defenses of Baltimore consisted of two separate activities, construction at Fort McHenry and strengthening of the line of fortifications on the east. We may presume that all the work done at the fort at this time was by Godefroy, including two powder magazines in the outerworks, a wellhead and repair of the existing powder magazine inside the fort and the sally port with two related bomb-proof shelters (Fig. II–34). The two outer magazines are no longer standing, but they are documented by a letter and an advertisement. Shown in a map of 1819 but removed before the Civil War, they were substantial brick structures about 26 by 28 feet, presumably thick-walled and vaulted, with the customary precautions for ventilation and entrance. The wellhead, a roofed structure some 15 feet square, formerly stood between the junior officers' quarters and a barracks building. The powder magazine in one angle of the star fort had been hit during the bombardment and was rebuilt as it appears today. Its 9-foot-thick walls and barrel vault were strengthened under Godefroy's direction; about a quarter-million bricks were laid in a few weeks. A void above the vault was to be filled with earth and roofed with sod, but on the objections of an artillery officer this was not done; the slate roof dates from November, 1815. A spur wall once stood before the entrance to contain the effects of an accidental explosion.[52]

[51] William D. Hoyt, Jr., "Civilian Defense in Baltimore, 1814–1815," *Maryland Historical Magazine* 40 (1945):7–23, 137–53; John M. Duncan, *Travels through Part of the United States and Canada*, 2 vols. (Glasgow and New York, 1822), 1:225. For Godefroy's appointment, see Letters Received, G-70(8), and Military Book, no. 7, pp. 331, 346, 405, War Department, Record Group 107, National Archives; Samuel Smith Papers, Box 7, Library of Congress. For Godefroy's praise of Latrobe, see Latrobe to Harper, Washington, June 15, 1815, Mrs. Gamble Latrobe Collection, Maryland Historical Society.

[52] I wish to acknowledge the extensive aid of Richard N. Walsh of Georgetown University and S. Sydney Bradford and Lee Nelson of the

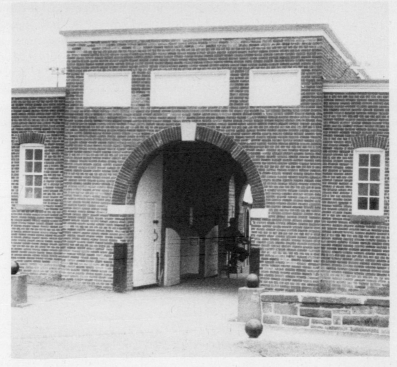

II–34. Sally port, Ft. McHenry, Baltimore. 1814.

The entrance complex, comprised of the sally port and two flanking casemates, is the only part of the construction with architectural pretensions. Built with a wide arched opening at either end, the massive brick structure is varied by sandstone impost blocks and keystones and three rectangular panels re-

National Park Service. See Richard N. Walsh et al., "Fort McHenry: 1814," *Maryland Historical Magazine* 54 (1959):61–103, 188–209, 296–309. Mr. Nelson has expressed the opinion that Godefroy was primarily responsible for works at Ft. McHenry at this time. For the outer magazines, see Godefroy to the Committee for the Monument, Mar. 22, 1815, Maryland Historical Society; *Baltimore Federal Gazette*, Sept. 27–Oct. 11, 1815. They are shown in the plan of Ft. McHenry, 1819, by William Tell Poussin, Cartographic Records Division, Drawer 51, Sheet 2, Record Group 77, National Archives. For the well, cf. the Renaissance examples of similar wells illustrated in Charles Percier and P.-F.-L. Fontaine, *Palais, maisons, et autres édifices modernes, dessinés à Rome* (Paris, 1798), pls. 37, 55. For the powder magazine, see Capt. F. Evans to Smith, Baltimore, Oct. 9, 1814, S. Smith Papers, Box 7, Library of Congress. Captain Frederick Evans, an artilleryman, opposed the use of earth and sod, claiming that it retained moisture and led to powder spoilage.

cessed into the high attic. A wooden cornice around the top of the sally port gives a note of elegance. Thick, heavy groin vaults over the passage render the tall attic necessary. The rectangular panels could have been designed by Godefroy or by Robert Cary Long I, who was active in the militia and in preparation of the fort before the bombardment. Supporting an attribution to Godefroy is the fact that he had earlier been preoccupied with structures having an arched opening flanked by heavy piers and topped with an attic, e.g., the Washington Monument design and the Commercial and Farmers Bank.

The underground bomb-proof shelters were built at the same time or even before the sally port. A low arched opening with stairs on either side of the sally port passage provides the only access to them. The casemates are simple, thick barrel vaults, about 18 feet wide and 50 feet long. Aside from the entry, there was no lighting, although a series of long tubes stretching back through protective mounds of earth provided ventilation. The whole was characteristic of recent French military engineering and thus supports the statement of Captain F. Evans that Godefroy was designing the casemates. An earlier start on a bomb-proof shelter in September had been for a timber structure below ground level.[53]

Godefroy's work on the line of fortifications east of the city, part of the area now Patterson Park, is well documented. He began the project under General Smith, who resigned when Major-General Winfield Scott of the U.S. Army came to Baltimore. Godefroy continued under Scott and submitted several reports of his activities and needs in October and November. Robert Goodloe Harper succeeded Smith as head of the militia and wrote Latrobe of Godefroy's appointment as engineer. Latrobe's congratulatory letters contain some information on the preparations of 1813–14; under Long and William Stuart the work had been done in reverse: the ditch was dug inside the breastworks so that, instead of presenting an obstacle to the enemy, it was a hindrance to the defenders. Godefroy had much of the old work leveled and by mid-October had planned a

[53] Smith to J. Monroe, Baltimore, Sept. 29, 1814, and Evans to Smith, Baltimore, Oct. 10, 1814, Smith Papers, Box 7, Library of Congress; cf. similar work in French publications that might have been known to Godefroy or even owned by him: Belidor, *La science des ingenieurs*, bk. 3, pl. 11, fig. 1; Charles-François Mandar, *De l'architecture des forteresses* (Paris, 1801), pls. 3–5. In his *Military Reflections* (p. 10) Godefroy pointed out that the use of howitzers and bombs in modern warfare made casemates indispensable.

new line. It began near the sugar house on the basin, stretched north along the ridge of Hampstead Hill to the hospital, and turned west for a short distance along the ridge. A number of bastions were constructed along the lines, several of them strongly armed. Trees outside were cut, ravines filled, and Harris' Creek carefully channeled to prevent a surreptitious approach. Damp areas were strengthened with fascines in the approved manner, layers of bundled twigs and branches alternating with earth. Armed with a pass from General Scott, Godefroy daily moved in and out of the works, occasionally supervising activities at the fort, continually requesting more men and supplies. The long line, defending the easy eastern approach via the Philadelphia road, was well recorded in a contemporary map and remained a landmark for many years.[54]

Godefroy was proud of his military works and mentioned them in later years as evidence of the breadth of his activities. One immediate reward for this work was the high esteem of his fellow Baltimoreans, which undoubtedly led to the immediate acceptance of his Battle Monument design and was in part the basis for his recommendation as an engineer for works in Richmond, Virginia. Limited as it was, the experience in earth moving was certainly of practical value for the designing of Capitol Square.

The Didier House The house formerly at 22 East Lexington (then New Church) Street, at the corner of St. Paul Street, was built about 1812 by Robert Cary Long I for Dr. John B. Davidge. Henry Didier, Jr., acquired it about 1814 (Fig. II-35). By March, 1815, Godefroy had begun alterations, employing among others John G. Neale, a stonecutter. The alterations probably included the addition of back buildings and the stone lintels and archivolt of

[54] Several manuscript sources record Godefroy's work: Godefroy to Monroe, Washington, Oct. 14, 1814, Letters Received, G-70(8), War Department, Record Group 107, National Archives; Godefroy to Smith, Washington, Oct. 14, 1814, Smith Papers, Box 7, Library of Congress; Orderly Book, Oct. 22, 1814, Third Division, Maryland Militia, Maryland Historical Society; 1814, nos. 541, 543–45, 565–66, City Archives, Baltimore; James Kearny, "Military Topography of Baltimore," ca. 1818, Cartographic Records Division, Map G-4, Sheet 12, Record Group 77, National Archives. See also [Latrobe], *Picture of Baltimore*, p. 195; James Piper, "Defence of Baltimore, 1814," *Maryland Historical Magazine* 7 (1912):378; Hoyt, "Civilian Defense," pp. 9, 22–23, 139–44. For Latrobe's comments, see Latrobe to Godefroy, Pittsburgh, Oct. 10, Dec. 12, 1814 (quoted in part in Davison, "Godefroy," p. 206), Latrobe to Harper, Pittsburgh, Nov. 28, 1814, all in Letterbooks.

II–35. Entrance, Didier house, Baltimore. 1814. Photo Peale Museum.

the facade. In September work was near completion. By 1937, when an explosion led to its demolition, the house had undergone extensive rebuilding. The site is now a parking lot.[55]

[55] Godefroy to the Committee for the Monument, Baltimore, Mar. 22, 1815, Maryland Historical Society; George A. Fredericks, "Recollections," 1912, Maryland Historical Society, p. 5; "Old Lawyers' Homes Soon To Be a Memory," *Baltimore News*, Mar. 24, 1918, p. 13; *Baltimore News-Post*, Sept. 22, 1937, p. 1. See also Baltimore directories for the years concerned here. On July 17, 1807, in behalf of Brice, Winder, and Davidge, Long

Godefroy employed the uncommon feature of flat stone lintels in domestic work. He made them more prominent by framing the exposed surface with a raised band, a treatment applied also to the archivolt of the doorway. To make the structure even more unusual, he supported the archivolt on stone blocks bearing the head of Mercury in high relief. Similar sculptured consoles were inserted, perhaps because of Godefroy's example, in the next two houses, nos. 18 and 20. It is possible that Nicholas Brice, owner of no. 18, also employed Godefroy to enlarge his house, which he reinsured in March, 1816, for a sum much larger than its original evaluation in 1809.[56] The alterations of the Didier house were intended to make it unusual, probably the desire of both the owner and the architect. Its stonework and sculpture singled it out from the mass of domestic work in brick, which may be why John H. B. Latrobe bought it many years later.

The
Battle
Monument

To the amazement of all concerned, Baltimore emerged victorious from the battle with the English forces on September 12 and 13, 1814. After the death of General Robert Ross, British land forces were restrained at the northern defense lines. Despite a heavy bombardment, the fleet of Admirals Cochrane and Cockburn could not get past Fort McHenry and the city's temporary defenses against invasion. While Francis Scott Key's "Star-Spangled Banner" is better known as a memorial of this battle, initially it did not arouse the enthusiasm generated by Godefroy's Battle Monument. As much a product of the sentiments of the age as is the song, the monument specifically commemorates the thirty-nine Baltimoreans who died in the conflict.

petitioned the city council to set the boundaries of New Church Street (1807, no. 119, City Archives, Baltimore). The first two houses were constructed immediately. Nicholas Brice, attorney and judge, owned no. 18 (Record of Surveys, bk. A, p. 203, no. 2360, Mar. 15, 1809, value $7,500, Baltimore Equitable Society). William Winder, an attorney and a brigadier general, owned no. 20 (bk. A, p. 174, no. 2361, Mar. 15, 1809, value $10,500, ibid.). John Davidge, a physician and professor of anatomy at the Medical College, owned but did not live in no. 22; Didier, a merchant of French lineage, owned and lived in the house by 1816; no early insurance policy has been found (Baltimore Equitable Society policy no. 39,429, dated Apr. 30, 1869, was canceled Dec. 8, 1937). The remaining structures in this block were razed in 1968–69, parts being reserved for the Baltimore Museum of Art, including two console blocks with the head of Ceres, perhaps designed by Godefroy.

[56] Record of Surveys, bk. D, no. 4488, Mar. 1, 1816, value $12,000, Baltimore Equitable Society.

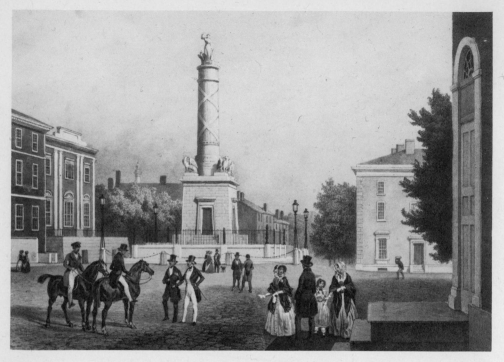

II–36. Battle Monument, Baltimore. 1815–22; after drawing by A. Kollner of 1847. [The second building from the left is the courthouse of 1805–9 by George Milleman.] I. N. Phelps Stokes Collection, Prints Division, The New York Public Library, Astor, Lenox and Tilden Foundations.

The decision to raise a monument was made by the same Committee of Vigilance and Safety that had hastily supervised the arming of Baltimore months before. Its resolution was taken on March 1, 1815; on March 25 the selection of one of the three designs submitted by Godefroy was announced. For the elaborate cornerstone ceremonies on September 12, 1815, the first anniversary of the battle, Godefroy and the mayor were in the van of the procession, followed by high officers of the army and militia and the clergy. A cart bearing a model of the monument, by John Finley and Rembrandt Peale, led the parade. During the ceremony Godefroy laid the cornerstone on the prominent central site, Courthouse Square. From the beginning the fund-raising activities had a good press, and money was speedily collected. The initial funds included public subscriptions and the contribution by surviving militiamen of their active-duty pay; the city assumed the expenses of the last few years of the

work. Godefroy offered the designs free and was paid about $800 for superintending the construction.[57]

About a month after the committee announced its decision, a lengthy newspaper article described the three designs submitted by Godefroy: "The first was a simple obelisk of *Verd Antique*, (green antique) marble, ornamented with bronze—The Second, a Sarcophagus, or rather, a Cenotaph, in the antique style, adorned with appropriate bass [sic] reliefs; the length of each was to have been 39 feet, in allusion to the 39 years of American independence." The one selected, the writer pointed out, was "entirely allegorical," and the description, if not actually by Godefroy, leaned heavily on his turn of mind and phrase. The project was described in three parts:

> 1st. A square base of stones, simply rusticated, of sepulchral antique form. It is composed of 18 layers of stone, in allusion to the 18 states. Each front will be decorated with a door, in the antique style, like that of the temple of Vesta at Tivoli. They will be shut with tablets of black marble, each bearing an inscription.
>
> 2d. Above the first base will be a second base, square also, each angle of which will be adorned with a Griffin, the symbol of immortality. By giving the head of the Griffin the form of an Eagle, it will have the character of the emblem of the United States. A circular *Fasus*, in marble, 18 feet high, will rise from the socle, as a symbol of the Union. On the fillets of the *Fasus* will be in-

[57] Mayor Edward Johnson, patron of Godefroy on several occasions, was chairman of the committee. An additional reason for giving the commission to Godefroy was a general feeling of guilt over the lack of recognition and remuneration he received for his two months of hard work, October-November, 1814, on the Baltimore defenses. Full accounts of the monument's early history are given in *Niles's Weekly Register*, Mar. 25, Apr. 29, 1815, the 1816 *Supplement*, pp. 3–8, and regular issues for June 2, 1819, and Sept. 7, 21, 1822. The manuscript of the procession and cornerstone arrangements is preserved in the Maryland Historical Society; see also announcements in the *Baltimore Federal Gazette*, Sept. 8–11, 1815; "Naval and Military Chronicle of the United States Monument, Commemorative of the Attack on the City of Baltimore," *Port Folio*, 4th ser., 1 (1816):1–12 and illus.; Griffith, *Annals of Baltimore*, p. 213. For modern accounts, see Jackson, *American Architecture*, pp. 187–88; Howland and Spencer, *Architecture of Baltimore*, pp. 42–43; Robert L. Alexander, "The Public Memorial and Godefroy's Battle Monument," *Journal of the Society of Architectural Historians* 17 (1958):19–24. In the Maryland Historical Society and the City Archives, Baltimore, are numerous manuscript records of contributions, bids, bills, receipts, and other financial accounts which have been utilized in the brief report of the construction given here. Godefroy was to receive $900 for superintendence of the construction; since there are records of payment of $800, perhaps he did not receive the full amount because he left before the work was completed (1816, nos. 558–61, 1819, nos. 409–13, 1820, no. 550, 1821, nos. 937, 1067–68, 1822, no. 390, City Archives, Baltimore).

scribed the names of those men [whom] valor and gratitude have thus immortalized.

It is from this principal and characteristic part of the monument, and from the Latin word Fascia (in plain English, a bundle of rods) that the ingenious author has elegantly designated this plan under the title of a FASCIAL MONUMENT.

The lower part of the *Fasus* leaves room for a small circular bass relief, which will represent the bombardment of the Fort and the engagement at North Point.

3d. The *Fasus* will be crowned with a marble figure, representing either the United States, or one emblematical of the city of Baltimore. The face will be turned toward the bay. In one hand will be the antique rudder, the symbol of navigation; and in the other a laurel crown, the symbol of glory. Beside her will be the Eagle of the United States.

The monument will be raised on three steps, in allusion to the duration of the war; and at the angles of the pavement which is to surround it, will be placed, instead of posts, four cannons of brass or bronze, from the mouths of which a ball will appear to be issuing. The execution of the statue, which is to be 7 or 8 feet high, will be entrusted to the chizel of one of the foremost masters of Europe in order that it may be [in] every way worthy of the object—a classical and dignified commemoration of the bravery, the virtue, and the gratitude of the citizens of Baltimore.[58]

Some details were added in other descriptions published in 1816 and 1822 (Figs. II–36–II–38). A mural crown definitely established the statue as a personification of Baltimore; a bomb at her feet recalled the naval bombardment. The statue was to measure 7½ feet high, the whole monument 47 feet. Around the top of the fasces two wreaths were planned, one of laurel, expressive of glory, and one of cypress, sepulchral and mourning. The relief of the North Point engagement was to show the death of General Ross, and the two reliefs would be separated by lachrymal urns, the emblem of regret and tears. The base was now specifically described as Egyptian, with the black marble doors giving it the quality of a cenotaph. The symbolism included the winged globe on the Egyptian cornice, calling to mind eternity and the flight of time, and the rustication of the base, denoting strength. Except for the added fence of lances and fasces, which were not mentioned, the entire monument followed Godefroy's design. The allegorical character he gave found a responsive public, and this element was emphasized in

[58] "Description of the Monument," *Niles's Weekly Register*, Apr. 29, 1815.

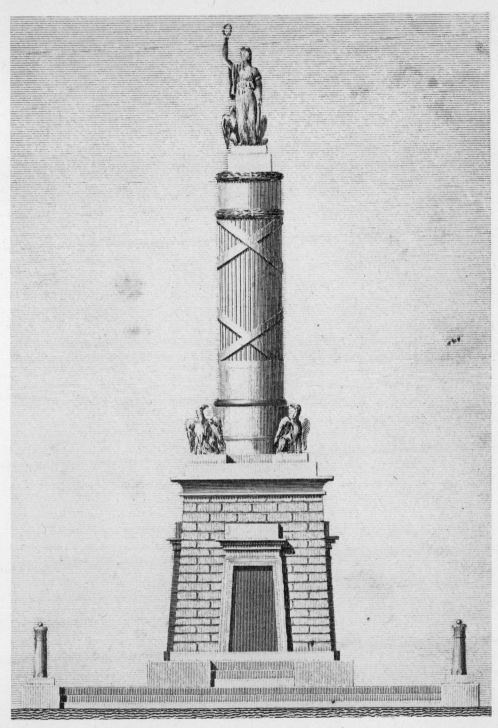

II–37. Battle Monument. Engraving by B. Tanner of 1816. Photo Peale Museum.

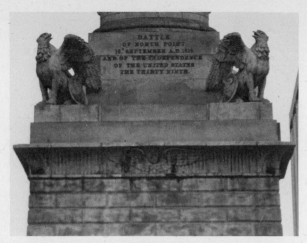

II–38. Detail, Battle Monument.

all the early descriptions. European travelers, moreover, from the very first saw it as part of the international development of the columnar monument.[59]

During the last decades of the eighteenth century and the first years of the nineteenth, public memorials changed from large portrait sculptures to more general architectural forms—arch, column, obelisk. At the same time from honoring a dynastic figure they became commemorations of the undying spirit of man in its quest for liberty and democracy. The broadening of content and form was accompanied by greater freedom in combining symbols drawn from the two most popular sources of memorial iconography, classical antiquity and ancient Egypt, to the point where even the column and the obelisk became interchangeable. These monuments, finally, acquired new social utility in becoming associated with fountains and public water systems.[60] All this activity was undoubtedly known to Godefroy: competitions and foundation ceremonies received the

[59] See *Niles's Weekly Register*, the 1816 *Supplement*, pp. 3–8, and issue of Sept. 7, 1822. Some examples of the upright cannon show it to be part of the eighteenth-century French vocabulary: Delafosse, *Nouvelle iconologie*, pl. 26; Jean-François de Neufforge, *Recueil élémentaire d'architecture*, 8 vols. in 3 (Paris, 1757–68), 4:270. For a similar use of a wreath surrounding a cylindrical element, see Delafosse, *Nouvelle iconologie*, pl. 86. For a European comment, see Duncan, *Travels*, 1:224–25.

[60] This development is considered in some detail in Alexander, "The Public Memorial," pp. 19–24.

broadest publicity, and projects were published with descriptions that had special appeal to the intellectual and the allegorically inclined. Even after leaving France he kept informed of current activities; one of his Washington Monument projects in 1810 revealed his knowledge of Napoleon's fountain monuments. What is surprising in his Battle Monument is not the combination of Egyptian and classical elements but the unusual forms in which those elements appear.

The Egyptian theme is present not in the shape of an obelisk but in the base of the monument, which is a slightly modified version of a small pylon published by Denon. Although the original at Apollinopolis Parva (Fig. II–39) is actually Ptolemaic, to the early nineteenth century it was perfectly Egyptian. The cavetto cornice, winged solar disk, and battered walls convey the desired sepulchral message. Durand recommended the frank use of battered walls and rustication, which, he felt, expressed character in architecture; Godefroy's use of rustication was decorative here, not always marking the actual stone joints; moreover, he went further in attributing allegorical meaning to both devices. Although it is by no means as Egyptian as it has sometimes been called, the base was striking for its novelty, and the widespread fame of the monument undoubtedly stimulated other uses of Egyptian motifs. Its novelty is tempered, however, by knowledge of Godefroy's cemetery vaults, where he used several of the details, the identical doorway with a

II–39. Detail, Ptolemaic temple at Apollinopolis Parva. Dominique-Vivant Denon, *Voyage dans la basse et la haute Egypte.*

black marble slab, the cavetto cornice, and the wings on the hourglass.[61]

The fascial form of the column on this base has been commented upon by both contemporary and later observers. It is one of the outstanding instances of Godefroy's free invention aided by his allegorical tendency as well as by his lack of formal architectural education. Awareness of variants in European columns may also have stimulated his invention. The fasces, symbolizing republican unity, occurred frequently in France and the United States. Houdon used them in his famous portrait of Washington of 1785; Jefferson suggested them for the emblem of the State of Virginia; and they formed parts of the frames of Trumbull's paintings in the Capitol in Washington. The French examples were related especially to obelisk and column projects. Ledoux employed them as prominent architectural decoration in two projects, but Godefroy had also used them on the Commercial and Farmers Bank, as had Robert Cary Long I on the Union Bank. Thus it was not the fasces, a perfectly respectable symbol before the twentieth century, but their magnification to huge size that was unique. With an indubitably allegorical reference to the United States, the fillets are inscribed with the names of the dead militiamen: "because of their glorious death, they strengthened the bonds of the union." [62]

[61] Denon, *Egypte*, pl. 80; see also Bertha Porter and Rosalind L. B. Moss, *Topographical Biliography of Ancient Egyptian Hieroglyphic Texts, Reliefs, and Paintings. V. Upper Egypt: Sites* (Oxford, 1937), p. 135. See Durand, *Précis*, 1:93, pt. 2, pl. 5, for battered walls; 1:55–56, pt. 1, pl. 2, for rustication. Although Quatremère de Quincy illustrated virtually the same form (*De l'architecture égyptienne*, pl. 6), Denon's plate included the vertical channels repeated in the Battle Monument.

[62] Examples of the fasces from the late eighteenth and early nineteenth centuries may be found in all countries. Their symbolic use in Fragonard's *Apotheosis of Franklin* (ca. 1780), Houdon's portrait of Washington (ca. 1785–92), and Ramée's design for a Washington Monument (1813) indicates their particular acceptance in the Franco-American ambient (*The French in America, 1520–1880*, exhibition at the Detroit Institute of Arts, 1951, p. 110; Georges Giacometti, *Le statuaire Jean-Antoine Houdon et son époque*, 3 vols. [Paris, 1918–19], 3:207–16; Hamlin, *Greek Revival Architecture*, pl. 9). Much earlier, Delafosse published a monument symbolizing Europe and America, in which fasces performed the functions of columns (*Nouvelle iconologie*, pl. 7). Among French examples, one is especially relevant, Jeaurat's *Peinture révolutionnaire*, in the Musée Carnavalet; the fasces appear with the Phrygian bonnet, a pyramidal obelisk, and the lower parts of two columns with medallion portraits of the hero-martyrs Marat and Saint-Fargeau (M. Hours-Miédan, *A la Découverte de la peinture* [Paris, 1957], p. 82). In view of these connections Bornemann seems too emphatic in deriving Godefroy's use of the fasces from Ledoux's Maison d'Union and Pacifère ("Ledoux-Inspired

Sculpture on the monument includes two narrative bas-reliefs of the battle and bombardment on the circular base of the fasces and several allegorical pieces, the lekythoi and winged disks, the eagle-headed griffons, and the personificaton of Baltimore. In a number of drawings Godefroy had displayed his ingenuity and proficiency in converting standard classical motifs into symbols of local and particular significance. Similar transmutations in the sculpture only underscore the thought processes that enabled him to transform the fasces into a columnar monument. Latrobe's Italian sculptors were no longer available, so Antonio Capellano, a student of Canova, was invited for this work. His classicistic manner was perfectly adequate for the literalism required of the allegorical sculpture.[63]

Before the selection of his design was publicly announced, Godefroy knew of it and knew also that he was to superintend the construction of the monument. He wrote to the committee recommending two builders in whom he had confidence and who understood his methods from past associations: the bricklayer Walter Athey and the stonecutter John G. Neale, who was associated with S. Baughman and E. Hore for this job. Over the years numerous other Baltimoreans supplied materials and labor. Godefroy's concern over suitable craftsmen and materials was in keeping with Blondel's strongly worded injunctions on these points.[64]

Although it extended over a decade, construction was concentrated in two major and several lesser building campaigns. From April to December, 1816, the base was completed up to the cornice and was roofed over for winter protection, especially for the core of some thirty thousand bricks. In 1817 the cavetto cornice and part of the column socle were installed. Construction then halted, except for minor work on the platform around the base, awaiting the carving of the bas-reliefs and the semi-drums of the fasces. In the spring and summer of 1819 the

Buildings," p. 16). Belanger used them similarly as applied ornament on a project for the improvement of the Pont-Neuf in 1787 (Jean Stern, *A l'Ombre de Sophie Arnould. François-Joseph Belanger*, 2 vols. [Paris, 1930], 1:233–34, illus. facing p. 232).

[63] Ihna T. Frary, "The Sculptured Panels of Old St. Paul's Church, Baltimore," *Maryland Historical Magazine* 34 (1939):64–66. Capellano's classicized naturalism is especially notable in the richly feathered wings floating against the grooved cavetto in a totally non-Egyptian manner.

[64] Godefroy to the Committee for the Monument, Baltimore, Mar. 22, 1815, Maryland Historical Society; see also Godefroy to James A. Buchanan, Apr. 2, July 23, 1818, all Maryland Historical Society; Blondel, *Cours*, 1:394, 406–7.

reliefs, urns, fasces, and statue base were raised into position; some 2,800 bricks went into the core of this construction. Capellano spent about a year carving the griffons, beginning in the spring of 1819; he spent about two years on the statue, which was finally raised to its position on September 12, 1822, an event celebrated by a banquet. Final details, completed in 1825, included the platform and the lance and fasces fence set up between the four cannon that Godefroy had designed as corner posts. The materials were of local origin except for the white marble of the column and statue, which was imported from Italy.

Situated in a center of Baltimore's political and social life, the monument has long been identified with the city. From its early days it was the central element of the municipal seal. Whether shown alone, as a reason for Baltimore's familiar name, the "Monumental City," or as the background for significant political events, it has a continuous history of representation. Early in 1816 the Philadelphian Benjamin Tanner engraved Godefroy's presentation drawing, with the indication "Max. Godefroy. Esqr. P. A. &c. invenit & delint. 1815." Niceties like clouds, figures, and foliage are omitted. The monument itself, carefully shaded but lacking fine details, appears flanked by the upright cannon on podia. A descriptive legend at the bottom, part of the original drawing, details the purpose of the monument. Published as the frontispiece of the *Port Folio* and republished in the *Casket*, this engraving brought nation-wide publicity to the monument and its designer. The citizens of Boston, for example, used it as a precedent in erecting the Bunker Hill Monument.[65]

Although the sentiment and the allegorical content were generally appreciated, Godefroy's contemporaries differed on the stylistic qualities of the monument. Americans in general thought it superb, classical, and the product of rare taste and

[65] *Port Folio*, 4th ser., 1 (1816), frontispiece; the *Casket* reference has not yet been identified. Several copies of both imprints are in The Peale Museum and the Maryland Historical Society. See also David M. Stauffer, *American Engravers upon Copper and Steel*, 2 vols. (New York, 1907), 1:263–65, 2:514. A riddle surrounds the engravings of the two reliefs. In the *Baltimore Federal Gazette* (Oct. 24, 27, 1817, Mar. 14, 18, 20, 1818) George Weiss announced that plates had been made in Philadelphia after Godefroy's designs. No prints of them are known. A drawing of the monument was exhibited in London (*The Exhibition of the Royal Academy* [London, 1821], p. 46). On its fame, see Wheildon, *Memoir of Solomon Willard*, p. 67; as far off as Georgia the Battle Monument was considered newsworthy: see *Columbian Museum, and Savannah Daily Gazette*, Feb. 26, 1816; *Savannah Georgian*, June 15, 1819.

talent. The English tended to be more critical, stressing incongruities that appeared bizarre to them. The French found it of "un style sévère," and worthy of being set up in Europe; apparently they recognized it as a product of their own tradition.[66]

Architectural historians of recent decades have made fewer value judgments on the monument. Some have stressed its Egyptian aspects, even calling it "the first complete Egyptian structure in America," while others have contrasted the Egyptian base with Roman fasces. Some felt it appropriate that after Napoleon's Egyptian campaign a Frenchman should lead in employing Egyptian elements. Still others have seen it as essentially classical, despite some Egyptianizing, and thus as an outgrowth of the seventeenth- and eighteenth-century European sepulchral tradition. Only recently has it been related to Revolutionary and particularly Napoleonic architecture in France. A student of that period provides a succinct explanation for the striking effectiveness of the monument: "The discovery of the immense artistic possibilities in disproportionality goes back to the era of the French Revolution." [67] Strongly differ-

[66] For American comment see [Latrobe], *Picture of Baltimore*, pp. 183–86; Varle, *Complete View of Baltimore*, pp. 62–63; "The Battle Monument," *American Magazine of Useful Knowledge* 1 (1834):25–28; Charles A. Goodrich, *The Family Tourist* (Hartford, Conn., 1848), p. 344 and illus. For English comment see [Frances W. d'Arusmont], *Views of Society and Manners in America* (London and New York, 1821), p. 361; Duncan, *Travels*, 1:224–25; [Isaac Candler], *A Summary View of America* (London, 1824), p. 32; James Silk Buckingham, *America, Historical, Statistical, and Descriptive*, 3 vols. (London, 1841), 1:422–24. The petulant Thomas Hamilton's comments deserve quotation: "The effect of the whole is sadly injured by a most anomalous complexity of petty details. Indeed, so vicious is this monument, in point of taste, that it is difficult to believe it the production of the same period which has adorned the city with the noble structure to Washington" (*Men and Manners in America* [Philadelphia, 1833], pp. 214–15). On the other hand, John H. Hinton deemed the monument worthy of illustration, although his artist mistakenly interpreted the griffons as eagles (*History and Topography of the United States*, 2 vols. [London, 1830–32], vol. 2, illus. facing p. 419). For French comment see [Auguste Levasseur], *Lafayette en Amérique, en 1824 et 1825*, 2 vols. (Paris, 1829), 1:351; for General Bernard's comment, see E. Godefroy to Jackson, Laval, Sept. 22, 1836, Maryland Historical Society.

[67] For the Egyptian emphasis see Frank J. Roos, Jr., "The Egyptian Style," *Magazine of Art*, 33 (1940):219–21, for the source of first quotation; Clay Lancaster, "Oriental Forms in American Architecture, 1800–1870," *Art Bulletin* 29 (1947):283; Hautecoeur, *Architecture classique*, 5:241; Wayne Andrews, *Architecture, Ambition and Americans* (New York, 1955), p. 87. For the French tradition see Jackson, *American Architecture*, pp. 187–88; Hamlin, *Greek Revival Architecture*, pp. 39, 187; Claire W. Eckels, "The Egyptian Revival in America," *Archaeology* 3 (1950):166; Howland and Spencer, *Architecture of Baltimore*, p. 42; Bornemann, "Ledoux-Inspired Buildings," p. 16; Hitchcock, *Architecture*, p. 7. The quotation appears in Kaufmann, *Three Revolutionary Architects*, p. 554.

entiated in dimensions and shapes, its three antithetical elements specify and clarify the meaning of the monument; victorious Baltimore leads the newly tested and strengthened Union in commemorating those who died for the democratic ideal.

In the first decade of his architectural practice Godefroy designed buildings for a variety of functions in a variety of forms. Not only lack of experience but indecisiveness and inconsistency mark this early work. Both medieval and classical quotations appear, even side by side. They work with other forms to establish the character of a building; allegorical sculpture and decoration further proclaim its nature. While aware of the need to respond to functional requirements, both pragmatic and commemorative, Godefroy concentrated his attention on the facade, the main entrance, and the allegorical elements. Certain patterns appear in the disposition of similar shapes, rectangular and arcuated, and in the recessed entrance porch flanked by rectangular piers or blocks. Toward the end of this decade his extensive reliance on surface pattern and decoration was accompanied by increased use of recent, more architectural French forms. The Masonic Hall vestibule screened by columns, the simple geometry of the apse of St. Thomas' Church, even the stark, pyramidal Calhoun-Buchanan vault, all witness Godefroy's growing confidence in handling architectural forms, as his practice led him to greater understanding of sources such as Durand's *Précis*.

III. Architectural Maturity: Late American Works, 1815-19

Godefroy's work up to the Battle Monument served as a preparation for his significant accomplishments of the succeeding four years. In 1815–19 he was occupied with a number of major public buildings, in Richmond as well as Baltimore. Some were public, owned by and housing institutions of the federal or local government, while others, of group ownership, became public monuments by virtue of their prominent urban situation. Perhaps because of his own predilection as well as his reputation as an architect, no domestic work came his way.

The monument signaled not only Godefroy's standing as a designer of public structures but also his apparent success in establishing a position in Baltimore. With the increasing number of large-scale commissions, his confidence also grew. Indeed, in 1818, as he saw his practice expanding and his income rising through superintendence of construction, he gave up the time-consuming teaching post at St. Mary's. Two years earlier Godefroy had been so despondent that he seriously considered his move to Richmond in 1816 to be the start of a new career. A year later, in the summer of 1819, in despair over his unemployment and lack of prospects, he hastily raised some money and moved hopefully to a new career in England.

Despite the violent fluctuations in Godefroy's emotional state, his designs of this brief period attained consistency and wholeness of form. Hesitation disappeared from his handling of stylisms, and his use of extensive amounts of allegorical decoration diminished. With experience came new understanding of his reference works, and at the same time his continued use of Blondel and Durand reinforced the maturity of his new designs.

On June 15, 1815, Latrobe suggested to Godefroy that they work together to offer designs in the competition for the Baltimore Exchange. The history of this association, which led to a violent break in their ten-year friendship, has been recounted elsewhere. The high hopes that Godefroy attached to the commission, and the jealousy displayed by him and his wife over Latrobe's fame, made it impossible for him to act effectively as the local representative for the project, as Latrobe wished. In that capacity he was to prepare detailed and working drawings; he borrowed Nicholson's *Principles of Architecture* twice in 1815, from July 17 to August 21 and from December 2 to 15, for this work.[1]

For several months the two collaborated, despite their conflicting tastes and worry over the strong opposition of Mills, Ramée, and several others. On February 5, 1816, the premium was awarded to the partners, and on his perspective view (Fig. III–1), completed in May, Latrobe wrote both their names as designers. In their H-shaped plan, one long side, the three-story

[1] For an account of the exchange and the personal relationships of Latrobe and Godefroy, see Talbot F. Hamlin, *Benjamin Henry Latrobe* (New York, 1955), pp. 486–97, pls. 31–32; see also Carolina V. Davison, "Maximilian Godefroy," *Maryland Historical Magazine* 29 (1934):204–5; and Richard H. Howland and Eleanor P. Spencer, *Architecture of Baltimore* (Baltimore, 1953), pp. 44–46, pls. 32–34. Among the members of the board, Robert Smith was "warmly interested" in Godefroy (Latrobe to Smith and Latrobe to R. G. Harper, both Washington, July 11, 1815, in Benjamin Henry Latrobe, Letterbooks, Maryland Historical Society). In his letter to Godefroy to suggest the partnership, Latrobe also thanked him for his warm recommendation to President Madison that he, Latrobe, be appointed to rebuild the Capitol (Latrobe to Godefroy, Washington, June 15, 1815, Letterbooks). Discussions on the appointment of an architect to repair war damage to buildings in Washington had been going on for some months (Helen M. P. Gallagher, *Robert Mills* [New York, 1935], p. 214). Godefroy refused the position when it was offered to him, Latrobe wrote to Harper, but took the opportunity to praise Latrobe to a degree that was actually embarrassing to the latter (letter of June 15, 1815, Letterbooks; see also Mrs. Gamble Latrobe Collection, Maryland Historical Society). Godefroy, when he later referred to this incident, judged that the offer was an attempt to compensate him for his efforts on the defenses of Baltimore (Godefroy to Jackson, Laval, Aug. 30, 1836, Maryland Historical Society). The book referred to is Peter Nicholson, *Principles of Architecture*, 3 vols. (London, 1795–98; rev. ed. London, 1836); Godefroy's borrowings from the Baltimore Library Company are recorded in the Librarian's Ledger in Maryland Historical Society. To Francis James Dallett, former secretary and Librarian of the Athenaeum in Philadelphia, I owe knowledge of the earliest public reference to Latrobe's and Godefroy's victory in the exchange competition, found in *L'Abeille Américaine* 2 (1816):356.

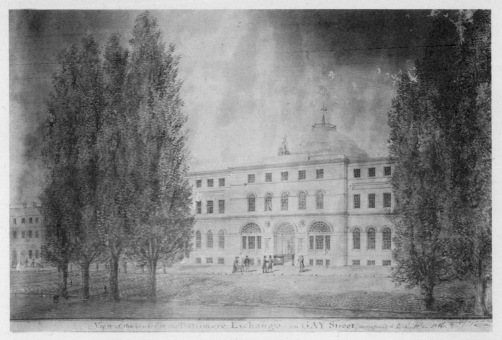

View at the center of the Baltimore Exchange—on GAY Street

III–1. Drawing for Baltimore Exchange. Benjamin H. Latrobe. 1816. Collection Maryland Historical Society. Photo Frick Art Reference Library.

Gay Street front, has a wide central pavilion flanked by short wings and sculpture on a long block above the top cornice; a broad dome rises over the crossbar of the H, visible above the facade. The trees in his drawing indicate that Latrobe's three-bay wings might be kept to that length or extended as financial circumstances permitted. The arches of the first-story windows, connected by continuous horizontal moldings, form the "aque-duct" motif, similar to the second-story windows in the center. A long recessed panel with an inner frame fills the space above the second-story windows of the wings. These motifs, used, for example, in the cathedral, accord better with Latrobe's more elegant style than with Godefroy's balder one.

The design of the central pavilion is highly unusual, despite the evident hand of Latrobe. The closest parallel for the pattern of three large arched openings on the ground floor and five smaller ones on each upper story was the facade of the Théâtre Feydeau, of 1791, by Legrand and Molinos, in Paris; well pub-lished, its conflicting rhythms of three huge openings on the ground floor and seven above may have been known to both

Godefroy and Latrobe.[2] The sculpture is probably Godefroy's conception, but Latrobe would readily accept the allegorical references to commerce in the figure of Baltimore above the cornice and the two busts and two panels of Mercury and the caduceus around the main entrance. As on the Hôtel de Salm in Paris, the busts appear in circular recesses, but here they destroy the stability of the spandrels, while the recessed panels below damage the sense of solidity of the piers flanking the large arched opening. Apart from these strong French accents, suggestive of Godefroy's taste, Latrobe never showed elsewhere such a lack of structural continuity between the main and the upper levels—piers rising above windows and windows above piers. The entry motif probably derives from Godefroy's earlier preoccupation with the large arch between piers, and the rest of the facade is forced into place around it.

Although Latrobe generously credited his partner for the effect of the Gay Street front, his statement has usually been ignored, and the disagreement of the two men over the arched, tripartite, "Venetian" windows in the central pavilion has been interpreted as an indication of Latrobe's sole authorship of the

[2] See [Charles-P. Landon], *Annales du musée* 7 (1803):63–64, pl. 28; Jean-G. Legrand and Charles-P. Landon, *Description de Paris*, 2 vols. (Paris, 1806–9), 2:95–96, pl. 31.

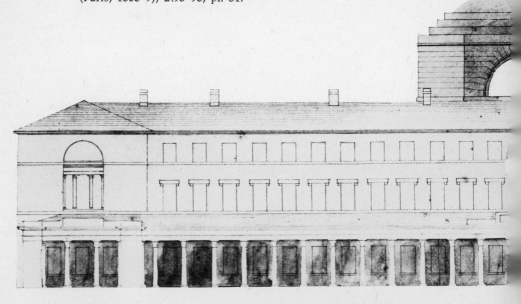

III–2. Drawing for Baltimore Exchange. 1816. Collection Maryland Historical Society. Photo Maryland Historical Society.

approved facade design. Probably the interior and the plan were Latrobe's; he did not attribute any parts of them to Godefroy; furthermore, Godefroy decried a waste of space in the interior arrangements. It was in the facade that Godefroy made his greatest contribution, and Latrobe endeavored to incorporate his friend's ideas as much as possible.[3]

Dissatisfied with the accepted design, Godefroy sent a new drawing (Fig. III–2) to Latrobe in which he offered a quite different facade on Gay Street. Two slightly projecting end pavilions terminate a block-long structure characterized by a seemingly endless repetition of identical windows on simple string courses in a wall plane barren of softening ornament. Tall arched windows occupy the pavilion walls; two columns and half-columns stand in the wall plane and carry a full entablature. A one-story portico fronts the whole facade of twenty-six columns and two half-columns with a simple architrave and frieze; three horizontal blocks form a parapet over the center; end pavilions, marked by heavy piers, prolong the colonnade, now with a full entablature and a parapet set above. A small arched door in the center provides the only entrance in this

[3] Latrobe to J. S. Smith, Washington, June 5, 1816, Letterbooks, quoted in part in Hamlin, *Latrobe*, pp. 491–92; Godefroy to Jackson, Richmond, Sept. 7, 1816, Maryland Historical Society.

lengthy front. Above the center appears a Pantheon-like dome with buttressing of three steps, set on a high octagonal drum lined with horizontal masonry courses that become the voussoirs of a huge semicircular window. The H-shaped plan with dome over crossbar served as starting point, but Godefroy intended to create a larger rental area than was incorporated in the one already approved. He added to Latrobe's plan a two- or three-story vaulted hall and offices at either end for a post office and the Baltimore branch of the Bank of the United States.[4] Executed in thin black lines and a few areas of gray wash (Fig. III–2), this conception of simple, large forms was probably begun immediately after the announcement on February 5, 1816, that the partners had been awarded the commission. By March 11 Latrobe had responded to Godefroy, admiring the new design but showing its impracticality; at one end the podium supporting the colonnade would be as high as a man, and for him this would be an unsightly wall or barrier. Three months later he commented again on the great merit of the study but explained that it was unusable because the board had approved large "Venetian" windows in the center.[5]

Little or nothing in his previous work had prepared Godefroy for the large, extensive building required by the exchange and the prospective additional federal facilities. With some haste he went back to his basic sources, searching for information on the character and the forms appropriate for a public exchange. Lack of prototypes for this new building type posed no problem, as Godefroy preferred to evolve a suitable "style"; he followed Blondel in employing this term to mean the expression of character and purpose.

Feeling that the flatness of the accepted design and the sinuous movement of the "aqueduct" motif were inappropriate for the seriousness of the proposed building, Godefroy offered an essentially French conception. Bare wall planes, simplified forms, enormous size, and repetition stamp the facade with the character of Revolutionary architecture. Their distance emphasized by the lengthy sequences of columns and windows, the sharply differentiated pavilions create a characteristic tension, evoking, for example, Durand's design for a palace (Fig. III–3). Piers, columns in antis, and the blocks above make the terminal

[4] Cf. Jean-Nicolas-Louis Durand, *Précis des leçons données à l'Ecole Polytechnique*, 2 vols. (Paris, 1802–5), 1:297, where semicircular windows are linked with large, high, vaulted chambers.
[5] Latrobe to Godefroy, Washington, Mar. 11, 1816, and Latrobe to Smith, Washington, June 5, 1816, Letterbooks.

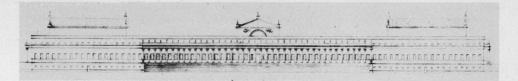

III–3. Design for a palace. J.-N.-L. Durand. Durand, *Précis des leçons d'architecture données à l'Ecole Polytechnique.*

sections of the colonnade appear as simplified versions of the facade for the Masonic Hall. In their specific shapes and proportions the multitudinous windows are related to Durand, as is the stark geometry of the stepped dome on the octagonal drum. The drawing, too—the frontality of the building and the primary reliance on fine black ink line with limited shading to denote the simple shapes of projecting elements—evokes Durand's engraved plates. On the other hand, the rectilinear patterns and the distinctiveness of the dome, main block, and projecting portico, along with Godefroy's own words of description, all show how he attempted to achieve the masculine character demanded by Blondel.[6]

Certain awkward and abrupt aspects of the facade arose in part from haste but perhaps even more from the use of French sources. In the portico, for example, which is merely set against the main block, there were jarring elements: its exposed lean-to roof, central door arch poorly related to the opening, podium an oppressive barrier at the high end, pavilions related awkwardly to the walls and Palladian windows above, portico simply appended to the facade. Although Latrobe objected only to the height of the podium, he surely was aware of Godefroy's weaknesses in design and of the uncompromising harshness of the modern French elements he introduced. Ten years of teaching and experience enabled Godefroy to minimize difficulties as he could not do at St. Mary's Chapel, for by now he had a firmer grasp on the whole conception.

[6] See Durand, *Précis*, vol. 2, pl. 4, for palace design; *ibid.*, pp. 25–26, for porticoed streets; *ibid.*, 1:84, for the colonnade and wall, or piers, in a single plane; *ibid.*, pp. 80–81, 90, on windows; *ibid.*, 2:42–43, for his recommendation of a dome rising from the structure rather than set on top of it like another building. See Jacques-François Blondel, *Cours d'architecture enseigné dans l'Académie Royale d'Architecture*, text 6 vols., plates 6 vols. in 3 (Paris, 1771–77), 1:411–13, on masculine architecture; *ibid.*, 2:391–92, for *bourses*, where porticoes and the Doric order are recommended. For Godefroy's expression of his ideas, see Chapter I, nn. 56–58, above.

Richmond,
Capitol
Square

On February 28, 1816, the legislature of Virginia empowered the governor of the state to improve and enclose the grounds around Jefferson's capitol. Several designs for this work had been solicited locally but were found unsatisfactory. Following his usual practice for locating experts, in May Governor W. C. Nicholas wrote to acquaintances for names of potential designers. Godefroy was strongly recommended, and on June 18 the Governor's Council authorized his employment as engineer for the improvement of Capitol Square. Godefroy arrived in Richmond early in July and completed his plans and detailed instructions on September 5, for the sum of $400. On August 19 and 28 the council further authorized Nicholas to enter into contracts for work according to Godefroy's plan. The drawings were publicly exhibited in the capitol during November, and in January, 1817, the work of leveling and enclosing began.[7]

Visible results were slow, and the project gave rise to some political infighting. In February, 1818, the next governor, James

[7] For work on the capitol and Capitol Square, see "Sources in the Archives Division of the Virginia State Library Pertaining to Capitol Square," boxed manuscript materials brought together in 1930–31, augmented in 1958, Virginia State Library. Although no manuscripts by Godefroy are included, Advices of Council, bids, contracts, bills, receipts, and various reports and accounts relevant to Godefroy's work are gathered together and provide much detail on his work for the capitol and square. The sum of $300 was authorized for the Capitol Square plans; the additional $100 probably covered the capitol restorations (see below). Godefroy's activities are recorded in several letters: Godefroy to Girardin, Richmond, Aug. 16, 1816, Avery Architectural Library, Columbia University; Godefroy to Girardin, Richmond, Sept. 19, 1816, Dreer Collection, Historical Society of Pennsylvania, Philadelphia; Godefroy to Jackson, Richmond, Sept. 7, 1816, Maryland Historical Society; Godefroy to Girardin, Richmond, Sept. 5, 1816, original lost, published in Anon., "Maximilian Godefroy," *Maryland Historical Magazine* 26 (1931):404–7. For the progress of the work and for attitudes toward it, see *Journal of the House of Delegates of the Commonwealth of Virginia*, 1817–18, pp. 194–96, 210–12, 216–19; 1818–19, pp. 43–44, 166–67. See also John P. Little, *History of Richmond* (Richmond, 1851), pp. 175–77; Samuel Mordecai, *Richmond in By-Gone Days*, 2d ed. (Richmond, 1860), pp. 75–78; Alexander A. Weddell, *Richmond, Virginia, in Old Prints, 1737–1887* (Richmond, 1932), pp. 31, 100–103; Mary W. Scott and Louise R. Catterall, *Virginia's Capitol Square* (Richmond, 1957), pp. 3–5. Robert Mills also offered a plan for Capitol Square: see Robert X. Evans, "The Daily Journals of Robert Mills. Baltimore, 1816," *Maryland Historical Magazine* 30 (1935):261. L. H. Girardin (1771–1825), a French refugee, taught at several colleges in Washington and Virginia and lived at Staunton while Godefroy was working in Richmond (Edith Philips, *Louis Hue Girardin and Nicholas Gouin Dufief and Their Relations with Thomas Jefferson*, Johns Hopkins Studies in Romance Literature and Languages, extra vol., no. 3 [Baltimore, 1926]).

Preston, reported on the expenses incurred and requested additional funds for completion of the square. A rather vocal group opposed further appropriations, bolstering their argument with the claim that Godefroy's plan was "not recommended by *practicability, good taste, good sense* or *economy.*" The former and present governors defended Godefroy, his plan, and the expense. Nicholas wrote:

> It was determined, in despair of succeeding in any other way, to have recourse to some of the northern cities, and employ an engineer, well recommended for his skill and taste in such matters. Maximilian Godefroy Esq. was so recommended; and his services were engaged for a very moderate sum. He was employed about three months under the Governor's eye, and the room which he occupied in the capitol was always open. . . .
>
> In justice to the character of Mr. Godefroy, it ought to be stated, that neither the Governor nor any member of the Council had any personal knowledge of him until he came to Richmond, to execute the contract above referred to. The compensation he received, could not have been a sufficient inducement, but he availed himself of that opportunity to display his talents as an engineer, in the hope that he might open the way to farther employment in this State. He had previously been very respectably recommended as civil engineer to the Board of Public Works of this Commonwealth.[8]

Perhaps as a sop to the opposition, Orris Paine, appointed superintendent in 1816, was replaced by Arthur S. Brockenbrough. Some parts of the work were completed in the next years, allaying further criticism, although the grounds were not finished until 1830.

When he arrived in Richmond early in July, 1816, Godefroy thought two weeks would suffice for his work. He was taken aback by the fourteen acres of rough, eroded ground surrounding the capitol and the rude wooden structures built close to it. Old prints and descriptions of the difficulties facing him were summarized by Alexander Weddell thus:

> The surface on which the city stood was untamed and broken. Almost inaccessible heights and deep ravines everywhere prevailed. The capitol Square was *ruda indigestaque moles*, and was but rudely, if at all, enclosed. The ascent to the building was painfully laborious. The two now beautiful valleys were then unsightly gullies, which threatened, unless soon arrested, to extend them-

[8] *Journal of the House of Delegates*, 1817–18, pp. 210–11, 217–18.

selves across the street north, so as to require a bridge to span them. If a tree had sprung up in the grounds, it obtained but a scanty substance from the sterile earth. Soil there was little or none. The street west of the Square was impassible for much of the way, except by a footpath.[9]

By the middle of August Godefroy solved the major problems and had the terracing, walks, and fencelines laid out. On September 5 he completed instructions for fountains, plantings, and the enclosure of the area. He had little hope that his plan would be followed carefully; Orris Paine, he expected, would make changes as soon as he left the city.

From the beginning Godefroy's intention was to lay out the grounds as a setting for the capitol (Fig. III–4). To this end he created around the building a major central terrace stretching 50 feet to either side and 100 feet in front of the south colonnade. An avenue cut straight across the upper part of the square, behind the capitol, led to the governor's mansion. Beside and below the terrace two broad walks ran down the slope and joined in a semicircle, providing a sequence of views of the building. A corresponding semicircle offered additional vantage points at the top of the hill. In this central area of the square no plantings obscured the view of the capitol. Above, along the sides, and below, the whole slope was shaped to induce prolonged contemplation of Jefferson's monument to reason. The intellectual control of nature enhanced the purpose of the building, that of rationalizing human relations.

On either side of the main axis and on the lower terraces the central motif was repeated in small. Two long walks were joined at the top by a curve. Here were trees, linden and chestnut, planted in a stiff, formal array. At this place they would conceal the irregularity and asymmetry of the whole plot. Somewhere along the central walks Godefroy planned two fountains; although they may have been erected, no representations of them have survived.[10]

By midcentury, objections to the formal scheme led to its replacement with romantic landscaping by J. Notman and others. The slope and irregularity of the site might have indicated that

[9] Weddell, *Richmond, Virginia*, p. 31. See the frontispiece of the *Virginia Almanack* for 1802 (reprinted in Scott and Catterall, *Virginia's Capitol Square*, p. 4).

[10] As late as Mar. 24, 1827, Richard Young submitted a design for a reservoir to supply water for "the Basins proposed by Mr. Godefroy" ("Sources . . . Pertaining to Capitol Square," box 11).

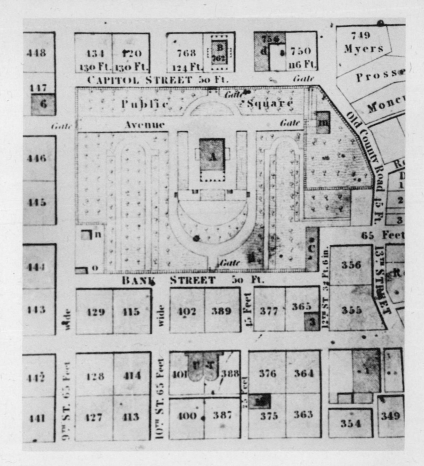

III–4. Detail of a plan of the city of Richmond, showing Capitol Square, the courthouse (B), and the Virginia and Farmer's Banks (U and T). Micajah Bates. 1835. Map Collection, Archives Division, Virginia State Library. Photo Virginia State Library.

treatment earlier. Godefroy certainly knew the *jardin anglais*; even Blondel devoted several pages to its denigration.[11] But the character of the building as the seat of state authority, he believed, required the traditional formal garden. This concern probably weighed more than a simple desire to plan the grounds in harmony with the classical style of the capitol.

The "traditional" French plan was not static; it had evolved continuously during the seventeenth and eighteenth centuries, as now one and then another aspect of layout claimed attention. In

[11] Blondel, *Cours*, 4:4–9.

his *Cours d'architecture* Blondel devoted an entire volume of text and one of plates to the problems of landscaping. No close prototype could be anticipated for Capitol Square, which had its very particular conditions. Yet there are in Godefroy's plan a number of similar details and an overall resemblance to the approach of Blondel. In general, Blondel wrote, a public garden should have long wide paths, and his plates often show them in parallel pairs.[12] Along with the main axis, there may be another strong one running perpendicularly near one end of the complex, and balancing apsidal shapes are not uncommon. The formal array of trees flanking paths was, of course, a common practice. Both men to some extent ignored natural features, Blondel rivers, Godefroy rises and ravines. Whether or not Godefroy used Blondel's publication, his plan shared the characteristics of that stage of park design.

During its brief history the Capitol Square was popular with Virginians. The orderly arrangement was a great improvement over its previous wasted condition. For several decades mapmakers represented the park as though it had been fully realized.[13] Legislative opposition to it in 1818 was based more on expense and political opportunism than on style. Until the high romantic age it complemented the capitol as an outstanding example of the French park in America.

Richmond, Capitol Restoration

Restoration of Jefferson's capitol was closely related to improvement of the square; both were authorized by the same act.[14] Certainly they were united in the minds of Governors Nicholas and Preston, Orris Paine, and Godefroy, and they were discussed together in the assembly. The whole course of action may have been triggered by the Senate resolution of January 1, 1816, that the governor have its chamber furnished with new curtains and other facilities. More than this, however, was undertaken, was understood by Godefroy to be part of his assignment, and was included in the $400 paid him.

Godefroy referred simply to interior and exterior renovations on the capitol building. A new slate roof was put on to keep out the rain and wind; exterior parts were painted or stuccoed;

[12] *Ibid.*, pp. 11–12, 14, pls. 23–24, 26.

[13] See maps of 1835 (from which Fig. III-4 is taken) and 1856 (Weddell, *Richmond, Virginia*, pl. 41).

[14] To the sources given in n. 7 above, add Executive Papers, 1816, MS in Virginia State Library.

the old elaborate staircases were replaced by simple ones with
two flights running parallel with the wall up to a landing in
front of the door. These operations were considered essential for
the appearance as well as the preservation of the building. In
the lobby, assembly room, Senate chamber, and elsewhere the
woodwork was completely renewed, but it followed the pattern
of the original work of the Federal carpenter more than inven-
tion by Godefroy (Fig. III–5). Paine wrote to Latrobe, doubtless
at Godefroy's instigation, for information on the material used
for curtains in the House of Delegates.[15]

All of this work was superseded by the later alterations and

[15] *Journal of the House of Delegates*, 1818–19, p. 167; for the exterior
after Godefroy's restorations, see John H. Hinton, *History and Topography
of the United States*, 2 vols. (London and Philadelphia, 1830–32), vol. 2,
illus. facing p. 444; Weddell, *Richmond, Virginia*, pls. 36–37; Latrobe to
Paine, Washington, Aug. 25, 1816, Letterbooks.

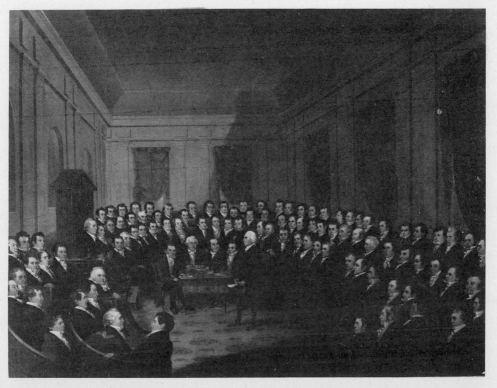

III–5. *The Virginia Convention of 1829–30.* George Catlin. 1840.
Reproduced through the courtesy of the Virginia Historical Society.

rebuilding in 1870 and 1904. However, Godefroy's restoration of the House of Delegates was recently re-created according to Catlin's representation of it as the meeting place for the Constitutional Convention of 1829–30.[16]

Richmond,
Courthouse

In March 8 to 16, 1816, Robert Mills designed a new courthouse and town hall to be erected in Richmond. Before he left the city five days later, the plans were approved. At the end of the year he noted that he had been paid only $200 of the $400 promised him. Apparently the small number of offices provided in the design appalled the authorities, and foundation work was halted. In August Godefroy was asked to "correct the errors" and transform it into a "regular edifice." He completed his drawings on September 19, shortly before he left the city, and received $200 for his work.[17]

As Godefroy described his design, "the fronts on Capitol Street and H Street should be similar, of antique Roman Doric order. The fronts on 11th Street and the yard should be similar, and of Tuscan order." Fortunately old photographs and drawings (Figs. III–6-III–8) clarify this description. The Tuscan order appeared in the columns and imposts of the modified Palladian motif which serves as the 11th Street entrance and in a large window intended for the back of the building. The Doric front, on the other hand, was two stories high, forming an imposing unpedimented portico at each end of the building. After Ledoux's use of it on his theater at Besançon of 1778–84, this kind of portico spread through French architecture.[18]

[16] Edward G. Dodson, *The Capitol* (Richmond, 1938), p. 33; George Catlin's painting, *The Virginia Convention*, is in the museum of the Virginia Historical Society.

[17] For Mills, see Evans, "Journals," Mar. 8–23, Dec. 28, 1816. The Mills drawings are reproduced in Robert L. Alexander, "Maximilian Godefroy in Virginia," *Virginia Magazine of History and Biography* 69 (1961):420–31. For Godefroy, see letters cited in n. 7 above; E. Patterson to E. Bonaparte, Baltimore, Sept. 25, 1816, Bonaparte Papers, Maryland Historical Society.

[18] For Godefroy's description, see Godefroy to Girardin, Richmond, Sept. 19, 1816, Historical Society of Pennsylvania. Standing behind Jefferson's capitol, the courthouse appears in many old views of Richmond. Excellent photos by Huestis Cook and Matthew Brady (23383/923, Brady Collection, Library of Congress) are known; see also Weddell, *Richmond, Virginia*, pp. 196–98 and pls. 79A-B. For the portico, see Henry-Russell Hitchcock, *Architecture, Nineteenth and Twentieth Centuries* (Baltimore, 1958), p. xxiv; Emil Kaufmann, *Three Revolutionary Architects*, Transactions of the American Philosophical Society, n.s., vol. 42, pt. 3 (Philadelphia, 1952), fig. 85. Other and earlier examples of this kind of portico by Ledoux are closer to Godefroy's in their attempt to assimilate the

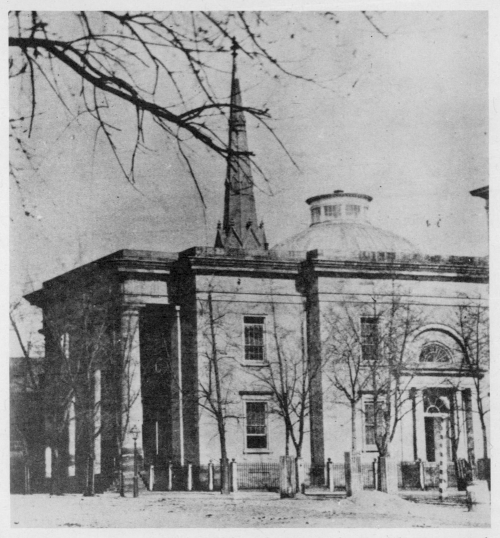

III–6. Courthouse, Richmond. 1816–17; photograph by Huestis Cook before 1879. Photo Valentine Museum.

Excellent drawings record the building and can be compared with Mills' sketches of his project. The original size of about 100 by 54 feet was slightly reduced. Mills had a two-story cen-

portico and the main body of the building through a continuous entablature and roofline; e.g., the pavilion at Louveciennes, of 1771 (*ibid.*, figs. 56, 91). Godefroy may have intended one-story tetrastyle porticoes for the Tuscan order on the long sides, as shown in the city plan of Micajah Bates.

tral block with low wings on either side. Godefroy raised the whole building to two stories with a level roof line, retained some of the saliencies, and tied them together tightly with a full entablature. Instead of a low pedimented front leading directly to the courtroom lobby, Godefroy made the longitudinal axis primary by putting the two huge colonnades at the ends. The dome, smaller than the one planned by Mills, rose higher, a hemisphere rather than a saucer. The lantern resembled some by Mills but was not indicated on his drawing.[19]

The French accent given to the exterior by Godefroy appeared inside as well. He changed the large two-story courtroom from an oval to a circle. A tribune on slim supports ran around two-thirds of the room, facing a one-story rectangular alcove for the judicial bench. Four small niches, already indicated by Mills, flanked the lateral entrances. Mills' interior was more clearly

[19] Cf. Mills' First Baptist Church, 1817–18, Baltimore (Howland and Spencer, *Architecture of Baltimore*, pl. 46). The dome and monitor may have followed Peter Nicholson, *New Carpenter's Guide*, rev. ed. (London, 1828), pl. 44 (earlier editions of this work were well known and used in America).

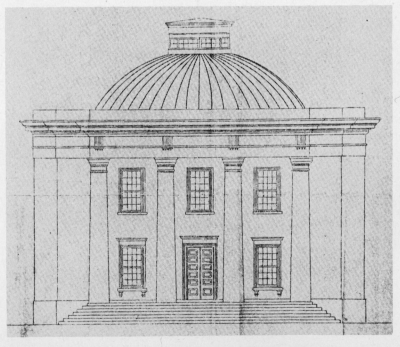

III–7. Facade, courthouse. Redrawn after Godefroy's building. Alexander A. Weddell, *Richmond, Virginia, in Old Prints, 1737–1887*.

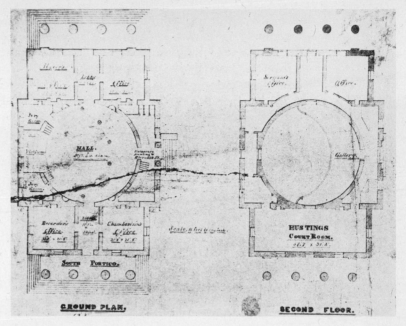

III–8. Plans, courthouse. Redrawn after Godefroy's buildings. Weddell, *Richmond*.

integrated as a single space: the jogs and hollows made less interruption in the flow from one area to another. Godefroy differentiated the volumes more specifically, contrasting the basic geometry of the hemispherical dome, the large cylinder, and the smaller rectilinear alcove. The play of the volumes would be heightened by the strong lights and shadows created by the glazed monitor. In its modest way the courtroom reflected the contrasts of shapes and voids that dramatized the assembly rooms of Gisors in the nineties.[20]

As far as can be judged, the building was constructed rapidly and essentially as Godefroy planned it. Virginians, even the opinionated John Little, admired the building:

> The City Hall, where the United States Court is held, stands opposite the capitol, and is a most beautiful piece of architecture. It is the most perfect in the city; even more so than the capitol. . . . It is admirably proportioned in length and height; at each end

[20] See Kaufmann's discussion of the interior of the Assembly Hall for the National Convention (Emil Kaufmann, *Architecture in the Age of Reason: Baroque and Post-Baroque in England, Italy and France* [Cambridge, Mass., 1955], pp. 205–6).

is a columned portico of the Doric order, with broad and low flights of steps extending the breadth of each. The roof is concealed by the arrangement and width of the cornice, so that only the dome of its centre can be seen. The exact proportion and perfect finish of the building would make it, if constructed of marble instead of freestone, among the best specimens of ancient style in this country.[21]

After its needless razing in 1879, the site was covered by the present city hall.

Richmond, Bank of Virginia and Farmer's Bank of Virginia

While in Richmond Godefroy was asked by two bank presidents, John Brockenbrough and John Wickham, to furnish an elevation uniting their adjacent buildings. On East Main Street, between 10th and 11th Streets, the Bank of Virginia and the Farmer's Bank of Virginia were already under construction. Three or four contractors had been at work, and Godefroy's task, as he put it, was to create an "orthodox" front. By September 7 he had completed the plans, fought for the $200 promised him, complained bitterly of being treated "Baltimorically," and resolved never to undertake another project without an order signed by a majority of the board. The front was constructed within months of Godefroy's departure; a half-century later the buildings were destroyed in the Evacuation Fire of 1865.[22]

To unite the fronts Godefroy stretched a one-story loggia across the two banks and ignored the upper stories of the main blocks (Fig. III–9). Most surprising, this portico was opened by five arches supported on piers of the Tuscan order. At the ends the plain wall rose and then crossed the whole front slightly above the arches. In front, a low sentry box stood at each end. Although the banks were set back from the street, making possible this solution, the structure was very shallow, probably only five or six feet deep.

Smacking of the Italian villa, the portico butted directly against the fronts of the buildings, like that on Godefroy's Baltimore Exchange study. Its position, the arcade and plain wall surface, and the geometric solids of the boxes at the ends recall

[21] Little, *Richmond*, p. 178.

[22] See the Godefroy letters cited in n. 7 above; Records, vol. 154, nos. 869, 874, Aug. 25, Sept. 4, 1817, Mutual Assurance Society of Virginia (microfilm), Virginia State Library; Mary W. Scott, *Old Richmond Neighborhoods* (Richmond, 1950), p. 136; Frances L. Williams, *They Faced the Future* (Richmond, 1951), p. 15.

III–9. Virginia and Farmer's Banks, Richmond. 1816–17; watercolor by W. L. Shepherd ca. 1860. Photo Valentine Museum.

features of designs by Ledoux as well as Durand.[23] Important as it was in being the first appearance of the Tuscan portico in Godefroy's work, it also illustrated his invention and taste. Despite the plainness of the wall, its light, open, airy arches flowing rhythmically across the surface gave the appearance of a screen, precisely what it was.

Richmond, Projects

Godefroy prepared several lesser designs while in Richmond. Since 1815 the governor had been preoccupied with the design of a state seal. On the basis of some conversations with him, Godefroy thought that he had been commissioned for this work,

[23] While there are some similarities in a general way (see Durand, *Précis*, vol. 1, pt. 2, pl. 6), it is clear that Durand did not provide a direct model. For Ledoux's use of a low arcaded portico before taller structures, see his inn, quai de la Rapée (Kaufmann, *Three Revolutionary Architects*, fig. 131). See also the very interesting parallel in Bricard's Paphos, 1795 (Jean-Charles Krafft and Nicolas Ransonnette, *Plans, coupes, élévations des plus belles maisons & des hôtels construits à Paris & dans les environs* [Paris, 1801–3], pl. 112).

but another artist was given a contract to design and engrave seals for the state and for each county. For his friend Louis-Hue Girardin, Godefroy agreed to design a capitol and town plan for Staunton.[24]

A memorial to Washington was under consideration at the beginning of 1816. A year later the legislature authorized a lottery to raise funds for this purpose. Nothing was done until the 'fifties, when Robert Mills and Thomas Crawford competed and Crawford won the prize. Godefroy knew of the agitation for a memorial, and in the summer of 1816 he displayed the drawings of his earlier project for a monument to Washington in Baltimore. Because of the favorable reception and comments on his arch, he may have gone so far as to select a site on the terrace in front of the capitol. When he exhibited the drawing in London in 1822 and in Paris in 1827, Godefroy wrote that the plan had been adopted and was on the verge of execution.[25] None of these projects came to fruition.

The Unitarian Church

Following informal meetings in 1816, the First Independent Church in Baltimore was established on February 10, 1817, with a congregation composed mostly of New Englanders. On March 1 Godefroy was chosen architect for the building and was offered the superintendency of its construction at a fee of $500, the building to cost no more than $20,000. His first plan was approved by the church trustees on March 14 and by the contributors on March 19. As the response to an appeal for funds was so encouraging, on March 24 Godefroy obtained permission from both the trustees and the contributors to enlarge the plan. Latrobe had also submitted a plan but declined to enlarge it after he heard that Godefroy was employed. He wrote that he retained a high opinion of Godefroy's talents and assured the trustees that they would not err in accepting his designs.[26]

[24] On the question of the seal, see Godefroy to Jackson, Richmond, Sept. 7, 1816, Maryland Historical Society; State Contracts, 1816–30, pp. 44–45, Aug. 1, 1818, contract with Samuel Brooks, Virginia State Library. On the town plan, see Anon., "Maximilian Godefroy," pp. 406–7.

[25] Executive Letter Book, 1813–16, pp. 242–43, Nicholas to B. Washington, Richmond, Feb. 21, 1816, Virginia State Library; Mordecai, *Richmond*, pp. 337–41; Gallagher, *Robert Mills*, pp. 110–13; Dodson, *The Capitol*, pp. 286–88. For Godefroy's connection, see Godefroy to Jackson, Richmond, Sept. 7, 1816, Maryland Historical Society; *Exhibition of the Royal Academy* (London, 1822), p. 42; F[13] 650 Archives Nationales, Paris.

[26] Unless otherwise indicated, information on this building is drawn from manuscript records at the Unitarian Church, the Building Treasurer's Records and the Trustees' Records of Proceedings, pp. 8–17. See also

The present lot, on the corner of Charles and Franklin Streets, was rented early in May, and elaborate cornerstone ceremonies were held on June 5.[27] Godefroy received his remuneration in installments ending in July, 1818, at which date the structure of the building must have been essentially complete. John Ready served as carpenter, Baughman and Hore as masons. The sculptor Antonio Capellano finished the interior decorations at the beginning of October; furnishings were installed; and the church was dedicated on October 29, 1818. In a few months Capellano began the terracotta Angel of Truth, which was finally affixed to the pediment in January, 1820.

From the first the building (Figs. III–10-III–12, III–14, III–19) received enthusiastic praise for its beauty, character, simplicity, and purity. Within six months of the dedication the Philadelphia *Port Folio* published a description so complete and so characteristic of Godefroy's thought that most of the text must be directly dependent on him. It deserves to be quoted at some length, as a record both of the original appearance of the building and of the intellectual outlook of the architect and his public.

> The whole length of the edifice, including the portico, is one hundred and eight feet, and its brea[d]th seventy-eight feet. The perystile, which has a front of fifty-six feet, nine inches, is formed by a colonade, of the Tuscan order. Four columns and two pilasters—one of the latter of which is at each extremity; forming altogether, three arcades, of about twelve feet opening, support the grand Tuscan cornice which runs around the exterior, and a pediment, in the center of which is to be placed a colossal figure of an angel—executed in burnt clay, by M. Capellano, formerly first sculptor at the court of Spain, now a resident in Baltimore, and an artist of the very first merit. This figure, which has been much admired by connoisseurs, is surrounded by rays, and holds

Godefroy to Jackson, Baltimore, Aug. 13, 1818; E. Godefroy to Jackson, Laval, Sept. 22, 1837, both Maryland Historical Society; Record of Surveys, bk. F, p. 153, no. 6666, Feb. 1, 1821, value $30,000, Baltimore Equitable Society; Thomas W. Griffith, *Annals of Baltimore* (Baltimore, 1824), p. 223. For modern accounts, see Joseph Jackson, *Development of American Architecture* (Philadelphia, 1926), p. 125; Talbot F. Hamlin, *Greek Revival Architecture in America* (New York, 1944), pp. 38–39, 102–3, 188, pl. 47; Howland and Spencer, *Architecture of Baltimore*, pp. 43–44, pls. 30–31; Rich Bornemann, "Some Ledoux-Inspired Buildings in America," *Journal of the Society of Architectural Historians* 13 (1954):16–17; Wayne Andrews, *Architecture, Ambition and Americans* (New York, 1955), p. 87; Hamlin, *Latrobe*, pp. 470–71; Hitchcock, *Architecture*, pp. 6–7; Rebecca Funk, *A Heritage To Hold in Fee, 1817–1917* (Baltimore, 1962) (a history of the congregation and the building).
[27] *Baltimore Federal Gazette*, June 9, 1817.

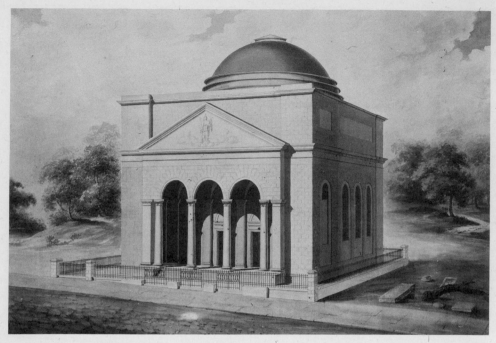

III–10. Unitarian Church, Baltimore. Rendering ca. 1817. Photo Frick Art Reference Library.

a scroll, on which are inscribed in Greek characters, bronzed, these words: "To the only God."

The attic, which rises above the whole extent of the great cornice, is in a simple style, and its cornice is raised fifty-two feet above the pavement of the portico; the whole is crowned toward the centre of the building by a dome.

The portico is ornamented in the back part with six pilasters, corresponding with the columns and pilasters of the front. It is ten feet deep, and fifty-four feet six inches long; and is ascended by five steps of Italian marble, stretching the whole length of the perystile—it is paved with flags of the same marble, and its ceiling is formed of what are denominated groin arches. Five doors all of equal dimensions, and well painted in imitation of bronze, open from the portico—three of these corresponding with the three arcades of the perystile, lead into the body of the church—the other two at each lateral end of the portico, lead to the staircases of the gallery; which are hidden from the view either within or without the church. These doors are an imitation of the doors of the Vatican, except that they have been simplified by suppressing the modern circular pediments; and substituting archivaults, in the style of the Farnesian Palace, assimilating them to the great sim-

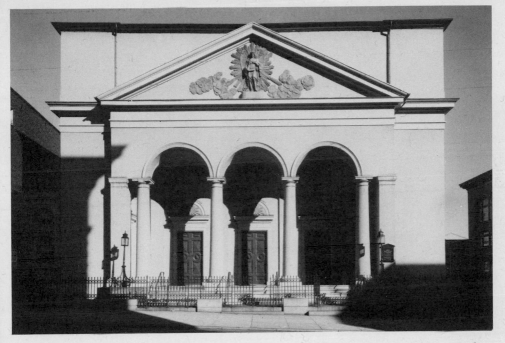

III–11. Facade, Unitarian Church. 1817–18. Photo A. Aubrey Bodine Collection, Peale Museum.

plicity of the Tuscan order. This portico, which necessarily gives a character to the whole exterior of the building, is exquisitely beautiful.

The nave of the church is a square, formed by four equal arches, in full semicircle of fifty-three feet six inches diameter. These arches support a dome, which is also a full semicircle of fifty-three feet six inches diameter—the base of which is about forty-nine feet, and the summit of the cupola, eighty feet, above the pavement of the nave—the cupola is terminated by a glass star. The recesses of the arches on the right and left of the nave, are occupied by pews—at the bottom of the nave, the recess is filled by the pulpit and several rows of semicircular pews on either side: under the arch opposite to this, at the entrance of the church, is a gallery for the organ and choir. This gallery, which is the only one in the church, is supported by eight columns, in two rows, the capitals of which are in the Egyptian style—the shape elegantly executed in white Italian stucco. The floor of the gallery, which serves as a diameter of the arch under which it is placed, rises above the cornices of the pilasters which run around the interior, and which are taken from those of the Palace Mattie at Rome—its front is finished with balustrades. The three principal

III–12. Section, Unitarian Church. Ca. 1817. Photo Frick Art Reference Library.

intercolumniations beneath, correspond with the three doors of entrance.

The arch at the bottom of the church, opposite to the gallery, is determined in the form of a niche, in its whole breadth and height, the form[er] of which is fifty-three feet six inches, and the latter forty-seven feet nine inches. The floor of this arcade or niche, is raised three steps above the pavement of the nave, and

III–13. Court, Palazzo Mattei, Rome. Charles Percier and P.-F.-L. Fontaine, *Palais, maisons, et autres édifices modernes, dessinés à Rome.*

is covered with an imitation of mosaick. In the centre of the arcade, rises the pulpit. This stands upon a double square base, the first of which is of the Verd Antique marble, or Connecticut, of great beauty—the second is of white Carrarra marble, of most exquisite polish, in the middle of which is a noble ornament of cast

III–14. Interior, Unitarian Church. Engraving by W. Goodacre ca. 1830. Photo Maryland Historical Society.

lead and bronze, executed by M. Capellano. The pulpit rests on the second socle—it is constructed of bird's eye maple, the most beautiful wood of our country, and is semicircular. On the frize [sic] of the cornice, are Grecian ornaments in relief of cast lead, bronzed, called palmets. It is ascended by a flight of eight wide steps on each side, which give it the style of a rostrum, or antique tribunal. These steps are enclosed by four large pedestals and balustrades of the same wood as the pulpit, and in the style of Grecian columns.—On the landing places, on each side of the pulpit, is an arm chair of antique form, made also of the bird's eye maple, and enriched with bronzed ornaments in relief; and behind the pulpit is an antique sopha. The workmanship of these seats and the pulpit, is by Mr. Camp, of Baltimore, and to those who know the skill of that excellent mechanik, it can hardly be necessary to add, that the whole is in the finest style of execution. Between the two pilasters on the wall, behind the pulpit, is a species of pedestal or Stylobatum, supporting two tables in basso relievo, which are surrounded with rays and clouds of white stucco, and on which are inscribed various appropriate passages of scripture.

The nave is lighted by three windows in arcades, on each side: the wall above which is ornamented with two garlands, three crowns, and two festoons of olive leaves, all in white stucco. It is divided into its whole length by three aisles, paved with the tiles of Italian marble—these aisles are adorned by the arms of the

pews, which are richly decorated with Grecian ornaments, sculptured in wood, and admirably bronzed, by Mr. Finley of Baltimore, whose taste and skill in ornamental work, are well known. The nave being square, the angles below the dome, are ornamented with triangular pannels, called pendentives, in each of which is a colossal basso relievo of white stucco, representing the various emblems of peace, toleration, fortitude, and union—and uniting with them the allegory of time, winging its way towards eternity.

The dome, which is imitated from the Pantheon at Rome, is ornamented with caissoons, or square pannels, as are also the four great arches which support the cupola—the caissoons of the latter are enriched with a rose in each. Each of the four arches is also embellished with an archivault; and the base of the dome is supported by a cornice in its whole circumference.

With the exception of the plinths and frames of the doors, which are admirably painted to imitate gray marble, no part of the decoration of the edifice is coloured—a circumstance which produces, in a remarkable degree, that imposing calm so appropriate to houses of devotion. Nothing can exceed the beauty of the plastering on the inside walls, arches and dome; the work of which was done by Mr. Whitlock of Baltimore. And the outside, which is roughcast, is done in so masterly a manner, by Mr. John Gill, of Richmond, as actually to have deceived many close observers into a belief that the building was of stone.

The organ merits particular mention, as well from the classick taste which has been displayed by Mr. Godefroy, in giving it a form perfectly novel, as from the intrinsick excellence of the instrument. Instead of the usual heavy, gothic shape, given to this instrument, it is constructed in the form of an antique lyre, of colossal dimensions, the strings of which are represented by the pipes. The two angles of the front are terminated by two columns, in the Egyptian taste, the shafts of which are formed by large pipes. The top of the lyre, which is generally enriched with some emblematick ornament, is formed by a half crown of stars, in the centre of which reposes a bronzed eagle, amidst gilded rays.— The body of the organ is of bird's eye maple and mahogany; and all the ornaments of the frize, the capitals, and the bases are bronzed.—This truly magnificent instrument which is twenty-two feet nine inches high, and sixteen feet nine inches wide, contains fourteen hundred pipes; the tones of which, as they sweep through the arches, under the masterly execution of Mr. Carr, are sublimely melodious. It was built by Mr. Thomas Hall, of Philadelphia, to whose skill it does infinite honour. The perspective behind the organ, is terminated by a higher gallery, which stretches along the whole length of the portico; and is ornamented with arcades and a balustrade, in the same style as that of the pulpit—the extremities are formed by horns in the manner of an antique altar.

Having thus attempted to describe the church, we must be permitted to add a few words, to express our admiration of the talents, the skill, and the taste of those concerned in the building. The public have already been informed, that the edifice was designed by Maximilian Godefroy, Esq. member of the Philadelphia Academy of Fine Arts, to whose merit as a gentleman, a scholar, and an artist, it gives us infinite pleasure to pay this public but feeble tribute. Whether this building be viewed in the beauty of the model, the correctness of the proportions, or the taste of its various details, it will be acknowledged to approach nearer to the perfection of architecture than any other edifice in America. What renders it particularly honourable to the taste and skill of the architect is, that notwithstanding the variety of novel and difficult details which abound in it, the perfect symmetry which prevails in the whole—the repose, as it is technically and appropriately called, of the edifice, produces that solemn and profound impression on the mind, so essential in public worship.[28]

Some details can be added from other sources. Although the massive foundations are stone, the fabric of the building is brick, and the original coat of stucco was lined in imitation of ashlar. The columns, too, both exterior and interior, are of brick covered with stucco. During the period of construction, November 26, 1817, to April 1, 1818, and August 22 to 31, 1818, Godefroy again borrowed the Library Company's copy of Nicholson's *Principles of Architecture*, and this undoubtedly was his source for the detailing of the Tuscan order, and in handling the shadows in the rendering of the building. From January to June, 1818, Solomon Willard was engaged to execute "some ornamental finishings." This phrase was occasionally thought to refer to the angel or to the interior sculpture, but it is more likely that with his experience in architectural ornament Willard handled complicated moldings, such as those of the cornices and doors, which would better explain the payment to him of $428.17 which has been recorded. Philip Tilyard, working from

[28] "Description of the First Independent Church in Baltimore," *Port Folio* 7 (1819):389–93. Other early descriptions and comments include John M. Duncan, *Travels through Part of the United States and Canada in 1818 and 1819*, 2 vols. (Glasgow and New York, 1823), 1:240–41; [Frances W. d'Arusmont], *Views of Society and Manners in America* (London, 1821), p. 32; [Auguste Levasseur], *Lafayette en Amérique, en 1824 et 1825*, 2 vols. (Paris, 1829), 1:351; Mrs. Frances Trollope, *Domestic Manners of the Americans*, 2 vols. (London, 1832), 1:294; [John H. B. Latrobe], *Picture of Baltimore* (Baltimore, 1832), pp. 143–45; Charles Varle, *Complete View of Baltimore* (Baltimore, 1833), p. 53; James S. Buckingham, *America, Historical, Statistic, and Descriptive*, 3 vols. (London, 1841), 1:412–13; Charles A. Goodrich, *The Family Tourist* (Hartford, Conn., 1848), p. 343.

August to October, was paid $186, probably for bronzing the interior and exterior decorations.[29]

Godefroy gave his sources for some details: the five doors imitated those of the Vatican but with archivolts resembling those of the Palazzo Farnese (Figs. III–15-III–16); the interior cornice was like that of the Palazzo Mattei (Figs. III–13-III–14). When the pulpit is related to a Renaissance wellhead (Figs. III–17-III–18), then it becomes certain that Godefroy drew all of these parts from the publication by Percier and Fontaine, in 1798, of their drawings of sixteenth-century buildings in Rome.[30] If their volume offered models for these details, it did not include examples that might have been the source for the facade as a whole.

Despite some touches of ornament, the Unitarian Church possessed the austerity of the strict Romantic Classicism of French architecture of a generation earlier. As in Godefroy's earlier buildings, attention was concentrated on the front, in the pedimented central area with Tuscan columns and pilasters supporting arches and in the repetition of the pattern on the back wall of the recessed portico. Ledoux's work has been suggested as offering prototypes, especially the Maisons Hosten of 1792 and some of the barrières of 1784–89. Sobre, a pupil of Ledoux, offered in his Théâtre des Jeunes Artistes a surprisingly similar front with columns and arcade and a garland decoration reminiscent of those inside the Unitarian Church. Durand, too, suggested a recessed porch with a triple arch and groin vaults. In his derogation of engaged columns Durand may have supplied the model for Godefroy's clear separation of the end columns from the pilasters, repeating the disposition of the Masonic Hall; the recessing of a portico-vestibule complex between corner structures was prominently exemplified in Saint-Philippe-du-Roule, in Paris. All these comparisons, and some are very close, place the Unitarian Church in the strongest Revolutionary tradition, yet, paradoxically, nothing here contradicts the verbal instruction of Blondel. Four columns made the church more important than two, and vertical supports might carry a pediment on an avant-corps; in this way the desired pyramidal facade

[29] See Peter Nicholson, *Principles of Architecture*, 3 vols. (rev. ed. London, 1836; orig. pub. London, 1795–98), vol. 3, pls. 193–98. On Willard, see William Wheildon, *Memoir of Solomon Willard* (Boston, 1865), pp. 38–41. For payments, see Building Treasurer's Records (n. 26 above).

[30] Charles Percier and P.-F.-L. Fontaine, *Palais, maisons, et autres édifices modernes, dessinés à Rome* (Paris, 1798), pls. 42, 55, 73.

III–15. Portico, Unitarian Church.

would be reinforced.[31] Indeed, Godefroy's Blondellian attitude during this period is underscored by the comment in the *Port Folio* description that the portico "gives a character to the whole exterior of the building."

[31] For Ledoux parallels, see Bornemann, "Ledoux-Inspired Buildings," pp. 16–17; Hitchcock, *Architecture*, pp. 6–7. On the front, knowledge of Sobre's building was available to Godefroy through Legrand and Landon, *Paris*, 2:97–98, pl. 32 (reproduced in Louis Hautecoeur, *Histoire de l'architecture classique en France*, 6 vols. [Paris, 1943–55], vol. 5, fig. 150). So effective in contrasting light curvilinear shapes with a cubical form and in opening a void in a solid mass, the motif was frequently used in France, especially during the 1780s. Ledoux's tollhouse on the boulevard de Clichy had a form close to that of the church, and several other *barrières* had variants or enlargements of the motif (Kaufmann, *Three Revolutionary Architects*, figs. 113, 129). Belanger was particularly fond of the motif; cf. esp. his house in the Carmelite Convent near Beauvais, the house on the rue Pigalle of 1788, the house on the rue Neuve-des-Capuchins of 1787, and the folie St-James of 1777 (Krafft and Ransonnette, *Plans*, pls. 4, 63; Jean-Charles Krafft, *Maisons de campagne* [Paris, 1849; published in 1812 as *Recueil d'architecture civile*], pl. 10). See also Bruyère's use of the motif on his Parisian house, 1798, and L. LeMasson's on the *palais abbatial* of 1785–89, Royaumont (Krafft and Ransonnette,

III–16. Door, Palazzo Farnese, Rome. Percier and Fontaine, *Palais*.

For all this listing of sources and influences, however, there remains the possibility that they were effective only in a general way, in forming the atmosphere within which Godefroy worked. The building may owe its overall resemblances to that atmosphere, but its particular forms may be selected and reorganized from motifs already present in Godefroy's works. A portico be-

Plans, pl. 59; Aubin-Louis Millin, *Antiquités nationales*, 5 vols. [Paris, 1790–99], vol. 2, pt. 11, p. 3, pl. 1). Rather similar Renaissance examples were published by Percier and Fontaine (*Choix des plus célèbres maisons de plaisance de Rome et de ses environs* [Paris, 1809], pls. 48, 75). The motif came into great favor in the Revolutionary milieu in the last quarter of the eighteenth century. This popularity influenced Percier and Fontaine in their selection of Renaissance works, and Godefroy reproduced the motif in America. On the column-pilaster juxtaposition, see Durand, *Précis*, 1:43–44, pt. 2, pls. 9–10; 2:9. For Saint-Philippe-du-Roule, see Legrand and Landon, *Paris*, vol. 1, pl. 129; Krafft and Ransonnette, *Plans*, pl. 103; also Hautecoeur, *Architecture classique*, vol. 4, fig. 99. On the pyramidal facade, see Blondel, *Cours*, 2:353.

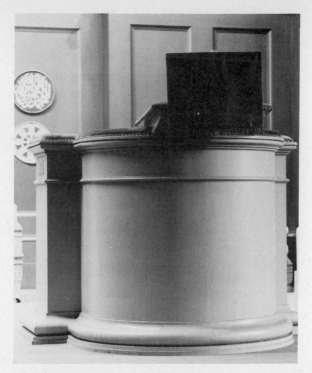

III–17. Pulpit, Unitarian Church. Photo Peale Museum.

tween piers, with four columns in the wall plane, appeared in
the Masonic Hall; for the Richmond banks he used an arcaded
Tuscan portico; steps flanked by blocks, a high attic, recessed
panels, and lined stucco appeared in or were planned for several
previous buildings. In the Richmond courthouse he learned how
to handle the dome, and he gave it the Pantheon silhouette ad-
mired by Durand. The curved projection of the broad chancel
was more specifically French; although not a full semicircle, it
reflected the dispositions offered by Durand.[32] As in previous
works, then, Godefroy used extensively forms with which he
was familiar, introducing an occasional new element, like the
pediment. As the forms were familiar, he was able to give par-
ticular attention to the overall organization of the design.

To some extent the air of completeness and self-sufficiency of
the church arose from devices adopted from Latrobe, whose
cathedral, only a short distance from the church site, still lacked
its roof, dome, and portico. From this building Godefroy took
the broad, projecting piers wrapped around the corners enclosing

[32] Durand, *Précis*, vol. 1, pt. 2, pls. 6, 13.

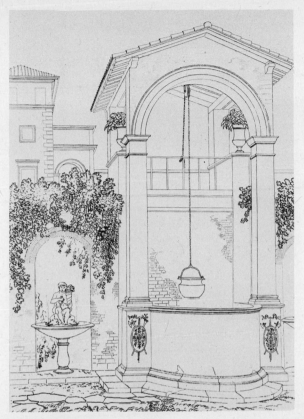

III–18. Well, S. Pietro nel Borgo, Rome. Percier and Fontaine, *Palais*.

the block and, on the front, framing the portico. The windows in arched recesses and the sunken panels on both sides and on the back of the church were additional Latrobean devices used prominently on the cathedral, although the total lack of supplementary moldings owes much to the drastic simplifications practiced by French Revolutionary architects. Perhaps the most revealing sign that Godefroy learned much from his association with Latrobe is his rendering (Fig. III–10), still owned by the church. He abandoned Durand's insistence on "geometric" elevation drawings and gave his clients a perspectival view, with a range of shadows and details of both building and setting that he had not employed previously. It was Latrobe's flippant reference to his own perspectival renderings as "professional charlatanism" that Godefroy had misconstrued as a personal attack. Yet from the experience with the Baltimore Exchange competition Godefroy saw the value of such a rendering for

suggesting to laymen the monumentality of his design. For us, too, the three-quarter view emphasizes the simple shapes and bulk of the structure; it in no way diminishes the importance of the facade, yet at the same time reveals the more Latrobean forms along the side.[33]

The one piece of sculpture gracing the exterior of the church was the terracotta Angel of Truth in the pediment, an allegorical frontispiece supplementing the idea of character presented by the architectural forms. Capellano turned Godefroy's self-conscious Rococo figure into a Neoclassical stalwart. Both versions, however, were applied like surface decorations, which would have been as much suited to a rectangle as to the triangular pediment; only the billowing clouds spread to the sides. Neither the sculptor nor the architect, apparently, was disturbed by the discrepancy between the clouds and rays of effulgence drawn from the Baroque-Rococo tradition and the figure and building of the strictest Neoclassicism. Still paying homage to Blondel and the past in allegorical compositions, Godefroy at the same time was drawing close to his own generation in France, whose members had become less content than the Revolutionary generation with the pure forms of an *architecture parlante* and had turned to more explicit symbolism.[34]

The exterior of the church has suffered little change. Resurfacing has eliminated the lines imitating masonry joints; the angel, long deteriorating, has been replaced by a modern copy. The interior, on the other hand, has little resemblance to the original composition. A fire in the late 'sixties damaged the vestibule and gallery area, destroying the magnificent organ designed by Godefroy. In 1893 a false ceiling was introduced and the walls and sanctuary were completely altered. The dome and pendentives and the original upper gallery can still be seen above the plaster barrel vault.

The *Port Folio* article identifies the parts and gives the dimensions, and in addition Godefroy's own drawing and an old print (Figs. III–12, III–14) provide a visual basis for our reconstruction of the interior of the church (Fig. III–19). They show a

[33] Measuring 20.5 by 28 inches, executed in black ink and gray washes, the drawing is one of Godefroy's most accomplished. For a discussion of "professional charlatanism," see Chapter V, n. 9, below.

[34] See Blondel, *Cours,* 1:340, 362–63, 410–11. From Dec. 26, 1818, to Jan. 18, 1820, Capellano received $1,302 for his work on this figure. The last payment included a fee for assistance in affixing the angel to the pediment. This may be the first large-scale terracotta figure baked in the United States. The original, in several fragments, is now kept inside the church; it was replaced in 1960 by a modern copy by Henry Berge.

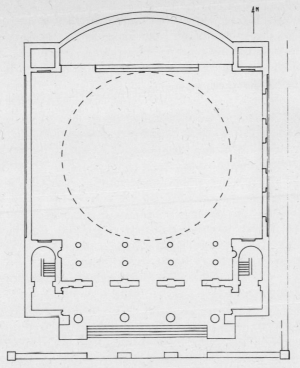

III–19. Plan [restored], Unitarian Church.

grandiose volume, light in color and well-illuminated, dominated by large arches and curving planes that transformed classical elements into a mobile composition. Decoration, coffers, and openings further reduced the extent and stability of wall surfaces. Entering through a double colonnade screen, the viewer was constrained to follow a longitudinal axis down the aisle; only later would his first impressions be succeeded by comprehension of the centralized geometry of the interior. The auditorium was square in plan, made slightly cruciform by the vestibule, apse, and lateral extensions. This shape carried upward about a third of the height of the building, where the right angles gave way to circular forms and the hemisphere of the dome. Altogether the breadth and mobility of the voluminous interior contrasted with the self-sufficient enclosure and stability felt outside.

Despite this contrast Godefroy achieved a correlation and integration of parts surpassing all his designs of the preceding decade. Not simply a union of the elements of the exterior and facade design, the building parts, as Durand termed them, were

as interlocked here as they were separated in some earlier works. Three vestibules led from the recessed portico. Those in the piers gave access to staircases rising to the tribune. The main vestibule, under the organ loft, was reached by the three central doors, and the axes of the exterior supports were continued by the interior columns. The gallery rested upon the columns of the vestibule, deepened at the back by arched recesses built over the portico vaulting. Although the vestibule and gallery were separate from the main hall of the church, spatial, structural, and decorative continuities united them with the interior. Four piers and huge arches handsomely modeled the extension of space from the central square to the apse, the sides, and the entrance, as the hemispherical dome extended it upward. The diameter of the arch formed the gallery front, and it also coincided with the level of the main cornice that moved at the same height around all interior walls to link them together. Certainly the maturity of this design was aided by Godefroy's recent total revision of Mills' plans for the Richmond courthouse, but the change in his architectural conception was that which Durand had described: while the student deals separately with the parts of a building and puts them together, the master conceives the whole within which the parts are coherently disposed.[35] With this demonstration of his ability to integrate the parts in the compact whole, Godefroy produced his masterpiece.

An unusual group of sources seems to lie behind the Renaissance ordonnance of piers, arches, pendentives, and dome, and the manner of their combination and development presents a model of Godefroy's process of composition. The classicizing treatment is easily understood in view of the Pantheon dome and Godefroy's general stylistic expression. Pendentives were common enough, especially in major Parisian churches, e.g., the Val de Grace, the Invalides, and the Panthéon. The suggestion, made in London in 1824, that the dome on four arches was a plagiarism from St. Stephen's Walbrook can be refuted on the grounds of Godefroy's ignorance of Wren's church. A much closer source is the French background and especially Sainte-Geneviève, which was illustrated by both Durand and Blondel, the latter using it as a prime example of the Greek-cross plan. The central part of Sainte-Geneviève reappeared in the Unitarian Church, a domed square flanked on all sides by a deep arch, actually a short vault. The Roman dome was preferable to the

[35] Durand, *Précis*, 2:96–97.

French example on the grounds of economy and of the ex-
igencies of construction in this country. It offered, in addition,
what Durand advised, a dome rising from the structure rather
than one simply set upon it.[36]

Yet it is doubtful that Sainte-Geneviève served as a starting
point, a model to be stripped and reduced to a structure feasible
in Baltimore in 1817. Godefroy tended rather to build up and
elaborate a motif, as he did, for example, in his adaptation of
Denon's plate for the Battle Monument. This process is sug-
gested in a comparison of the Unitarian Church interior with
the groin-vaulted bay shown in Percier and Fontaine's view of
the court of the Palazzo Mattei (Fig. III–13).[37] In addition to
providing a model for the interior cornice of the church, this
plate seems also to have supplied the plan: a square with short
arms forming a Greek cross, complex piers at the four corners
with pilaster strips carrying large arches, plain wall surfaces that
emphasize the structural function of the pilasters and piers, and
the sense of lightness and openness of the basically simple motif.
Godefroy employed the same block and vase shapes in his
gallery balustrade, and perhaps its position was suggested by the

[36] For the Wren comparison, see A. C., review article of [Candler],
"Summary View of America," in *Blackwood's Edinburgh Magazine* 16
(1824):625; and the letter of response by A. B. in *ibid.*, 17 (1825):414. On
Sainte-Geneviève, see Blondel, *Cours*, 2:320–21; 6:64–79, pl. 91; Durand,
Précis, 1:20–22, pt. 1, pl. 1. While discussing Sainte-Geneviève, Blondel
commented on the proper design of tribunes and the altar setting, and his
words may account for the considered incorporation of the organ loft and
the high pulpit. The differences between Godefroy's building and Sainte-
Geneviève are marked; see, e.g., the discussion in Wolfgang Herrmann,
Laugier and Eighteenth Century French Theory (London, 1962), pp. 113–
16, pls. 27–30, 34–36. On the dome, see Durand, *Précis*, 2:42–43. Con-
struction of the pendentives probably depended on Nicholson, *New Car-
penter's Guide*, pls. 29–30. A conical skylight was also illustrated by
Nicholson (pl. 45). Parenthetically it may be suggested here that Nicholson
provided the model for the staircases (pls. 49, 50, 58). The influence of
Latrobe's dome for the Baltimore Exchange cannot be ignored, inasmuch
as Godefroy participated to some extent in its planning. A sectional draw-
ing (Hamlin, *Latrobe*, fig. 31) shows pilastered piers and triangular decora-
tive panels in the pendentives. There are suggestions also of the gallery
supported on a colonnade with the arched recesses farther back. A similar
arrangement of the organ gallery on four columns, the whole enclosed
within an arch, appears in Latrobe's cathedral section (*ibid.*, pl. 19), though
with a more complex dome and pendentives. Negative evidence for Gode-
froy's knowledge of the cathedral arrangement may lie in his pointed em-
phasis on the classical taste of his organ design, rather than "the usual
heavy, gothic shape" mentioned by the *Port Folio*, such as Latrobe em-
ployed.

[37] Percier and Fontaine, *Palais*, pl. 73.

fortuitous juxtaposition, in the book plate, of the balustrade and pier moldings. A niche on either side recalls those in the church vestibule. There is, as well, the sequence of clearly marked volumes that Godefroy sought in his sectional drawing. Undoubtedly the plate supplied the germ of Godefroy's building. Replacing the groin vault with pendentives and dome, he enlarged the motif to form the whole interior of the church.

Publication of the Renaissance work in France around the turn of the century made it acceptable to Godefroy, who came to maturity in the same time and place. Blondel's admiration for Sainte-Geneviève could have made it the model from which Godefroy adapted his motif. French practice, known perhaps from Durand, and the tutelage of Latrobe aided him in bringing together a series of related forms. Reused elements of his own previous interiors are difficult to pinpoint, as only two are known, his first building, St. Mary's Chapel, and his latest, the courthouse in Richmond. In the chapel the elevated altar of his small drawing (Fig. II–17), with its high canopy and Rococo monstrance, filled the sanctuary vault; in the gallery over the arcaded entrance vestibule the organ stood in the newly enlarged case he designed. These two focal points thus paralleled those later used for the church. Quite different was the courtroom in Richmond, where functional requirements were resolved in a play of volumes that might have served as a dress rehearsal for the church interior.[38] At the least, the Pantheon dome of the courthouse with its overhead lighting reappeared as the vault of the centralized church. The free invention Godefroy displayed in adapting the Renaissance bay and juxtaposing forms of quite different sources was in keeping with his previous methods and informal training: simple copying on his part would have been much more surprising.

In describing the interior for the *Port Folio* writer, Godefroy emphasized the overall dominance of white in stucco ornament,

[38] The reduced, drastically simplified version of the chapel in Bardstown hardly qualifies as a third interior. At least one lost work, the Commercial and Farmers Bank, was described as having vaults, and spacious interiors must have been contemplated for others, e.g., the Masonic Hall. On Mar. 29, 1817, less than a week after the enlargement of the Unitarian Church plan had been approved, Godefroy wrote to the Sulpicians denouncing their alterations in his chapel plan (see Chapter II, n. 6, above). Foremost among his complaints was the lowering of the ceiling and the extension of the gallery into an "amphitheater." Both changes reduced the clear volume of the nave, and the latter one certainly reduced the effectiveness of the organ as a focal point. This letter thus informs us that the chapel was in the front of Godefroy's mind while he was designing the church.

in the plaster of the walls, and in orders. Bronzing provided the major contrast; it was limited to the doors, pew ornaments, and the areas of pulpit and organ. Characteristically Federal, the scheme was but a slight variation on the basically white and gold interior of Latrobe's then still unroofed cathedral. Godefroy gave another interpretation to this coloristic restraint, attributing to it the "calm so appropriate to houses of devotion." In France, too, around the turn of the century, the all-white color scheme was customary, but in addition architects were beginning to use color and rare woods for contrast.[39] In the Unitarian Church bird's-eye maple and mahogany, accompanied by colored marbles and bronzed ornament, not only heightened the contrasts between pulpit and organ but made them focal points at opposite ends of the auditorium.

For religious services in which the sermon replaced the ritual in importance, Godefroy provided an imposing pulpit of bird's-eye maple in the center of the apse. This tall structure was based upon two blocks of marble, one green and one white with bronzed ornament applied to its surface. The pulpit proper

[39] Hautecoeur, *Architecture classique,* 5:508–9; Kaufmann, *Age of Reason,* p. 207.

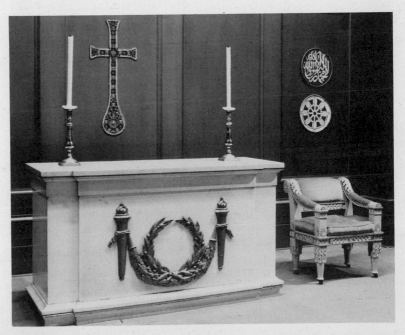

III–20. Altar and armchair, Unitarian Church. Photo Peale Museum.

(Fig. III–17) (adapted from a Renaissance wellhead published by Percier and Fontaine, as noted above) had a Tuscan frieze and cornice and base molding, and the consequent suggestion of a telescoped column was enhanced by the bronzed lead palmettes in the frieze. Before it, at the head of the aisle, a small white bowl-shaped font (Fig. III–21) actually supported on the lower part of an Ionic column, stood on a block of red porphyry. The staircases and chairs (Fig. III–20) around the pulpit, of bird's-eye maple, had carved foliate ornament, also bronzed. As he stood in the pulpit, the minister was silhouetted against a pair of white stucco tablets inscribed with Biblical verses and surrounded by clouds and rays. Two tall lamps and broad pilasters behind them framed and isolated the whole group. From the font in the aisle, through the lamps and pulpit, to the tablets and pilasters, a single composition was formed, one in which rectilinear solids predominated, but with curved elements —vase, pulpit, and tablets—emerging like the dome that crowned the whole structure. Fortunately, although the whole setting was remodeled out of existence, several of the pieces have survived and some are still in use.[40]

Godefroy designed the unusual organ for the traditional loft over the entrance. A large symbolic lyre served as centerpiece

[40] In his vignette for the Baltimore Fire Insurance Company, ca. 1814–15, Godefroy had shown a fountain shaped as the lower part of a column (Robert L. Alexander, "The Drawings and Allegories of Maximilian Godefroy," *Maryland Historical Magazine* 53 [1958]:19–20 and illus.). The Unitarian Church font varies considerably from the one he designed ca. 1816 for St. Paul's Episcopal Church (Fig. III–22), which presents a more eighteenth-century appearance with its obelisk, cherubs, and rayed crosses in the abrupt juxtaposition that became characteristic of compositions of the third quarter of the century (see, e.g., the publications of Neufforge and Delafosse). The decoration and furniture of the church highlight Godefroy's eclectic use of varying sources. The stucco reliefs have the character of the turn of the century, recalling work by Sobre, Durand, and Percier and Fontaine. The furniture is markedly different; the chairs, for example, do not have the slim, light forms, curving lines, and flowing decoration of Percier and Fontaine (cf. Charles Percier and P.-F.-L. Fontaine, *Recueil de décorations intérieures* [Paris, 1801], pls. 15, 29). Rather they resemble work of a generation earlier, e.g., the designs of Neufforge and Delafosse (Jean-François de Neufforge, *Recueil élémentaire d'architecture*, 8 vols. in 3 [Paris, 1757–68], vol. 5, pl. 310; vol. 8, pls. 584–85; Jean-Charles Delafosse, *Nouvelle iconologie historique* [Paris, 1768], pls. 28, 30, 56). Decorative motifs on Godefroy's furniture, organ, and pulpit have a similar sharp, metallic elegance and lushness and abrupt contrasts of shapes and sizes. The same character marks other works, like the Battle Monument and the gates of the First Presbyterian Churchyard. The two exterior lampstands of the church may follow a design by Godefroy; they have the characteristic curving and rectilinear lines of Delafosse's metal work (e.g., *Nouvelle iconologie*, pl. 8).

III–21. (left) Baptismal font, Unitarian Church. III–22. (right) Baptismal font, St. Paul's Church, Baltimore, ca. 1816. Photos Peale Museum.

for the instrument, with some of the pipes arranged as its strings; other pipes were clustered as columns at either end of the organ, topped by Egyptianizing capitals. Mahogany, bird's-eye maple, bronzed stars and eagle, and other ornament enriched the composition. The gallery, fronted by a balustrade, rested on two rows of four columns with capitals modeled on the Tower of the Winds order. For Godefroy this order was Egyptian and thus made an intellectual link with the columns on the organ above. Seen more abstractly as a composition, the wide-spaced verticals of the colonnade screen were compactly massed in the organ pipes, and the curves of the lyre were

echoed in the balusters, the gallery arcade, and the large arch crossing the whole interior.

In both the description and his cross-section (Fig. III–12) of the church Godefroy drew attention to the organ and pulpit. For the drawing he adopted a method unique in America at the time. He split it vertically and showed the entrance in one half, the apse in the other, thus emphasizing the significance to him of the two interior views toward opposite ends of the church.[41] Here constrasts in round and rectilinear shapes and in sizes, as in the impossibly large lyre at one end and the small basin at the other, are added to the concentration of color and rich-grained woods. These focal points, placed in two arched voids opening off the central domed volume, were completed by the symbolic and representational elements. Set far apart, they could not be perceived at the same time, as could, for example, the sentry boxes of the Richmond bank facade. They functioned to draw the viewer's attention in one or the other direction successively. This kind of polar opposition developed in St. Mary's Chapel over the extended period of its design and construction, partly by accident; the original design of the Unitarian Church incorporated the idea of two focal points to control the viewer's architectural experience on entering and leaving the building.

The interior achieved some of its effect by illusion. The dome, pendentives, and arches were lath and plaster constructions, and although the coffers were worked in three dimensions, their rosettes were painted illusionistically in grisaille. Blondel recommended rosettes in the dome and arch coffers, but the term "caisson," used in the early description, as well as the lack of enframement are links with Durand. Both preferred sculpture to polychromy in pendentives. The present barrel vault, introduced for acoustical reasons at the time of the remodeling, pushed through the pendentives, leaving only a few fragments to show that the allegorical "sculpture" also was illusionistic painting. In all of this work, including the garlands and wreaths on the side walls, Capellano apparently followed Godefroy's

[41] In black ink, with yellow and gray washes, the drawing itself and two labels are pasted to a base measuring 22.5 by 25.5 inches. That Godefroy showed no structural details in this drawing only emphasizes the importance of the two interior views in his mind. The device of dividing an architectural drawing into two parts was an old one, certainly known in the sixteenth century, and was a matter of economy; two alternative projects, or an exterior and interior, could be combined in one plate. Blondel occasionally employed the split elevation (*Cours*, vol. 1, pl. 17; vol. 3, pls. 49–50).

designs, but the idea of using paint rather than actual relief sculpture may have been his own contribution. Whether in paint or stucco, however, the ornament has the *appliqué* character introduced to French architecture during the Revolutionary period and formalized by the time of Percier and Fontaine's publication of their interiors in 1801. The surviving pulpit base and several large chairs (Fig. III–20), though they have since been repainted, show the same decorative treatment.[42]

Many elements of the interior decoration show quite specifically Godefroy's habit of making new use of familiar forms and supplementing the statement of architectural character through symbolism. Like the fasces of the Battle Monument, the lyre had appeared earlier in several allegorical drawings, and it now emerged in giant size in the organ with pipes arranged as its strings.[43] The eagle and stars on its crossbar he had also used previously. More than a simple conceit, for Godefroy the lyre represented all that the arts contributed to Western culture, a point of concern to the Unitarians as well. The pulpit, of an almost architectural complexity of shape and structure, had its complement of symbolic decoration. Cast and bronzed lead ornament, a wreath of olive leaves on a festoon of oak hanging from flaming torches, was applied to its base of white Carrara marble to symbolize peace supported by strength and knowledge. The allegorical decoration in the upper parts of the church took the form of grisaille painting creating the illusion of stucco reliefs. Olive was used for the decoration of garlands, festoons, and wreaths applied to the side walls. Triangular panels on the pendentives showing the effulgent star, fasces, and branches of oak and olive bore the Unitarian message of tolerance, union, fortitude, and peace. A pair of wings on the fasces united the

[42] On coffers, see Blondel, *Cours*, 1:365–66, 2:320–21; Durand, *Précis*, 1:83. On ornament, see Percier and Fontaine, *Recueil*, passim. According to the bill for services, still preserved at the Unitarian Church, Capellano spent twelve days on the pendentive ornaments and five on the garlands of the side walls; the tablets behind the pulpit, actually modeled in stucco, required three days and the eight interior capitals sixteen days.

[43] Godefroy's interpretation and reuse of symbolic elements is detailed in Alexander, "Drawings and Allegories," pp. 17–33; see esp. pp. 31–33 for the lyre. The lyre was a common motif in France; cf. Brongniart's Salle de Spectacle of 1770, on the rue de Provence, for the Duc d'Orléans, and Mandar's house of 1792, near Malmaison (Krafft and Ransonnette, *Plans*, pl. 30; Charles-François Mandar, *Etudes d'architecture civile*, 2d ed. [Paris, 1826], pls. 28, 63, 69, 74, 99). Most interesting for comparison with Godefroy is Chalgrin's organ of 1775 for Saint-Sulpice, where a large decorative lyre stands in the center of the main cornice (Hautecoeur, *Architecture classique*, 4:360–61, fig. 208).

emblem, symbolizing as the *Port Folio* put it, "the allegory of time, winging its way towards eternity."

The star against a field of rays specified tolerance, but it seems to be used here equally as a compositional theme. Each of the overdoors, inside and out, bears such a star, which were originally all bronzed. It reappears on the organ, in the pendentives, and finally in the glazed oculus of the dome, a source of literal and figurative illumination. The widespread reiteration of symbolic decorative motifs, whether large or small, transparent or opaque, indicates an attempt at a unifying allegorical character, Godefroy's interpretation of *architecture parlante*.

The building testifies to Godefroy's architectural maturity by its integration of the parts within the whole. Its functional relationships brought the parts together in a three-dimensional composition. In spite of the apparent contradictions in their disparate components, the two focal points firmly controlled the complex of interior solids and voids around the main axis, facilitating the spectator's ready visual comprehension. Allegorical content joined distant and different forms through related meanings. The light, bright interior produced the effect of the Sublime—"that solemn and profound impression on the mind, so essential in public worship," as the *Port Folio* put it. This judgment applies as well to the exterior: although its solidity and containment contrasted so greatly with the open, spacious interior, its clearly defined and self-sufficient mass was a virtual image of unity. The severe, formal bulk of the church, its appearance of masonry, exemplified Godefroy's conception of a public monument.

The Bank of the United States, Baltimore Branch

In the winter of 1816–17, a decision was taken to house the Baltimore branch of the Bank of the United States in part of the Baltimore Exchange building. By the following August the directors of the branch bank had received designs from Latrobe, Godefroy, Robert Cary Long I, Robert Mills, a carpenter named Collins, and others. The board included a large number of Godefroy's friends, and they almost succeeded in having his design adopted for the whole Gay Street front of the Exchange before Latrobe could rally his supporters to stop the move. It was at this time that Godefroy, confident of the strength of his party, resigned his teaching post at St. Mary's College to take on the job. The decision on its design was not made until the autumn of 1818, when Godefroy contracted to supply plans and supervise construction of the bank for $1,500, but this work

was limited to the interior disposition. By June, 1819, he had received $1,250, evidence that much had been completed.[44]

The depression of 1818–19 and mismanagement of the bank's affairs led to the dismissal of Godefroy's friends from the board on June 9, 1819. Despite several letters and a meeting with the new board, he could get no information on his status. Jacob Small, builder for both the exchange and the bank, demolished all that had been constructed and started anew, probably from plans he and his son developed from Latrobe's sketches.

On August 13, 1819, Godefroy requested payment of the final $250, insisting that it was due him because the board had broken its contract. Two weeks later he sailed for Europe, taking along his drawings for the bank, which he exhibited in London in 1821 and in Paris in 1827 as evidence of his abilities.[45] Nothing is now known of his actual work or designs for this project.

Other Projects

Godefroy developed several projects which were never carried out and the only record of which exists in his correspondence. About September 1, 1816, while in Richmond he sent two sketches to the Reverend Kollock for the Independent Presbyterian Church in Savannah, Georgia. A prominent parishioner, Major John Bolton, commented favorably on the designs, one in a "regular" style, the other in Gothic. Ebenezer Jackson, a former pupil of his, solicited Godefroy's contribution, but the commission went to John Holden Greene of Providence. Per-

[44] The question of the bank is closely related to the exchange in Latrobe's correspondence of 1816–17 as recorded in his Letterbooks; especially important are letters to R. G. Harper, J. R. Colt, William Patterson, J. Donnell, R. Smith, and J. Small, in December, 1816 through January, 1817, and Aug. 16–18, 1817; also Latrobe to Mary Latrobe, Sept. 10, 1818, Mrs. Gamble Latrobe Collection, Maryland Historical Society. Most information on Godefroy's work is derived from his letters: see Godefroy to Jackson, Baltimore, Aug. 13, 1818; Godefroy to Tessier, Baltimore, June 22, 1819; Godefroy to the president and directors of the office of Discount and Deposit, Baltimore, Aug. 13, 1819; all at the Maryland Historical Society. Brief allusions to this work are made in Davison, "Godefroy," pp. 204–5, and Hamlin, *Latrobe*, p. 490. Purely in the interests of completeness rather than significance, a signed drawing by Latrobe should be noted. The parchment deed of sale of the premises in the exchange to the officers of the bank, Dec. 31, 1817, has a plan, about 6 inches square, in black ink and colored washes ("Customs House (Old)," Records of the Public Building Service, Title Papers, Baltimore, Record Group 121, National Archives).

[45] *Exhibition of the Royal Academy* (London, 1821), p. 41; F^{13} 650, Archives Nationales.

haps Godefroy's conditions for superintending the construction turned the trustees against him. Still smarting from his experience in Richmond when he sought payment for work on the banks and courthouse, Godefroy stated his terms very strongly:

1. five per cent on a sum of $40,000: that is *$2000—*
2. five per cent on completion of the front at $4000 that is *$200* more.
3. the total fixed, without increase in *salary*, if the cost exceeds the estimate, unless this occurs through new arrangements *coming from the Board itself—*
4. my travel expenses ought to be paid at the rate of one round trip *by sea*. And considering the displacement, I submit to these gentlemen
5. the proposition of granting me the sum that would be devoted to a *competition prize*—declaring at the same time that henceforth I shall never compete. on these conditions I promise that following the response that I expect
6. I shall leave toward the middle *of October* and shall send the necessary drawings ahead of me.[46]

The Jesuit seminary in Georgetown was enlarging its quarters in 1817 in order to take on more day students. At this time Godefroy may have been asked to sketch a new church for the group, but nothing was built. In 1827 he sent a drawing of this project to French officials as evidence of his ability.[47]

In the summer of 1818 he worked hastily on a project for the Philadelphia branch of the bank of the United States. He had difficulty in obtaining the circular giving specifications, and when it finally arrived on July 24, seven days before the closing of the competition, he realized his previous plans were unusable. About July 27 he went to Philadelphia to point out his feelings that the specifications prevented a real stylistic expression. Major Bolton of Savannah again supported Godefroy, and the directors postponed the closing date of the competition for one month. Even with the help of a student Godefroy barely succeeded in preparing one instead of three projects. He sought Ebenezer Jackson's aid in using his influence to sway some of the directors, but to no avail. Godefroy expected defeat at the hands of Latrobe, but he continued to work on the project because of the persuasion of some friends, and he personally

[46] Godefroy to Jackson, Richmond, Sept. 7, 1816, Maryland Historical Society.
[47] F[13] 650, Archives Nationales.

took the final drawings to Philadelphia to submit them to the directors.[48]

Because a new street was to cut through the property on North Paca Street in Baltimore, Godefroy sketched a reorganization of the Sulpician seminary and college. The superior, Father Tessier, sought Godefroy's advice on the most advantageous method of laying out the new street and selling parcels of the ground detached. Godefroy cavalierly drew the street through a group of buildings with an insurance valuation of over $30,000 and conceived a handsome court in front of his chapel, flanked by new college and seminary buildings.[49] The street was never opened, and Godefroy's project was forgotten.

Godefroy's work in these few years shows a consistent growth toward maturity. Most remarkable was his confident handling and control of space, which resulted in dramatic interior compositions. The interweaving of mass and space, evidence of his greater understanding of both structural and functional demands, occurred in buildings that presented large, simplified forms in three-dimensional architectural conceptions. In rendering, too, his early reliance on books and his inexperience had led to emphasis on the front; now the perspectival representation underscored the integration of parts within the whole. This new comprehension can also be seen in more theoretical areas—in his specific criticisms of buildings and his speeches and writings on architectural character.

[48] Godefroy to Jackson, Baltimore, Aug. 13, 1818; E. Godefroy to Jackson, Baltimore, Aug. 13, 25, 1818; E. Godefroy to Girardin, Baltimore, [Aug.] 25, 1818; all at the Maryland Historical Society. For details on the competition, see Gilchrist, *Strickland*, pp. 53–57; Strickland's building, the winning design, still stands as a primary monument of the Greek Revival in America. Mills' drawings are lost, but his long descriptive letters, which deserve publication, survive (Mills to the president and directors, Baltimore, Aug. 31, 1818, Letters of Robert Mills, Library of Congress).

[49] Godefroy to Tessier and Bruté, Baltimore, Jan. 18, 1818, Maryland Historical Society.

IV. European Career

The last two decades of Godefroy's life were passed in Europe. When he left America at the age of fifty-five, expecting greater recognition and success abroad, he displayed his drawings in both England and France and planned to have them engraved. Through participation in competitions, the intervention of friends, and personal appeals, he sought architectural commissions and better employment. The posts he received were minor ones and the financial reward meager. Although his hopes were frequently dashed, he and his wife never gave up their search for better positions, even in the last years of their lives.

Grief and difficulty marked the Godefroys' voyage itself. Before their ship cleared the Chesapeake Bay, Mrs. Godefroy's daughter Eliza grew ill and died of yellow fever. Upon reaching Liverpool most of Godefroy's studies, drawings, and books were seized by customs officials. Nearly a year passed before he could return to Liverpool and redeem his possessions, some of which, especially the books, had been vandalized.[1]

The Godefroys spent seven years in London, from late in 1819 to the end of 1826. By January, 1827, Godefroy was in Paris seeking employment in a government architectural post. He served as city architect in Rennes from July 1, 1827, to August 31, 1828. On January 1, 1829, he took up the duties of architect of the Department of Mayenne, residing in Laval, and still held this post in August, 1840, the date of his last writing. He expended much of his effort on small, insignificant works and fruitless projects and produced only a few buildings, but these show how he had been affected by recent developments and by the architecture he observed after his return to Europe.

[1] For the life and works of Godefroy after his return to Europe, see Carolina V. Davison, "Maximilian and Eliza Godefroy," *Maryland Historical Magazine* 29 (1934):12–20, 184–87, 211–12; Dorothy M. Quynn, "Maximilian and Eliza Godefroy," *ibid.*, 52 (1957):21–31; see also William D. Hoyt, Jr., "Eliza Godefroy: Destiny's Football," *ibid.*, 36 (1941):10–21.

Both England and France were responding architecturally to the changing social, political, and economic demands of the early nineteenth century. Urbanization and industrialization required more and larger buildings, and indeed new types of structures—hospitals and asylums, for example, designed in accord with the increasingly humane treatment of the physically and mentally ill. The accidents of publication of the time perhaps give an unbalanced picture of these activities, so that English work seems to have been concentrated in a few major cities: James Elmes, as the titles of his two large works suggest, was concerned with urban beautification. In France, on the other hand, a broader national architectural scene is presented by the monumental corpus of Charles-P. Gourlier and his colleagues with its depictions of market halls, prisons, slaughterhouses, prefectures. There is no record of Godefroy's attitude toward these French and English developments. However, one can assume that the search for monumentality in a Romantic-Classical vein and the increasing awareness of the importance of functional organization of space would have appealed to him, for he had expressed such interests shortly before he left America. To him Soanic decoration would seem petty and the Picturesque foreign, in part because of the dominance of the Durandesque that greeted him on his return to France.[2]

Work in England In London the Godefroys settled in Somers Town, now the location of Clarendon Square. Here, where rents were low, they were surrounded by refugees from France. Through correspondence they kept in touch with their American friends and occasionally saw some of them when they passed through London. At the same time they tried to reestablish themselves in this new setting. By his own statement Godefroy received many notices in English newspapers and periodicals. He became acquainted with the local clergy and members of the French embassy, as well as Englishmen like Lord Lyndhurst, son of John Singleton Copley, and his few architectural opportunities in England came primarily through them. Each year from 1820

[2] James Elmes, *Metropolitan Improvements* (London, 1827), and *London and Its Environs in the Nineteenth Century* (London, 1829); Charles-P. Gourlier et al., *Choix d'édifices publics projetés et construits en France depuis le commencement du XIXme siècle*, 3 vols. (Paris, 1825–50). For a modern account of this work, see Henry-Russell Hitchcock, *Architecture, Nineteenth and Twentieth Centuries* (Baltimore, 1958), chs. 1–4.

to 1824 Godefroy showed his drawings at the annual exhibition of the Royal Academy; they included some elevations of his American buildings and several landscapes. The attendant publicity brought him to the attention of the French ambassador, the Prince de Polignac, who commissioned a French chapel. However, the government failed to allocate funds for the purpose, and it was not built. He also designed a rectory in the Gothic style on the order of an Anglican chapter, intended, but not built, near Worcester.[3]

The building committee of the Salters' Company met on April 19, 1821, to open a competition for plans for its new hall. Sixty-three designs were submitted by the closing date, July 18. At the judging on August 2 Godefroy was awarded the third premium of forty pounds. Henry Carr, the company surveyor, composed a final design (Fig. IV–1) constructed in 1823–27, choosing desirable elements from the three prize-winning plans. Godefroy submitted three drawings, plans of the ground and the upper story and an elevation. On the company's request

[3] Godefroy's addresses appear in the catalogs of the Royal Academy for 1820–24 (*The Exhibition of the Royal Academy* [London, 1769 *et seqq.*]). His exhibits in London have been summarized in Algernon Graves, *A Dictionary of Artists Who Have Exhibited Works in the Principal London Exhibitions from 1760 to 1893*, 3d ed. (London, 1901), p. 112. For the French chapel, see Davison, "Godefroy," p. 186.

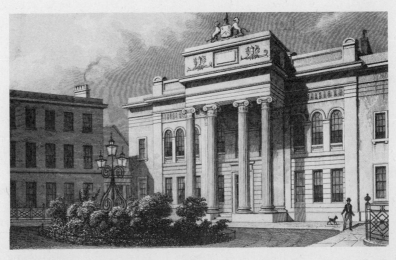

IV–1. Salters' Hall, London. Henry Carr. 1823–27. James Elmes, *Metropolitan Improvements.*

after the competition, he also prepared a basement plan, to which he added a transverse section of the whole building.[4]

Fire bombing during World War II destroyed this building, but prints and photographs suggest that several elements derived from Godefroy. An attic story above the projecting portico was virtually unknown in other contemporary work in London, while it appeared in Godefroy's work as early as his Washington arch. Continuous arched windows in the "aqueduct" motif, certainly by Latrobe, appeared in the Merchants Exchange in Baltimore; unusual in London, this motif may also have derived from Godefroy's project. The simplification of the corner pilasters of Salters' Hall into vertical strips crossed by the three bands of the architrave resembled the treatment of the Unitarian Church. Godefroy's design may have provided many specific details of the spacious interior halls; for example, the handsome lyre ornamenting the center of the cast-iron gallery rail in the Livery Hall. One of his letters describes a "great Hall" with "pillars . . . of Scagliola," suggesting the Salters' Banquet Hall with its Ionic column screen of Sienese marble. On the other hand, the rather Soanic end blocks above the facade cornice were certainly not Godefroy's, yet they caught his attention, and he used the form several years later in France.

Godefroy stated that he designed and constructed the Catholic Charities School (Fig. IV–2), a foundation established by Abbé G.-T.-J. Carron, who had returned to France in 1814. The

[4] [Thomas Gillespy], *Some Account of the Worshipful Company of Salters* (London, 1827), pp. 19–20; "The City Companies and Their Halls. No. 8. The Salters' Company," *Builder* 111 (1916):213–14 and illus. The archives of the Salters' Company preserve four letters from Godefroy, dated July 18, Aug. 7 (two), Aug. 15, 1821. According to the company records, the first two premiums went to John Clement Mead and Francis Pouget, of whom nothing else is known. George Smith received credit for this building in Elmes (*Metropolitan Improvements*, pp. 146–47, pl. facing p. 152). This attribution was followed by Charles F. Partington (*An Illustrated History of London and Its Environs*, 2 vols. [London, 1835–37], 2:57–60). As architect of the Mercers' Company, Smith constructed the tower and refurbished the Royal Exchange in 1820 (Elmes, *Metropolitan Improvements*, p. 158, pl. following p. 148; Augustus Charles Pugin and J. Britton, *Public Buildings of London*, 2 vols., 2d ed. [London, 1838], 2:42–53 and pls.). He designed St. Paul's School (Elmes, *Metropolitan Improvements*, pp. 126–27, pl. facing p. 125), the New Corn Exchange, his finest building (Elmes, *Metropolitan Improvements*, pp. 146–47, pl. facing p. 131; Pugin and Britton, *Public Buildings*, 2:11–22 and pl.), and Whittington's Alms Houses (Elmes, *Metropolitan Improvements*, pp. 141–42, pl. facing p. 141). He handled various styles easily, yet his work was more conservative, heavier, and more richly ornamented than the Salters' Hall. The attribution to him is probably erroneous. An inscription on the foundation stone read "Mr. Henry Carr, Architect" ([Gillespy], *Some Account*, p. 19).

IV–2. Catholic Charities School, London. 1825–26. *Centenary of St. Aloysius' Convent, F.C.J., Clarendon Square, London.*

cornerstone was laid in 1825 at a ceremony attended by all the Catholic ambassadors in London. This was evidently the same building, newly erected at a cost of six thousand pounds, which in 1830 was turned over to French nuns as a school for girls and formed the nucleus of St. Aloysius' Convent, Clarendon Square.[5] Seriously damaged during World War II and demolished soon thereafter, the structure was of brick covered with stucco. A central pavilion of three bays projected slightly, but the angle of the eight-bay wings brought their ends several feet forward of the center. The triangular pediment of the pavilion, only a front above roof level, had a cross applied to the central area, a simple bell support on its peak, and two antefixes resembling those on the O'Donnell vault and the tribune of the Unitarian Church. The horizontal entablature continued across the long wings, stopping abruptly at the ends, with the wall plane rising above it like the attic Godefroy had used in several American designs. The single entrance, an arched opening, was recessed slightly into the pavilion wall. The simple windows were all identical, those on the upper story just two-thirds the height of the lower ones, in the proportions recommended by Durand. With slightly arched brick lintels, windows looked like holes

[5] *Centenary of St. Aloysius' Convent, F.C.J., Clarendon Square, London* [London, 1930], pp. 2–5.

cut into the wall because of their lack of frames. On both levels the windows rested on string courses running the length of the building and, like the entablature, stopping abruptly at the ends. A small touch reminiscent of Godefroy appeared in the heavy blocks serving as podia for two amphorae in front of the pavilion. In its bare simplicity, overall symmetry, and regular repetition of openings, the school showed Godefroy approaching the functional, economic, astylar manner taught by Durand. Perhaps his return to a French milieu strengthened the influence on him of current practices in France.

It is difficult to understand how the Godefroys managed to subsist in England. Godefroy's recorded income for seven years totaled forty pounds from the Salters' Hall competition and about sixty pounds more if we assume that he received 1 percent on the Catholic Charities School construction. He reported that they had been defrauded of a small legacy his wife had expected to receive on their arrival. His lack of professional success made him receptive to friendly suggestions that he return to France. Encouraged by the Prince de Polignac, he may have begun negotiations for his return as early as 1823, when his police record was reexamined.[6]

Work in France Early in 1827 Godefroy, now sixty-two, hurriedly moved to Paris. He was given a small pension of six hundred francs, which was cut off in 1831. His request for employment in the Travaux-publics was accompanied by the first of his autobiographical résumés, dated December, 1826, and registered on January 30, 1827, in the office of H. Rohault de Fleury, inspecteur général des édifices civils. Francoeur and Quéquet, his guarantors in 1805, both wrote letters of recommendation for him and helped him find positions. Godefroy submitted to one official a large roll of his drawings, which were examined and reported on with considerable praise by the architect J.-J.-M. Huvé. Rohault de Fleury, a student of Durand at the Ecole Polytechnique, must have joined Huvé, a student of Percier, in admiring the modern elements in the work as well as the allegorical parts. Three buildings were singled out for special comment, the Washington Monument, the Battle Monument, and St. Mary's Chapel, and the drawing of the last was com-

[6] It is more probable that the early investigations of his police record, in 1823–24, were made in connection with the chapel he designed for the Prince de Polignac, who was French ambassador to London from 1823 to 1829, and premier and foreign minister from 1829 to 1830.

mended for its liveliness and skillful coloring. Godefroy's talents and taste were similar to Rohault's own, and his undoubted loyalty to the Bourbons made him acceptable for governmental service.[7]

Personal influence—Francoeur was a friend of the mayor—secured Godefroy the appointment as city architect in Rennes. His tenure was brief, from July 1, 1827, to August 31, 1828. Mayor de Lorgeril complained that Godefroy turned in work late and often unfinished, changed dimensions arbitrarily, and submitted estimates so inaccurate as to be useless. Godefroy argued that he had frequently been told of required revisions only twenty-four hours before the deadline, that he had offered to pay up to five hundred francs to have a Parisian architect friend complete the drawings in question, that his changes of dimensions amounted to inches or less, and that the estimates were based on the latest work done for civil, military, and religious authorities. He pointed to his financial losses, moving expenses, the effort of familiarizing himself with building practices of the region, and the private work he had given up because of a sudden increase in municipal demands. Using a chart, he demonstrated his contention that in one year he had accomplished three times as much as his predecessor had in three years. Despite lengthy harangues by the mayor, the city council sided unanimously with Godefroy, praised his talents and labor, and voted him three thousand francs as indemnity for his personal losses. In later years Godefroy claimed that de Lorgeril's opposition arose from his refusal to give falsely inflated estimates. However this may be, his personal reputation was enhanced rather than diminished by the incident, and almost immediately he was offered the post of architect for the neighboring department of Mayenne.[8]

[7] For the numerous records of this activity, see F[13] 650, Archives Nationales, Paris. Rohault de Fleury (1777–1846), father of the art and liturgical historian, designed several markets and casernes and achieved his highest positions during the Restoration. Huvé (1783–1852), son of an architect of the late eighteenth century, worked primarily during the Restoration and is best known for his Marché aux Vaches Grasses of 1818, in Paris, his theater of 1828 at Tours, and the completion of the interior of the Madeleine of 1828–42.

[8] K 2/19 (Godefroy's dossier); Régistre des arrêtés du maire de la ville de Rennes, July 1, 1827, D 4/8; Délibérations du conseil municipale de la ville de Rennes, séances ordinaires des 2, 4 et 5 août, 1828, D/1 19; Régistre de correspondance, July 31, Dec. 26, 1828, D/5 9; all in Archives Municipales, Rennes. See also Godefroy to the prefect, Laval, Jan. 27, 1833, N. 825, Archives de la Mayenne, Laval. I am indebted to H.-F. Buffet, chief archivist, and M. Jézéquel, city archivist, for aid in research in Rennes.

Godefroy's works in Rennes included both small and large projects, some begun by his predecessor, others his own. While the mayor of Rennes was visiting Paris in May, 1828, Godefroy wrote him several letters containing long descriptions and estimates and also sent a roll of drawings, now lost, for most of the works which he had under way. These documents and his letters to the city council suggest the nature of his projects. New abbatoirs, for example, were to be housed in a long, symmetrical structure with four equally spaced pavilions on the lateral facades; official approval had been given and the stakes set in place on the site. Undoubtedly Godefroy employed Durand's method of laying out a large, complex structure in a gridlike pattern; the scheme was probably used for the hospital for syphilitic women, plans of which were approved by Rohault de Fleury and de Lorgeril in June, 1827, as the basis for Godefroy's employment. Other descriptions are less informative. He submitted a drawing for a new permanent base for the statue of du Guesclin in Thabor, the public garden; erected in 1825, by 1828 the arm of the statue had already been broken by vandals. To restore the Fontaine Saint Aubin, he designed a large vase with grotesque masks and lions' feet. Proposals for a new street

IV–3. Decorations for ballroom, city hall, Rennes. 1827. Paul Banéat, *Le Vieux Rennes.*

plan and improvement of the square de la Motte came to nothing. To retain the artillery school the city had paid half the cost of new stables; they were soon to be turned over to the military authorities, who were already demanding some repairs. Preparations for an artesian well were advancing despite the opposition of neighboring propertyowners. Godefroy also presented plans for an unidentified task which he called simply "croix de la mission." [9]

Soon after Godefroy's arrival in Rennes, the visit in mid-September of the dauphine, the Duchesse d'Angoulême, necessitated an interruption in his regular duties: the ballroom of the hôtel de ville was to be decorated and a triumphal arch erected along her path through the city (Figs. IV–3-IV–4). Little out of the ordinary, these decorations display several marks of their period. A throne under a regal canopy was erected at one end of the ballroom, and the walls were hung with draperies. Several panels with painted inscriptions and garlands, festoons, and wreaths of foliage and flowers completed the decoration. The simple arch, undoubtedly the usual wood and canvas construction, was comprised of four poles creating a wide central passage; the structure supporting the poles formed two platforms

[9] Information on Godefroy's work in Rennes is drawn primarily from K 2/19 and M 12/1 5, Archives Municipales, Rennes. Other references to specific works mentioned here are found in Emile Ducrest de Villeneuve and D. Maillet, *Histoire de Rennes* (Rennes, 1845), pp. 520, 525–28; Adolphe Orain, *Géographie pittoresque du département d'Ille-et-Vilaine* (Rennes, 1882), p. 65; Paul Banéat, *Le Département d'Ille-et-Vilaine*, 4 vols. (Rennes, 1927–29), 3:212, 326.

IV–4. Street arch, Rennes. 1827. Banéat, *Le Vieux Rennes.*

holding large brazier-like lamps in the lateral openings; and the whole was hung and draped with garlands. Instead of capitals, Godefroy set a basket of flowers on each pole, recalling the legend of the invention of the Corinthian capital—this order, in addition, Blondel had designated as appropriate for royal festival architecture. Inscriptions and royal devices gave the decorations a nineteenth-century flavor. Suggestions of Godefroy's compositional habits appear in the repeated blocks, two flanking the throne and others serving as podia for the lamps. Three drawings, in pink, yellow, green, and blue, have disappeared since they were reproduced in color in 1911. Two sections, like that of the Unitarian Church, were intended to show the interior rather than structural details. The other sketchily indicated two groups of trees behind the arch; tree trunks similar to those in the Unitarian Church perspective rose from mounds of earth and were staggered in depth.[10]

In the mayor's eyes one of Godefroy's most important tasks was the design of a funerary chapel to serve as entrance to the cemetery. The previous architect had more or less established the dimensions: it was to be about seven meters wide and seventeen meters long, standing on a vaulted passage five meters high and twenty-two meters long. In addition, Mayor de Lorgeril owned four column shafts which he insisted must be used in the structure. In recognition of the problems involved in adjusting the shafts to a building with dimensions established, Godefroy prepared drawings of three different projects. In his brief presentation of the pros and cons, he considered difficulties of an aesthetic nature, differences in costs, archeological correctness, and the question of architectural character:

> The first shows how the shafts of which you spoke can be adapted to the Greek Doric; but since their dimensions determine the height of the order and its pediment, the cross-section would present a great problem in that the interior cornice, even being let slightly into the curvature of the vault, would still be a little lower

[10] Paul Banéat, *Le Vieux Rennes* (Rennes, 1911), pp. 304, 505, illus. facing pp. 288, 304, 504 (illustrations were omitted from the 1926 edition). Cf. the arcaded gate and trellis François Belanger set up on the property of Mme Belanger at Santeny (Jean-Charles Krafft, *Maisons de campagne* [Paris, 1849], pl. 36). Belanger did not replace the capitals with baskets; the latter were set above the entablature, over the columns. Published by 1812, this plate may have been the germ of Godefroy's idea for the triumphal arch. Cf. also Belanger's decorations of 1814 in the Palais-Royal, for Louis XVIII's entry into Paris (Jean Stern, *A l'Ombre de Sophie Arnaud. François-Belanger*, 2 vols. [Paris, 1930], 2:267, illus. facing p. 268).

than the door frame. I have tried to mitigate this major objection by placing two monumental pilasters inside, flanking the door, in order to explain this strange interruption of the cornice. But this appears to me an audacity I should not risk without consulting the learned artists of the Commission des Batiments Civils, to whom I wish to submit this suggestion as a difficulty of the art.

This weighty obstacle therefore forced me to make a second interior project, without vaults, a ceiling only which, while removing the difficulty, would save on the expense (since the walls would be less strong) and would be more in the character of the Greek temples, which are not vaulted.

In case, however, the vault is kept, as especially appropriate for a funerary chapel, nothing remained but to offer a third project in Roman Doric, of the Theater of Marcellus, with Attic base (which I was obliged to articulate myself, not having anyone who could draw a profile well enough to preserve the character of the moldings). Because of the greater elevation this order would give, everything would be arranged much better, with respect to the interior as well as to the roofing, which would not be as flat as with a Greek pediment; but inevitably more expense would result since the over-all dimensions would be larger.[11]

Rennes was a busy city and de Lorgeril a willful, energetic, impatient official. The pace in Laval, capital of Mayenne, was more leisurely. The post of architect was a departmental rather than municipal appointment; its duties included fewer small works, like wells and statue bases, and more of the large structures for public services which were rising throughout France under the Restoration. The Department of Mayenne needed new or improved structures for its prisons, gendarmerie, palais de justice, prefecture, insane asylum—a typical list of the kinds of buildings undertaken under the auspices of the Batiments-civils. The records indicate that all were under active consideration and that the departmental prefect realized the need for a fulltime architect to plan and conduct these operations. Godefroy spent the rest of his life in Laval and apparently completed all the works he actually started building.

[11] Godefroy to de Lorgeril, Rennes, May 10, 1828, K 2/19, Archives Municipales. The Roman Doric of the Theater of Marcellus was widely published and easily available to Godefroy; e.g., Jacques-François Blondel, *Cours d'architecture enseigné dans l'Académie Royale d'Architecture*, text 6 vols., plates 6 vols. in 3 (Paris, 1771–77), vol. 2, pl. 2. Godefroy's successor abandoned the temple form and created a circular structure with altar and crucifix, one side half-closed and the other a semicircle of four Doric columns; a large substructure, serving as a mausoleum, was fronted by a circular court with two detached pavilions; see Ducrest de Villeneuve and Maillet, *Histoire de Rennes*, p. 529; Gourlier et al., *Choix d'édifices publics*, 2:34, pls. 228–29.

Godefroy began his duties on January 1, 1829, in his sixty-fourth year, and carried them out faithfully and successfully. He maintained correct and reasonably good relations with a succession of prefects and other officials. At one point, in 1833, he apparently felt that the need for his services was in question, and in a lengthy report to departmental authorities he listed all his work, and estimated the considerable savings that resulted from his employment. While protecting his present position, he kept in touch with Quéquet and other friends in Paris, always hoping for a better appointment. The work in Laval was not always easy and was never well paid. In May, 1834, he requested that the prefect order guards around walls and grills under construction; in protecting them himself, he had been hit several times by stones. In her last known letter, dated December, 1838, Eliza Godefroy pictured him, then seventy-three years old, working day in and day out in deep mud and cold weather, surveying for new streets and laying out plots for public sale. After her death in September, 1839, Godefroy kept alive his petitions for another appointment while continuing to plan new works; his last letter to the prefect of Mayenne, dated August 25, 1840, included drawings and detailed estimates for two departmental projects. The time, place, and circumstances of his death are unknown.[12]

[12] Specific information on Godefroy's life and work in Laval is provided by Alphonse Angot, *Dictionnaire historique, topographique et biographique de la Mayenne*, 4 vols. (Laval, 1900–1910), 2:626–27; N. 825 (containing the report of 1833), N. 833, Godefroy to the prefect, Laval, May 31, 1834, (including the reference to stoning), and N. 834, Archives de la Mayenne, Laval. For his aid and advice during my work at Laval, I am much indebted to Marcel Weber, assistant archivist. After the July Revolution Godefroy stayed with Quéquet in Paris from September, 1830, to February, 1831, seeking, through General Simon Bernard (1779–1839), an appointment as French consul in the United States. Bernard, an engineer, headed the map division of Napoleon's army during the Hundred Days. He was active in America from 1816 to 1830 directing a topographical survey of existing and proposed fortifications from Louisiana to New England and studying the problem of linking all parts of the United States by roads, canals, and navigable rivers. After the July Revolution he became an aide to the king and served briefly as minister of war in 1836. While he was in Baltimore, in 1816–18, he frequently visited the Godefroys. Godefroy visited Ebenezer Jackson in Paris from December, 1836, to January, 1837, and Quéquet in May, 1837, seeking work as a curator in a museum or a chateau or in building restoration. He also enlisted two other friends, the Baron Trigant de la Tour and William Tell Poussin, in this cause. Trigant, a lawyer, had studied at St. Mary's College. He graduated in 1806 but remained in Baltimore for another ten years. Poussin (1794–1876), a student of Percier, sought refuge in America in 1815, worked briefly for Latrobe on the Capitol in 1816, and then worked under General Bernard until 1830. Poussin wrote several books, and probably this publicity helped Godefroy to locate him in France. For a recent study of some American

Mayenne,
Hospice des
Aliénés
(Asile de la
Roche-
Gandon)

Shortly before Godefroy's appointment as the department's first architect two plans for an insane asylum had been drawn up, and the plain of La Roche-Gandon in the small city of Mayenne, about fifty kilometers north of Laval, had come under consideration as a possible site.[13] On August 26, 1829, Godefroy offered his project, which he described in a long letter, with estimates of costs and three sheets of drawings. His general plan (Fig. IV–5) of the building and terrain of La Roche-Gandon still exists; the two lost drawings had plans, sections, and elevations of every part of his project. Approximately sixty-eight meters square, the complex was to be constructed in successive stages as funds became available. The principal structure and enclosing walls would be built first, followed by cells for violent patients on the far side of a rectangular court, then the bath pavilion in the center. Godefroy's letter indicates some of the reasoning behind the design:

> The whole establishment is divided lengthwise into two large sections to separate the sexes, and in the center of the 4 courtyards is the pavilion for baths, showers, and guardians.
> A covered, well ventilated gallery connects the entrance of the facade building with the opposite end of the establishment, passing through the bath pavilion; its windows are placed above the height of a man, and should not be glazed.
> From the bath pavilion a simple wall is drawn across the entire

fortification works by Bernard and Poussin, see Willard B. Robinson, "Military Architecture at Mobile Bay," *Journal of the Society of Architectural Historians* 20 (1971):125–29. For Mrs. Godefroy's last letter, see E. Godefroy to Jackson, Laval, December 15, 1838 (fragment), Maryland Historical Society. For Godefroy's last letter, see N.825, Archives de la Mayenne. The duties of departmental architect were assumed by P. A. Renous, in September, 1842. A search through the records of hospitals and the asylum at Mayenne reveals no further information on Godefroy.

[13] Information on this asylum is drawn largely from the Archives of the Asylum in Mayenne, doss. 1, and N. 852, Archives de la Mayenne. See also Angot, *Dictionnaire*, 2:834–35; "Rapports du Docteur Fellion concernant le centre psychothérapique de Mayenne" (mimeographed, Mayenne, 1959–64). For the establishment by post-Revolutionary governments of hospitals, asylums, and similar charitable institutions, see Armand Husson, *Etude sur les hôpitaux* (Paris, 1862), pp. 170–71, 525–26. Two signed drawings by Godefroy for the asylum have been preserved: a general building and site plan, dated Aug. 26, 1829, Dec. 26–28, 1831, and August, 1839, and a plan and elevation, dated Dec. 26–28, 1831, bearing notice of verifications on Jan. 8 and Feb. 10, 1832; see N. 852, Archives de la Mayenne. I am much indebted to M. Maccarinelli, head of administrative services, for his aid and guidance in my study of this building.

IV–5. General plan, Asile de la Roche-Gandon, Mayenne. 1829. Archives de la Mayenne, Laval.

width of the courts. As a result of this new division the first part of the interior contains the two courts reserved for the tranquil insane of both sexes, and the 2nd part for the two groups, men and women, of violent insane, who are entirely out of sight of the first class, or tranquil ill, and thus each of the four groups has a separate courtyard or promenade.

Having collected all possible information and supported by the formal recommendation of the general commission on hospitals, I have settled on construction of the cells with double wooden partitions, the method that has always seemed healthiest to me. The expense is a little greater, it is true; but in a permanent establishment and especially when I have offered the possibility of completing the cells in succession, I cannot believe this higher cost could halt [construction] when it is a question of a beneficence aimed at one of the greatest and most touching misfortunes of humanity.[14]

Godefroy was aided considerably by the "formal recommendation" to which he referred. It stressed the necessity for separating patients according to sex and degree of insanity and offered typical plans showing the most economical layouts for institutions of different sizes, with least duplication of such facilities as baths.[15] Quarters for close relatives were recommended, not only for the income thus produced but also for the therapeutic value of their presence. Godefroy provided rooms for this purpose in the upper story of the principal structure, above the quarters of the tranquil patients. For therapeutic reasons, too, the enclosed, covered passage was desirable; others were spared the alarming sight of a violent or self-soiled patient being conducted to the baths. The report also supplied reasons for selecting the site at La Roche-Gandon—clean air, pleasant surroundings, and an abundant supply of fresh water.

More than two years passed before the necessary decisions were taken and funds became available for construction of the

[14] Godefroy to the prefect, Laval, Aug. 29, 1829, N. 852, Archives de la Mayenne. The report from which Godefroy drew, *Rapport fait au conseil général des hospices civils de Paris . . . sur le service des aliénés . . .* (Paris, 1823), was the first official publication on the treatment of the insane (see Léonce de Lamothe, *Nouvelle étude sur la législation charitable* [Paris, 1850], p. 341).

[15] Separation of the patients by sex and degree of insanity and centralization of services in order to avoid duplication are the principles which governed the design of asylums for the greater part of the nineteenth century. Such a program readily lent itself to the Durandesque approach for laying out a complex of buildings. For examples of buildings of the 1820s in which these elements were already combined, see Gourlier et al., *Choix d'édifices publics*, vol. 1, pls. 101–2, 128–29, 151–52.

principal building and walls. Inasmuch as the site finally selected almost coincided with his own choice, Godefroy could indicate the placement of the foundations on his original plan. His specifications, dated October 28, 1831, record the dimensions: a facade 67.16 meters long, including two corner pavilions of 7.24 meters and a center pavilion of 8.10 meters; a depth of 7.2 meters increased to 13.92 meters at the corners and 10 meters in the center; a height of 8.5 meters including the socle, two stories, and high roof. With dimensions and site established, a new series of drawings became necessary, one of which has been preserved (Fig. IV–6). Dated December 26–28, 1831, it is a plan of the foundations with four sections and an elevation of the lower part of the facade; dimensions are indicated on the section lines of the plan. Red and black inks are used, along with washes of pink, yellow, and a gray-yellow, to distinguish materials, i.e., brick and various kinds of stone.

IV–6. Drawing for foundations, Asile de la Roche-Gandon. 1831. Archives de la Mayenne.

P.-A. Renous was appointed contractor on December 31, 1831; he discussed specific problems with Godefroy during the next few months, and at one of their conferences the voussoirs of the rear door arch were sketched in pencil at the bottom of this plan.[16]

There was some delay in construction because the Ministère des travaux-publics, after postponing its approval for eight months, now suggested some changes and additions—in particular, the inclusion of the bath pavilion was insisted upon. By the beginning of 1833 the contractor had submitted material and labor bills amounting to more than 56,000 francs, a third of the total anticipated cost. The inaugural reception took place on September 22, 1836.[17] Some work requested by the mayor of Mayenne kept Godefroy busy at the Asile intermittently until the following summer, when repairs were already necessary. Evidently certain faults had come to light when the building was occupied, and Renous was required to replace the water pump, eight baths and showers, and a section of plumbing.

Godefroy's main building (Fig. IV-7) still stands, but higher, as another story has been added.[18] No longer the entrance, it has been surrounded by the haphazard addition of other buildings and walls, so that its facade is scarcely visible as a whole. The large gates and lanceolate grill now at the main, south entrance of the Asile were probably set up by Godefroy to the west, in front of this building. His bath pavilion, cells, and enclosure walls have long since been replaced by new construction as the institution has grown.

Although the facade of Godefroy's building has been altered, many of its original elements survive, so that his design can be understood. Two long arcaded wings join the rather mas-

[16] Godefroy's partial elevation, showing the center and end pavilions and connecting wings, the strong quoins, and the battered foundations, bears a strong resemblance to the principal facade of the Nouveau Quartier de Femmes Aliénées of 1823 at Charenton Saint-Maurice (ibid., vol. 3, pl. 43). For the battered walls of the foundation, see Jean-Nicolas-Louis Durand, Précis des leçons d'architecture données à l'Ecole Polytechnique, 2 vols. (Paris, 1802–5), 1:93, pt. 2, pl. 5. Godefroy's insistence on a massive masonry is characteristic of his French works. The arch detail here discussed has its closest parallel in a work on fortification: Lazare Carnot, De la Défense des places fortes, 3d ed. (Paris, 1812), pl. 11.

[17] E. Godefroy to Jackson, Laval, Sept. 22, 1836, Maryland Historical Society.

[18] Around 1860 the third story and new roof were added, but the increased height required some strengthening and rebuilding of the walls. In this reconstruction taller blocks of masonry were introduced for corner quoins and window frames above the ground floor, and lateral windows were opened in the central pavilion.

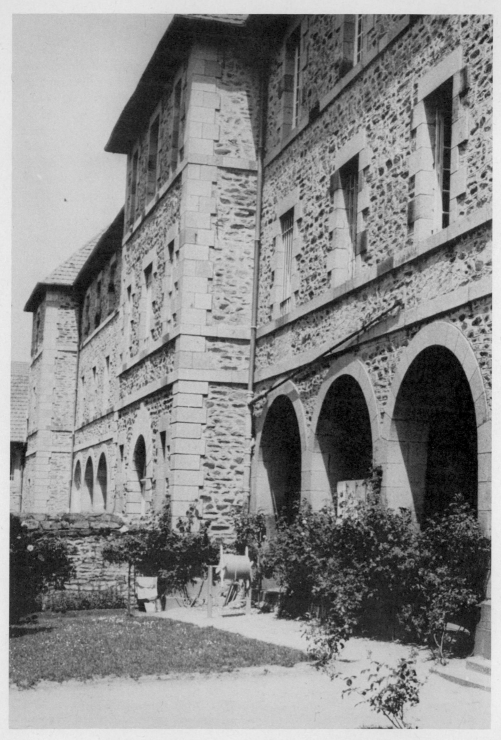

IV–7. Facade, Asile de la Roche-Gandon. 1829–36.

sive, projecting pavilions at the center and ends; granite blocks add to the impression of strength as they reinforce all corners and surround all openings, including the series of rectangular windows in the upper level. The pavilions each have one opening; at the outer ends the voussoirs of the arched central doorway extend to form an elliptical rather than a semicircular shape; perhaps the end pavilions had windows of similar shapes. Seven broad arches on simple piers fill each wing, creating a long porch on either side of the axis. Two string courses cross the whole building, one just above the arcades, the other slightly higher in order to form the sills of the upper windows. Well above the windows, still another continuous course of masonry originally topped the wall, and a short flight of steps by the central entrance interrupted the double course of masonry forming the visible foundation for the whole facade. Alternating long and short quoins bind the corners of the projecting pavilions, and similar masonry frames the windows. The joints of these stones, like those of the central doorway, are recessed for emphasis, while the horizontal string courses and the arcades have continuous, smooth surfaces. All these granite parts had only the slightest relief as long as the rubble walls possessed their thick coat of stucco. Against that textureless surface the structural forms in masonry acted as a decorative pattern. A horizontal linkage became necessary to overcome the separation of the pavilions, emphasized by their projection, about three meters deep, and individuated by the framing bands of quoins. The string courses linked together the several blocks of the structure with a certain bluntness, while the rhythmically flowing arcades opened and lightened the masses with a degree of elegance.

Except for the arched door in the center, the openings of the long rear face are rectangular, framed by alternating quoins, and on axis with the openings of the front. On the ground floor several doors replace windows to facilitate the moving of groups of patients. No projection breaks the wall plane in the center, and the end pavilions (Fig. IV–8) open with wide arches for easy passage. Limestone was to be used for these piers and arches, but granite was substituted because of its resistance to damage at these points of intensive use; describing this change, Godefroy sketched a plan and elevation (Fig. IV–9) of one corner passageway.[19]

[19] The drawing of the corner passage occurs in Godefroy's letter to the prefect, May 15, 1832, N. 852, Archives de la Mayenne. Although it shows no framing for the upper window, the rear facade openings probably did

IV–8. Tower doorway, Asile de la Roche-Gandon.

Little is known of the interior because it has been extensively altered. The foundation plan suggests that on the ground floor each wing contained one small and one large room and each corner pavilion a single large chamber; these rooms housed the calm patients, males on one side and females on the other. Small square areas in the central pavilion probably contained staircases, with access supervised by administrative personnel

have simple frames, a distinction between front and back windows that Godefroy was making at the same time on the pavilions of the prefecture in Laval. The sketch shows only one string course between the stories; the double course of the facade continued around the sides but not across the back of the building. During reconstruction the passageway arch was partially closed, as is indicated by the larger blocks of masonry in the door frame (Fig. IV–8).

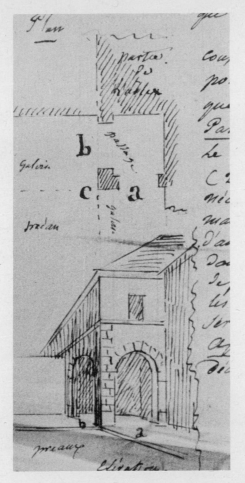

IV–9. Drawing for tower doorway, Asile de la Roche-Gandon. Archives de la Mayenne.

in offices flanking the entrance vestibule and hallway. These are the signs of Godefroy's concern for practicality, for effective operation of the building.

To the traditional scheme dominating the long facade of the asylum Godefroy added details borrowed from Durand or based on his own earlier works. Tradition was, indeed, supported by Durand in the clear emphasis on the three pavilions projecting forward of the wings. Durand illustrated designs (Fig. IV–10) that might have served as Godefroy's sources for the separation of stories of the facade by two close-set horizontal courses, the windows resting on the upper one. The arcaded porticos were

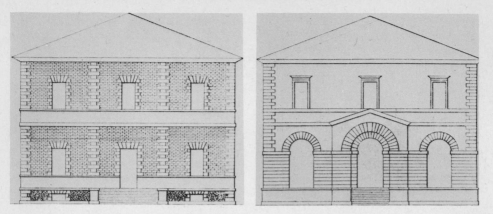

IV–10. Two house designs. J.-N.-L. Durand. Durand, *Précis des leçons d'architecture données à l'Ecole Polytechnique.*

derived from the Richmond bank facade but became more Durandesque by the suppression of pier capitals and bases. Although it was a new detail in his work, the arched entrance with the elliptical extrados of the voussoirs suggests an old interest, for this kind of arch occurred in Italian Renaissance portals. Its precise rustication, along with that of the quoins and window frames, was becoming a mannerism of this late stage of Romantic Classicism.

Perhaps Godefroy remembered Blondel's description of a masculine style achieved by simple and bold projecting masses and elimination of petty details. Plain wall surfaces with horizontal bands, repetition of arches and windows, and concern for structural expression are marks of Durand's teachings. The sense of strength, almost that of a fortress, is especially strong in the pavilions. The *contrefort* of the basement at the north end is still pointed out with pride by the local authorities as a pyramidal, "Egyptian" construction. Battered walls, patterns of rustication, and exaggerated quoins and voussoirs that had expressed character for the generation of Ledoux now were decorative structural commonplaces, signs of Durand's success. Perhaps this explains the approval of the building by local and Parisian authorities.

Laval, Palais de Justice The sixteenth-century structure used as the palais de justice (Fig. IV–11) was the former Nouveau-Château, or Galerie, of the comtes de Laval. Built for more modern living than was offered by the medieval Vieux-Château, both structures were

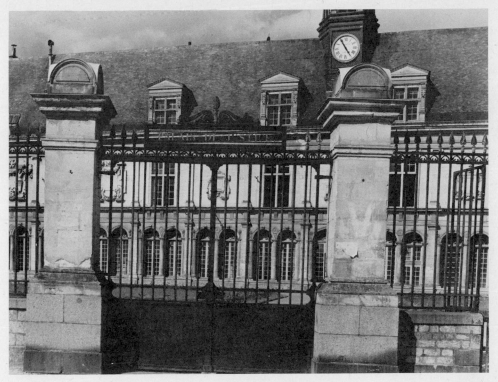

IV–11. Main gate, palais de justice, Laval. 1837.

confiscated by the department in 1792, the one for a tribunal, the other for a prison. The body of the later structure was a typical Mannerist work, one room deep and composed essentially of a single large gallery on the ground floor, with separate chambers above. It was thirteen bays long; the entrance was in the center; a tower rose above the center of the steep roof with skylights for the rooms under its slope. Following its acquisition by the department, irregular additions on the right or south end provided space for juryroom and related needs. After three decades of use the dangerous condition and unsatisfactory quarters of the building had become disturbing to both prefectural and judicial officials, and on December 1, 1827, and on August 30, 1828, unsatisfactory plans for remodeling had been offered. Because this work of reconstruction was one of the most imperative jobs allotted to Godefroy on his appointment, he immediately prepared plans for a new wing (Fig. IV–12). On June 6 and August 31, 1829, the prominent contractor E. Raimbault was named the successful bidder; by January,

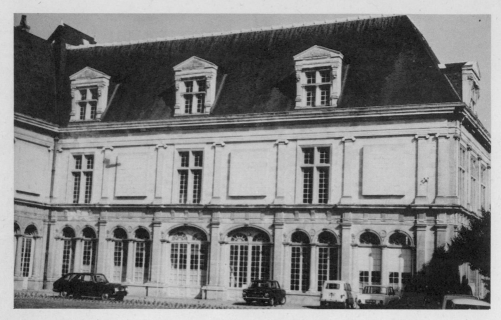

IV–12. Right wing, palais de justice. 1829–36.

1833, only finishing touches remained to be made on the 50,000-franc construction, and Godefroy was ready to turn over to the prefect a file of some fifty drawings for transmission to Paris.[20]

With the new wing virtually completed, empty rooms in both the old and new parts were rented for storage of grain and hay. Godefroy requested that this practice be stopped, pointing out that the heavy carts and transfer of these materials were causing serious damage; in the main building the attic floor had been temporarily strengthened, but the load was loosening the masonry of the walls. Additional work on the main structure continued intermittently until 1837, including the rebuilding of the roof, the substitution of six dormers for skylights, and the

[20] Information on Godefroy's work here is drawn from his report of Jan. 27, 1833, N. 825, and Godefroy to the prefect, Laval, Aug. 24, 1837, N. 834, Archives de la Mayenne. The Nouveau-Château, built in 1535–42, is attributed to Jean Garnier, d. 1588 (Jules-Marie Richard, "Deux documents relatifs au château de Laval, 1542 et 1631," *Bulletin de la commission historique et archéologique de la Mayenne*, 2d ser., 16 [1900]:422–38); the wing constructed by Godefroy is not considered. His work is not distinguished from the small left wing of 1854 in the discussions in Abbé E.-L. Couanier de Launay, *Histoire de Laval* (Laval, 1894), p. 476, and Angot, *Dictionnaire*, 2:375, 579, 626–29. A map of 1753 shows this building with no end projections (Couanier de Launay, *Histoire de Laval*, illus. facing p. 13).

IV–13. Detail, right wing, palais de justice.

replacement of the whole upper entablature and two or three courses of wall masonry. A grilled fence and gates were set up in the latter part of 1837.

The new wing covers about 225 square meters and rises 15 meters from the ground in front to the ridge beam. Located on the edge of the steep slope to the river, foundations and buttressing on that side reach down as much as 12 meters. In addition to the grand and lesser staircases, the vestibule, and the cloakrooms, an apartment for the presiding justice of the assizes, a room for his servant, offices for sheriffs and a notary, juryrooms, chambers for council and for witnesses, and an archive were specified. Ceiling cornices, iron balcony railings, and repairs to the vestibule of the main building were added to the job. The last two bays (Fig. IV–14) of the main facade were rebuilt along with the interior to ensure suitable connections between the two sections.

In the decorative treatment Godefroy was obligated to follow the pattern set by the existing facade. The two stories have Doric and Ionic pilasters superposed in the classical manner, each supporting a full entablature. On the ground floor two arches for windows are carried on engaged columns in each

IV–14. Right end, main facade, palais de justice. Rebuilt 1829–36.

bay; above, large rectangular windows alternate with blind bays decorated either with sculptured cartouches or the bed of stone for such treatment. In the rebuilt bays of the main facade Godefroy intended to have appropriate attributes of justice carved, and he obtained a bid of 250 francs from A. Barrée, a sculptor acquaintance in Rennes, to do so.[21] For the addition he continued and enhanced the existing scheme of decorative sculpture. The paterae and vases of flowers in the ground-floor spandrels and the rich Doric and Ionic capitals are carried around to the new wing (Fig. IV–13). On the dormers, whose windows repeat the rectangular shapes of the second floor, composite pilaster capitals rest on shafts decorated with motifs drawn from the rich cartouches; the upper half of each shaft is covered by an acanthus leaf and the lower half is channeled; each shaft tapers inversely, finishing in a base treated as a lion's paw. Arch keystones are small consoles, each with a leaf. Although the motifs resemble the sixteenth-century decoration,

[21] Barrée to the prefect, Rennes, Nov. 12, 1831, N. 833, Archives de la Mayenne.

the nineteenth-century work is easily distinguished by its deep, clean, precise carving.

Godefroy's passion for regularity and stability appears throughout the new construction. The spandrels of the paired arches are themselves inverted arches. Archivolt moldings, instead of being separate stones, are cut on large voussoirs which are keyed into and form the spandrels. Rather than being built of small stones as on the old structure, each member of an entablature—architrave, frieze, cornice—is a single course of masonry. Lintels in the dormers are flat arches. Except for the sculpture panels, Godefroy used ashlar blocks of uniform size; thus joints of alternate courses form vertical lines on the pilasters and wall surface. He built as though for eternity, and despite bomb damage in the 1940s which rendered his wing temporarily unusable, it remains standing.

The fence erected in 1837 is characteristic of Godefroy's methods of design. The grill of lances was cast at the same time as the fencing for the prefecture garden, with a saving in the total cost. The most elaborate part is the gate (Fig. IV–11) of two sections, with a handsome rectangular panel bearing the name of the building and carrying two scrolls and a large pine cone. Letters and lance heads are gilded, the rest painted black. The posts rest on large blocks; they have a base molding, a small cornice at the level of the cross-pieces of the grill, and a large cornice near the top. Both cornices look as though they are applied to the surface of the rectangular pier, which continues to rise to a cap composed of two intersecting semi-cylinders. Their slightly domed shape and engraved lunettes suggest similar post caps used by Soane and known to Godefroy through the posts used above the eaves of Salters' Hall.[22]

In the palais de justice Godefroy was constrained to follow the established pattern of decoration. Signs of the nineteenth century appear in the sharp and precise elegance of the carving and in the structural emphasis which had become an increasing concern of his during his years in America. Here and there, particularly in the gateposts, the emphasis on continuous wall surfaces and the interplay of simple geometric forms survive from his earliest designs. The projected relief of judicial attributes represents the allegorical approach to sculptural decoration. The formal elements of Godefroy's style and way of thinking are thus apparent despite the Renaissance trappings of the building.

[22] Cf. John Summerson, *Sir John Soane* (London, 1952), pp. 30–32, fig. 51.

The third large undertaking entrusted to Godefroy as departmental architect was centered around the departmental headquarters, the prefecture.[23] This work began simply as the creation of a new monumental entrance, yet it led to the longest and most diversified activity of his career. The prefecture occupied the site of a former Dominican convent whose materials had been reused for the new hôtel de la préfecture about 1819. Numerous dependencies had been thrown up, but stringent economies led to shoddy work, especially in the carpentry, necessitating continual repairs. Godefroy, too, had to make some repairs, but he also constructed several auxiliary buildings and established an orderly plan for the whole complex. Aside from minor changes and repairs, the prefecture survives as he left it (Fig. IV–15).

On Godefroy's arrival the hôtel de la préfecture already had a *jardin anglais* on three sides and a *cour d'honneur* before its east front (see plan, Fig. IV–17).[24] Across the court stood two isolated buildings, always called pavilions, which served as residences for minor officials. Two diagonal avenues led from the court by the pavilions to the corners of the plot. Between the pavilions and the rue des Trois Croix farther east was an assortment of structures, including stables, a coachhouse, chicken coops, privies, a *corps de garde*, and storage buildings. The main portico and adjacent *loges* stood at the southeast corner. All these buildings except the pavilions were demolished and their facilities rehoused in new buildings on the grounds.

Godefroy's detailed specifications of August 31, 1831, originally accompanied by drawings, state what was demolished, how the new place de la Préfecture was established on the axis of the hôtel, and what was to be built. The two pavilions are the base line for one straight side of the *place* (Figs. IV–15-IV–16). At the extreme ends two walls curve outward to make an area some 16 meters deep and a maximum of 67 meters long. Three years later, in the summer of 1834, J.-L.-D. Fournier, the contractor, completed the leveling, paving, wall construction, and erection of short granite posts (now gone) separating the *place* from the street. Another contractor,

[23] Godefroy's work on the prefecture is exceptionally well documented by a series of manuscripts from 1831 to 1839, including twelve drawings, in N. 833 and N. 834; see also N. 825, Archives de la Mayenne.

[24] A *jardin anglais* was customary for prefectures; see examples in Gourlier et al., *Choix d'édifices publics*, vol. 2, pl. 103; vol. 3, pl. 284.

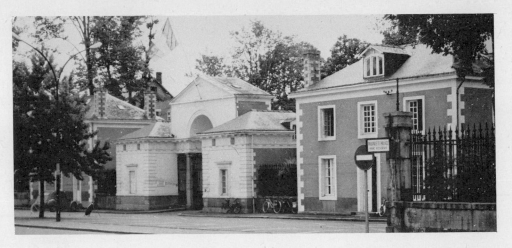

IV–15. Place de la Préfecture entrance, prefecture, Laval. 1831–34.

M. Dubois, had completed the gates and fence grill (Fig. IV–18) by May 20, 1834. Although the lances are standard forms for such grills, the fasciform supports on the curved sections are reminiscent of a motif used frequently by Godefroy and, used in a fence, strongly recall the grill of the Commercial and Farmers Bank. His detailed drawings for the fence show the meticulousness of his planning.[25]

Much more was in process during this period. The old entrance portico and lodges had to be taken down carefully in order to be reconstructed between the two pavilions. Fournier, who was appointed September 13, 1831, accomplished this move rapidly; by April 7, 1832, the new foundations and walls were considered settled sufficiently to allow the installation of the grill and large gates. The lodges were rebuilt close to their original disposition, although the windows on the court were given more elaborate frames to conform with those on the exterior fronts. Greater changes were made in the entrance arch. Perhaps originally square, it had four small triangular pediments supported by pilasters. Godefroy altered it to present a large pediment on each facade. He also suppressed the pilasters, introduced the large granite supporting piers, and raised

[25] In its small size and shape, this place resembles the entry of a private hotel, e.g., that of the older Gabriel's Hôtel du Maine, of 1728, and Courtonne's Hôtel de Matignon, of 1721 (Jacques-François Blondel, *Architecture francaise*, 4 vols. [Paris, 1752–56], 1:205–8, 217–21, and adjacent plates). Four signed drawings for the fence, dated April, 1832, are in N. 833, Archives de la Mayenne.

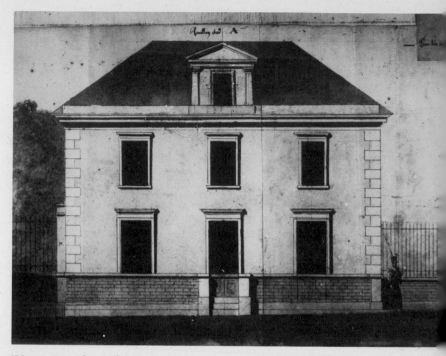

IV–16. Detail of drawing for prefectural buildings on place de la Préfecture [the drawing continues to the right, showing a north pavilion duplicating that on the south]. 1835. Archives de la Mayenne.

the pediment, leaving bare wall surface around and above the arch. Thus, in an accidental way, Godefroy was given an opportunity to use again a familiar motif, the arched opening flanked by two rectangular elements. Increasing the size and height of the arch and topping it with a triangular pediment, as he had on the Unitarian Church, gave it self-sufficiency and provided a strong contrast to the massive lodges. Comparison of his drawing with the existing structure shows that he wanted to go even further: each lodge was to have its width reduced by one metope and triglyph, and the portico was to be wider. Such an emphasis on the center was closer to Godefroy's earlier use of this motif and would still have utilized the salvaged materials, including the Doric frieze. Searching for another means of accent, he eliminated corner quoins and separated the archivolt and cornice, specifying an interval between them of no less than 32 centimeters. This expansion of the smooth wall surface contrasted the rising central form with the lower, heavily articulated lodges.

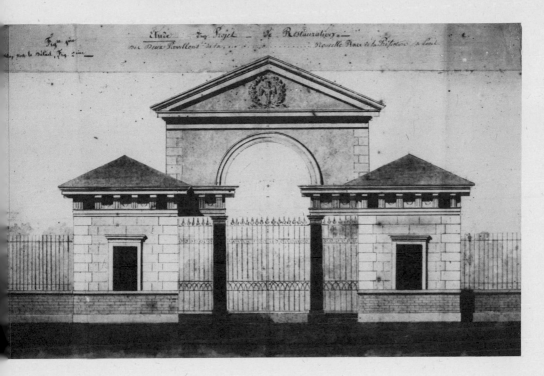

Additional emphasis on the center was to come from sculptural compositions in the pediments, which were never made. The allegorical nature of Godefroy's design appears clearly in his separate sketch for these reliefs.[26] A French cock with wings outspread, resembling the eagles on the Washington Monument project, stands on a globe. A large wreath, half palm and half oak, symbolizes victory and heroism. Between the upper tips of the wreath is the star of immortality. Except for the cock, all these elements had appeared in American works.

Godefroy's precision in both drawings and written specifications went beyond a meticulous concern for details to larger aspects of composition. The Doric entablature, he pointed out, would move from the walls of the lodges to the granite piers and through the archway to join and unite ("lier et raccorder") the two facades. He was concerned as well with the relation-

[26] A signed drawing, probably of 1831, is found in N. 833, Archives de la Mayenne.

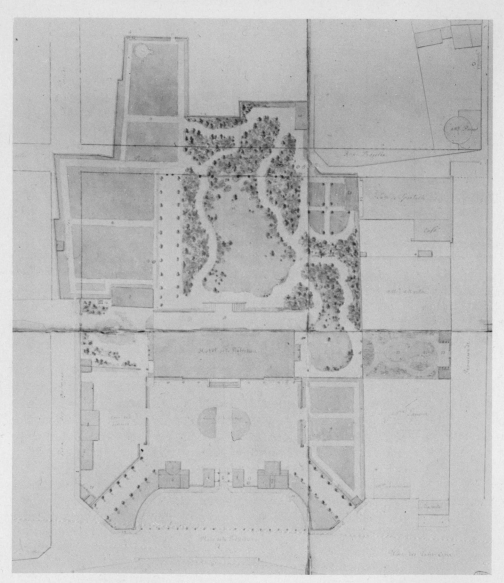

IV–17. Plan, prefectural grounds. 1836. Archives de la Mayenne.

ships between the several structures. String courses across the
lodges and the flanking pavilions, at the level of the window-
sills, established a line continued in the coping of the low walls
connecting the buildings and marking off the place de le Pré-
fecture. Moreover, the walls below the string courses and cop-
ings which were painted to imitate brickwork, a contrasting

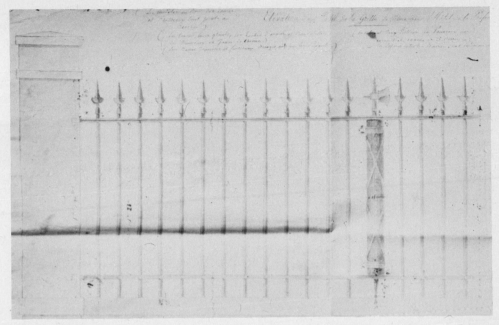

IV–18. Drawing for grill, place de la Préfecture. 1832. Archives de la Mayenne.

material, as suggested by Durand, appeared to form a continuous plinth. They now served both to unify the whole length of the *place* with a platform supporting the individual buildings and to draw the north and south pavilions into the whole composition.[27]

Once the large pavilions were exposed on their neglected east sides, they had to be dressed up for prominent display on the public square. With the basement plinth, centered doors, door and window frames topped by a cornice, and corner quoins, the new fronts not only harmonized with the arch and lodges but also resembled models given by Durand; indeed, some details, e.g., the window frames, are virtually identical with Durand's. Most of Godefroy's proposed changes were dropped for the sake of economy: the attic strip, a course of masonry above the eave, found consistently in his work from the Washington Monument to the Catholic School, was not added; existing dormers were not remodeled according to the detailed drawing;

[27] Godefroy's specifications, "Programme: Grille et portique sur la nouvelle place de la prefecture de Laval," Aug. 31, 1831, N. 833, Archives de la Mayenne.

windows and doors did not receive the richer frames he re-
quested. Some of his work has since been altered: the south
pavilion, which he disposed internally as a double dwelling,
has had its central door changed into a window and its lateral
windows opened as doors; his steps with side blocks have dis-
appeared; grayish-brown paint now covers the long stuccoed
plinth. In sum, these pavilions actually owe little to Godefroy.[28]

While the place de la Préfecture and the new entrance were
in process, the contractor Fournier was raising storage buildings,
new stables, and a coachhouse along the south side of the prop-
erty, on the rue des Auberges (now rue Mazran). The simple
treatment of these functional structures is well illustrated by
the coachhouse (Fig. IV–19), a rectangular building opened by
three arched double doors. The brick arches with large key-
stones are depressed to give the loft more height; they rest on

[28] Signed drawing of Sept. 8, 1835, in N. 833, Archives de la Mayenne;
Durand, *Précis*, vol. 1, pt. 1, pl. 2; cf. also the Caserne de Gendarmerie,
1824–30, rue Mouffetard, Paris, by Rohault de Fleury (Gourlier et al.,
Choix d'édifices publics, vol. 1, pls. 74–75). A marginal note in the estimate
for the alteration of the pavilions indicates Godefroy's purpose in planning
the attic strips: "This topping is indispensable so that the attic dormer
may not appear extraneous to the structure; in addition it is essential in
order to give some character to the facades of the two pavilions and to
palliate the anti-architectural effect of the roofs" (*devis* of Sept. 8, 1835,
N. 833, Archives de la Mayenne). A signed drawing of the dormers, dated
Sept. 8, 1835, is also in N. 833. The dormers closely resemble those by
Percier and Fontaine on the rue de Rivoli (Jean-Charles Krafft and F.
Thiollet, *Choix des plus jolies maisons de Paris et des environs* [Paris,
1849], pl. 71).

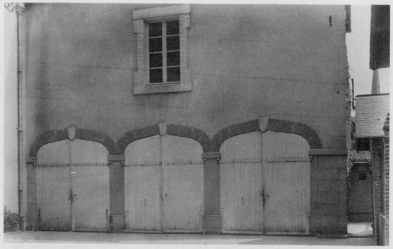

IV–19. Coachhouse, prefecture. 1831–35.

two isolated monolithic piers and two angle piers built up of carefully aligned ashlars. With its unframed windows on the street and extensive stuccoed wall surfaces, this was one of Godefroy's most Durandesque buildings.[29] Its impressive severity is diminished by the window opened after September, 1835, to permit loading directly into the loft.

As for the minor work included in the first design, the court and diagonal avenues were more carefully regulated by low enclosing walls, the drainage of paved areas was improved, several sections of fence were repaired, and minor structures such as privies, a coachman's lodging, and storage buildings, including one for salt, were built. The new organization of the prefecture was essentially completed as preserved in Godefroy's plan of June, 1836 (Fig. IV–17).[30]

As departmental architect Godefroy was also responsible for maintaining the prefecture. He made small repairs to its roof in 1832 and 1834 and in May, 1837, submitted projects and estimates for four methods of rebuilding the entire roof. He strongly recommended, and the prefect approved, Delorme's method of cross-bracing the beams to ensure a strong and stable construction. In the course of this work the dormers were probably rebuilt in their present form, simpler than those Godefroy had designed for the pavilions but coming forward to the edge of the building as he preferred. Of greatest interest in this undertaking is his recommendation of Delorme's method, for this also received the high approval of Durand.[31]

The plan of 1836 went beyond recording the status quo. With appropriate alterations it became the blueprint for Godefroy's architectural activities of the next four years. A piece of property on the north was acquired in order to give the prefecture direct access to the rue de la Paix and the Promenade. Streets were pierced to form rectangular boundaries on the south and west sides of the grounds. In 1837 new walls and grills were erected, and the *jardin anglais* was slightly altered to fit its smaller enclosure. From October, 1837, to December, 1838, Godefroy surveyed the new streets, the private property which

[29] Although a specific comparison is impossible, this building possesses some elements—stuccoed walls, arcades on piers, prominent roof, gable on the long axis—to be seen in Durand, *Précis*, vol. 1, pt. 2, pls. 5–7. Some of these elements are certainly Italianisms (see Emil Kaufmann, *Architecture in the Age of Reason* [Cambridge, Mass., 1955], pp. 201–4).

[30] A drawing for a *hangar*, including storage area and latrines, signed and dated Aug. 20, 1835, is in N. 833; Godefroy's signed and dated overall plan is in N. 834, Archives de la Mayenne.

[31] See Jean Prévost, *Philibert Delorme* (Paris, 1948), pp. 64–74; Durand, *Précis*, 1:61–62, pt. 1, pl. 3.

had to be condemned, and the excess prefectural property which was parceled for sale on December 20, 1838.[32]

On April 29, 1838, he raised the question of the gardener's lodge (Fig. IV–20). It had to be removed from its site, which was about to be sold. It was rebuilt almost twice as large in the spot Godefroy had indicated on the 1836 plan, on the northwest boundaries of the prefecture. Like the coachhouse in the opposite corner, it is rectangular, with bare stuccoed walls. The second-story windows, four bays long, light the gardener's apartment; wide arched openings on the ground provide ample passage for work and storage areas. The brick arches, with large rounded keystones, and the brickwork imitating stone quoins on the corners, windows, and imposts provide a decoration that stresses the building's construction. Evoking the "aqueduct" motif that spread so widely in Baltimore, a string course connects impost blocks and arches. It is another device approved by Durand in both text and plates of his *Précis*.[33]

[32] This work is recorded in two signed drawings, dated Sept. 12 and Oct. 18, 1838, and one with neither signature nor date, N. 834, Archives de la Mayenne; see also Couanier de Launay, *Histoire de Laval*, p. 474.

[33] Richard H. Howland and Eleanor P. Spencer, *Architecture of Baltimore* (Baltimore, 1953), pp. 45–46; Durand, *Précis*, 1:80, pt. 1, pl. 8, pt. 2, pls. 5, 7, et al.

IV–20. Gardener's lodge, prefecture. 1838–39.

At the other end of the the new western boundary line Gode-
froy introduced two small gateways and a stretch of lanceolate
grill (Fig. IV–21). This work had been planned by October,
1837, and was carried out in the following spring and summer,
along with the gardener's lodge. Time has not been kind to
the worn sandstone of the archway; its damaged parts belie
the strength implied by its rusticated imposts and voussoirs.
Protected from accident by its height, a modillion cornice
surrounds the structure near the top. Fenceposts built of granite
blocks repeat the profile of the posts used on the east side:
they have just two projecting bands at the top. Without orna-
ment, they suggest a naked functionalism.

Godefroy's last work at the prefecture concerned the rec-
tangular plot leading north to the *promenade*. Early in March,
1839, he submitted drawings, now lost, and letters describing
the pillars, gate, and grill, and contracts for the work were

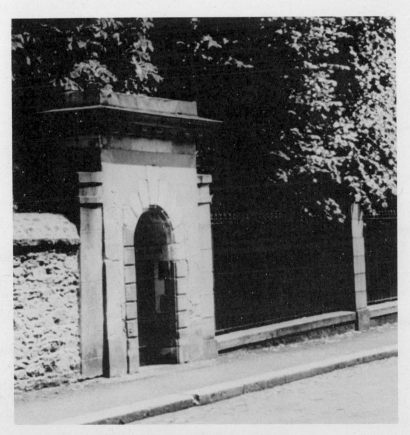

IV–21. West garden entrance, prefecture. 1838–39.

let out at the end of the month.[34] Like those in other parts of the prefecture and at the palais de justice, the pillar consists of a rectangular pier rising from a large base and emerging at the top above minor and major cornices. Keeping in mind the appropriateness of richer ornament on the *promenade*, Godefroy designed the upper cornice with a complex profile of rectangular and curvilinear moldings and the lower one with a series of dentils; he filled the space between the two with a wreath of oak leaves. Thus these piers, almost four meters high, have allegorical sculpture to fortify their statement of strength. During the summer he laid out the small *jardin anglais* in this plot.

Eminently practical and carried out with restricted funds, all these operations bear witness to Godefroy's competence in several aspects of architecture and engineering. Whether for budgetary reasons or because of the prevailing taste in France, the influence of Durand is appreciably greater here than in Godefroy's American works. At the same time, however, especially in areas of the design where he was less constrained, like the entrance portico, there is a continuation of elements and ideas first seen in Baltimore. He was an old man, but in this provincial capital his work was not yet considered old-fashioned.

Château-Gontier, Tribunal and Mairie, Projects

The structure housing the mairie and courts in Château-Gontier required both restoration and enlargement. From December, 1829, to October, 1831, Godefroy made several visits to the city to offer various designs, but the work was given to an engineer.[35] One sheet of Godefroy's drawings (Fig. IV–22) shows two variant elevations on a common plan, schemes dated January, 1830. The addition of a one-story projection, as on his exchange study, allows a reworking of the former vestibule with new space to provide an apartment for the concierge, rooms for firemen and police, a kitchen, privy, lockup, and two stairways.[36] Behind a column screen, a semicircular vestibule with a central door leads to the old building. Not only had

[34] Godefroy to the prefect, Laval, Mar. 1 and 7, 1839, N. 834, Archives de la Mayenne.

[35] All information on this project is drawn from N. 825, Archives de la Mayenne, which contains a signed drawing, dated January, 1830, with plan and two elevations, and a lengthy report on his services, dated Jan. 27, 1833. Château-Gontier is about fifty kilometers south of Laval.

[36] This is a characteristic group of services to be housed near the entrance; cf. the hôtel de ville of 1829, at Quimper-Corentin (Gourlier et al., *Choix d'édifices publics*, 3:8, pls. 93–4).

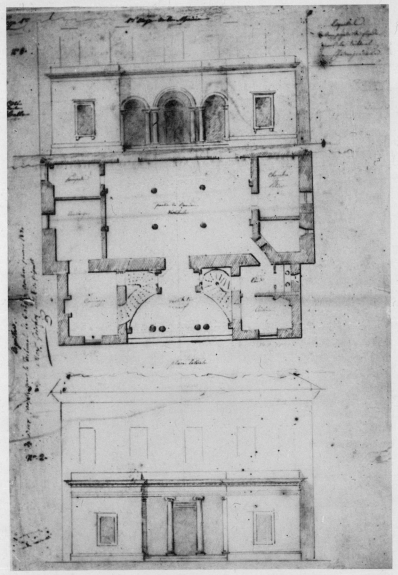

IV–22. Project for enlargement of mairie, Château-Gontier. 1830. Archives de la Mayenne.

Godefroy previously employed the device of hollowing the vestibule out of the building mass, but it was almost a hallmark of Revolutionary architects like Ledoux.

Both elevations show a central entrance raised on two steps and recessed slightly behind two end blocks. Although the

proportions are different from those of his Masonic Hall and Unitarian Church, the idea here is still another reworking of the old entry motif, and it may have influenced the slightly later portico of the prefecture in Laval. One elevation has a triple arcade carried by two pairs of Doric columns and two antae. A simple frieze and cornice run across and around the side of the building. With simple archivolts and bare wall above them, this project has the air of a Revolutionary design, despite the outdated dominance of the larger central arch. In this project the central area is necessarily wider than in the second one, where two Ionic columns in antis support a full Ionic entablature. Both facades show the wall masonry continuing above the cornice.

In their slightly different ways, both projects reveal Godefroy's aims in the manipulation of his primary design motif. By opposing open against closed parts, by contrasting shapes and sizes, and by manipulating light and shadow, he sought to achieve the greatest differentiation between the central and the flanking elements.

Other Departmental Works

Little is known of several works and projects of Godefroy's.[37] The drawings for them have disappeared, and in some cases existing records contain little more than a bare mention of them. The place, date, and extent of the first work to be discussed here are all known, but the loss of the drawings for it makes this analysis speculative. By December, 1829, Godefroy had outlined additions and repairs for the prison in Mayenne, an old Gothic structure. Jarry and Drouet, the successful bidders, received their contract on January 7, 1830, finished the work by the winter of 1831–32, and received their final payment on August 27, 1832, after the foundations proved satisfactory. Intended simply as the addition of a new lockup and two police rooms when it was begun, the project grew in scope to include heavier foundations and a second story, repairs on the old city wall adjacent, and terracing and paving of the neighboring promenade. Even so, Godefroy reported, the old building needed buttressing, a new stairway, and repairs on the enclosing wall. All traces of this work have disappeared.

In July and August, 1829, and for a short while thereafter, Godefroy offered a series of minor projects to improve the un-

[37] Information on this activity is drawn from N. 825, Archives de la Mayenne. Some works are referred to in Angot, *Dictionnaire*, 2:375, 574, 598–99, 613–14, 627.

healthy conditions at the prison of Laval. In the former Vieux-Château of the comtes de Laval, begun in the eleventh century and converted to prison use in 1792, clouds of bats hovered over the heads of the chained prisoners in the dark vaults; rainwater stagnated underfoot. His reports were filed and forgotten. In November, 1831, he designed a residence for nuns serving the prisoners, but another project was chosen.

During his first few years in the city Godefroy was asked to design several projects for barracks for the gendarmerie in Laval. A former chapel and convent of the Cordeliers, dating ca. 1400, had been converted to this function, which it continues to perform today. In 1829 he made preliminary studies for a building on the rue de la Paix, near the prefecture, but it was decided to erect a hospital on the site instead. In 1830 he made measured drawings of the old barracks and projected a new one in its neighborhood. In 1830–31 he drew up a most ambitious plan for the development of a new quarter of the city. From a new quai east to a new avenue opposite the theater of 1827–30, and from the rue de la Paix north to the Pont Neuf, built during the First Empire, a *ville neuve* would be laid out and the new *caserne* would give impetus to its growth. However, military engineers took the problem out of Godefroy's hands by enlarging the existing gendarmerie. Undoubtedly Godefroy was occupied with similar works in Laval and other cities of the department after 1832. What is certain, however, is that he was continually occupied by festival and holiday decorations which, as is their nature, generally leave no trace.

For all his seven years in London and extended stays in Paris, there is but small evidence that Godefroy was a student of contemporary architectural activities. Although the grandiose undertakings of Soane, the urbanizations of Nash, the many terraces, and the commissioners' churches were changing the face of London, Godefroy was predisposed to scorn English public architecture. Even Soane's work must have seemed to him overly articulated, its grandeur diminished by small divisions, and its idiosyncratic surface decoration too personal. Paradoxically, it was Soane's work which provided the inspiration for the one new element—the post caps of the palais de justice—indicating that Godefroy was familiar with modern English work. In France, too, there was concerted architectural activity under the restored Bourbons and Louis-Philippe such as had never before been seen. Although specific models can-

not always be pointed out, the quality of Godefroy's late work suggests an awareness of contemporary events. His expression of structure through exaggerated masonry, formal layout of large building complexes, and emphasis on bare wall planes display the dry and already academic taste of nineteenth-century France. If he avoided the long colonnades of both Durand and the Beaux-Arts, it was in part the result of the economy which he was required to practice in his commissions.

Throughout his work after returning to Europe Godefroy displayed a mastery of the details of his profession. Problems of design and draftsmanship, writing of specifications, supervision and certification of construction, legal formalities, liaison, minor engineering functions—all came within his competence, and he handled them successfully, de Lorgeril to the contrary notwithstanding. His buildings have, for the most part, served satisfactorily for over a century. He had bad luck, limited resources, and difficulties of a personal nature. He was no world-shaker, creating patterns for the future; rather, he perpetuated, with slight alterations, elements that were present in his American works, and in this respect his European work was an anticlimax.

V. Personality and Architectural Style

Within the general architectural style of the period, Godefroy's assumed a particular shape determined by his artistic personality, the unique blend of his unusual training, preferences, and experiences. In the Baltimore where his architectural conception first reached maturity, the general style called Federal incorporated several different tendencies. An Americanized version of the late Georgian Adamesque, known from several handbooks, survived and spread throughout the city in the buildings of carpenter-architects like George Milleman. The modern European manners entered, with a strong French accent in the work of Godefroy, more English in that of Latrobe, and became the basis for the immediate future after this Federal age. As a substratum the great mass of construction in the ageless vernacular of brick exerted an incalculable effect on taste by presenting everywhere its simple rectilinear shapes.

The late work adds to our understanding of Godefroy, although its significance in France was infinitesimal. In Baltimore, on the other hand, Godefroy's inclination toward simplified, compact buildings and new methods of organizing surface patterns, his ideas on expressive character and the place of allegorical sculpture, and his taste for substantial construction in masonry were unique. Evaluation of his success as an architect thus rests upon his career in Baltimore, where he developed these aspects of his manner.

A few clues in his writings and works point to some of the architectural sources of his style. A corresponding study of nonarchitectural data concerning Godefroy can illuminate his understanding and practice of architecture. His personal qualities and taste, his physical and mental condition, even his nonarchitectural knowledge may be relevant, and occasionally a specific architectural relationship may be established. More often we must be satisfied with only approaching an understanding of his thought processes.

There are several accounts of the way in which contemporaries viewed him. All stress his probity, from the friends

who sought his freedom in 1803–5, to Francoeur and Quéquet in 1827, and, later, to Poussin, who knew him in 1817–18 and saw him again in Paris as late as 1840. The stress on honor appears in the report made by the architect Huvé to Rohault de Fleury. Upon Henry Latrobe's graduation from St. Mary's College, his father thanked Godefroy for teaching his son and especially for offering the boy a model of probity. It was the destruction of this image of Godefroy that grieved Latrobe most when Godefroy displayed their private correspondence at the time of the rupture of their friendship in 1816.[1]

Godefroy's pride was also an important element in his character. In repetition an honorable incident grew, and was probably exaggerated, to become a new basis for it.[2] Pride, too, aggravated his contempt for Mills, and he never became reconciled to his loss in 1814 in the competition for the Washington Monument in Baltimore. Despite the fact that the quantity of his production was low over many years, Godefroy felt that it was qualitatively high. Accordingly, for a long time he planned to have his drawings engraved, sure that financial success would follow this undertaking. He kept duplicates of all his architectural designs, along with written records, with an eye toward publication. Several times he misinterpreted a favorable comment as high praise and felt thwarted when commensurate rewards were not forthcoming. Despite this apparently blinding pride and his unwillingness to admit error, Godefroy did practice a silent self-criticism which was the basis of continued growth and development as an architect. Godefroy's pride and integrity were combined with a high degree of irresponsibility. Occasionally he made designs without full awareness of the architectural and other requirements of the project and later

[1] Many relevant statements appear in Godefroy's police file, F⁷ 6366, doss. 7484, and those of Francoeur, Quéquet, and Huvé are in F¹³ 650, Archives Nationales, Paris. The picture drawn by Poussin is worth quoting: "M. Godefroy was, for me, a very interesting man, a true artist of the old stamp, full of memories of a past taken up as much in wars as in the arts" (Guillaume-Tell Poussin, Les Etats-Unis d'Amérique [Paris, 1874], pp. 57–58). Latrobe's views appeared in letters: Latrobe to Godefroy, Washington, Oct. 1, 1808, and Baltimore, June 5, 1816, Benjamin Henry Latrobe, Letterbooks, Maryland Historical Society.

[2] E.g., Godefroy's accounts of his prison escape and surrender (Dorothy M. Quynn, "Maximilian and Eliza Godefroy," Maryland Historical Magazine 52 [1957]: 9–10; see n. 20 below for the accounts). As a bit of evidence of Godefroy's pride, his membership in the Pennsylvania Academy was foremost among the titles accompanying his signature on several reports and drawings he made in France in the 1820s and 1830s, although that organization could have little or no importance in the French provinces.

complained about the resultant dissatisfaction with his plans. At other times differences arose because he mistook an expression of interest in one of his projects for a positive commission.

His chronic financial distress was caused in part by his inability to manage his small income. He was extravagant in purchases of books and prints, and felt the need to "act the gentleman," as he put it, which led him to commission a portrait of himself by Rembrandt Peale and another in clay, probably by Antonio Capellano.[3] When he received an advance on his salary at St. Mary's College, he usually gave a note or receipt. Yet despite this evidence of good faith he left behind some sizable debts when he sailed for England, one such loan cosigned by the fathers at St. Mary's. In ten years he never repaid a cent on the loan made him in 1809 by Robert Oliver and Mrs. John Craig. Financial obligations apparently did not rank as high as personal loyalty in Godefroy's definition of probity. His hatred for Latrobe raged for twenty years, so strongly because he felt Latrobe had betrayed their former friendship. His reverses in 1817–19 he laid to a cabal directed by Latrobe. Flight to Europe was an escape from a situation that had overwhelmed him, and paralleled the flight from responsibility that led him to place all the blame for his various failures on Latrobe.[4]

Godefroy's social failure—to refer thus to his inability to achieve a decent living and adequate recognition from his professional activities—arose in part from his irrationality and lack of discipline. Actions which to him were matters of honor and pride seemed causes of affront or examples of downright stupidity to others. Edward Patterson, for example, made the latter interpretation of Godefroy's despair over the Baltimore Exchange struggle, when he wrote to his sister, Mme Bonaparte, that the Godefroys "have caricatured themselves out of a liv-

[3] For the quotation, see Godefroy to Dubourg, Baltimore, Nov. 1, 1806, Maryland Historical Society. The Peale portrait, done about 1814, is owned by the Peabody Institute and is on deposit at the Maryland Historical Society; for the bust (now lost), see E. and M. Godefroy to Jackson, Laval, Sept. 22, 1836, Maryland Historical Society.

[4] On Godefroy's indebtedness, see Godefroy to Tessier, Baltimore, June 22, 1819; Ledger B, p. 20, Robert Oliver Papers, both Maryland Historical Society; Quynn, "Godefroy," pp. 17–19. Contrary to Quynn's implication, Godefroy's requests to the Sulpicians were usually for advances on his salary; see Godefroy to Castet, Baltimore, Dec. 13, 1810, Maryland Historical Society. For his attacks on Latrobe, see Godefroy to Jackson, Richmond, Sept. 7, 1816, Baltimore, Aug. 13, 1818, Laval, Aug. 30, 1836; Godefroy to Tessier, Baltimore, June 22, 1819; all at the Maryland Historical Society.

ing." Godefroy may well have lost professional opportunities because of making excessive demands dictated by pride rather than reason. His drawings for a church in Savannah were accompanied by a long series of conditions under which he would take on the complete designing and superintendence of the building. One condition was that no other architect be consulted, and another that no competition be held. Leapfrogging from this point, he requested that he be paid the sum that might be spent on competition premiums. A seemingly rational, business-like proposition, it was in fact absurd if, as seems to have been the case, the trustees had never had any intention of establishing a competition in the first place.[5]

Of a piece with Godefroy's irrationality was the impulsiveness of many of his important actions. The decision to leave for England was made so hastily that the Godefroys did not even have time to see some friends from whom they wished letters of introduction. No hint of his departure appears in his correspondence even as late as two weeks before departure. Godefroy described the next move, from England to France, as so hasty that he had no time to pack his belongings. As a result he had to pay rent for four years on the house in London where he had left all his furniture, books and prints, drawings, and personal papers.[6]

This combination of personal qualities made Godefroy unsympathetic to many people, and he, like his wife, made many enemies. He did have, however, deep and long-lasting friendships such as those with Francoeur and Quéquet. Trigant de la Tour and Jackson, two of his former pupils at St. Mary's College in Baltimore, also remained close to him. The former housed him in Paris and helped him in his job search; Jackson, who was traveling in Europe in 1836, tried to contact Godefroy in England and France and finally located him through Trigant. Jackson advanced money to enable Godefroy to bring his books, drawings, and four chests of papers from London after ten years of storage. To aid him further he purchased some of the drawings for 3,500 francs, over four times the amount of his loan.[7]

[5] For the Patterson letter, see Quynn, "Godefroy," p. 20. For the Savannah design, see Chapter III, n. 46, above.

[6] Godefroy to Jackson, Laval, Sept. 7–10, 1836, Maryland Historical Society.

[7] Two and a half years after Godefroy's arrival in Baltimore a satirical pamphlet of French verses was published by "Edward Je m'en Fiche." Its critical tone and strong language led to its popular attribution to Godefroy. He and his friends found it necessary to publish a denial and defense. See *Baltimore American*, June 16, 18, 1808; "Maximilian Godefroy," *Mary-*

All these friends were able men who achieved some degree of eminence in their various professions, and their friendship was testimony of their faith in Godefroy's abilities. In the correspondence between Latrobe and Godefroy, in which a virtuoso brilliance shone on both sides, Latrobe's letters were more consistently profound, joking, and worldly, while Godefroy's often flashed with a caustic and erudite wit that Latrobe was quick to appreciate. Each man realized he could learn much from the other, although Godefroy was both less ready to admit it and less reluctant to ask for aid. Latrobe admired the integrity, taste, and intelligence he recognized in Godefroy. The relationship began within a few months after Godefroy arrived in Baltimore, and it rapidly became a very personal interchange between two well-educated and cultivated men of the Old World, who felt they had more in common than they had with with those born in the New World. Latrobe's correspondence offers no evidence that he became equally intimate with anyone else in America.

The relation between these two unusual men is documented almost entirely by Latrobe's side of their correspondence. Godefroy's letters can, in small part, be reconstructed from Latrobe's, and a sizable fragment of one of them is happily preserved. Four pages in Godefroy's small and elegant hand, it ranges from the poor state of his health to his prediction of English strategy in the war with America. Responding to a suggestion of Latrobe's, he wrote that it was impossible to hire strong men and a wagon to move his books and other valuables to a place safe from English marauding; large parts of the population of Baltimore were fleeing, and even that very afternoon (probably May 9, 1813) the British had made a feint at the city. Deploring its defenses, Godefroy observed bitterly that the carpenters and builders were "the Phydiases and Vaubans of Baltimore," a comment that so attracted Latrobe that he later used and enlarged upon it.[8]

land Historical Magazine 21 (1926), 273–77. On Jackson's aid, see Quynn, "Godefroy," pp. 23–24, 27–30.

[8] This letter was in response to one of Latrobe's (Latrobe to Godefroy, Washington, May 6, 1813, Letterbooks). He took up and expanded several of Latrobe's points, especially the question of British strategy and reasons for the destruction of captured towns. Latrobe separated this analysis from the rest of the letter and sent it to the secretary of war in an effort to obtain an official appointment for Godefroy (Godefroy to Latrobe, Baltimore, May 9, 1813, War Department, Letters Received, G-73[7] Enc., Record Group 107, National Archives, Washington). For Latrobe's reuse of Godefroy's expression, see Latrobe to Godefroy, Pittsburgh, Oct. 10, Dec. 12, 1814, Letterbooks.

A similiar bitter and pointed comment triggered the break between Latrobe and Godefroy. After they had worked for eight months in a despondent atmosphere, their plans for the Baltimore Exchange were selected in February, 1816. Godefroy was dissatisfied with the predominance of Latrobe's style, taste, and ideas in the composition. In one of his several attempts to settle this dispute, Latrobe explained how much he was indebted to Godefroy's grand conceptions, which he considered superior to his own for the whole work, while at the same time, he said, he felt himself superior in "the lingua Carpenteria and Stonecutteria . . . and in the habitual flippancy of professional charlatanism." Although this last expression was Godefroy's own term for perspective renderings, as Latrobe later noted between the lines, he chose to interpret its use here as an attack on his probity and abilities. Godefroy met with the board of directors and tried to have Latrobe eliminated from the job, but the board, in due time, appointed Latrobe as the sole superintendent of the work. To the end of his life Godefroy felt that Latrobe had betrayed him, had persisted in undermining his later opportunities, and had forced his departure from Baltimore in 1819. In justice to Latrobe, it is necessary to repeat that even after the break he gave Godefroy credit for the main front of the exchange and refused to compete against him for the Unitarian Church design.[9]

Although his unhappy personal qualities led to misfortune, it cannot be said that Godefroy's work suffered from them, except perhaps quantitatively. Something more than simple financial need and the desire for glory drove him toward impossible goals and frequent misunderstandings. A thorough conviction of his own superiority continued to blind him to the admirable elements in the work of other men. As a result, he rarely copied directly from the work of others or from books.

Further, his lack of discipline was responsible for much of his versatility and invention. Neither the books which he collected avidly nor formal architectural training restrained him from roving widely through the history of styles. He related fragments from disparate styles and periods and grouped elements in unorthodox ways. His unusual and striking architectural and sculptural arrangements were often combinations of

[9] Latrobe to Godefroy, May 27, 1816, and Latrobe to J. S. Smith, Washington, June 5, 1816, Letterbooks; both quoted in part, but without the passage dealing with "professional charlatanism," in Talbot F. Hamlin, *Benjamin Henry Latrobe* (New York, 1955), pp. 491–92. On the Unitarian Church design, see *ibid.*, pp. 470–71.

only a very few motifs. Godefroy, without the profound imagination of Latrobe, was a contriver of new relationships rather than a creator of new forms. Since he lacked the usual training and used books capriciously, the only control over his invention was his increasing concern with construction, which became most evident in his later work in France.

With such a complex, highly emotional temperament Godefroy could hardly be expected to possess a consistent theory of art. Only once, indeed, in all his surviving pages does he refer specifically to the theoretical aspects of architecture. While designing the *chapelle funéraire* to employ the four granite shafts contributed by Mayor de Lorgeril in 1828, Godefroy described briefly his varying devices for using the shafts in a pleasing, yet academically acceptable manner. One solution in Greek Doric he labeled so bold as to need official sanction by the savants of the Commission des bâtiments civils. In any case, he added, he intended to submit the artistic problem to the commission as an especially difficult one. This episode does not indicate formal academic training but rather a long exposure to books. Yet for all his expressed concern for rules Godefroy's three designs were curiously unacademic and exemplify the workings of his untrammeled, self-trained architectural imagination. It was this kind of imagination that led him to fuse Egyptian elements with the Tower of the Winds order for the Smith double tomb (Fig. II–31) of about 1815 in Baltimore. Almost a decade earlier he had experimented with the unusual capital of St. Mary's Chapel (Fig. II–14), perhaps inspired there by Egyptian sources; in the vestibule and organ (Fig. III–12) of the Unitarian Church of 1817 he again associated the Tower of the Winds order with Egypt. These are evidences of his awareness of French theoretical analyses of architectural development from the primitive cabin through classical Greek structures, but with his own generation, as he read Durand, he placed Egyptian architecture at a point more ancient and therefore more fundamental than the Greek. If Godefroy saw himself as contributing to theoretical studies, therefore, he was unable to carry them out systematically.

Especially characteristic of Godefroy was his habit of preparing alternative designs for a specific building, sometimes differing in the decoration or stylism employed, at other times offering two or more totally different conceptions. He usually expressed no preference himself and left the responsibility for selection to the owners as long as he was certain that one of

the designs he submitted would be chosen.[10] Yet it was not the irresponsibility, lack of discipline, and impetuousness that mattered; his taste for alternative solutions was not confined to architectural problems but was the product of a mind that enjoyed complications and ingenious variations. When his friend Jackson offered in 1836 to help bring Godefroy's belongings from London, the latter computed the cost for different routes, comparing distances, portage in different harbors, and other factors, in order to determine the safest and least expensive route. Similar considerations governed his discussions of alternate methods of reconstructing a roof, of organizing a plan for the greatest economy and usefulness, and of arranging architectural and sculptural features for their symbolic value.

Associated with Godefroy's analytical bent were his love of mathematics and his concern for detail. It has been noted that on his arrest in 1803 the police found thousands of pages of notes on geometry and algebra, studies deemed essential for the engineer and architect. The archives in Laval preserve dozens of pages of minute calculations, sometimes comparing alternate procedures, always listing dimensions and costs almost down to the last nails and bolts. His plan and elevation drawings, too, may show the finest measurements.[11]

In contrast to the irresponsibility he often showed in his personal affairs, in architecture he desired to be self-sufficient and found it difficult to delegate tasks to others. He was not afraid of work, whether it was directing hundreds of untrained volunteers in digging ditches for fortifications or working at the drawing board on plans he thought would be altered or even discarded. As a result, during his Baltimore days he repeatedly reached the end of a school year in a state of exhaustion.

Physically he must have been strong, for he suffered few of the ordinary illnesses of which Latrobe, for example, frequently complained. A chest injury, which may have caused his army discharge in 1795, continued to trouble him for many

[10] E.g., for the Independent Presbyterian Church in Savannah. Godefroy offered two or three designs for most of his American projects and for several in Europe. Latrobe differed in that his Gothic and classical designs for the Baltimore cathedral were sequential. Soane did suggest different stylisms on the same plan for his Commissioners' churches in the early 1820s (Dorothy Stroud, *The Architecture of Sir John Soane* [London, 1961], p. 131, fig. 185).

[11] The inventory of Godefroy's papers is preserved in F⁷ 6366, doss. 7484, Archives Nationales. His drawings and specifications for the grilled fence of the prefecture of Laval are a good example of his detailed calculation of costs (N. 833, Archives de la Mayenne, Laval).

years. More serious was a recurrent inflammation of the eyes, which he mentions in 1806, in 1813, and again in 1836 at a time when, despite the pain of the infection, he was spending six to eight hours each day at his desk. Disregard of one's physical condition to such a degree suggests some sort of emotional imbalance, and indeed in 1803 the French police reported signs of an exaggerated imagination and his sister sought his release partially on the grounds that Godefroy suffered a "weakness in the head." His letters, and those of his wife and Latrobe, show how much he was at the mercy of events. He oscillated between exaltation and despair, but as frustrations, disappointments, and signs of opposition multiplied in his affairs the latter state became more frequent. At these times he voiced paranoiac suspicions, made the most arrogant accusations, and talked of his impending execution for indebtedness. Yet at fifty-four and again at sixty-one he was able to start life in a new country with the highest hopes.

To support his architectural designs and conceptions Godefroy consistently appealed to taste rather than theory. Although documented infrequently, this emphasis strongly impressed his pupils, was at the center of his disagreement with Latrobe in 1816, and formed his major argument for the completion of works at Laval in the 1830s. From the time of their first contacts in 1806 Latrobe and Godefroy shared the feeling that American taste was deplorable. Latrobe readily agreed to Godefroy's request for articles for the *Observer*, the newspaper edited by Eliza Anderson, Godefroy's future wife. Latrobe's two-part essay, "Ideas on the Encouragement of the Fine Arts in America," emphasized his shock on observing much recent architecture. In numerous letters, and doubtless in their conversations, Latrobe recognized Godefroy as his only ally in the war against the Goths and Vandals of America and paid as much respect to his taste as to his probity. It is significant that he retained this attitude even after their break.[12]

[12] When the lances of the entrance grill of the prefecture were not set erect and in line, Godefroy wrote, "This fault is too shocking . . . for me to be able to accept them in this condition." The completion of the buildings on the new place de la Préfecture, he wrote, was "demanded by taste" (Godefroy to the prefect, Laval, Apr. 8, 1833, Feb. 18, 1834, N. 833, Archives de la Mayenne). There can be no doubt that Godefroy inspired some of the opinions expressed in the *Observer*: see, for example, the editorial essay "Painting" (May 30, 1807), in which the United States is described as a Siberia of the arts. The references to Volozan in this essay and a later item (Nov. 7, 1807) undoubtedly stemmed from Godefroy. He probably wrote the letter signed "G." (Sept. 19, 1807) which considered the melancholy plight of unrecognized artists; a long account of the

In their emphasis on taste Latrobe and Godefroy showed their common origins in the eighteenth century. Godefroy could assume that everyone agreed on its importance when he advertised for students: "Drawing [is] so indispensable to the progress not only of public taste in general, but also of the mechanic arts, and the *improvement of national manufactures.*" [13] This statement points up what Godefroy owed to the Neoclassical theory of drawing as the basis of art: linear precision and measurable proportions, with an emphasis on perfected nature, underlay the form of beauty that could be comprehended by reason. Two drawings which Godefroy considered among his most important similarly indicate the origins of his taste. A large representation of Harpers Ferry, probably made in 1810, was described when first exhibited as "the first of a series of the principal picturesque views of the United States" and was to be engraved on a subscription basis. Several years later, in 1816, he drew as a pendant the *Natural Bridge* in Virginia, which was accompanied on its first exhibition by a long quotation from Jefferson, beginning "the natural bridge is the most sublime of Nature's works." Thus the two drawings were conceived as a pair exemplifying the Picturesque and the Sublime, two terms with which the eighteenth century rationalized the pleasures derived from the enriching experience of nature's irregularities and the excitement of such emotions as the awe and terror arising from encounters with infinity and divine works. Artists, in turn, sought devices to exploit these sensory and emotional sources of pleasure. [14] Like most French

neglect of Eustache Le Sueur, it ended with the statement that he was now recognized as "one of the greatest ornaments of the 17th century." For Latrobe's repeated statements of respect for Godefroy, see Latrobe to Godefroy, Washington, Aug. 18, 27, Oct. 29, Dec. 27, 1806, Jan. 8, 1807, Oct. 23, 1808, Letterbooks. One sentence from the letter of Jan. 8, 1807, will characterize their attitude: "I believe anything that can be said of the Vandalism of the Baltimoreans in the arts, provided it is exceedingly absurd & ridiculous."

[13] *Baltimore American*, Nov. 19–28, 1812.

[14] *First Annual Exhibition of the Society of Artists of the United States. 1811* (Philadelphia, 1811), p. 19; *The Exhibition of the Royal Academy* (London, 1823), p. 30; Thomas Jefferson, *Notes on the State of Virginia*, ed. W. Peden (Chapel Hill, N.C., 1955), pp. 24–25. Edmund Burke's *Inquiry into the Origin of Our Ideas of the Sublime and Beautiful* of 1757 defined the variety of relevant emotional experiences as well as means for evoking them; see also Samuel Holt Monk, *The Sublime* (New York, 1935; Ann Arbor, Mich., 1960). Uvedale Price made clearer distinctions between the two while defining the Picturesque in his *An Essay on the Picturesque* (London, 1794); the basic modern study is Christopher Hussey, *The Picturesque* (New York, 1927; Hamden, Conn., 1967). For an overview of this intellectual activity, see Walter John Hipple, *The Beautiful, the Sublime, and the Picturesque* (Carbondale, Ill., 1957).

architects of the period, Godefroy was more concerned with
the Sublime, appealing to the Picturesque in only the most
limited way in the small prefectural *jardin anglais* in Laval,
designed in his last years; in the humbler buildings there he
avoided the potential irregularities of the Italianate manner.

Godefroy's conflict with Latrobe over the Baltimore Exchange
indicates that his preferences were essentially dependent on the
French world in which he spent his first forty years. Explaining
his side of the disagreement he wrote that he wanted to correct
errors of a practical nature, i.e., wasted space in Latrobe's plan,
as well as faults in taste, in order to make the exchange less
English and more suitable as a public edifice. "In Europe we
do not accept modern English architecture as either masculine
or pure," he declared.[15] Godefroy was clearly extrapolating from
his readings and the salon conversations in which he had par-
ticipated and from his sources in French architecture and theory,
which presented a program linking buildings and ideas. While
his Battle Monument of 1815 (Fig. II–37) bore the precision
and elegance of Consular France, his Exchange study of 1816
(Fig. III–2) joined the Unitarian Church of 1817 (Fig. III–10) in
reverting even further to the Revolutionary strength and direct-
ness of the 1780s and 1790s.

A third influence on Godefroy's architecture, the intellectual
climate of the times, is perhaps even more important than his
personality and taste. One aspect of late eighteenth-century
habits of thought predominated in Godefroy's attitudes and
methods—that of allegorical expression. Allegory, with its two
levels of meaning and traditionally classical forms, persisted
through the seventeenth and eighteenth centuries and received
new impetus during the Revolutionary period.[16] The concern
for liberty, republican forms of government, and the spirit of
man found artistic expression, in America as well as France,
through the Phrygian cap, fasces, wreaths and palms of victory,
and other symbols of immortality and eternity. Aside from
specific allegorical representations, the symbolic aspect of archi-
tecture was a prominent concern of the Revolutionary age.
Blondel had emphasized the relation between architectural form
and its meaning, declaring that the style should symbolize

[15] Godefroy to Jackson, Richmond, Sept. 7, 1816, Maryland Historical
Society.
[16] For a brief history of allegory, see Edward A. Bloom, "The Allegorical
Principle," *ELH* 18 (1951):163–90. The interest in allegory was so intense
during the eighteenth century that it provoked reactions; e.g., Lessing's
Laokoon, first published in 1766, discussing the limitations of the several
arts, considered the relation between allegory and the methods appropriate
to each of the arts.

rather specifically the purpose of a building. For him symbolism was to be embodied in a classical vocabulary; the five orders expressed the needs to be served by architecture, e.g., the Tuscan for military works, Doric for sacred edifices, Corinthian for royal palaces, and so on. For theorists and practicing architects like Ledoux and Boullée the expressiveness of architecture was as important as problems of construction and practicality of plan, and the richness of the allegorical explanations they offered occasionally makes their writings difficult to understand. Their students retained in varying degrees a respect for the symbolic nature of architectural form, but with the symbolism treated along literary lines and decorative vocabulary expanded. Godefroy made but one use of the word style, writing of his effort to make the facade of the Baltimore Exchange "a little more worthy of the style of a public building and a little less English." He equated style with expressive character and distinguished it from the variety of architectural historicisms he employed in his buildings. Indeed, eclectic quotations from the past virtually disappeared from the Durandesque forms of his "masculine" exchange study; the Gothic details of St. Mary's Chapel (Fig. II–18) and the Tuscan of the Unitarian Church were chosen to lend their linear rhythms and masses to the Blondellian expression of a building's purpose, rather than for the poetic associations prized by the later Romantic age.[17]

Godefroy not only designed but wrote in an allegorical manner, supported and stimulated by his wife, who exhibited the same mental habit. Their personal letters were studded with oblique references, particularly to themselves, but also to other people and to events. Mrs. Godefroy compared her husband to a Corinthian capital, the highest attainment of art, torn from its support and trodden by careless feet. He in turn referred to himself as Apollo, exiled from Olympus and become a mason at Troy. No doubt a noble simile soothed the wounded pride of

[17] For Blondel's use of the orders, see Jacques-François Blondel, *Cours d'architecture enseigné dans l'Académie Royale d'Architecture*, text 6 vols., plates 6 vols. in 3 (Paris, 1771–77), 1:410; on style, see *ibid.*, p. 401n. For Blondel style was the "poetry" of architecture, the source of the character appropriate for a structure; see Robin Middleton, "Jacques François Blondel and the *Cours d'Architecture*," *Journal of the Society of Architectural Historians* 18 (1959):145–46. For the change in symbolism, see Henry-Russell Hitchcock, *Architecture, Nineteenth and Twentieth Centuries* (Baltimore, 1958), p. xxvi, and Sigfried Giedion, *Mechanization Takes Command* (New York, 1948), pp. 329–43. For the Godefroy quotation, see Godefroy to Jackson, Richmond, Sept. 7, 1816, Maryland Historical Society.

these two rather vain people. His selection of literary quotations similarly reveals his attitude and hopes. Drawing up a résumé of his life and achievements in 1837, Godefroy headed it with a quotation from Mazarin: "He is a worthy man, you say? but first of all, *Is he lucky?* Otherwise I shall do nothing for him." He employed a Shakespearean quotation in 1821 as the emblem for his identification in the Salters' Hall competition: "our doubts are traitors, and make us lose the good we oft might win, by fearing to attempt." [18]

The allegorical bent is related, moreover, to the web of mystery and falsification or exaggeration Godefroy wove around his personal history. The problem begins with his very name. Christened Jean Maur Godefroy, he became Maximilien (Maximilian after his move to America) after entering the army in 1794, to avoid confusion with another Godefroy named Jean in the same regiment. He used Maximilian consistently for the rest of his life, sometimes adding unexplained initials. Except for a line in a late letter by his wife, which suggests that his father was Hungarian, there is no reason to doubt that his parents were both French, if not native Parisians. In America Godefroy created a new past for himself, starting with the statement to Jefferson in 1806 that he had arrived in France so young that he looked upon it as his native land. Beyond his wife's single reference to a Hungarian father, the suggestion of foreign birth was not carried further. He did succeed, though, in creating a false nobility for himself; Latrobe often referred to him as the former Count LaMard or St. Mard, and his wife, to her last years, signed herself as Eliza St. M. Godefroy. Godefroy retained this affectation as late as 1825, when he was living in England, but dropped it after he returned to France. It seems that he adapted his story to fit the situation and times.[19]

[18] About to design a military device, Godefroy wrote, "I mount my Pegasus for such a noble subject" (Godefroy to J. Williams, Baltimore, May 21, 1806, Papers of the U.S. Military Philosophical Society, New-York Historical Society). Mrs. Godefroy could not write a letter without complex allusions; see, e.g., those quoted in William D. Hoyt, Jr., "Eliza Godefroy: Destiny's Football," *Maryland Historical Magazine* 36 (1941):10–21. See also E. Godefroy to Jackson, Baltimore, Aug. 23, 1818; Godefroy to Jackson, Richmond, Sept. 7, 1816, and Baltimore, Aug. 13, 1818, all at the Maryland Historical Society. For the Mazarin quotation, see Davison, "Godefroy," p. 177. The Shakespeare quotation is from *Measure for Measure*, act 1, sc. 4, lines 79–81 (Godefroy to the Salters' Company, London, July 18, 1821, Salters' Hall, London).

[19] Davison, "Godefroy," p. 19; Quynn, "Godefroy," pp. 6, 16. The Hungarian lineage may have been an outgrowth of Godefroy's earlier vi-

The way in which Godefroy developed an incident, changing it to fit new circumstances, is shown in his account of his escape in 1804 from the prison-fortress Bellegarde near the Spanish border.[20] When he surrendered at the fortress about two weeks after his escape, he explained that he had merely been searching for proper materials to make an appeal to Napoleon. His story in America was that the Duchesse d'Orléans, mother of the future Louis-Philippe, had made arrangements for Nelson to receive him aboard ship at Barcelona, but that he returned to exonerate the prison commander, who was being held accountable for his escape. Napoleon, Godefroy reported, praised this honorable action and sought his services. When the account was published in England in 1825, however, the emphasis was on his hardships in the Pyrenees, eating acorns, pursued by hounds, and with a price on his head. No mention was made of the Duchesse, Nelson, or Napoleon; perhaps these connections were not timely enough to be useful. His voluntary surrender was mentioned, and his hardships and sacrifice for the sake of honor were stressed to arouse sympathy and perhaps bring him commissions. In December of the following year, to support his request for aid and employment in France, he prepared a résumé of his military and other activities, including imprisonment, in behalf of the royal cause. Those details that have been checked by modern scholars have proved true; the episode concerning the Duchesse was not mentioned, only the escape, the surrender, and the reason for it. In 1837, with Louis-Philippe on the throne, Godefroy sought to improve his position and rewrote the résumé with the role of the Duchesse considerably enlarged. Expanding on her noble character and her concern for him, Godefroy expressed the hope that her interest might be shared by her son.

Godefroy's manipulation of the story to fit varying circumstances parallels his handling of motifs like the fasces and lyre

sions recorded in a fictitious account, *Mémoires d'une famille d'indé-pendans hongrois*, a manuscript seized by the police at the time of his arrest (F⁷ 6366, doss. 7484, Archives Nationales). For his suggestion of non-French birth, see Godefroy to Jefferson, Baltimore, Jan. 10, 1806, vol. 155, Thomas Jefferson Papers, Library of Congress, Washington. On LaMard or St. Mard, see Hamlin, *Latrobe*, pp. 385–86; Hoyt, "Eliza Godefroy," pp. 12, 15, 18, 20–21, where the ligature "St." is misread as "H."

[20] Davison, "Godefroy," pp. 194–97, 200, 211; Quynn, "Godefroy," pp. 9–10; not otherwise referred to is the brief account in Godefroy's résumé of December, 1826 (F¹³ 650, Archives Nationales). The English form of the account was published in the letter of "A. B." to the editor, *Blackwood's Edinburgh Magazine* 17 (1825):414.

in allegorical drawings and sculpture. With respect to the Duchesse d'Orléans, it was the symbolic value of the relationship that was important to him. In disputes with others—with Latrobe and Mills, for example—his symbolic interpretation of events prevented him from comprehending opposing views; rather, he simply tried to avoid such situations in the future. However, if this distorted point of view spelled failure in his daily life, it worked effectively in his art. His successes testify to the degree to which his contemporaries shared his taste and views.

Born of the Enlightenment, the great *Encylopédie* was the monument to society's attempt to reduce human experience to verbal formulas. The allegorical method was natural to its desire for clarity, precision, and rationality: "The iconographic ideal of humanist allegory is to make its emblem yield a single clear meaning or effect." [21] In appealing to the intellect, allegory runs the risk of missing the spiritual content of great art and of becoming superficial, adolescent, and even ridiculous in the eyes of later generations. As often demonstrated in Godefroy's sculpture and drawings, as designs become more completely translatable into words they become less satisfying. Where a work is more an analogue or spiritual equivalent of an idea, it continues to please. This distinction is made perhaps unconsciously by those who are appalled by the allegorical complexities of Godefroy's Battle Monument but find Mills' towering image of Washington's greatness acceptable. The Unitarian Church (Figs. III–10, III–12), however, is strikingly successful as the architectural equivalent of the rationalized religious experience still celebrated there. (In the same way in his monument to Newton Boullée sought to evoke a response to the Sublime by presenting a vast starlit sphere as an image of the genius that discerned the laws governing the universe.[22]) Both the architectural style of the church and Unitarianism itself were offspring of the Enlightenment, and the voluminous, complexly shaped, yet precisely defined church interior accorded with its far-reaching intellectualized fervor. The building pictured the spirit rather than the dogma of religion. Undoubtedly his finest work, it

[21] Harry Berger, Jr., *The Allegorical Temper* (New Haven, Conn., 1957), p. 225; see also Joyce Cary, *Art and Reality: Ways of the Creative Process* (New York, 1958), p. 163.

[22] Boullée's text and drawing are most easily found in Elizabeth Gilmore Holt, *From the Classicists to the Impressionists* (Garden City, N.Y., 1966), pp. 269–71, pl. 30; see also Emil Kaufmann, *Architecture in the Age of Reason* (Cambridge, Mass., 1955), pp. 185–86.

came from Godefroy during one of the most difficult times of his life. His finances were in chaos, his reputation at a low point, his emotional state critical;[23] yet the building displayed a serene balance and austere harmony. A summation of his taste and knowledge, it testifies to a creative force that overrode nonessential and destructive demands and arose from the interaction between the liberal religious spirit and Godefroy's architectural maturity.

Godefroy's habit of recasting a narrative, of reusing motifs with variations in his sculpture and drawings, had its parallel in his architecture. Restricting himself to a small number of motifs, moreover, limited the architectural problems he had to face and thus facilitated his growth as a designer. The primary motif in his works was the prominent open entry, usually arched, flanked by closed rectangular elements. In its simplest form, the sallyport (Fig. II–34) of Fort McHenry, the nice balance between the solid block and the clean-cut hollow was enhanced by the rectangular panels and by the stones in the brick arch. Its first appearance in Godefroy's work, in the Washington Monument project (Fig. II–20), was more diffuse; the circular form of the vault was carried outward in the cylindrical shapes of the columns, and the rectilinear shapes of the piers and top-heavy attic were dispersed to the five blocks grouped around the base. For the corner entry (Fig. II–22) of the Commercial and Farmers Bank the arch and apsidal shape dominated, although contrasting rectangular shapes were emphasized in the steps, the rusticated piers, and the horizontal courses above the cornice.

Variety and complexity were introduced by tripling the opening in large and rich examples of the motif as well as in small and simple ones. In the center of the Baltimore Exchange (Fig. III–1) as built, the three great Venetian windows on the main story and five arched windows on the upper levels emphasize the entrance vault hollowed out of the building. In the coachhouse (Fig. IV–19) at Laval the contrast between opening and solid was exaggerated by the heavy molded arches worked in the bare stuccoed walls. A second variation concentrated the openings in the central section set before or behind the plane of the flanking elements, thus increasing the opposition of solid

[23] In his one preserved letter of 1817, written only five days after the decision to enlarge the Unitarian Church, Godefroy showed his agitation in his nearly illegible hand, incorrect grammar, and incoherence and vehemence of his statements (Godefroy to [Tessier], Baltimore, Mar. 29, 1817, Maryland Historical Society).

and void and making a definitely tripartite facade. The Masonic Hall (Fig. II–25), the Unitarian Church (Fig. III–10), and both projects for the mairie (Fig. IV–22) of Château-Gontier exemplified this variant; in two the columns supported arches, and in two they carried a high entablature or attic, creating rectangular openings. The greater equivalence of the three parts in the Château-Gontier projects undoubtedly resulted from the return to a modern French milieu, while the dominance of the central portion in the earlier Baltimore works reflected the continuing influence of Blondel. Nevertheless, the triangular pediment that entered Godefroy's vocabulary with the Unitarian Church served also to distinguish the portico arch (Fig. IV–16) of the prefecture entrance at Laval, but in the more modern manner. In strong contrast with the flanking lodges, which are large advancing blocks with a heavy masonry treatment, the arch here grows wider and much higher and appears lighter because of its plain unrusticated wall surfaces. It thus becomes a tripartite structure, whose strongly differentiated parts achieve the isolation and independence that were Revolutionary goals. The motif may, of course, be found elsewhere in the history of architecture. Appearing early and running through his career, it served Godefroy as a means of identifying and isolating the entrance.

Certain aspects of the French manner of composing dominated Godefroy's long buildings, quite different in shape from the relatively small and compact structures associated with the entrance motif.[24] Their extreme length is in accord with the generally long and low horizontal silhouette characteristic of the age. The abbatoirs of Rennes were to be one long structure with four similar, equidistant pavilions projecting from each side. The use of wide spacing and repetition to organize a large front with a few similar elements is seen in the Baltimore Exchange study (Fig. III–2), where rows of columns and windows and the end pavilions of both the main building and the projecting portico draw the eye from one side to the other. The shallow five-bay arcade (Fig. III–9) of the Richmond banks was similarly flanked, in this case by the small enclosed sentry boxes. Elements of these two designs are brought together in the Asile de la Roche-Gandon (Fig. IV–7); the flowing movement of the two seven-bay arcades both separates and joins the three strongly defined pavilions. Repetition of identical

[24] This discussion of Godefroy's compositions is dependent on the principles defined in Kaufmann, *Age of Reason*, pp. 188–91.

elements characterizes the facades of the Baltimore Exchange, the Catholic Charities School (Fig. IV–2), and the Asile. The school lacks the widely spaced end pavilions of the Asile, although they were probably intended.

As a concomitant aspect of the design of isolated and independent parts, construction might be carried out in stages as money permitted and need required. Godefroy was familiar with this procedure from Latrobe's recommendations for the Medical College and the exchange in Baltimore. The whole Asile complex was designed for successive building campaigns, while at the Catholic Charities School the next stage of construction never arrived. The concept of juxtaposed sections facilitated the planning of one-story projections for the Baltimore Exchange study, the Richmond banks, and the Château-Gontier projects (Fig. IV–22). A striking antithesis occurred in the Richmond courthouse (Figs. III–6-III–8), where the imposing Roman Doric porticoes were juxtaposed to the massive block of masonry; the flatness and intricacy of the single Venetian window on the long side contrasted with the massive unfluted columns at the ends, and while the smaller arched form led fairly directly to the huge space of the courtroom, the tall orders fronted municipal offices of more limited size. Contrast was a significant aspect of the buildings arrayed on the new place de la Préfecture (Fig. IV–15) in Laval as well.

The handling of these compositional devices in St. Mary's Chapel (Fig. II–18) indicates that it is Godefroy's first substantial design. Here the enthusiasm of the novice resulted in a relatively simple, even obvious interweaving of separate themes, the pointed arch and the rectangle, opposing shapes and sizes. Tension is developed between the widely spaced portals and contrast in the richly worked attic over the simple main wall. The topheavy attic, a feature soon repeated in the Washington Monument project (Fig. II–20), was to be increased by a fantastic tower, itself a topheavy design, nipped in below its topmost pinnacle in a precarious balance. It is of interest that Godefroy intended rectangular windows in the attic, increasing the antagonism of the two basic themes. Diversity and diffusion, also marks of the beginner, linger on in the Washington Monument project.

The new compositional procedures were not designed to give a unity based on dominant and subordinate elements. Rather, the ruling principle of independence required the elements to maintain their separation and equivalence through contrast and differentiation. The base, fascial column, and allegorical figure

of the Battle Monument are three juxtaposed portions, each clearly distinguished by shape and texture and equated by the effects of disproportionality. The gates and vaults (Figs. II–26-II–31) of the Presbyterian Churchyard and the furniture (Figs. III–12, III–17, III–20) of the Unitarian Church approach the same antihierarchical composition through individuation of the parts rather than uniformity.

In most of his designs Godefroy continued the wall above the cornice. Use of the course of masonry on the wall plane was common enough to be characteristic of this age, although Romantic Classicism had no monopoly on it. A reduction of the attic, it accentuated the *appliqué* nature of the architectural decoration, in which the sculpture, bands, and cornices appeared to be applied to the surface, whether on a gatepost (Fig. IV–21) or on a large structure, such as the Catholic Charities School (Fig. IV–2). Godefroy also employed this method, characteristic of the Empire, for decorating furniture, for example, the bronzed ornament of the pulpit, organ, and chairs of the Unitarian Church. In some instances the lack of specific supporting orders or chains increased the surface quality of an entablature.

Godefroy's plans and interiors also show some close parallels with French examples.[25] Five plans are known: St. Mary's Chapel (Fig. II–7); the Richmond courthouse (Fig. III–8), made some decades after its construction; the Unitarian Church (Fig. III–19, in restoration), the project (Fig. IV–22) for Château-Gontier, and the overall layout and foundation plan for the Asile (Figs. IV–5-IV–6). Despite the different purposes of the buildings, all the plans had a traditional symmetry and a rather straightforward, unsophisticated approach to function. In this respect Durand's emphatic separation of the parts of a building became most apparent; portico, vestibule, stairs, and large and small rooms were distinct parts, with an occasional overlap of vestibule and stairway. The parts were so clearly separated that the grand vista through a series of rooms virtually disappeared; the arrangement was eminently practical in permitting circulation and use of stairways without interruption of activities within the church, courtroom, or asylum. The Asile, like the Baltimore Exchange study and the Catholic Charities School, had only one small entrance on the exterior facade, but the through-running hall and several rear exits provided necessary facilities. Over a period of seven years Godefroy worked on

[25] See *ibid.*, pp. 186–88.

plans for five banks, but the total loss of all buildings and drawings has eliminated what might be the best evidence of his functional designing. Without them, however, enough survives to suggest his response to this element in planning. It was partly practical, as in the separation of the entrances, vestibules, and stairways of St. Mary's Chapel, but partly expressive of purpose, as in the emphatic distinction of the chapel nave from the choir and entry. One of his surviving comments on architecture refers to functional planning; he criticized Latrobe's plan for the Baltimore Exchange, saying that his own was more practical and profitable for the owners.

Godefroy's employment of geometric shapes, so popular with some French designers, was more limited, both in number and degree. Only two of his plans and interiors revealed such an interest, those of the Richmond courthouse and the Unitarian Church. The first undoubtedly was affected by the preceding plan of Mills, but the change to a circular courtroom with a square chamber at each corner signaled a major exercise in geometry. Its practicality was lessened by the smaller size of the vestibules, staircases, and gallery access. The interior spatial drama, on the other hand, was heightened; the cylindrical chamber was clearly separated from the contrasting cubical niche for the judicial bench and the tiny semicylinders of the four wall niches. The large shape was not revealed outside, only echoed in the cylindrical lantern on the dome.

Dating only months later than the courthouse, the geometric arrangement of the Unitarian Church was completely different. With few curved elements—the staircases and two vestibule niches—the great arc of the pulpit area was that much more emphatic in the primarily rectilinear plan. There were none of the inconvenient circular corridors of the courthouse, but the two corners flanking the apse were sealed off, completely lost space. Although the Greek cross plan was rectilinear, curves dominated the interior elevation. The four great arches led to a domed segment over the pulpit and short barrel vaults on the other three sides and to the hemisphere overhead, where a circular oculus provided dramatic top lighting. Despite the apparent centrality of the plan, the whole interior space was in fact longitudinal. The cross-axis of the lateral vaults was diminished by aisles and pews, and the pulpit and organ established a focus at either end of the long axis. While the pulpit was a small complex of solids reflecting the interplay of the large voids, the representational aspect of the organ made it a complete contrast. In the white plaster interior the concentration

of rich woods and color on the two foci increased the tension set up at opposite ends of the axis, further countering the centralizing effect of the geometric voids. The arrangement of the sectional drawing to show the two focal points stresses Godefroy's awareness of what he was doing.

While Godefroy's work did reflect developments in French plans and interiors, the abstract geometric interests of the age were subordinated. This was equally true of his exterior compositions. For the courthouse he suppressed Mills' low separate wings and tied the parts together with a high entablature. In the Unitarian Church the minor disengagement of the reinforced corners was negated by the continuous entablature and the slight projection of the portico. On both, the horizontality of the eaves was unbroken; domes rose from roofs without any colonnade or drum disturbing the continuous outlines of the supporting blocks. Where a facade broke into front and back planes, it tended to emphasize a void hollowed out of the mass, as in the entrance of the church, the Masonic Hall, and the Château-Gontier projects. More complex than the early simple apsidal recess found in the Commercial and Farmers Bank, the vestibule expressed the purpose of a specific part of the building, as did the dome over a large hall. Practicality and the expression of purpose assumed more significance than abstract design. Instead of a drastic interpenetration of geometric solids, Godefroy's buildings moved toward the repose and compactness of the simple cube.

Godefroy's work thus shared the formal qualities of French architecture of the later eighteenth century. Certain aspects of the latter were minimized, and Godefroy occasionally revealed an academic trait or a personal innovation. More significant, the generally retardataire nature of his work, which could be paralleled in French work in the provinces, becomes clear. This stylistic dependence not only explains persistent devices like the attic, rusticated masonry or its imitation, and the appliqué treatment of decoration but also clarifies the relations between his designs as successive works of one just beginning in architecture.

Godefroy's preferences in and treatment of architectural forms lay at the base of the differences that developed into a personal quarrel between him and Latrobe. As their correspondence indicates, their dispute was over the matter of style. Godefroy emphasized the importance of content, and Latrobe the formal nature of a building, the grouping of masses. From these comments and the evidence of his buildings it seems clear that the opinions expressed by Blondel had as much significance for

Godefroy as for the slightly earlier Revolutionary architects in France. It is impossible to say whether he perceived a similarity between his aims and those of *architecture parlante*, but the similarity of forms resulted from his effort to be "modern" in a French manner rather than from independent invention. Memory and recent publications were his aids, and having an analytical mind, he recognized some of the new compositional devices and motifs that endowed his work with similar qualities. Perhaps a few elements, like the triangular pediment, derived from Blondel's emphasis on a manner of design common into the middle of the eighteenth century, but Godefroy tended to draw his motifs from the latter part of the century. Several comparisons have been made with the work of Delafosse and Neufforge, all quite characteristic of the third quarter of the century.[26] These examples of borrowing, if such they were, were relatively minor, and some were dictated by the desire for specific allegorical references.

Godefroy drew most heavily from the architecture that was most modern for him, the work of the last quarter of the eighteenth century and the early nineteenth. This was not old or traditional, but rather the work he saw rising in his own day. Its ready approbation in the several publications of Landon, Krafft, and others could only have firmed his resolution to transplant to America the manner of the Revolutionary generations. From this milieu he drew motifs, like the portico recessed into the mass of a building; from this milieu he drew the compositional principles that determined the form of his buildings and to which he subordinated all his borrowings, whatever their source. Durand's *Précis* might have been the basis of his understanding of modern design and construction, but comparisons with Durand's plates suggest that Godefroy did not depend heavily on them. For us, however, the *Précis* represents the modern French style that Godefroy espoused.

Related to the question of style is the practice of eclecticism, the use of characteristic forms borrowed from other, older styles. Godefroy drew from a mixed lot of sources. Nowhere in his work did he attempt an adaptation of a specific older building, as Jefferson did in the Virginia Capitol. He did not use, and perhaps deliberately ignored, works like Stuart and Revett's

[26] In his discussion of Neufforge and Delafosse, Kaufmann emphasized the formal aspects of their work that seemed to him most advanced (*ibid.*, pp. 151–57). Our comparisons have been made on the basis of their being characteristic of their age, whether or not they were innovators.

publication of ancient Greek buildings.[27] Only details, like the orders supplied by Nicholson, appear in his works. The picturesqueness of the Gothic and the exoticism of the Egyptian crop up as well, but again as details on buildings of non-Gothic and non-Egyptian form; if his sources for Gothic are uncertain, we can be quite sure he used Denon and Quatremère de Quincy for the Egyptian. The very modern interest in Italian Renaissance architecture is reflected in a few moldings and door frames, all adapted with slight modifications from Percier and Fontaine's documentation.

Well before the mid-nineteenth century such a use of details was dictated by the romantic associations of exotic and past styles. Godefroy's eclecticism, however, belonged to an earlier stage and was practiced in the shadow of Blondel. When the French drew new inspiration from antiquity in the middle of the eighteenth century, it was not a stylistic revival but rather a search for new or reformed architectural principles. Blondel recommended the obelisk not because it was Egyptian but because of its sacred character or symbolism. He admired Gothic for its structural system and for the appropriateness of its Sublime atmosphere, but neither of these was the reason for reviving it; knowledge of both system and atmosphere, on the other hand, was important for restoration work. Nor did Blondel recommend the revival or the use for poetic associations of the Greek, Roman, and Renaissance styles; rather, he emphasized the symbolic function of the individual orders, e.g., the use of Corinthian for royal palaces. Although his followers may not all have been in agreement on the meaning of these symbols, Blondel's attitude persisted through the stage of *architecture parlante*. Even after the turn of the century, when decorative symbols began to replace architectural forms as the vehicles of meaning, the Blondellian mode of interpretation continued, for example, in the discussions of Legrand and Landon.[28]

To apply Romantic and associational interpretations to Godefroy's work would be both insufficient and incorrect. It is not enough to say that the Commercial and Farmers Bank (Fig. II–21) gave the impression of solidity and substance or that the Battle Monument (Fig. II–37) looked sepulchral. Not until the 1830s did the Egyptian detail of the monument acquire specific mortuary significance;[29] for early viewers its most important

[27] James Stuart and Nicholas Revett, *The Antiquities of Athens*, 4 vols. (London, 1762–1816).

[28] See Chapter I, n. 59, above.

[29] "The Battle Monument," *American Magazine* 1 (1834):25.

symbol was the fasces. Nor should we assume that the Gothic was appropriate for St. Mary's Chapel (Fig. II–18) as an ecclesiastical building, for that stylism had been rejected by the Roman Catholic hierarchy in the case of Latrobe's cathedral design of 1804. The earliest descriptions of the chapel make no attempt to link its Gothic details and "holy thoughts."

Godefroy's eclecticism developed from the French idea that the character of a building lay in the expression of its purpose. Blondel's definitions of sacred and profane, public and private, and masculine and feminine architecture were somewhat expanded and embodied in different forms by the Revolutionary generations; Durand offered architects further flexibility by discarding the classical proportions and spacing of orders. Godefroy employed exotic elements when forms or shapes of an unconventional style gave the desired character, as the Gothic did for St. Mary's Chapel, which was not a public building but private and dedicated to the Virgin. Bold and simplified parts with few but large projections and strong shadows gave an appropriate masculine character to the Commercial and Farmers Bank and the Baltimore Exchange study, public buildings housing activities of economic importance. The seriousness of judicial procedures and of rationalized Transcendentalism required the same large and simple forms for the Richmond courthouse and the Unitarian Church; the Doric and Tuscan orders symbolized the gravity of the buildings and their purposes. The "Italianate" aspect of the coachhouse and gardener's lodge (Figs. IV–19-IV–20) at Laval was perhaps an expression of the humbler purposes of those buildings. Everywhere that he planned sculptural decoration it was to clarify and specify the purpose of the structure through allegorical meanings rather than representing later nineteenth-century Romantic associationism.

That Godefroy adapted the Blondellian symbolism to Revolutionary compositional methods and forms posed no great difficulty, since the latter were developed hand in hand with the concept of *architecture parlante*. His interpretation led to a relatively simple conception of mass and space relationships; there is nothing, for example, of the complex and sophisticated shifting and changing of ceiling levels revealed by a section of the Baltimore cathedral.[30] His American buildings had block-like proportions; the stress on horizontality became stronger in the long low shapes of his European buildings. Isolation and simplification permitted emphasis on the elements with symbolic meaning. Complexity was relegated to the allegorical sculpture

[30] Hamlin, *Latrobe*, pl. 19.

and decoration, which, though sometimes obscure today, had a meaning as explicit as the function of the separate building parts was specific. Although occasionally inclined toward archeological pedantry, as in Rennes, he was willing to use incorrect forms, as well as nonclassical styles, when they possessed an appropriate symbolic character or desired compositional pattern.

A final aspect of Godefroy's work, related to his stylistic expression and to important theoretical developments in France, is the problem of construction. The overlapping and sometimes conflicting demands for expression of the material and expression of the structural system were important questions in the mid-eighteenth century. The anthropomorphic proportions of the orders were brought into question, and research into the origins of architecture led to the primitive cabin hypothesized by Laugier and others. Baroque and Rococo uses of materials were attacked, not on moral grounds alone, but on aesthetic ones as well. Durand questioned the ideal of the primitive cabin, offered his own formulas for determining the proportions of the orders, and found architectural beauty to be a function of structural revelation. Godefroy's claim of experience in both civil and military engineering must also be considered. St. Mary's Chapel, while demonstrating his innocence of building procedures, attests to his desire to build in stone, or at least the appearance of stone. He continued to work in this vein until his late buildings appeared as strong and solid as fortifications. In his last, humble works at Laval the bare stuccoed walls took on an "Italianate" character and the enlarged arches became a major part of the decoration. This exaggerated expression of structure is another sign of the increasing influence of Durand on Godefroy following his return to France.

Structural deceits posed no "moral" problems for Godefroy. He used simulated materials, such as stucco lined as ashlar, even imitation sculpture, frequently, especially in his American works. False construction appeared, too, whether in a rustication conforming to a paper design rather than produced by the actual cutting of stones (Fig. II–38) or in wood and plaster arches, pendentives, and domes (Fig. III–14). Adopted for the sake of appearances, these subterfuges have never created structural difficulties. When opportunities to use stone did arise, he made elements like quoins and voussoirs express and perform as solid structure, as, for example, in the Asile (Fig. IV–8) and the prefectural buildings (Figs. IV–19–IV–20). And in the palais de justice the Renaissance arcuation gave rise to the unusual engineering with inverted arches built into the walls (Fig. IV–13).

In search of technical proficiency Godefroy sought aid from

Latrobe, from builders, from books. By 1812 he assumed nominal superintendence of construction and later sought that work actively, and by his last years he was advising the contractors on his projects. In an age when builders were beginning to style themselves architects, the architect Godefroy also became a builder. An important reason for this unusual reversal must have been his personal predilection for engineering problems.

The taste for building in masonry, evident in Godefroy's earliest American works, was part of his French heritage and was linked in his mind with public buildings in the modern style. Baltimore, on the other hand, was a city of brick, possessing abundant supplies of excellent clay.[31] Brick served for its Georgian and Federal buildings; local stone and marble were available to enrich expensive homes and occasional churches and public buildings. The general use of brick determined the compact, sharply defined block that persisted in Baltimore and perhaps facilitated public acceptance of Godefroy's buildings with their simple, low silhouettes. Although it remained the common material, however, the city awakened to the potential of stone for its monumental architecture. It became the province of "imported" architects, as men like Milleman and Robert Cary Long I were never converted from brick. By necessity Latrobe, Mills, and Godefroy used brick, but stone, real or imitation, was associated with their style, and they were responsible for the five actual masonry structures of the period—the cathedral, the exchange, two monuments, and the Masonic Hall.

Smooth, solid, calm massing characterized the Romantic Classicism these men were establishing not only in Baltimore but throughout America. The Unitarian Church, for example, was one of a small family of similar religious structures built in the first two decades of the nineteenth century, all auditorium-type and essentially geometric in plan. Latrobe's Saint John's of 1815–16, in Washington, and his alterations on Dr. Herron's Presbyterian Church of 1814, in Pittsburgh, used the Greek cross plan in a rather more complex way. Mills was most versatile in this respect: he used the circle in the Sansom Street Baptist Church of 1808–11, in Philadelphia, the Baptist Church of 1817–18, in Baltimore, and a church of the 1820s in Charleston; he used an octagonal plan for the Monumental Church,

[31] Richard H. Howland and Eleanor P. Spencer, *Architecture of Baltimore* (Baltimore, 1953), p. 5; the predominance of brick was the basis of the English traveler Francis Hall's poor opinion of Baltimore's architecture (*Travels in Canada, and the United States, in 1816 and 1817* [Boston, 1818], p. 195).

begun 1812, in Richmond, and for the Unitarian Church of 1812–13, in Philadelphia. William Strickland essayed a similar form in his Temple of the New Jerusalem of 1816, in Philadelphia. They gave the appearance of centralized structures: several had domes, and all lacked the strong vertical accent of towers and steeples common to churches of the eighteenth century and of the medieval revivals soon to come; even Greek Revival belfries began to grow into towers in the 1820s and 1830s. The type was avoided in New York and New England, and it dominated neither the cities in which it was employed nor the work of the architects who used it. In Baltimore, for example, churches with towers and steeples were still being constructed at this time, notably Long's Saint Paul's of 1814–17.[32]

The type appeared primarily in cities with a strong merchant class which supported the modern, international taste in its other buildings of the first two decades of the century. The economic and commercial position of this class in Baltimore was sufficient to make the city a prime target for the British during the War of 1812. Great increases in population and in accumulated wealth had created a need for buildings of every sort, and little monumental public building had been undertaken since the Revolutionary War. The gentleman-architect was disappearing, and design was attracting builders like Milleman, the elder Long, and John Sinclair. Some professional architects paused in their travels from city to city to work in Baltimore. Latrobe provided the designs for the Roman Catholic Cathedral, the exchange,

[32] Hamlin, *Latrobe*, pp. 460–63, pls. 27, 30; Helen M. P. Gallagher, *Robert Mills* (New York, 1935), pp. 77–81 and pls.; Agnes A. Gilchrist, *William Strickland* (Philadelphia, 1950), p. 49, pl. 18A. Christopher Tunnard and Henry Hope Reed attribute the discarding of the steeple to a desire by some sects to avoid display (*American Skyline* [Boston, 1955], p. 67). This may be true for the Quakers; cf. Biddle's Arch Street Meeting House of 1803–5 (Theo B. White et al., *Philadelphia Architecture in the Nineteenth Century* [Philadelphia, 1953], p. 23, pl. 6). The magnificence of many of the churches belies this aim for other sects; cf. the Unitarian churches of Philadelphia and Baltimore. The suppression of the steeple made possible the low, compact, essentially horizontal outline characteristic of the period. Mills, indeed, admired the effect of spires and steeples and planned them for his Charleston and Richmond churches. Godefroy, on the other hand, tended toward the lower, more compact structure; although he drew a stupendous tower for St. Mary's Chapel, he did not build it, and in the version illustrated on the fire insurance policy engraving, it was remodeled as a low, domed belfry. These formal qualities were not limited to a particular group of churches, but rather extended to a number of schools, banks, libraries, courthouses, and other public and private buildings. Nor were they limited to works closely related to the Revolutionary manner; they appeared in the early Greek Revival and the restrained verticality of the early Gothic Revival.

and some private buildings; Mills, who also superintended construction, remained for several years working on the Washington Monument, a church, and domestic commissions; the less successful Ramée offered projects for the Washington Monument and the exchange but actually built only a portico and laid out gardens for his patron Dennis Smith.

The Olivers, Smiths, Pattersons, Carrolls, O'Donnells, and others who were landowners, speculative builders, and political leaders as well as shipowners, had a cosmopolitan outlook. In architecture they sought to emulate European trends, and they were able to express their preferences, for they served as officers, directors, and members of building committees for both public and private works. That the builder Robert Cary Long I used a model by Soane as early as 1807 for his Union Bank is a measure of the demand for modern design in public buildings. During his fourteen years of residence Godefroy himself was associated in some way, as we have seen, with almost every important public building in Baltimore. Most of his commissions there, like those of Latrobe, Mills, and Ramée, can be associated with members of these merchant families. In addition to the depression of 1819, the merchants' loss of political supremacy to the growing mechanics class contributed to Godefroy's decision to return to Europe.

Apparently Godefroy became known as an expensive and demanding architect and one not always easy to deal with on a personal basis. Among the factors contributing to this attitude were his taste for sculptural decoration and masonry construction, fanatic pride in his own talents, and, as Latrobe pointed out, his sharp tongue and ready temper.[33] Certainly there was some basis for his reputation, and it kept him from commissions for what may be generally termed utilitarian buildings. His domestic work was limited to alterations. Not one of the warehouses and mills of the day came from his drawing board. His only work of this nature, at Fort McHenry, occurred during a time of war and desperate urgency when his special knowledge was required.

Despite these limitations, however, during construction and for many years afterward his works received public notice in Baltimore and throughout the country. As much and perhaps more praise was heaped upon the Battle Monument than on Mills' Washington Monument, on the Unitarian Church than

[33] Latrobe to Harper, Washington, Aug. 2, 1815, and Latrobe to J. Small, Washington, June 26, 1816, Letterbooks.

on Latrobe's cathedral or Long's St. Paul's. A generally favorable press admired the appropriateness of the allegorical decoration along with the expressive character and the practical functioning of the buildings. They were described inevitably as solid and handsome additions to the beauty of the city.

In the 1820s and 1830s, after Godefroy's departure, the architecture of Baltimore moved briefly in a direction indicated by his style. Interpenetrating forms, like those of Latrobe's cathedral, gave way to exaggerated block-like shapes, alone or in groups. Occasionally in masonry but frequently in stuccoed brick, exterior walls were articulated by shallow arched recesses that also contained the doors and windows. Architectural sculpture and orders were eliminated and moldings reduced to flat strips. This simplification marked the interiors as well; the vaulted ceilings, circular and polygonal room shapes, and alcoves and recesses that had given sophistication to buildings of the beginning of the century disappeared. The earlier taste had been that of the merchants; the new one was that of the mechanics, and its chief practitioner, William F. Small, was the son of a carpenter-builder who became mayor in the 1820s. In Washington he studied under Latrobe; he returned with him to Baltimore in 1818 to assist on the construction of the cathedral and the exchange, and soon after enlarged and completed Godefroy's Masonic Hall. Almost without ornament, for the cathedral portico was not built until the 1860s, these buildings and the recent Unitarian Church served as immediate sources for the new taste. Mills contributed as well, by the simple large geometry of his Washington Monument and the austerity of his housing in Waterloo Row. This style and its predecessor, the more cosmopolitan style of Latrobe and Godefroy, delayed the inception of the Greek Revival proper and strongly affected its nature. In this way Godefroy's forms and taste survived into the age of Jackson.[34]

[34] This stylistic change has been studied in more detail in Robert L. Alexander, "Architecture and Aristocracy: The Cosmopolitan Style of Latrobe and Godefroy," *Maryland Historical Magazine* 56 (1961):242–43; Alexander, "William F. Small, 'Architect of the City'," *Journal of the Society of Architectural Historians* 20 (1961):63–77.

Appendix:
The Construction
of St. Mary's Chapel

Father John Tessier noted in his journals (now in the archives of St. Mary's Seminary) each significant step in the building of the chapel designed by Godefroy. As a record of construction rare in the early nineteenth century, it deserves wider notice. More to the point here, it offers information bearing upon the relationship between the old *petite chapelle* and the new chapel, the use of the *chapelle basse*, and other questions.

1806

Mar.	29	*j'ai fait accord avec Mr Weis, Sur la batisse de la Chapelle*
	31	on Commence a apporter les briques pour la chapelle.
Apr.	13	*hier je fis marché pour des pierres pour notre chapelle a 12 6. par perche.*
	22	*on a marqué les lignes de la Chapelle future*
	25	on a changé la fence de la Cour d'entrée, pour proposer la place de la nouvelle Chapelle.
May	13	on a trouvé du Sable dans le Creux pour la chapelle basse.
	14	on a Commencé a faire du mortier pour la Chapelle
	17	*on a commencé a batir la muraille* de pierre de la chapelle basse, pour prevenir les aboutements, qui defaut a mesure qu'on Creuse
	22	on a presque fini le mur du fond de la Chapelle basse, ou doit etre l'autel.
June	17	on a fini la muraille en pierre des fondements de la chapelle
	18	on a Commencé les murailles en briques de la chapelle
	26	j'ai fait la benediction de la pierre principale, a la chapelle qui se batit
	27	Ce soir on place les Soling des planchers de la chapelle. on Creuse les fondements de la Sacristie
July	31	on commence a former la façade de la Chapelle

Aug. 19　on a Commencé a Couvrir la Sacristie de la Chapelle

29　la batisse de la Chapelle avance lentement, faute d'ouvriers.

Sept. 10　Les maçons ont fini les murs des Cotés de la chapelle, jusqu'a la charpente; reste encore beaucoup du front à faire

13　on a placé la croix de pierre Sur la porte de la Chapelle, aux premiers vepres de l'exaltation de la Ste. croix.

15　*on a Commencé a placer le toit de la Chapelle.*

26　point d'ouvriers maçons a la Chapelle.

30　on a fini la Retraite [begun the 22nd] par la Benediction dans la petite chapelle.

Oct. 3　on commence a batir la Corniche du front de la chapelle

8　on a commencé a clouer les Shingles du choeur de la chapelle.

22　les maçons ne Sont pas venus.

Nov. 8　on a Couvert tout un Coté du toit de la chapelle dans la journée il etaient jusqu'a neuf Couvreurs a la fois.

1807

Jan. 12　les ouvriers ont Commencé Samedi a niveller, autour de la Chapelle.

Feb. 18　vente SSE. d'une violence extreme, qui a renversé une partie des echaffaudages de la Chapelle, et causé quelques domages.

19　*on place la partie intérieure du clocher de la chapelle*

Mar. 11　on fixe la Situation du Cimitiere, au bout de la chapelle.

21　*on a monté ce matin le petit Clocher, placé Sur la Choeur de la chapelle.*

Apr. 8　on a Couvert le petit Clocher, de fer blanc, qu'on a ensuite peint en noir

May 3　un ouragon de vent, qui a fait Sauter des planchers de l'echaffaudage de la Chapelle, . . .

1808

Mar. 14　on a *commencé a fonder L'autel de la chapelle.*

Apr. 23　on a fini la fence du Seminaire, qui ferme le Cour de devant la chapelle.

May 6　*on commence un grand Crucifix pour mettre au fond du Choeur.*

June 6　Mr flaget es revenu de *Pigeon hill,* et annonce que Mr *Nagot se propose de venir a la benediction de la chapelle.*

15　*on a travaillé a force pour preparer la chapelle pour demain. malgré* la pluie, ce *Soir* on a bien orné le reposoir, au pié du Calvaire.

16　fete du St. Sacrement. *Notre chapelle a été benite par Mr L'Evèque qui y a pontifié.* mais la pluie Constante a empeché La procession de St. Sacrement qu'on Se propo-

sait de faire; les ornements au reposoir ont été faits
inutilement.

19 Ce soir après les vepres, nous avons fait la procession du
Ste. Sacrement autour de la chapelle; Mgr L'Evèque l'a
porté; . . . le reposoir fait [?] Sur le Calvaire etait Superbe.

July 3 j'ai prêché pour la Iere fois dans la chaire de notre
Eglise, *Sur L'Eglise*

17 nous avons cessé de garder le Ste. Sacrement dans la petite
chapelle ou il avait reside depuis le 15 decembre 1791.

1809
Mar. 5 *Ce matin la chapelle basse a été benite, et on y a dit la
messe pour la Iere fois*

7 *on a placé un Confessional dans la tribune de la Chapelle.*

24 j'ai commencé le Soir a me servir de mon nouveau Con-
fessional, a la chapelle basse.

May 24 *on travaille a force au Calvaire, pour le preparer pour le
Reposoir.*

July 6 *on a achevé d'abattre le toit de l'ancienne* petite chapelle,
qu'on va recouvrir, pour servir de chambre.

Dec. 9 on a placé les portes de la chapelle, a la Sacristie, et a la
petite chapelle, et une a la chapelle basse.

1810
Sept. 14 *Ce matin on est allé en procession benir la Croix de
Calvaire.*

1816
Nov. 28 Ce matin Mgr L'Evèque de Boston a consacré la pierre qui
Sert au grand autel de notre Chapelle. on a oté celle qui y
etait deja; parce qu'elle était beaucoup trop petit.

1818
Aug. 11 hier je fis blanchir la Chapelle basse; aujourd'hui on l'a
lavée; et demain on va repeindre les Colonnes, la table de
Communion et les portes et fenetres. on n'avait encore
jamais fait cela, depuis neuf ans et demi, qu'elle sert.

Index

THE JOHNS HOPKINS UNIVERSITY PRESS

This book was composed in Palatino text and Delphin display
type by Monotype Composition Company, Inc., from a design
by Beverly Baum. It was printed on 60-lb. Maple Danforth
408 paper and bound in Holliston Novelex linen by The
Maple Press Company.

Library of Congress Cataloging in Publication Data

Alexander, Robert L 1920–
 The architecture of Maximilian Godefroy.

 (Johns Hopkins studies in nineteenth-century architecture)
 1. Godefroy, Maximilian, fl. 1806–1824. I. Title. II. Series.
NA737.G55A78 720'.92'4 74-6810
ISBN 0-8018-1286-0